*American
Painting of the
Nineteenth
Century*

American Painting of the Nineteenth Century

REALISM, IDEALISM, AND THE AMERICAN EXPERIENCE

Second Edition

BARBARA NOVAK

ICON EDITIONS

HARPER & ROW, PUBLISHERS

NEW YORK

Cambridge London
Hagerstown Mexico City
Philadelphia São Paulo
San Francisco Sydney

1817

For My Mother and Father

FIRST ICON EDITION PUBLISHED 1979

ISBN: 0-06-430099-6
LIBRARY OF CONGRESS CATALOG CARD NUMBER: 79-2093

79 80 81 82 83 10 9 8 7 6 5 4 3 2 1

Contents

Preface 7

Preface to the Second Edition 9

Acknowledgments 11

1. *Prolegomena to the Nineteenth Century* 15
 COPLEY AND THE AMERICAN TRADITION

2. *Washington Allston* 44
 AN AMERICAN ROMANTIC TRADITION

3. *Thomas Cole* 61
 THE DILEMMA OF THE REAL AND THE IDEAL

4. *Asher B. Durand* 80
 HUDSON RIVER SCHOOL SOLUTIONS

5. *Luminism* 92
 AN ALTERNATIVE TRADITION

6. *Fitz Hugh Lane* 110
 A PARADIGM OF LUMINISM

7. *Martin Johnson Heade* 125
 HAYSTACKS AND LIGHT

8. *William Sidney Mount* 138
 MONUMENTAL GENRE

9. *George Caleb Bingham* 152
 MISSOURI CLASSICISM

10. *Winslow Homer* 165
 CONCEPT AND PERCEPT

11. *Thomas Eakins* 191
 SCIENCE AND SIGHT

12. *Albert Pinkham Ryder* 211
 EVEN WITH A THOUGHT

13. *William Harnett* 221
 EVERY OBJECT RIGHTLY SEEN

14. *The Painterly Mode in America* 235

15. *Epilogue* 262
 THE TWENTIETH CENTURY

Notes 289

Brief Biographies of Eighteenth- and Nineteenth-Century Artists 319

Bibliography 335

List of Illustrations 340

Index 345

Preface

This volume has two main purposes. First, it is an attempt to isolate more specifically certain characteristics in American art that we can with some degree of confidence denote as American. The problem, quite apart from any chauvinist or nationalist intent, is whether there is a particular artistic identity that can be defined in terms both of American traditions and experience and of the Western world at large.

Thus, if it appears to raise the old question "What is American in American Art?" it does so with an awareness that *what* is American is sometimes not as apt as *how* is American. For we are dealing not only with indigenous properties but with processes of transformation of European traditions. Those qualities that I would call indigenous are not, I must add, necessarily unique to American art, though they may be unique within its context. In some instances they are not unique at all in the sense of being exclusively absent from other traditions. (Germany, and particularly Scandinavia, can be found to have interesting parallels.) What makes them indigenous is not their uniqueness to America but rather the *frequency or constancy of their occurrence within continuing American traditions to which they also contribute.* Certain concerns, qualities of form, and modes of procedure seem to occur again and again, though time and circumstances may have changed. These characteristics can, I believe, be isolated and defined, though I realize that all such definition is conditional.

The second purpose is didactic, and has to do with the nature of the available literature on American art. Surveys cataloguing countless nineteenth-century artists abound, and they are useful. Normally, the student of American art has to go directly from a survey to a monograph (though some monographs remain unwritten) to find a more thorough consideration of a major figure. My aim has been to provide an intermediary literature of

intensive essays or some of the key figures, and I have deliberately omitted many interesting artists.

These essays are also intended to establish a perspective of ideas against which some of the more important American artists of the nineteenth century can be studied. The artists have been chosen both for their inherent interest and for the way in which their works elucidate the ideas that concern me. Since I am primarily concerned with the American tradition, I have focused mainly on figures who relate most directly to that tradition. Chapter 14, on the painterly mode, deals with those artists who, in my opinion, relate more to European developments. It is intended as a sketch for considering these figures who require, within this context, a volume of their own. Hopefully, the book may also provide some coordinates for locating the works of other artists not included.

I have begun my consideration in the eighteenth century and ended it with the present, in order to frame the period with which this book is concerned, the nineteenth century. It was in the nineteenth century that an American artistic identity was vigorously formed. The myth that that identity was lacking in American art until recently is surely dispelled by the works of art illustrated in this volume. The continuities traced here from the beginning attest to the strength of that identity.

I am aware that this book raises more questions than it answers. Those answers will have to come from further research. Thousands of documents, pictures, and artists are still to be reclaimed and reevaluated. This prospect is a continuing challenge, for it may lead us toward a sharper definition of what Kubler has called a "shape in time": a "visible portrait of the collective identity, whether tribe, class or nation."

Barnard College, Columbia University
April, 1968

Preface to the Second Edition

In the decade since the publication of the first edition, scholarship in the field of American art has matured, and methodology has become more sophisticated. Further study of the ideas forming the matrix for the art has yielded useful insights, in the process establishing firmer liaisons with the field of American Studies.

American artists once lost to us are surfacing; their works are being catalogued and their ideas made available. Some of the missing monographs have been written, or are in progress. Graduate student papers, dissertations and articles have been highly productive. Archival research has proved especially helpful: letters, journals and notebooks, as well as contemporary periodicals, continue to give us a fuller picture of the society and the attitudes that produced American art. Despite all this diligent activity, there seems to be more to do than ever. The "archaeologists" of the American nineteenth century are discovering that the more they dig, the more they find.

Several of the ideas in this volume have been fortified by further research. The relationship of photography to painting in America has received more adequate notice. The connections between primitivism, classic planarism, and concept have become a useful key to the understanding of American pictorial space. Certain national traits, once recognized, have been identified in new contexts.

Some of the ideas offered in the first edition have, however, been misread. Perhaps it is in the nature of interpretation that meanings may sometimes be compromised in ways that quite contradict the original text. Most of these misunderstandings center around luminism and its American traits.

As stressed in the preface to the first edition, my reading of the factors that comprise American luminism does not claim uniqueness for that complex mode, in the sense that certain of its properties are absent from other traditions.

No one nation or group can claim exclusive rights to any single artistic property. The formal repertory of art is not that varied; what is frequently new is the permutation of these forms, cued in turn by social attitudes and assumptions. Each group creates its own blend of artistic traits, a "mix" of form and content, of shape and meaning that emerges from the specific experience of life at a particular time and place. That experience, I believe, registers and is readable in the work of art. The characteristics of "style" can be broken down from the larger period factors to smaller ones of group or nation, and ultimately to the individual. These simple Wölfflinian observations, it seems to me, have proved useful, and thus durable.

Parallels between nations, within the art of a certain period, or even in more extended time sequences, reflect not only formal but philosophical similarities, such as those I have claimed for American art in relation to German and Scandinavian art. Yet the differences will remain, since experiences have different social and cultural roots. These differences enable us to isolate the specific "mix" of factors that marks each national or group contribution. That contribution can, as I have suggested, extend beyond "style."

The American experience tempers its art from the first moment of its making. Yet from that moment, American art is part of the art of the Western world. It enters with indigenous factors, that is, native to this place, that blend with European influences. At any given moment, it partakes of life in the Western world as well as of life in America. Our job is to isolate the factors that make American art what it is. National characteristics, it seems necessary to say, have nothing to do with "nationalistic" rhetoric. They have everything to do with self-recognition. Let us continue to discover who and what we are.

For this edition I have made a few minor corrections in the text and have revised and updated the bibliography.

<div align="right">B. N.</div>

Barnard College, Columbia University

April 1979

Acknowledgments

I am grateful to the countless individuals and institutions who have aided in the preparation of this book. I am particularly indebted to the staff of The New-York Historical Society, to Carolyn Scoon, Wilmer Leech, and Edward Santrucek for cooperation over many years, a consideration that has continually nourished my research in the nineteenth century. Jane des Grange and Anne Klein of the Suffolk Museum and Carriage House at Stony Brook, Long Island, were most generous in giving me access to Mount material. E. Hyde Cox and Caroline Benham of the Cape Ann Historical Association, Gloucester, Massachusetts, were helpful with photographs of Lane's work. Wendy Goodel of the Museum of Fine Arts, Boston, made photographs from the collections available with the greatest good will.

I am indebted to the following publications for permitting me to adapt these articles: *Art News,* "Copley: Eye and Idea," September, 1965; *Bulletin of the Rhode Island School of Design, Museum Notes,* "Thomas Cole," December, 1965; *College Art Journal,* "Asher B. Durand and European Art," Summer 1962.

The ideas presented in Chapter 5, on luminism, were first offered in a lecture at The Metropolitan Museum of Art on "Light and Space in Nineteenth-Century American Landscape Painting," in April, 1965.

I take this opportunity to thank the Trustees of Barnard College, Henry Boorse, Dean of the Faculty, and the Department of Art History for granting me the leave from my teaching duties that made it possible to complete this volume. My gratitude to my mentors and colleagues Marion Lawrence and Julius Held extends far beyond the few years during which the book was in preparation. To Benjamin Rowland, Jr., of Harvard, my thanks for initial encouragement of my work in the American field. I would like also

to mention here the late Maxim Karolik, whose collection and enthusiasm were so important to me.

I am especially grateful to my editor, Brenda Gilchrist, for the generous disposal of her time and many useful suggestions; to Nancy Landau and Ellyn Childs for utmost care with all manner of details; and to Helene Berinsky for dedication to problems of design.

Since many of the ideas presented here were worked out over the years in teaching American art at Barnard and in the Graduate Faculty of the Department of Art History and Archaeology at Columbia, I owe a special debt to my students. I am, of course, not ungrateful to my husband, Brian O'Doherty, for his patience during this volume's parturition.

American Painting of the Nineteenth Century

. . . ridiculous as may seem the dualities in conflict at any given time, it does not follow that dualism is in itself a worthless process. Truth is a river that is always splitting up into arms that reunite. Islanded between the arms the inhabitants argue for a lifetime as to which is the main river.—Palinurus (Cyril Connolly), *The Unquiet Grave*

1.

Prolegomena to the Nineteenth Century
COPLEY AND THE AMERICAN TRADITION

The roots of an enduring American vision were first put down with the mature paintings of John Singleton Copley (1738–1815), from about 1765 to 1774. In Copley's art of this period, the unique relation of object to idea that characterizes so much American realism from colonial times to the present assumes forceful and explicit form (*Ill. 1-1*).

Behind it lies a long limner tradition distilled from national and international sources into a vocabulary relevant to the American experience.[1] That experience can only partly be explained by the lack of direct contact with academic traditions and teaching, for it also involved a need to grasp the idea behind reality, to outline an absolute in the wilderness of the new world.

Whatever the source, the translation into limner style tended to be the same, for the limner, as an untrained artist, presented reality conceptually, as idea, and pinned it down with two-dimensional surface patterns characterized by linear boundedness and equal emphasis of parts (*Ill. 1-2*). But unlike the American folk tradition (*Ill. 1-3*), which maintained fixed characteristics into the twentieth century, it could be said that the limner tradition, though generically primitive, was essentially archaic, having within it the potential for change and development. For the limner often tried to make drapery shine as it did in the available mezzotint examples of the English courtly tradition that made their way across the Atlantic. But he had not yet learned to accommodate idea and observation through nuances of tone and value, and the most frequent result was a summary reduction to flat patterns of light and dark (*Ill. 1-4*). Yet the *intent* to learn, to divine the mystery of academic formulae that more closely approximated the "appearance of reality," is precisely what made the limner tradition an archaic one.

The catalysts for change were to be found in the courtly tradition and in

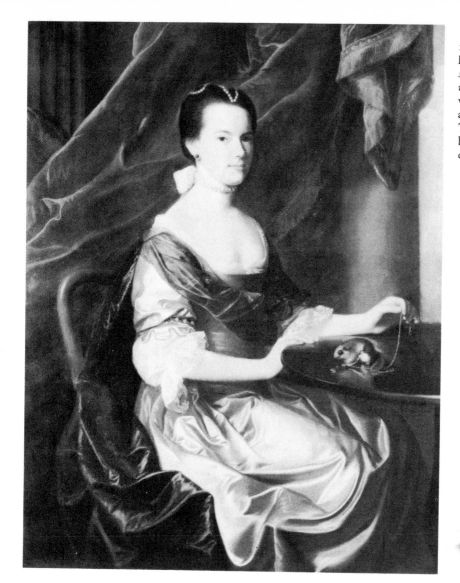

the empirical response to the direct confrontation with the sitter. Thus, Copley's immediate predecessors in colonial portraiture, most especially Feke (1705/10–after 1750) and Blackburn, utilized the formula settings of the English tradition but altered the generalized painterliness of the courtly examples by their more specific responses to the object. In Boston, in the 1750's, Joseph Blackburn, born probably in England, painted some individually observed sitters in glistening satin costumes, though almost all of them shared the "Blackburn smirk," a colonial version of Leonardesque archaism. Robert Feke's figures were more solid than the limner portraits that preceded them, but their flesh and attitudes were curiously wooden, like geometric manikins composed of Locke's primary matter (*Ill. 1-5*). It

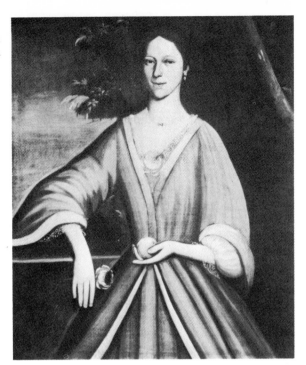

1-2 Anonymous: *Lavinia Van Vechten, ca.* 1720. Oil on canvas, 39 x 33¾ inches. Courtesy of The Brooklyn Museum, New York.

1-3 Anonymous: *Girl in Red, ca.* 1830–40. Oil on canvas, 53¼ x 39 inches. Courtesy, Museum of Fine Arts, Boston; M. and M. Karolik Collection.

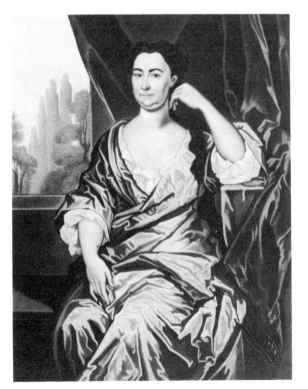

1-4 Attributed to John Watson: *Mrs. Kiliaen Van Rensselaer (Maria Van Cortlandt)*, n.d. Oil on canvas, 50 x 40½ inches. Courtesy of The New-York Historical Society, New York.

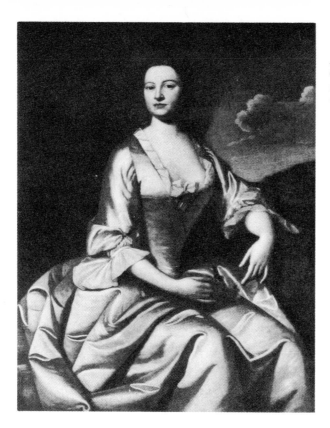

1-5 Robert Feke: *Mrs. Josiah Martin, ca.* 1748–50. Oil on canvas, 50½ x 40½ inches. Courtesy of The Detroit Institute of Arts.

remained for Copley to carry Feke's advances further, to abandon formula even more radically for the specific, moving the archaic tradition toward a special kind of colonial classicism.

Copley grew out of the limner tradition, sophisticating his earliest ideographic forms through the snob attributes of landscape backgrounds, poses, and so on, that he found in the courtly mezzotints. His early work was characterized by a pull toward the plane, an over-all uniformity of painted surface, and an equalization of parts and linear distinctness that continued far into his maturity. In the early portrait of *Mrs. Joseph Mann* (1753) (*Ill. 1-6*), there is an acquaintance with and reliance on a *recipe,* a formula, for making pictures, as well as a practical conceptual bias—a belief in the *idea* of what is seen. The more specific and solid quality of the head also indicates a strong empiricism, which was to temper and qualify these abstract properties as he developed.

Like that of the primitive artist, Copley's intent was to record reality as clearly and accurately as possible. But the true primitive never seems to learn the mastery of volume and texture that could lead him toward the *trompe l'oeil* representation to which he often seems to aspire. It is as though his eye, idea-bound, cannot really comprehend either the empirical example of a three-dimensional reality or the academic formula that could teach him to approximate sensations of reality through properties of light

and color as conveyed by brushstroke. As Gombrich has stated so well, the primitive "makes," he does not "match."[2]

Copley's sensibility was largely that of "maker"—not "matcher." Like the primitive, he found it necessary first to establish the essential and unbroken identity of an object through linear contour. But, unlike the primitive, he could direct his eye with painstaking curiosity to the reality that he not only knew and saw but could feel and experience tactilely (*Ill. 1-7*).

Again unlike the folk primitive, but following the example of the archaic limner tradition that was his generic root, he cast half an eye always on the example of the courtly tradition (stemming from Van Dyck) that was the paradigm of the academic painterly formula for "matching." This tradition, which always held for him the snob appeal of its educated European origins, was ultimately to master and, in many ways, destroy him after he fled from Boston to Europe during the colonial disruptions of 1774. Holding out a Utopian dream of access to the noble superiority of the Grand Style, it lured abroad many other Americans—West, Trumbull, Vanderlyn, Morse, Allston, Cole—in search of a heroic ideal they could not find or did not see at home, creating schisms in their works that caused them to paint like children of divorced parents—as indeed they were—with visiting rights on one side of the ocean or the other.

In his colonial phase, however, the courtly tradition seems to have served Copley as it had the limners, furnishing props and setting that he alternated sporadically with the simpler, less derivative settings more appropriate to the

1-6 John Singleton Copley: *Mrs. Joseph Mann (Bethia Torrey)*, 1753. Oil on canvas, 35⅘ x 28³⁄₁₀ inches. Courtesy, Museum of Fine Arts, Boston; Gift of Frederick H. Metcalf and Holbrook E. Metcalf.

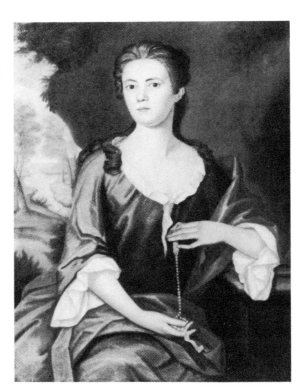

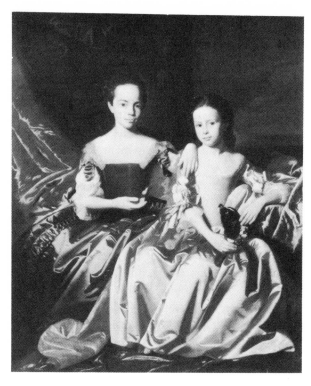

1-7 John Singleton Copley: *The Royall Sisters, ca.* 1758. Oil on canvas, 57½ x 48 inches. Courtesy, Museum of Fine Arts, Boston; Julia Knight Fox Fund.

lives of the colonists he painted. Yet perhaps a subtler effect of the courtly style on Copley's early development may have been to instill in him the goal of "matching"—a goal he did not really attempt to fulfill stylistically until he had brought the conceptual realism that grew out of primitive "making" to its logical conclusion.

For in his mature American works, Copley depends much less on formula. In an exciting self-reliance, his conceptual bias is modified by his pungent empiricism. This leads to his specific kind of ideal or conceptual realism— idea is amplified to become form. To say it differently, abstract knowledge is fortified by the *stuff* of empiricism, distinctive and tactile properties of objects, qualities of weight and texture. The object, as it were, *presents* itself, and the result is a "higher coefficient of reality," making the real somehow more than real. Predictably, on occasion, as with *Mrs. Ezekiel Goldthwait* (*see Ill. 1-18*), there is the switch of the animate to the inanimate, the inanimate to the animate. The face, painted with relentless responsibility to likeness, tends toward still life, while the brocades, satins, and shining table top are filled with a suppressed vitality (*Ill. 1-8*).

The magic of this illusionism is too easily passed off as *trompe l'oeil*. It is one of the great art historical mysteries, an alchemistic transmutation of paint into texture that has to do not only with the empirically developed ability to control the subtlest tonal nuances but also with the removal of the artist's intermediary presence through a virtual erasure of brushstroke. The

1-8 John Singleton Copley: *Mrs. Ezekiel Goldthwait* (detail).

object thus created takes its place beside other examples of so-called magic realism in the history of art—beside the Flemish Eyckian tradition of conceptual realism, which emerged, as did Copley, from an abstract tradition (though a medieval one) and continued ultimately into the suggestive realism of the painterly Rubens–Van Dyck line, as did Copley himself in his

1-9 Raphaelle Peale: *Still Life, ca.* 1820. Oil on panel, 18½ x 22½ inches. The Toledo Museum of Art, Ohio; Gift of Florence Scott Libbey.

21

English period. Thus, Copley's early realism is, in some respects, as Wölfflin has certainly made us aware, a problem in the history of vision. We can perhaps gain better understanding of it if we consider it in the context of other examples of such realism—Caravaggio, Sánchez Cotán, Menéndez and, in America, a good part of the nineteenth-century still-life tradition (*Ill. 1-9*) that culminated in William Harnett toward the end of the century (*see Ill. 13-1*).

Perhaps we can come closer to an understanding of the significance of Copley's realism as a unique union of object and idea when we consider the cultural history of the object, or thing, within the American experience. Even earlier than Copley, Jonathan Edwards, the great New England preacher and theologian (1703–58), had sought to make the jump from word to idea via the thing, maintaining that in the education of children "the child should be taught to understand *things,* as well as *words.*"[3] As Perry Miller has observed, Edwards, inhibited by dogma, tried to suppress his own mystical and pantheist inclinations, yet had sought "the images or shadows of divine things" in nature.[4] Copley gave existence to the thing through an American empiricism determined to conquer the physical rather than philosophical presentation of substance. Like Edwards, he did not stress the mystical, but implied it nonetheless through an intensity that transcended the real. He thus set the stage for a mode of vision that, "once the husks of dogma"[5] were discarded in the nineteenth century, could more freely indulge, through the licenses of Transcendentalism, in a philosophical as well as physical union of idea and thing—a union that presupposed the pantheist and mystical fusion of God and nature. For Emerson, "The feat of imagination is in showing the convertibility of every thing into every other thing. Facts which had never before left their stark common sense suddenly figure as Eleusinian mysteries. . . . All the facts in nature are nouns of the intellect, and make the grammar of the eternal language."[6] To the transcendental mind, object and idea were one, and all matter was an extension of God. Thus, the landscape artists, and especially the luminists after Copley, could value the smallest fact in nature—the leaf, the pebble in the foreground of a Heade landscape (*see Ill. 7-4*)—and embrace also the larger equivalence of God with nature through the infinite space of a Kensett distance (*see Ill. 5-12*) or the other-worldly light of a Bierstadt sky (*see Ill. 5-7*).

Respect for nature as evidence of God's handiwork was to become one of the major aesthetic tenets of the nineteenth century, at least until the end of the Civil War. In 1855, the *North American Review* proclaimed, "the mountains and the ocean, the forest and the river, the blooming clover and the waving grain, the wondrous forms of animals and of man and woman, touch us with the same emotions as the perception of intellectual truth and the contemplation of virtuous deeds. They are manifestations of the moral

and inner life of the world, of the Eternal Mind whose thoughts are constant laws, and which is revealed alike by the small and the great, in each as in all."[7] And one of the most important and perceptive of American critics, James Jackson Jarves, wrote as late as 1864, "the artistic love which animates modern landscape is based upon the feeling that it is not, as the ancients in general fancied, the material expression or disguise of many gods, but the creation of the one God—his sensuous image and revelation, through the investigation of which by science or its representation by art men's hearts are lifted toward him."[8]

The continuous critical caution against tampering too much with God's world might, in fact, be what kept the imagination at bay, and may explain why pure imaginary romanticism was rare in America; romanticism was more likely to appear guised in the super-real techniques finally appropriated by the more obvious fantasy of the surrealists in our own century. In this century, too, though nineteenth-century moral and religious considerations have been virtually obliterated, Americans are still uniquely aware of *things.* For the need to grasp reality, to ascertain the physical *thereness* of things seems to be a necessary component of the American experience. Jarves' mention of scientific investigation reminds us of the important coincidence of aim and attitude between artists and scientists in America. From the very beginning, artists in America have tried to create measurable certainties and have utilized scientific, mathematical, and mechanical aids to achieve their aims.

In Copley's *Mrs. Goldthwait,* the impact of the object, which is presented with ultra-clarity (the laces, as it were, resewn into the canvas), depends not only on a skin of surface texture but ultimately on properties of weight and volume. Copley's American sitters displace space; yet without stroke, time freezes, and they exist in hermetically sealed environments. Their personalities are synthesized painfully out of repeated encounters, the characteristic laboriously distilled from the transient.

This essentially conceptual vision, tempered by the primitive urge toward the clarity of the known and the bounded, would seem to be a dominant quality in American art from Copley on. It is a mode of seeing and feeling (for the projection of feeling into these objects is as intense as the more obvious feeling-into-paint of an Expressionist) that was shared by the American luminists Martin Johnson Heade and Fitz Hugh Lane in the nineteenth century and by, for instance, Charles Sheeler with his clarified geometries in the twentieth. Often resulting in a kind of classicism of the fixed and contained, it characterizes Copley's finest portraits of the American period, giving to *Mrs. Goldthwait* or to *Mrs. Richard Skinner (see Ill. 1-21)* a monumentality of the specific, in which object and sitter share the personality of matter.

1-10 John Singleton Copley: *Portrait of Paul Revere, ca.* 1768–70. Oil on canvas, 34⅘ x 28½ inches. Courtesy, Museum of Fine Arts, Boston; Gift of Joseph W. Revere, William B. and Edward H. R. Revere.

It could also be said, however, that Copley's concern with the thing led him to treat people as things, that he was actually a still life painter of portraits. This was hardly to be avoided, since his search for the characteristic and the essential, which necessitated innumerable sittings, could, in removing all evidence of the transient moment, also remove all sense of flesh and blood. Capturing the moment of *being* rather than *becoming* (an attitude that was to run through much American art that followed in the nineteenth century), his planar classicism was in some respects almost an embalming process. There is the perfect simulacrum, but perhaps little psychological penetration.

Yet in portraits of people whom Copley knew well, such as Paul Revere (*Ill. 1-10*) and Nathaniel Hurd (*Ill. 1-11*), where the subject is presented much closer to the picture plane and rendered informally, with little or no recourse to courtly setting, he managed to penetrate the shell of surface likeness and allow the eyes to become "the windows of the soul." The *Portrait of Nathaniel Hurd* offers a clue to Copley's failures in other works at "living

24

I-II John Singleton Copley: *Portrait of Nathaniel Hurd, ca.* 1765. Oil on canvas, 30 x 25½ inches. The Cleveland Museum of Art; John Huntington Collection.

portraiture." For here a slackening of intensity enables the figure to be handled more spontaneously. This release from his strict conceptualism allows the movement necessary to imply breath and life. Perhaps this is one of the several reasons why Copley changed his style so completely when he reached England. Ultimately, he was willing to sacrifice the intense penetration of things to a style that captured more genuinely the substance of flesh, a change from the inorganic to the organic.

That sacrifice, however, was long in coming. Before it occurred, Copley had painted some of the greatest names in colonial history: Samuel Adams, Paul Revere, and John Hancock all sat for him; dutifully recording their faces, he painted Whigs and Tories alike, trying desperately to retain an artist's neutrality between them.

Yet it is doubtful that Copley himself ever fully valued his portraits. Like Samuel F. B. Morse and Washington Allston after him, he preferred another kind of history painting—more noble and ambitious. Compared to what little he knew of the Grand Style, his American portraits, with their

25

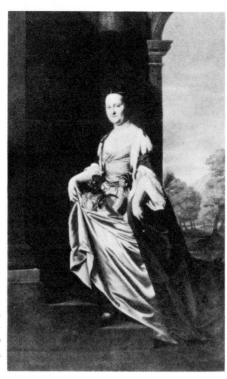

I-12 John Singleton Copley: *Portrait of Mrs. Jeremiah Lee,* 1769. Oil on canvas, 94⅞ x 58⅞ inches. Courtesy, Wadsworth Atheneum, Hartford; Ella Gallup Sumner and Mary Catlin Sumner Collection.

differentiated stuffs and particular rather than universal qualities, must have seemed inferior to him. When he sent one of his masterpieces, *Boy with a Squirrel* (1765), a portrait of his half brother Henry Pelham, to London for exhibition at the Society of Artists in 1766, Benjamin West wrote to him (August 4, 1766) that:

> ... while it was Excibited to View the Criticizems was, that at first Sight the picture struck the Eye as being to liney, which was judgd to have arose from there being so much neetness in the lines, which indeed as fare as I was Capable of judgeing was some what the Case. for I very well know from endevouring at great Correctness in ones out line it is apt to Produce a Poverty in the look of ones work. when ever great Desition is attended to they lines are apt to be to fine and edgey. This is a thing in works of great Painter[s] I have remark[ed] has been strictly a voyded, and have given Correctness in a breadth of out line, which is finishing out into the Canves by no determind line when Closely examined; tho when seen at a short distanc, as when one looks at a Picture, shall appear with the greatest Bewty and freedom.[9]

There is a note of desperation in Copley's communication to West on November 12, 1766:

It would give me inexpressable pleasure to make a trip to Europe, where I should see those fair examples of art that have stood so long the admiration of all the world. the Paintings, Sculptors and Basso Releivos that adourn Italy, and which You have had the pleasure of making Your Studies from would, I am sure, annimate my pencil, and inable me to acquire that bold free and gracefull stile of Painting that will, if ever, come much slower from the mere dictates of Nature, which has hither too been my only instructor.[10]

Feeling frustrated and deprived, he continued: "I think myself peculiarly unlucky in Liveing in a place into which there has not been one portrait brought that is worthy to be call'd a Picture within my memory, which leaves me at a great loss to gess the stile that You, Mr. Renolds, and the other Artists pracktice."[11] And, in a later letter to either West or Captain R. G. Bruce, he complained:

A taste of painting is too much Wanting to affoard any kind of helps; and was it not for preserving the resembla[n]ce of perticular persons, painting would not be known in the plac[e]. The people generally regard it no more than any other usefull trade, as they somtimes term it, like that of a Carpenter tailor or shew maker, not as one of the most noble Arts in the World. Which is not a little Mortifiing to me.[12]

The attributes of the courtly tradition turned up in his settings from time to time, threatening the frugal morality of his style. Sometimes he went on an ambitious courtly binge, and the results were affected and ludicrous, as in the full-length *Portrait of Mrs. Jeremiah Lee,* of 1769, a fat provincial dame mincing heavily in rococo costume (*Ill. 1-12*). He couldn't wait to give it all up. He left for Europe in 1774, with the cries of compatriots dumping his father-in-law's tea into Boston Harbor still ringing in his ears, having already established in his American works a discernible American vision with a continuing tradition.

THE EXPATRIATE TRADITION

When Copley arrived in London, he unknowingly became one of the early founders of an American expatriate tradition that has offered a constant dialectical foil against which the more indigenous aspects of the American vision can be measured and judged. This volume deliberately places less emphasis on that tradition, because it is my belief that American art is too often judged solely in relation to European developments, without sufficient attention to the shaping factors in the American experience.

Of course, the conventions offered by the European traditions have sporadically affected the nature of American art, depending on whether it was in a more native or international phase. When transformed and assimilated to the needs of an American expression, these European modes have become

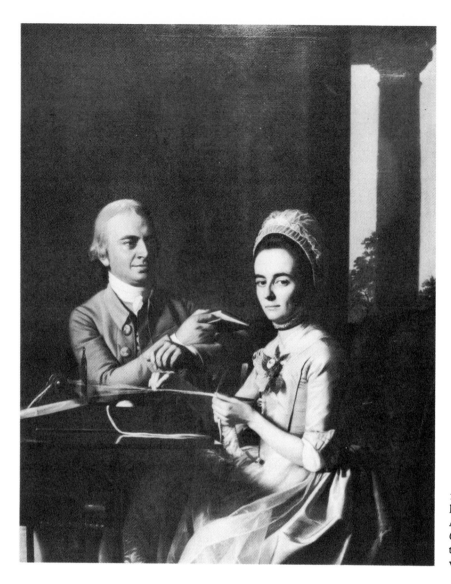

1-13 John Singleton Copley: *Mr. and Mrs. Thomas Mifflin,* 1773. Oil on canvas, 61½ x 48 inches. The Historical Society of Pennsylvania, Philadelphia.

a vital aspect of an American style. Insufficiently digested or inappropriately adapted, they have been responsible for a curious kind of unresolved graft of alien forms and subjects onto a more indigenous idiom. With Copley, they robbed a great individual of his uniqueness and submerged him in the collective manner of a school.

The change in the expatriate Copley came quickly. In the span of two years, from *Mr. and Mrs. Thomas Mifflin,* of 1773 (*Ill. 1-13*), to *Mr. and Mrs. Ralph Izard,* painted in Rome in 1775 (*Ill. 1-14*), tactile properties of specific objects begin to give way to a uniform painterliness, and simplicity to crowdedness. The concern for specifics is still sufficient to enable

archaeologists to recognize a vase by the Niobid painter in the upper left corner, but with the compulsion of the *nouveau riche,* Copley displays all the gold that glitters.

During his Grand Tour, before settling down in England, Copley swallowed as much old master technique as he could. He wrote to Henry Pelham in 1775, "Raphael has studied the life very carefully. his Transfiguration, after he had got the composition of it on the Canvis, he has painted with the same attention that I painted Mr. Mifflins portrait and his Ladys."[13]

The same letter reveals his inner struggle between idea and the use of memory on the one hand, and working from the model on the other, that same struggle between concept and empirical experience that had characterized his early development—now, however, beginning to shift in still another direction:

1-14 John Singleton Copley: *Mr. and Mrs. Ralph Izard,* 1775. Oil on canvas, 69 x 88⅝ inches. Courtesy, Museum of Fine Arts, Boston; Edward Ingersoll Brown Fund.

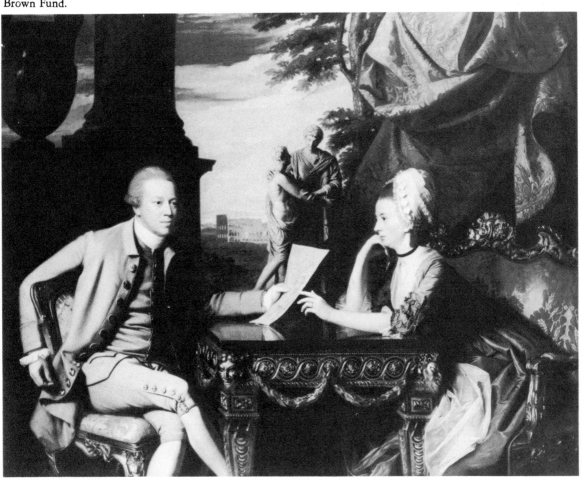

I will not contend with those that say a man may paint from his Ideas only, for I will admit it; I will admit that all men do; only I will observe that the Memory of all men is not equilly retentive. . . . for all our Ideas of things is no more than a remembrance of what we have seen. so that when the Artist has a model in his Appartment and Views it, than turns to his picture and marks whatever he wishes to express on his Picture, what is it but remembrance of what he has seen? . . . we see all Ideal performances of but little merit, and those who have made the great figure in the Arts are those that have shewn more jeloussy of the goodness of their memory and refreshed it by having the life by them.

He had imagined that Titian's works were ". . . Painted in a Body of Oyl colours with great precision, smooth, Glossy and Delicate, something like Enamil wrought up with care and great attention to the smallest parts, with a rich brilliantcy that would astonish at first sight." But when he saw them, he "found them otherwise. . . . Titiano is no ways minute, but sacrifices all the small parts to the General effect."[14]

It is perhaps fortunate for those of us who prefer Copley's American style that he was then so ignorant of Titian's works, for the qualities he supposed Titian to have are the very ones that characterize his own best achievements. The change in him lay precisely in his discovery of what the painterly tradition was all about: the sacrifice of the "small parts to the General Effect."

Yet what occurred as the English style developed was not only a simple Wölfflinian change from linear to painterly, from plane to recession, though this it was too. It was also an exchange of the essentially primitive re-creation of the *stuff* of reality for the learned European formula wherein quick bravura stroke approximates sensation—impulses of light, color, and atmosphere. The weight and texture of the object were ultimately sacrificed to the neutral demands of a Grand Style, necessitating the dissolution of all tactile distinctions in a common integument of brushstrokes.

Within this formula, a different kind of return to the reliance on formula with which he began, Copley still managed to produce such magnificent late portraits as *Mrs. John Montresor (Ill. 1-15)*. He had made atmospheric discoveries. He was on occasion able to penetrate the personality of the sitter. But he was now no longer an isolated and unique talent, sharing with the van Eycks and the Caravaggios of this world a rare ability to apprehend the hidden core of object reality. He was instead a good, at times excellent, portraitist, operating within the established and accepted English tradition.

To compare his achievements in his English phase with those of Gilbert Stuart (1755–1828) may be instructive. Had Copley really been able to make the jump from the conceptual realism of the indigenous American tradition to the painterly fluency of such English painters as Gainsborough, one might not have any serious objections to the change in style. But, with few exceptions, the change was also one of quality. We can ask ourselves how much

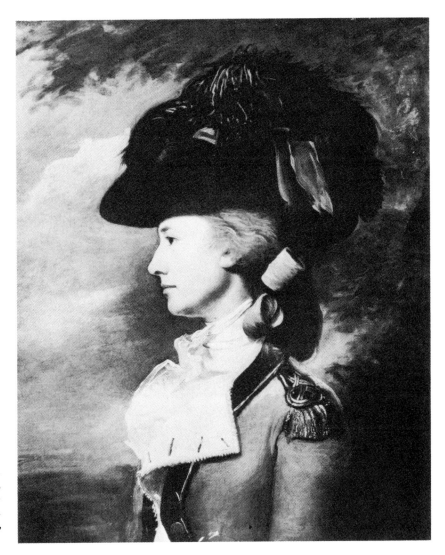

1-15 John Singleton Copley: *Mrs. John Montresor*, 1776–80. Oil on canvas, 30⅜ x 25⅛ inches. Collection, Mr. and Mrs. Richard I. Robinson, Greenwich, Connecticut.

the adoption of the new style was due to a sense of inferiority and inadequacy in the face of the grander European traditions, how much of it had to do with the durable American feeling that the European way must be better. How much did the surrender of individualism to the dictates of a school affect Copley's truth to his deepest feeling?

Gilbert Stuart, by contrast, was almost from the outset a painterly artist. He was also largely an expatriate, who received the greater part of his training abroad, first briefly in Scotland (1771/72–73), then, from 1775 on, in England and Ireland; he returned to America as a mature artist in 1792.

Thus, for all the chauvinism attached to his participation in the Washington legend, he cannot really be considered a wholly American product. Stuart's earliest works, executed in America in 1773–75, after his initial trip to Scotland with the Scottish artist Cosmo Alexander but before his long internship abroad, grew like Copley's out of an ideographic linear tradition (*Ill. 1-16*). But here already there is a weightlessness of form that anticipates the ultimate feather-lightness of his stroke. Perhaps it was this disposition to delicacy, this natural facility for the painterly, that made Stuart capable, as few American artists have been, of mastering the European painterly conventions. This facility could find ample room for development in the England of Gainsborough, and it is not surprising that Stuart's brilliant portrait of William Grant, *The Skater* (1782) (*Ill. 1-17*), was attributed to Gainsborough in an exhibition at the Royal Academy in 1878.[15]

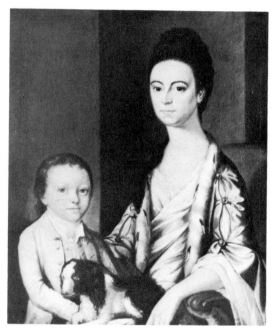

1-16 Gilbert Stuart: *Mrs. John Bannister and her Son, ca.* 1774. Oil on canvas, 36 x 30 inches. Redwood Library and Athenaeum, Newport, Rhode Island.

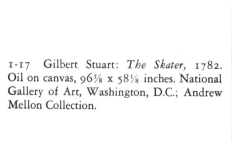

1-17 Gilbert Stuart: *The Skater,* 1782. Oil on canvas, 96⅛ x 58⅛ inches. National Gallery of Art, Washington, D.C.; Andrew Mellon Collection.

1-18 John Singleton Copley: *Mrs. Ezekiel Goldthwait,* 1770–71. Oil on canvas, 50 x 39½ inches. Courtesy, Museum of Fine Arts, Boston; Bequest of John T. Bowen.

Stuart's sensibility, again in direct contrast to Copley's, was that of a proto-Impressionist. He was quick, impatient, eager to catch the momentary aspect of the sitter, aware of the luminous possibilities of brushstroke as applied through the layered glaze technique, and as indifferent to the object as Copley was obsessed with it. Clothes and still-life appurtenances hardly interested him. One of the most telling of Stuart's comments was made to the painter John Neagle (1796–1865) and quoted by William Dunlap: "While criticizing a half-finished engraving, he would not talk of *breadth, drawing, proportion,* or the like; but would say of a portrait, 'this man's eyes appear as if he was looking at the sun'. Instead of saying 'make a background *neutral,*' he would say 'make nothing of it'."[16]

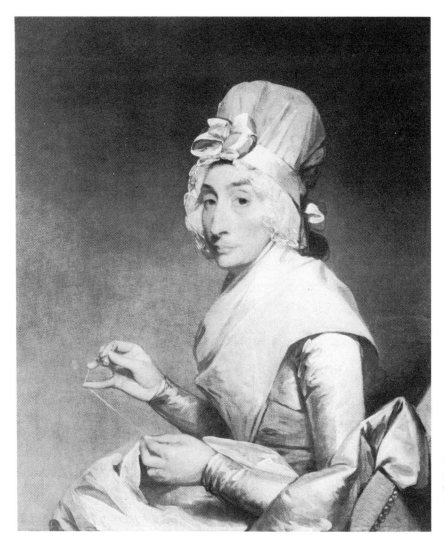

1-19 Gilbert Stuart: *Mrs. Richard Yates,* 1793–94. Oil on canvas, 30¼ x 25 inches. National Gallery of Art, Washington, D.C.; Andrew Mellon Collection.

What concerned him almost exclusively was the mobile expressiveness of the face and the sensuous quality of paint for its own sake—both essentially properties of the European rather than the American tradition. Yet it is especially important to emphasize that Stuart was one of the few American expatriates who was thoroughly capable not only of assimilating but, more important, of transforming the European mode. He was able to fortify his understanding of the European "matching" formula with an American pragmatism underscored by his remark to Neagle, "While you have nature before you as a model, paint what you see and look with your own eyes."[17] And when he told his student Matthew Jouett, "No blending, 'tis destruction to clear & bea[u]tiful effect. it takes of the transparency & liquidity of colour-

ing & renders the flesh of the consistency of buckskin,"[18] he was establishing a painterly tradition of transparent luminosity that was to run through much romantic art in America as part of what may be called an "alternative convention."

Copley often ended up with buckskin. When Stuart returned to America, it was with an awareness of Copley's American portraits that caused him to tighten his style slightly, and to display a short-lived interest in the object and the arrested moment. Thus, comparing Stuart's *Mrs. Richard Yates,* of 1793–94 (*Ill. 1-19*), with Copley's *Portrait of Mrs. Seymour Fort* [?] (*Ill. 1-20*), an English Copley until recently ascribed to about the same time, we encounter these disparate artists at a rare moment of juncture. Stuart, developing out of the painterly and suggestive, moves toward a somewhat weightier depiction of the object, with its concomitant textures, and open

1-20 John Singleton Copley: *Portrait of Mrs. Seymour Fort*[?], *ca.* 1778. Oil on canvas, 49½ x 39⅝ inches. Courtesy, Wadsworth Atheneum, Hartford.

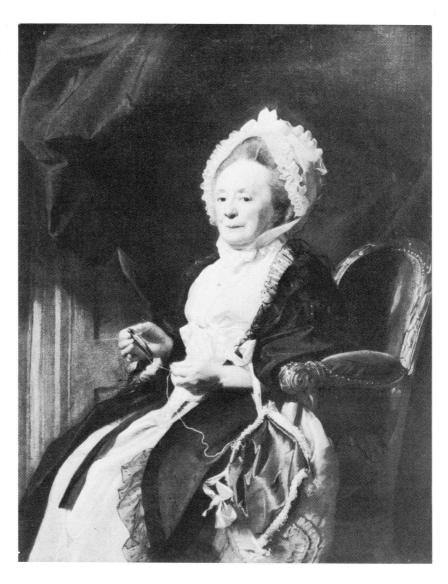

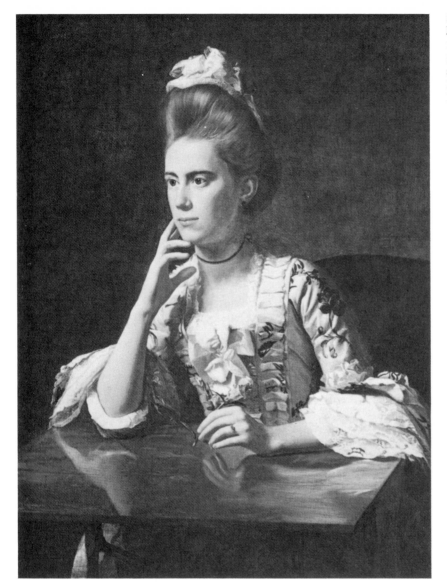

1-21 John Singleton Copley: *Mrs. Richard Skinner,* 1772. Oil on canvas, 39⅘ x 30½ inches. Courtesy, Museum of Fine Arts, Boston; Bequest of Mrs. Martin Brimmer.

stroke is held in a new balance with line. Copley, in transit from the opposite direction, lessens the intensity of object reality with an atmospheric activation of stroke, breaking the hermetic seal of environment. A similar tempering of the European painterly formula with an American stress on the unbroken identity of weighted form (or vice versa) characterized the line of portraitists including Thomas Sully (1783–1872), who in the early

36

nineteenth century followed Stuart's example in forging a link with the English portrait tradition (*Ill. 1-22*).

But for Copley, even such a merger was insufficient. Once the history painting bug had bitten, portraiture alone could not satisfy him. His sense of status in the artistic hierarchy was contingent on his involvement with the Grand Style. In thus seeking out within the older European traditions a heroic tradition that he could not find in the New World, he helped to set the framework for a continual process of borrowing, both formal and iconographic, that was to characterize the "ideal" aspect of American romanticism well into the nineteenth century. (In still another sense, the American search for a tradition was ultimately converted into a concern for anything old and past; much American realism, both still life and genre, was thus transformed into a form of nostalgic romanticism.)

The earliest manifestation of this American tropism toward the venerable was, however, more nostalgically neoclassic than romantic. For the Pennsylvania Quaker Benjamin West (1738–1820), after he had spent a few years in Rome, neoclassicism as practiced by the German artist Anton Raphael

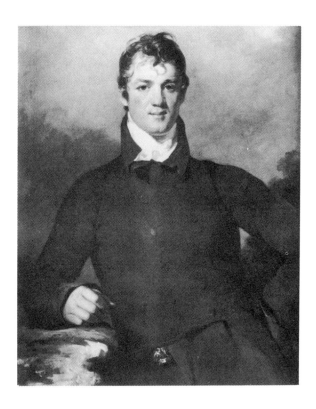

1-22 Thomas Sully: *John Myers,* 1814. Oil on canvas, 36 x 30 inches. Courtesy, Museum of Fine Arts, Boston; M. and M. Karolik Collection.

Mengs and advocated by the antiquarian Winckelmann was the only rewarding form of expression. When he arrived in London in 1763 and established himself at the English court, West also established an artistic mecca for the generation of American artists who thronged to his London studio, eager to identify themselves with the heroic and ancient traditions denied them in America.[19] As Chateaubriand later said, "Il n'y a de vieux en Amérique que les bois."[20] When at last Americans, in discovering their continent, recognized and valued this, landscape painting came largely to satisfy the need for a tradition. But this only happened some fifty years after West, and before it occurred, some of America's most promising artists were sacrificed on the altar of history painting.

When Copley arrived in London in July, 1774, West took him quickly under wing and introduced him to Sir Joshua Reynolds. It was not long before Copley wrote to Henry Pelham, recommending that he read Sir Joshua's *Discourses*.[21] The full insidious effect of the *Discourses* on America's aspiring history painters and on the whole American expatriate concept of the ideal requires more intensive study than it has thus far received. Certainly, literal adherence to Sir Joshua's "rules" for the Grand Style could easily result in academic eclecticism of the lowest order. Denying the definition of genius as a mysterious and unique quality (a definition that was to be central to the romanticism that was slowly developing all through the years 1769–90, during which the *Discourses* were being delivered to the Royal Academy), he proclaimed, "Invention is one of the great marks of genius; but if we consult experience, we shall find, that it is by being conversant with the inventions of others, that we learn to invent; as by reading the thoughts of others we learn to think,"[22] and also, "The greatest natural genius cannot subsist on its own stock; he who resolves never to ransack any mind but his own, will soon be reduced, from mere barrenness, to the poorest of all imitations; he will be obliged to imitate himself, and to repeat what he has before often repeated."[23]

It was all too easy for the artists who heard Sir Joshua's dicta to warm their imaginations from the "great events of Greek and Roman fable and history, which early education and the usual course of reading have made familiar to all Europe, without being degraded by the vulgarism of ordinary life in any country,"[24] and to combine the literary themes and eclectically borrowed forms in works of art that had little unified artistic integrity. Beyond this, we may well ask whether the failure of such paintings was not a natural result of the contradictions inherent in the *Discourses* themselves, and of the discrepancies between Sir Joshua's theory and the examples he presented in his own practice. For it is well known that Sir Joshua's practical interest in Venetian color was largely at odds with his demotion of the Venetian mode, in the *Discourses,* to the merely ornamental. An

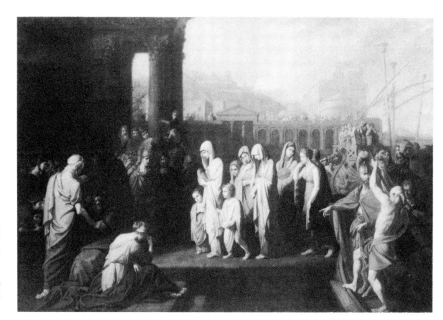

1-23 Benjamin West: *Agrippina Landing at Brundisium with the Ashes of Germanicus,* 1768. Oil on canvas, 64½ x 94½ inches. Yale University Art Gallery, New Haven; Gift of Louis M. Rabinowitz.

eclecticism that attempted to combine, without proper assimilation, the severity of neoclassic linearism with the painterly freedom of the Venetians might well fall between two stools.

Certainly, the works of West, Reynolds' chief American disciple, show much less understanding of the essential nature of classic form than was evident shortly thereafter in the works of David in Paris. David practiced a kind of classicism that can be said to have been the perfect blend of classical heroic subject with classic style: order, measure, logical restriction of each object to its own sequential location in space, both on the surface and three-dimensionally. West, on the other hand, often used just the superficial attributes of classicism: the theatrical gestures, the togas, the classical architectural motifs.

Only very early, in such a painting as *Agrippina Landing at Brundisium with the Ashes of Germanicus* (1768) (*Ill. 1-23*), was there any genuine understanding of classic form. Here West seems to have made consistent structural use of classical formal sources, basing the central group on a section of the Ara Pacis, and taking the arcaded façade that forms the frontal plane of the architectural backdrop from a plate in Robert Adam's *Palace of Diocletian*.[25] For the most part, however, West used an impure classicism larded with touches of romantic passion and hampered formally by spatial ambiguities and misunderstandings (*Ill. 1-24*).

39

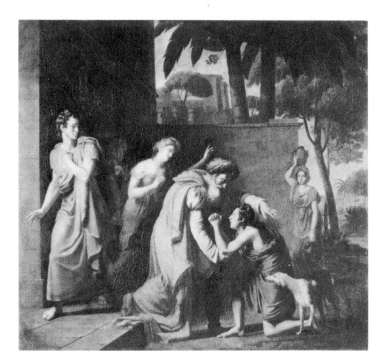

I-24 Benjamin West: *Return of the Prodigal Son, ca.* 1770. Oil on canvas, 54½ x 60⅛ inches. The Metropolitan Museum of Art, New York; Maria De Witt Jesup Fund, 1923.

It is not unimportant that the word "romantic" should arise here, for the failure of such paintings may have been due not only to unassimilated eclectic methodology but to precisely the struggle between the neoclassic and romantic aesthetic that showed itself in Sir Joshua's works, and that, as a matter of fact, created those curious theoretical inconsistencies as well. Throughout the *Discourses,* one senses the intrusion on Sir Joshua's thinking of an alternative aesthetic of energy, strength, and power, as opposed to the beauty and serenity of the neoclassic mode.

As early as the fifth Discourse, in 1772, he found himself torn between Raphael and Michelangelo and opted for Raphael, while admitting that if "as Longinus thinks, the sublime, being the highest excellence that human composition can attain to, abundantly compensates the absence of every other beauty, and atones for all other deficiencies, then Michael Angelo demands the preference."[26]

Thus, it is not surprising that by the fifteenth, and last, Discourse, of 1790, when the romantic-Gothick aesthetic had taken still firmer hold in England and had found plastic formulation in the works of Fuseli and Blake, Sir Joshua finally ceded to the sublime, and stated: "I should desire that the last words which I should pronounce in this Academy, and from this place, might be the name of—Michael Angelo."[27]

Caught in a similar struggle between two aesthetics, Benjamin West made

what is perhaps his strongest contribution to the history of Western art by feeding the romantic current. Like Fuseli and, later, Allston and Delacroix, he subscribed to the Shakespeare cult and, in 1788, painted a gigantic *King Lear,* cited by Richardson as "one of his most powerful romantic melodramas."[28]

Even earlier, in 1770, against Sir Joshua's most adamant protestations—delivered to West in countless discussions and formalized in the fourth Discourse: "Present time and future may be considered as rivals, and he who solicits the one must expect to be discountenanced by the other"[29]—West introduced the present into *The Death of Wolfe (Ill. 1-25)* by depicting the historic moment in contemporary dress, thereby abdicating his claim to the future. This introduction by an American artist of *specific* time, an indulgence not unlike Copley's early feeling for the specific textures of fabrics, violated in the same way Sir Joshua's concept of an undifferentiated universality that would remain timeless.

1-25 Benjamin West: *The Death of Wolfe,* 1770. Oil on canvas, 59½ x 84 inches. The National Gallery of Canada, Ottawa; Canadian War Memorials Collection.

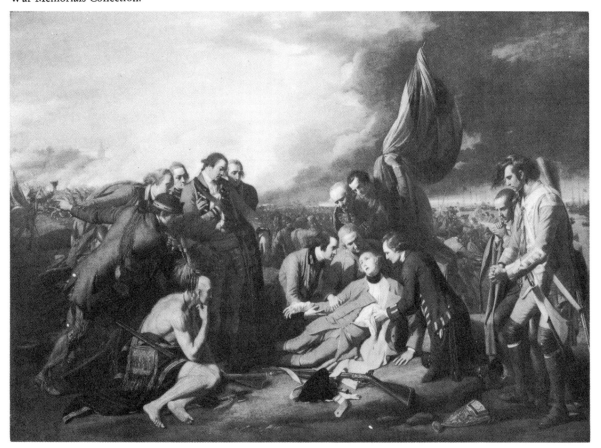

Edward Penny had already broken this "time barrier" in 1764 by depicting Wolfe in modern dress. But West's combination of the contemporary with a swooning death pose that recalled earlier "inventions" by the masters in the rendering of the Deposition of Christ, exalted a potential genre scene to the level of the heroic Grand Style. Thus, he anticipated Géricault's romantic use in 1819, in *The Raft of the "Medusa,"* of a contemporary theme within a monumental composition.

As with West, some of the worst paintings of Copley's English phase— for example, the *Ascension of Christ* (1775) (*Ill. 1-26*)—were executed in the Grand Manner, sadly eclectic misuses of classic prototypes. Yet some of Copley's major contributions during this period came also within this framework. Once again, the tempering of his empiricism—a persistent respect for fact—caused him to paint history at the moment it happened, to allow the Earl of Chatham to die dramatically in the House of Lords surrounded by his peers, each captured individually by Copley's portrait brush. (Chatham died in 1778. By 1781, Copley was showing his version of the event and charging admission.) When he showed the youthful Watson's encounter with the shark (*Ill. 1-27*) in all its immediate horror, a horror reserved traditionally for episodes from the distant past, Copley joined West as a

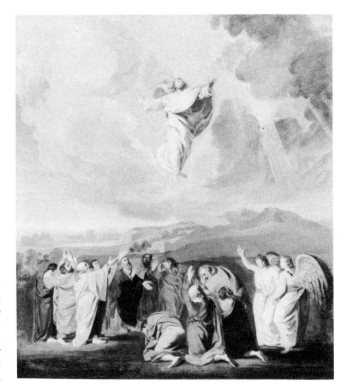

1-26 John Singleton Copley: *Ascension of Christ,* 1775. Oil on canvas, 32⁷⁄10 x 29½ inches. Courtesy, Museum of Fine Arts, Boston; Bequest of Susan Greene Dexter, in memory of Charles and Martha Babcock Amory.

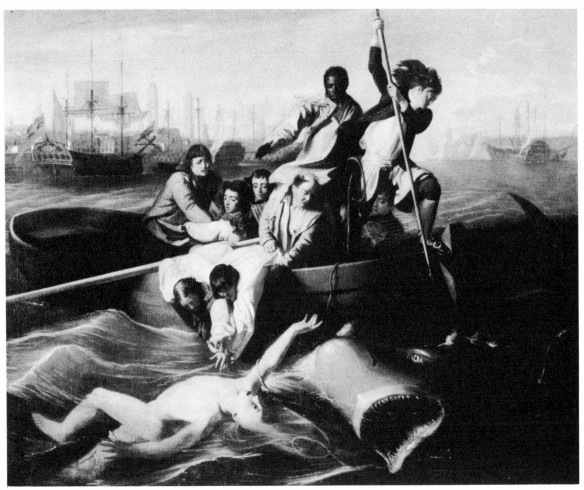

I-27 John Singleton Copley: *Watson and the Shark,* 1778. Oil on canvas, 72 x 90½ inches. Courtesy, Museum of Fine Arts, Boston; Gift of Mrs. George von Lengerke Meyer.

pioneer in the history of ideas. His development had gone from idea to fact to the fact of idea, making dramatic episodes within his own lifetime real and factual. In Watson, he also opened the door still wider to an aesthetic of the terrible that was to excite America's first true romantic, Washington Allston. Allston arrived in London in 1801. Like West and Copley, he was to be swallowed up, and partly destroyed, by the chimera of history painting; but, again like them, he was to display a marked individualism, making even greater contributions to the development of an American romantic tradition through a more thorough assimilation of European modes. He thus carried into the nineteenth century the search for those venerable traditions that had caused his compatriots before him to cross the Atlantic.

43

Washington Allston

AN AMERICAN ROMANTIC TRADITION

In 1859, in his preface to *The Marble Faun,* Nathaniel Hawthorne wrote: "No author without a trial can conceive of the difficulty of writing a romance about a country where there is no shadow, no antiquity, no mystery, no picturesque and gloomy wrong, nor anything but a commonplace prosperity, in broad and simple daylight, as is happily the case with my dear native land."[1] Years later, the nineteenth-century critic Sarah Tytler wrote of Washington Allston (1779-1843) that he "shared with the writers, Hawthorne and Wendell Holmes, not merely the love of the supernatural, but the predilection for what is abnormal and weird, which strikes us dwellers in the mother country as something in itself abnormal, when it springs up

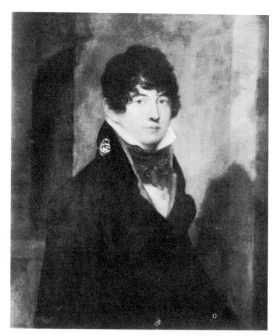

2-1 Washington Allston: *Self Portrait, Rome,* 1801—5. Oil on canvas, 31³⁄₁₀ x 26⅖ inches. Courtesy, Museum of Fine Arts, Boston; Bequest of Alice Hooper.

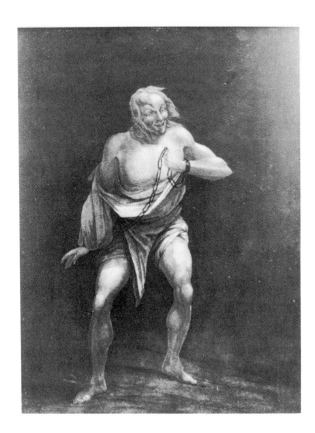

2-2 Washington Allston:
Tragic Figure in Chains,
1800. Oil on panel, 12⅜ x
9½ inches. Addison Gallery
of American Art, Phillips
Academy, Andover, Massa-
chusetts.

in the sons of a fresh young world, but which is notably the re-action from
the very fresh materialism of their surroundings" (*Ill. 2-1*).[2]

Allston shared Hawthorne's feeling for shadow, antiquity, mystery, and
picturesque and gloomy wrong. Yet if his romanticism was, as Miss Tytler
suggests, a reaction from the "fresh materialism" of an America concerned
largely with the palpable fact, it was to become, nonetheless, the other pole
of an American vision. Though romanticism has never had as extensive or
uninterrupted a tradition in America as realism, it has been a potent second-
ary strain, manifest most often in hybridized form, in tandem with various
modes of realism. Occasionally, in the hands of a few—Allston, Ryder,
Whistler, Rothko—it has emerged more purely, at the extreme of a dialectic
between fact and antifact, in which the palpable finds its antithesis in the
impalpable, the seen and touched in the remembered and distilled.

Though Hawthorne was right about the difficulties of breeding a romantic
sensibility on American soil, Allston had been fortunate enough to be raised
in South Carolina, where at an early age he developed "a stronger love for
the wild and marvellous. I delighted in being terrified by the tales of witches
and hags, which the negroes used to tell me; and I well remember with how
much pleasure I recalled these feelings on my return to Carolina; especially

45

on revisiting a gigantic wild grape-vine in the woods, which had been the favorite swing for one of these witches."[3]

At Harvard, he gave form to his taste for the wild and marvelous by painting subjects from Schiller's *The Robbers* and Mrs. Radcliffe's *The Mysteries of Udolpho*. By 1800, he had painted the Gothick *Tragic Figure in Chains* (*Ill. 2-2*), which linked his sensibility to that of the Swiss artist Henry Fuseli, whose illustrations for John Boydell's famous Shakespeare Gallery he had already seen in the Charleston library (and who was professor of painting at the Royal Academy in London when Allston arrived there in 1801).

He greatly admired Fuseli; but he was so enthusiastic over West's study for *Death on the Pale Horse* that shortly after his arrival he ranked

> Mr. West as first. . . . No fancy could have better conceived and no pencil more happily embodied the visions of sublimity than he has in his inimitable picture from Revelation. Its subject is the opening of the seven seals, and a more sublime and awful picture I never beheld. It is impossible to conceive anything more terrible than Death on the white horse, and I am sure no painter has exceeded Mr. West in the fury, horror and despair which he has represented in the surrounding figures.[4]

A study by West for *Death on the Pale Horse,* exhibited in Paris at the Salon in 1802 (*Ill. 2-3*),[5] is believed to have made an impression on budding French romanticism, but the way Allston describes this picture indicates its importance for English and American romanticism as well. Allston's use of the word "sublime" in 1801, in an England still concerned with Burke's famous *Philosophical Enquiry into the Origin of our Ideas of the Sublime and Beautiful* (1757), is worth noting. For "sublimity" had all the power of a relatively recent aesthetic. Thus, it carried overtones of the terrible and fantastic that belonged more to the Gothick romanticism of the turn of the century in England and Germany than to the romanticism of Delacroix and the French generation of the 1830's. By the time the word "sublimity" entered Delacroix's vocabulary, it was hardly more than a cliché. For all the bloody horror of *The Death of Sardanapalus* (1827), Delacroix's romanticism was more rational and less bizarre than that of Fuseli, or even Blake, artists closer in sensibility to Allston than to his French romantic counterpart.

How would Delacroix have judged Allston? Perhaps we have an indirect clue. Since something of Allston's early Gothick fantasy could be found later in Hawthorne and Poe, it seems pertinent that Delacroix could not quite share Baudelaire's enthusiasm for Poe, writing of him on April 6, 1856:

> For the past few days I have been reading Baudelaire's translations from Edgar Poe with great interest. In these truly *extraordinary*—I mean *extra-human*—conceptions, there is the fascination of the fantastic which may be

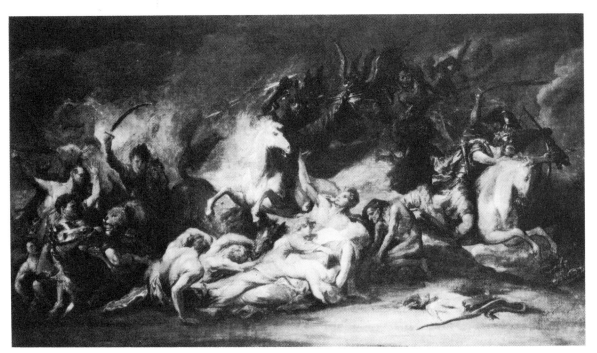

2-3 Benjamin West: *Death on the Pale Horse,* 1802. Oil on canvas, 21 x 36 inches. Collection of the Philadelphia Museum of Art.

an attribute of some temperaments from the North or elsewhere, but which is certainly not in the nature of Frenchmen like ourselves. Such people only care about what is beyond nature, or extra-natural, but the rest of us cannot lose our balance to such a degree; we must have some foundation of reason in all our vagaries. . . . I am sure that any German would feel at home with them.[6]

Allston and Delacroix might have found agreement on basic attitudes pertaining to the imagination (including the spectator's), the artist's originality, and the projection of his sensibility into the objective world.[7] But it was precisely the Northern, or German, sense of mysticism and fantasy that distinguished some aspects of early American romanticism from that of the French[8]—a reminder of the strong German influence that gained such importance in both England and America after 1800 and fed the growth of Transcendentalism in America in the 1830's. It was in German literature and philosophy that the Transcendentalists found confirmation for the development of their own spiritual beliefs. Many sources fostered their sense of an infinite life in all matter—animate and inanimate—and their emphasis on God in nature and in man. In 1833, Frederic Henry Hedge, the leading Transcendentalist Germanic scholar, reviewed an 1829 publication of *Aids to Reflection* written by Allston's close friend Coleridge. Emerson borrowed Hedge's translation of Schiller's *Wallenstein* from the Boston Athenaeum

library in 1831. The Transcendentalists read Carlyle's essays on German literature, especially on Goethe, and their own readings included Goethe, Schelling, Richter, the Schlegels, and Novalis, among others.[9] Their beliefs were to find most profound visual form in what John I. H. Baur has termed the "pantheist realism" of the luminists in the 1850's and 1860's. Allston's romanticism, however, was an important initial step, for his sense of the divinity of the artist, the infinite realm of the imagination, and the originality of the individual mind had correlates in Transcendental attitudes.

Actually, if Allston's early inclinations were towards rattling-chain Gothick, such bizarre fantasy was only a part of his vision. More important (from the standpoint of an American romantic tradition) was the nature feeling expressed in his landscapes, a feeling more closely akin to the incipient development of Transcendental thought. For Nature, not History, was the dominating theme in America from about 1825 to the Civil War. Contemplating nature, Allston wrote:

> How vast a theatre is here laid open . . . where the physical eye is permitted to travel for millions and millions of miles, while that of the mind may, swifter than thought, follow out the journey from star to star, till it falls back upon itself with the humbling conviction that the measureless journey is there but begun! It is needless to dwell on the immeasureable mass of materials which a world like this may supply to the artist. The very thought of its vastness darkens into wonder.[10]

Allston had executed important landscapes as early as 1804 (*Ill. 2-4*). Though as he traversed the ruins of Italy with typical romantic nostalgia in the company of Washington Irving in 1805 and of Coleridge in the following year, he still maintained Sir Joshua's conviction that history painting

2-4 Washington Allston: *Landscape with a Lake*, 1804. Oil on canvas, 38 x 51¼ inches. Courtesy, Museum of Fine Arts, Boston; M. and M. Karolik Collection.

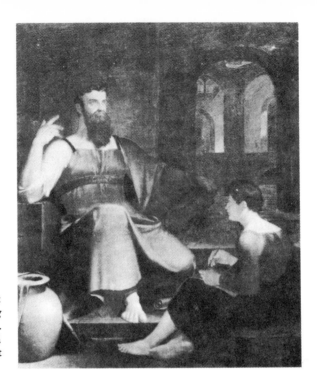

2-5 Washington Allston: *Prophet Jeremiah Dictating to the Scribe Baruch,* 1820. Oil on canvas, 89¾ x 74¾ inches. Yale University Art Gallery, New Haven.

ranked highest in the subject hierarchy.[11] He was taken, as was Copley, with the noble and superior claims of the Grand Style. Like both Copley and West, he quickly adapted the neoclassic eclecticism preached by Sir Joshua, applying Claudian and Poussinesque formulae to his landscapes of that period.

Fortunately, his romantic imagination was more capable than West's of investing neoclassic form with feeling. He arrived, like William Blake, at a kind of eclectic romanticism, often derived from Michelangelo and gaining its power through sheer exaggeration of size and proportion. His admiration for Michelangelo was shared by Fuseli, Blake, Delacroix, and, as pointed out earlier, the aging Sir Joshua. A poem to Michelangelo by Allston reads in part:

> Thou stands't alone, and needest not to shine
> With borrowed lustre; for the light is thine
> Which no man giveth . . .[12]

What the romantics seem to have seen in Michelangelo was that *terribilità,* that quality of massive strength, which in the twentieth century would appeal to the expressionist sensibility. Indeed, some of Allston's neoclassic paintings, such as *Uriel in the Sun* (1817) and the *Prophet Jeremiah Dictating to the Scribe Baruch (Ill. 2-5),* are redeemed mainly by their recourse to a Michelangelesque gigantism.[13] There was, in addition, the growing recognition of

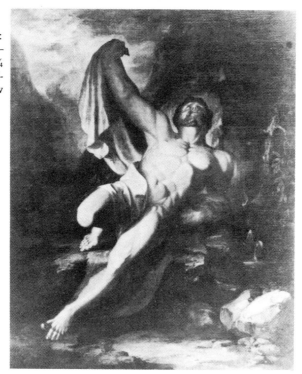

2-6 Samuel F. B. Morse: *Dying Hercules,* 1812–13. Oil on canvas, 96¼ x 78⅛ inches. Yale University Art Gallery, New Haven.

Michelangelo as a prototype of the romantic artist who relied on the unique powers of the imagination. "The genius of Michelangelo," Allston wrote, "was essentially Imaginative."[14]

But history painting for the American artist was doomed to failure. America's "early art," as Jarves was to suggest, had "no root in the people." Elevated and noble themes were lost on the American public—one of the

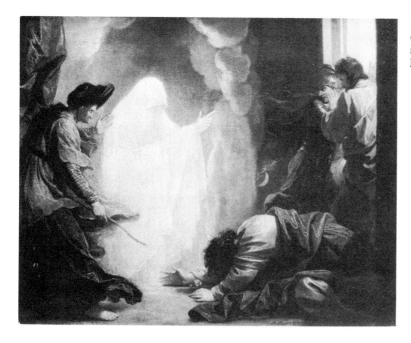

2-7 Benjamin West: *Saul and the Witch of Endor,* 1777. Oil on canvas, 19¹⁵⁄₁₆ x 25¾ inches. Courtesy, Wadsworth Atheneum, Hartford.

most striking instances of a conflict between the aspirations of a whole generation of artists and a thoroughly unreceptive public taste.

When Allston left Boston for his second English sojourn in 1811 (he had returned from Europe in 1808), the young Samuel F. B. Morse (1791–1872) accompanied him. Morse's histrionic handling of the *Dying Hercules* theme was a great success in England in 1812, bringing him a Gold Medal from the Society of Arts for his sculpture and accolades from the Royal Academy for the painted version as well (*Ill. 2-6*). But when he made his famous statement, "I cannot be happy unless I am pursuing the intellectual branch of the art. Portraits have none of it; landscape has some of it, but history has it wholly," his mother replied, "You must not expect to paint anything in this country for which you will receive any money to support you, but portraits."[15] Out of the American rejection of history painting came the Morse code.

As a category of history painting, religious themes, too, found little favor with the public, and the genre is very sparse in America.[16] But, as Salvator Rosa and West (*Ill. 2-7*) had before him, Allston found in religious subject matter that romantic wonder at the miraculous that caused him to paint *Saul and the Witch of Endor* (*Ill. 2-8*) and *The Dead Man Revived by Touching the Bones of the Prophet Elisha* (1811–13). Ultimately, however, America's religion in the nineteenth century was to be found in the landscapes of the "pantheist realists."[17]

Taste in America seems always to have gone against the frankly literary romantic sensibility in the visual arts. Allston—like Cole and Ryder—wrote poetry, and of the three, only Ryder was really successful in interfusing the literary idea and visual form. Quite apart from public and critical taste, did the literary sensibility displayed by Cole and Allston actually hinder formal

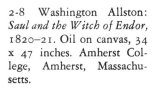

2-8 Washington Allston: *Saul and the Witch of Endor,* 1820–21. Oil on canvas, 34 x 47 inches. Amherst College, Amherst, Massachusetts.

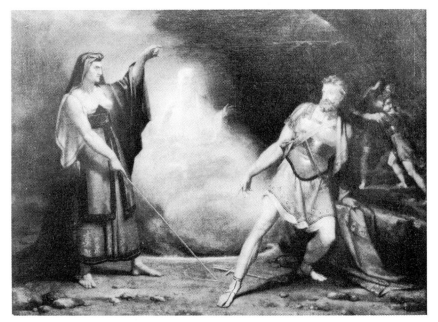

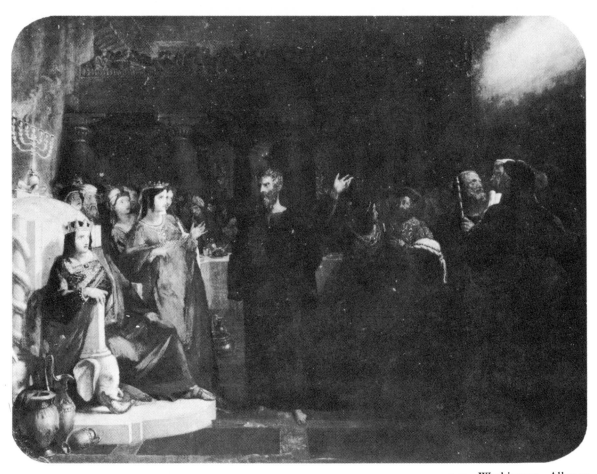

2-9 Washington Allston: Study for *Belshazzar's Feast*, 1817. Oil on millboard, 25⅜ x 34¼ inches. Courtesy, Museum of Fine Arts, Boston; Bequest of Miss Ruth Charlotte Dana.

achievement? With both, the "story" often took over, the subject—and its exhaustive explication—becoming the most important aspect of the painting. In such instances, what resulted were stories in paint, but not necessarily paintings. Moral didacticism paradoxically redeemed Cole's "Voyage of Life" series (*see Ill. 3-5*) for an American public that did not much care for his "ideal" paintings; but the series is too obsessed with theme to have great plastic strength.

In this category falls *Belshazzar's Feast,* the albatross around Allston's neck for the last twenty-five years of his life (*Ill. 2-9*). He had undertaken it as early as 1817, at a moment when the grandeur of the subject still held some fascination for him. After some criticism of its perspective by the aged Gilbert Stuart in 1820 and some evidently ill-considered adjustments by Allston to meet that criticism, the painting seemed always out of gear, and resisted solution to the day of his death. The pathos of Allston's continued involvement with the picture is revealed in his letters over the years, which poignantly underline his continued hope of a completion that would free his

sensibilities and his conscience to undertake other large commissions.[18] Contributions of $1,000 each from ten Boston gentlemen served only to heighten the painfulness of the situation, for without these he might have had the courage to abandon the project, admitting that it had just gone wrong. An added complication was the long-term change in his artistic interests. Over the years, he moved from an emphasis on subject to more painterly investigations of color and form. So in *Belshazzar* he must have found himself trying to reconcile past concerns with present interests. The difficulties of creating a unified picture when the artistic personality itself was undergoing changes are obvious.

The *Belshazzar* obsession is a convenient romantic blight to lay over the latter part of Allston's life. Yet it was after his return in 1818 from his second stay in England that he embarked on his most fruitful period, marred though it was by the ubiquitous presence of that picture. In America again, his early Gothick romanticism was transformed further into that lyric emphasis on a sustained mood that we can on occasion identify in subsequent American art.[19]

That mood is perfectly summoned in his remarkable *Moonlit Landscape* (1819) (*Ill. 2-10*), a fantasy that seems related to a specific experience at the very moment of his return from Europe:

2-10 Washington Allston: *Moonlit Landscape,* 1819. Oil on canvas, 24 x 35 inches. Courtesy, Museum of Fine Arts, Boston; Gift of Dr. W. S. Bigelow.

A homesickness which (in spite of some of the best and kindest friends, and every encouragement that I could wish as an artist) I could not overcome, brought me back to my own country in 1818. We made Boston Harbour on a clear evening in October. It was an evening to remember! The wind fell and left our ship almost stationary on a long low swell, as smooth as glass and undulating under one of our gorgeous autumnal skies like a prairie of amber. The moon looked down on us like a living thing, as if to bid us welcome, and the fanciful thought is still in my memory that she broke her image on the water to make partners for a dance of fireflies—and they *did* dance, if I ever saw dancing.[20]

An earlier picture, *Coast Scene on the Mediterranean* (1811) (*Ill. 2-11*), is even more provocative. The painting itself is "smooth as glass." The ships are "almost stationary" against a cool but brilliant sunset. The smooth containment of the image, the curiously flattened and ambiguous space in which light radiates outward yet remains firm—establishing a wall-like plane—make it one of the earliest proto-luminist landscapes in American art. It shares with the luminism of the 1850's and 1860's the ultra-clarity of foreground detail (as in the shadows of the cart wheels), while the background blinds and dazzles. Richardson has noted that in this painting, "As in all Allston's landscapes, nature is seen through the veil of memory. . . . The

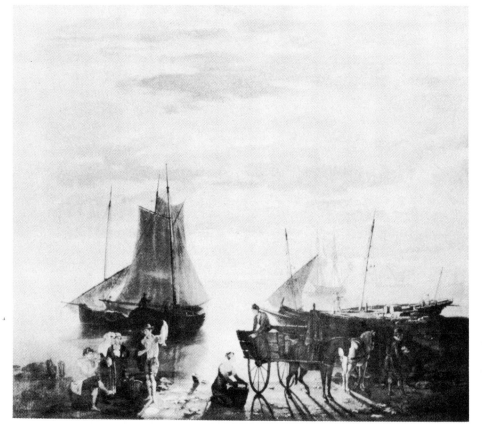

2-11 Washington Allston: *Coast Scene on the Mediterranean*, 1811. Oil on canvas, 36 x 40 inches. Columbia Museum of Art, Columbia, South Carolina.

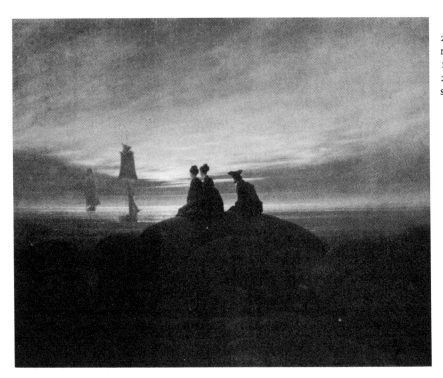

2-12 Caspar David Friedrich: *Moonrise over the Sea,* 1823. Oil on canvas, 21⅜ x 28 inches. Staatliche Museen, Berlin.

mood is one of reverie which a hidden intensity of feeling makes somehow poignant and dramatic."[21]

An ultimate distinction between Allston and the luminists is that the latter give the quality of dream to the scene perceived in reality, while Allston's images seem to derive more directly from the imagination, untempered by immediate confrontation with fact. Yet in both there is the importance of idea. Crystalline clarity and tangibility fix the luminist idea. In Allston, such hyaline lucidity is rare, and he is more likely to allow memory and the imagination to blur the edges and soften the atmosphere—that atmosphere, more substantial than air, which is one of the subtlest forms of romantic rhetoric.

In this one painting, however, Allston's proto-luminist imagery comes very close to that of Caspar David Friedrich in Germany (*Ill. 2-12*). This can be seen not as a coincidence but as a convergence of possible factors. Friedrich's early training was in Copenhagen where, as in America, there is a strong folk-art tradition with its concomitant conceptual root. And the development of Friedrich's art against a background of German nature philosophy—with its links to American Transcendentalism—would also suggest further clues, both formal and philosophical, to the character of the American luminist landscape later in the century.[22]

The mainstream of Allston's development, however, does not run directly into luminism but rather into that rarer current of pure romanticism which we find in Whistler and Ryder: the art of dream or, as Richardson has

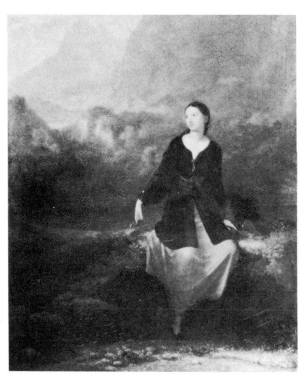

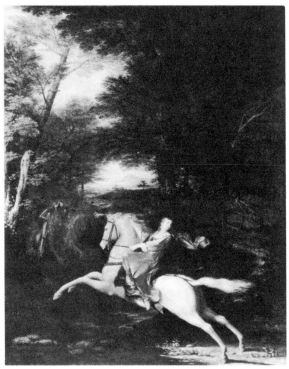

2-13 Washington Allston: *The Spanish Girl in Reverie,* 1831. Oil on canvas, 30 x 25 inches. The Metropolitan Museum of Art, New York; Gift of Lyman G. Bloomingdale, 1901.

2-14 Washington Allston: *Flight of Florimell,* 1819. Oil on canvas, 36 x 28 inches. Courtesy of The Detroit Institute of Arts.

2-15 Washington Allston: *Landscape, American Scenery: Time, Afternoon with a Southwest Haze,* 1835. Oil on canvas, 18½ x 24⅖ inches. Courtesy, Museum of Fine Arts, Boston; Bequest of Edmund Dwight.

called it, of reverie. A large number of Allston's later works float in a mist of hazy nostalgia, in a hushed quietude, deflected from being luminist not only by the domination of fancy over fact, but by a Venetian-inspired colorism.

The techniques of painterly artists in America can often be traced directly to European sources. As early as 1803, Allston had copied Rubens,[23] ultimately tracing Rubens' light and color back to their source in Venetian painting. Years later he wrote:

> Titian, Tintoret and Paul Veronese absolutely enchanted me, for they took away all sense of subject. When I stood before the *Peter Martyr, The Miracle of the Slave,* and *The Marriage of Cana,* I thought of nothing but the gorgeous concert of colors, or rather of the indefinite forms (I cannot call them sensations) of pleasure with which they filled the imagination. It was the poetry of color which I felt; procreative in its nature, giving birth to a thousand things which the eye cannot see, and distinct from their cause. . . . I . . . *think* I understand why so many colorists, especially Tintoret and Paul Veronese, gave so little heed to the ostensible *stories* of their compositions. In some of them, *The Marriage of Cana* for instance, there is not the slightest clue given by which the spectator can guess at the subject. They addressed themselves, not to the senses merely, as some have supposed, but rather through them to that region (if I may so speak) of the imagination which is supposed to be under the exclusive domination

2-16 Washington Allston: *Elijah Being Fed by the Ravens,* 1818. Casein on canvas, 49 x 72½ inches. Courtesy, Museum of Fine Arts, Boston; Gift of Mrs. Samuel and Miss Alice Hooper.

of music, and which, by similar excitement, they caused to teem with visions that "lap the soul in Elysium." In other words they leave the subject to be made by the spectator, provided he possessed the imaginative faculty —otherwise they will have little more meaning to him than a calico counterpane.[24]

After his second return to America, Allston increasingly restricted himself to less heroic and simpler themes. In *The Spanish Girl in Reverie* (*Ill. 2-13*) and *Italian Shepherd Boy* (1819), single figures dream in a landscape. In some of the most evocative of his landscapes, such as *Landscape, American Scenery: Time, Afternoon with a Southwest Haze* (*Ill. 2-15*), even the titles reveal a concern with specific time and climate, which moves him again into the mainstream of American attitudes to landscape. He could still derive his themes from literary sources, as in *Flight of Florimell,* from Spenser's *Faerie Queene* (*Ill. 2-14*). More and more, however, the paintings depend for their success not on subject but on qualities of light, color, and atmosphere.

And in mastering Venetian color theory, Allston, like Delacroix, made prophetic discoveries. He commented to his friend Henry Greenough:

You must have observed the difference in lustre between silks woven from different colored threads and those dyed with a compound hue. A purple silk woven of two sets of threads, one blue and the other red, cannot be matched by any plain silk dyed purple. The first has a luminous appearance like the human complexion. This luminousness is the grand characteristic of flesh. It is what Titian calls the "luce di dentro" or internal light. When I first heard that expression of Titian's it opened to me a world of light.[25]

Hazlitt had told Allston that it looked to him as if Titian had "twiddled" his colors and this idea made a great impression on him.[26] Thus Allston, at the beginning of the nineteenth century, made observations about the use of pure color and of separated strokes in producing effects of luminosity that were to change the course of art history when Delacroix developed similar ideas a generation later (*Ill. 2-16*). Richardson observes:

When in France, Delacroix and Corot achieved this same return to the coloristic tradition, they founded the greatness of French nineteenth-century painting, for which French painters of all shades of opinion have since paid them honor. That American painters were neither willing nor able (for the most part) to learn from Allston what the French learned from their romantic painters is regrettable but hardly affects the importance of his discovery.[27]

But does Richardson overlook the most significant implications of this neglect of Allston's coloristic discoveries? Though artists like Mount and

Homer owned copies of Chevreul, whose writing on color theory was so important for the development of Impressionism in France, Americans were not by inclination or expressive intent really colorists. The dominant American vision seems to have been essentially linear, possibly a result of the insistence on the palpability of fact. There seems, throughout the nineteenth century in America, to have been a basic distrust of *sensation* that militated against the indigenous development of a perceptual art of painterly color. Unless restricted within the clear-cut boundaries of luminist form, coloristic atmosphere tends to destroy fact. This could only be acceptable in American art when fact was virtually erased—thoroughly transmuted into dreamy amorphousness. Only a very small number of American artists have ever been willing to give themselves over to the vague world of the irrational and impalpable, with no hold on reality.

Is this the reason that American artists never really evolved an Impressionism of their own? All through the nineteenth century, American discoveries of the keys to Impressionist color and atmosphere either presaged or paralleled European developments. Durand's objective revelations in the 1850's occur at the same time as Courbet's. There are striking similarities between Homer and Monet around 1867. But in America there was a vested interest in the preservation of the fact, behind which we can perhaps identify deeper religious and philosophical attitudes to the substance of God's world, attitudes proscribing the analytical irreverence of Impressionism. Light as an iconic symbol of Godly immanence was possible, but the objective analysis of light as pure color (the avowed ideal of Impressionism, with its correlative destruction of the object) was not. Given this, Impressionism could reach America only in the hybrid, imported style of Hassam and Twachtman. The

2-17 Washington Allston: *Ship in a Squall,* before 1837. Chalk on canvas, 47¼ x 59½ inches. Courtesy of the Fogg Art Museum, Harvard University, Cambridge, Massachusetts; on loan from the Washington Allston Trust.

former hardened Impressionism, restoring the identity of the object. The latter gave to it some of the dreamlike quality found in Allston, adapting Impressionism to that minor note of contemplative romanticism in America.

Thus, it appears that in the early part of the century the only possible way for the idealist Allston to utilize his coloristic discoveries was to subvert reality by reverie, to convert the painterly to a lyric rather than an analytic end. His romanticism led him in many directions. Invention and idea, mingled with memory and imagination, seem somehow to have been more important to him than the finished paintings themselves. He therefore left an artistic bequest of unfinished promises chalked on brown primed canvases —like *Belshazzar,* victims of insatiable intention (*Ill. 2-17*).

Hawthorne, remembering this, recalls Allston in "The Artist of the Beautiful" when he writes:

The poet leaves his song half sung, or finishes it, beyond the scope of mortal ears, in a celestial choir. The painter—as Allston did—leaves half his conception on the canvas to sadden us with its imperfect beauty, and goes to picture forth the whole, if it be no irreverence to say so, in the hues of heaven. But rather such incomplete designs of this life will be perfected nowhere. This so frequent abortion of man's dearest projects must be taken as a proof that the deeds of earth, however etherealised by piety or genius, are without value, except as exercises and manifestations of the spirit.[28]

Allston, certainly, would have liked this reference, and, as Ryder did later, would have felt a kinship with Hawthorne's artist-hero Owen Warland, whose ruined butterfly was "yet no ruin. . . . When the artist rose high enough to achieve the beautiful, the symbol by which he made it perceptible to moral senses became of little value in his eyes, while the spirit possessed itself in the enjoyment of the reality."[29]

3.

Thomas Cole

THE DILEMMA OF THE REAL AND THE IDEAL

If, for Allston, the color of "Titian, Tintoret and Paul Veronese . . . took away all sense of subject," this was not possible for Thomas Cole (1801–48), who maintained that "the language of art should have the subserviency of a vehicle. It is not art itself. Chiaroscuro, colour, form, should always be subservient to the subject, and never be raised to the dignity of an end."[1] With Cole, even more than Allston, idea and story took precedence over form, and one might say that more than Allston, Cole a generation later, took Sir Joshua's dicta to heart. Cole was capable finally of transferring the heroic aims of the history painters to the landscape category, where at last they could take firm root in American soil. Thus, in the largest sense, he was a transitional figure.

This early nineteenth-century emphasis on Nature and landscape was hardly unique to America, having found expression abroad in Rousseau's concepts of natural primitivism, Schelling's *Naturphilosophie,* and Wordsworth's "God in Nature," as well as in Emerson's *Nature.*[2] But with the new respect for "unspoiled nature" on both sides of the Atlantic, an American landscape school was not long in developing. Nationalist pride was considerably bolstered by the realization that America more clearly fitted Rousseau's concept of a primeval paradise than any of the European countries with which, it was uneasily believed, America could not yet compete artistically. If we had no cultural traditions, we had at least our ancient trees. Thus, to Cole, "All nature here is new to art, no Tivolis, Ternis, Mont Blancs, Plinlimmons, hackneyed and worn by the daily pencils of hundreds; but primeval forests, virgin lakes and waterfalls."[3]

America's search for some sense of past in the raw new world focused on an idea of landscape that was at once strongly nationalist and moralist. Looking back for "the cause of the failure" of America's early art (that is,

history painting), James Jackson Jarves observed, "It had no root in the people." And America had, he noted, "no legendary lore more dignified than forest or savage life, no history more poetical or fabulous than the deeds of men almost of our own generation, too like ourselves in virtues and vices to seem heroic—men noble, good, and wise, but not yet arrived to be gods."[4]

He struck, of course, at the core of the problem. Vanderlyn's *Marius Amid the Ruins of Carthage* and Morse's *Dying Hercules* were hardly rooted in American experience. Whereas history painting often demanded of both artist and audience a firm grounding in literature, world history, and the classics, landscape painting, with true democratic spirit, required only the natural experience that was every man's rightful heritage. An editorial in *The Crayon,* 1855, entitled "Common Sense in Art," stated:

> Let it be remembered that the subject of the picture, the material object or objects from which it is constructed, are the essential parts of it. If you have no love for them, you can have no genuine feeling for the picture which represents them. . . . We love Nature and Beauty—we admire the artist who renders them in his works. . . . The man to whom nature, in her inanimate forms, has been a delight all his early life, will love a landscape and be better capable of feeling the merits of it than any city-bred artist, and so through the category of men and things. They are only capable of being just critics of art who have first learned to love the things that Art deals with.[5]

The American in love with nature approximated the aesthetic contemplation of a landscape painting with "the contemplation of virtuous deeds."[6] As Emerson stated: "He (the painter) should know that landscape has beauty for his eye because it expresses a thought which to him is good, and this because the same power which sees through his eyes is seen in that spectacle."[7]

A writer in the *North American Review* in 1830 considered the taste for beauty in nature and art "nearly allied to the love of good—so nearly indeed that it has often been doubted whether Beauty be anything more than a visible manifestation of those amiable moral qualities of which the mere idea fills the heart with delightful emotions, and confers a charm on every person or thing with which they appear to be associated."[8]

This emphasis on the moral value of the aesthetic experience, and, in particular, on the moral benefits to be derived from contemplating landscape, is vital to an understanding of landscape taste in nineteenth-century America. In its deepest sense, this morality encompassed not only the simpler ethical virtue of "love of good" but an awareness of landscape, as Jarves put it, as "God's sensuous image of revelation."[9]

Paradoxically, the same sense of divine immanence that characterized the American taste for landscape militated against the kind of Platonic idealism representative of Thomas Cole's most profound ambitions. For God's world, as noted earlier, was not to be tampered with. Critics and patrons cautioned the artist to be careful not to work too much from his own "imaginings," a pursuit leading to "mannerism," which was in strong disfavor; and while the artist must not descend to the level of "servile" or "mere" imitation, neither should he exert too forcefully his powers of transformation.

When Cole, around 1825, arrived on the artistic scene, Americans had just discovered, as it were, their natural aesthetic resources and were fast developing a taste for landscape painting that "produces happy and civilizing influences upon society . . . excites and gratifies intellectual desires, cultivates a love of nature and of beauty, and surrounds life with the charm of elegance and refinement."[10] Though this was a taste that required the artist always to elevate the "gift he possesses high above that of a mere mechanical power," at the same time, it was one that preferred specific and recognizable "home scenes." As a friend of Cole's wrote, "where you can have a beautiful painting representing Home how many more associations it brings than an equally beautiful one representing a foreign country."[11]

Cole, the dreamer, the arch-romantic who preferred to paint Arcadian compositions—waiting for "time to draw a veil over the common details, the unessential parts, which shall leave the great features, whether the beautiful or the sublime, dominant in the mind" (*Ill. 3-1*)[12]—found himself an idealist in a world that demanded a more discreet blend of the real with the ideal. His art offers an initial statement of a basic dilemma: a polarity of the real and the ideal that was resolved by his successors in the Hudson River school through the development of a compromise formula—a formula for which his art was, in a sense, germinal.

At a moment when the philosophical conception of the darkly sublime was giving way to the light of day, Cole attempted to transform the sublime into an artistic element within the painting itself, into a structural principle capable of evoking in the spectator feelings of nature's *terribilità*. As he wrote:

> In the terrible and the grand . . . when the mind is astonished, the eye does not dwell upon the minute but seizes the whole. In the forest, during an hour of tempest, it is not the bough playing in the wind, but the whole mass stooping to the blast that absorbs the attention: the detail, however fine, is comparatively unobserved. In a picture of such a subject detail should not attract the eye, but the whole. It should be, in this case, the aim of the artist to impress the spirit of the entire scene upon the mind of the beholder. . . . The finest scene in the world, one most fitted to awaken

3-1 Thomas Cole: *Study: Dream of Arcadia,* 1838. Oil on panel, 9 x 14 inches. Courtesy of The New-York Historical Society, New York.

sensations of the sublime, is made up of minutest parts. These ought all to be given, but so given as to render them subordinate and ministrative to one effect [*Ill. 3-2*].[13]

With William Gilpin before him, Cole might have remarked of the old tree with the hollow trunk, dead arm, drooping bough, or dying branch: "These splendid remnants of decaying grandeur speak to the imagination in a style of eloquence which the stripling cannot reach; they record the history of some storm, some blast of lightning, or other great event, which transfers its grand ideas to the landscape, and, in the representation of elevated subjects, assists the sublime."[14]

Like Allston, Cole was afflicted with a romantic literary sensibility that led him also to write poetry:

> Ye mountains, woods and rocks, impetuous streams,
> Ye wide-spread heavens, speak out, O speak for me!
> Have I not held communion deep with you,
> And like to one who is enamoured, gazed
> Intensely on your ever-varying charms?[15]

He left for Europe for a two-year stay on June 1, 1829, and wrote on the cover of a sketchbook:

Let not the ostentatious gaud of art
That tempts the eye, but touches not the heart,
Lure me from nature's purer love divine:
But, like a pilgrim, at some holy shrine,
Bow down to her devotedly, and learn
In her most sacred features, to discern
That truth is beauty.[16]

But it was precisely this acute awareness of "art" that kept him, in his historical landscape compositions, from thoroughly realizing "nature's purer love divine." A Reynoldsian disciple in landscape toga, he would have maintained with Sir Joshua that:

Like the history painter, a painter of landscapes in this style and with this conduct, sends the imagination back into antiquity; and, like the poet, he makes the elements sympathize with his subject; whether the clouds roll in volumes, like those of Titian or Salvator Rosa, or like those of Claude, are gilded with the setting sun . . . a landscape thus conducted, under the influence of a poetical mind, will have the same superiority over the more ordinary and common views as Milton's Allegro and Penseroso have over a cold prosaic narration or description, and such a picture would make a more forcible impression on the mind than the real scenes, were they presented before us.[17]

Though Cole's aim was to achieve more than a "cold prosaic narration," throughout his career he was torn between his noble ambitions and a less exalted public taste. In his later years, he wrote:

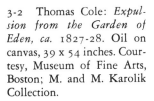

3-2 Thomas Cole: *Expulsion from the Garden of Eden, ca.* 1827-28. Oil on canvas, 39 x 54 inches. Courtesy, Museum of Fine Arts, Boston; M. and M. Karolik Collection.

I am not the painter I should have been had there been a higher taste. Instead of working according to the dictates of feeling and imagination, I have painted to please others in order to exist. Had fortune favoured me a little more than she has, even in spite of the taste of the age, and the country in which I live, my imagination should not have been cramped, as it has been; and I would have followed out principles of beauty and sublimity in my works, which have been cast aside, because the result would not be marketable.[18]

In America, by 1825, the words, "imagination" and "sublimity," which had been so crucial to the romantic generation of 1800 and to the American romantic Allston, had lost much of their original aesthetic significance. "Sublimity" now had heavy overtones of Christian moral sentiment but little of the overwhelming Gothick "awe" it had suggested earlier. "Imagination" had always been a dangerous word in America, and Cole was constantly defending his use of the imagination against charges of "mannerism." Throughout his life, Cole's romantic preference for the imaginative faculty and for the "compositions," rather than specific "views" of nature, that resulted from recourse to that faculty, involved him in continuing dialogues with reluctant patrons.

Perhaps Cole's most revealing exchange with a patron occurred at the very outset of his career, when Robert Gilmor, Jr., a Baltimore collector with an outstanding collection of medieval manuscripts, and Italian, Dutch, and English as well as American art, took it upon himself to give the young artist a few words of seasoned advice. Using Thomas Doughty's later works as a point of departure, Gilmor criticized them on the grounds that they lacked his earlier "pleasing verity of nature":

As long as Doughty studied and painted from Nature (who is always pleasing from even slightly rendered drawings or paintings made on the spot) his pictures were pleasing, because the scene was real, the foliage varied and unmannered and the broken ground and rocks and masses had the very impress of being after originals and not ideals. . . . I prefer real American scenes to compositions, leaving the distribution of light, choice of atmosphere and clouds, and in short all that is to render its natural effect as pleasing and spirited as the artist can feel permitted to do, without violation of its truth.[19]

Cole's reply, "I really do not conceive that compositions are so liable to be failures as you suppose. . . . If I am not misinformed, the first pictures which have been produced, both historical and landscapes, have been compositions, certainly the best antique statues are compositions; Raphael's pictures, those of all the great painters are something more than mere imitations

3-3 Thomas Cole: *The Course of Empire: The Consummation of Empire*, 1836. Oil on canvas, 51 x 76 inches. Courtesy of The New-York Historical Society, New York.

of nature as they found it,"[20] upheld the neoclassic respect for the composed picture, which he believed would surpass the prosaic narration of natural appearances. He went on to include a faithfully romantic assertion of the valid role of the imagination in creative endeavor: "If the Imagination is shackled, and nothing is described but what we see, seldom will anything truly great be produced, either in Painting or Poetry."[21] At the same time, however, Cole suggested that Doughty might have failed in his compositions because "he has painted from himself instead of recurring to those scenes in nature which formerly he imitated with such great success."[22]

Though he spoke and wrote at great length about the necessity to commune intimately and freshly with nature, in Cole's mind, as doubtless in Sir Joshua's, certain great painters became inextricably associated with specific moods of nature. Thus, when he sought an elegiac mood, he reached instinctively for Claude; for stormy nature, Salvator came to hand. Small wonder that the nineteenth-century critic Shearjashub Spooner (a versatile figure whose many accomplishments, like those of Charles Willson Peale, included dentistry) wrote of Cole's paintings: "The scenery is always nature,

3-4 Thomas Cole: *The Course of Empire: Desolation,* 1836. Oil on canvas, 39¼ x 63½ inches. Courtesy of The New-York Historical Society, New York.

closely copied, in her sweetest or most terrible aspects. His morning, evening and noon-day scenery, may be compared to that of Claude Lorrain, more subdued, but more true, and his storm scenes to those of Salvator Rosa, equally spirited but more highly finished. Whatever scene he painted, it was nature herself."[23]

The confusion was not Spooner's alone. Cole was in genuine danger of further formularizing formula. In his famous series "The Course of Empire" (1836), *The Savage State,* stormy and untamed, is reminiscent of Salvator; *The Arcadian or Pastoral State,* of Claude; *The Consummation of Empire (Ill. 3-3),* of Claude via Turner's *Building of Carthage; Destruction,* of John Martin; and *Desolation (Ill. 3-4),* again of Claude.

Such heroic cycles were the works dearest to Cole's heart. Pathetically grateful to his patron Luman Reed for giving him the opportunity to paint "The Course of Empire," he was nevertheless doubtful that the public would appreciate the series, conceived during his first visit to Italy in 1829–32. He wrote to Reed:

Will you excuse me if I say that you will be disappointed in the reception and notice my pictures will receive from the publick, let them be exhibited to ever so good advantage. They will be a subject for the whole pack of

mongrel criticks. They may be attacked unjustly as well as unjustly praised
—some will see nothing but beauties—others nothing but their faults.
There may be fulsome panegyrics and odious comparisons. And very
few of them will understand the whole scheme of them—the philosophy
there may be in them.[24]

The reception was perhaps a bit better than Cole had expected. While
the paintings were still in Cole's studio, the *New York Mirror* proclaimed:
"Claude never conceived anything so truly poetick!"[25] and noted, when the
series was ultimately exhibited:

He has accomplished his object: which was to show what has been the
history of empires and of man. Will it always be so? Philosophy and
religion forbid. Although such as the painter has delineated it, the fate
of individuals has been, still the progress of the species is continued, and
will be continued, in the road to greater and greater perfection, when
the lust to destroy shall cease and the arts, the sciences, and the ambition
to excell in all good shall characterize man, instead of the pride of the
triumph, or the desire of conquests, then will the empire of love be
permanent.[26]

But though the general response to such series was good, patrons for them
were very hard to come by.[27] Cole had to plead with the heirs to Samuel
Ward's estate to be allowed to continue "The Voyage of Life" (*Ill. 3-5*) after
Ward's death.[28] For his last great series, "The Cross and the World," he
was, at the time of his death in 1848, his own patron.[29] "Course of Empire"
and "Voyage of Life" were well received by the American public because
of their high moral content.[30] But when it came to hanging pictures in
their homes, the public wanted "truly American scenes." As the *New York*

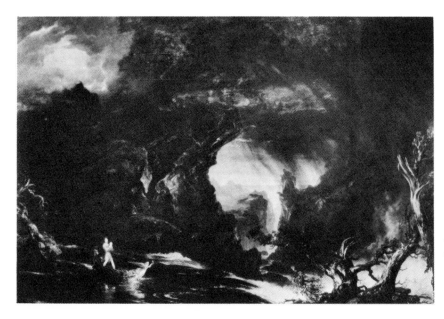

3-5 Thomas Cole: *The Voyage of Life: Manhood,* 1840. Oil on canvas, 52 x 78 inches. Collection of Munson-Williams-Proctor Institute, Utica, New York.

69

Mirror put it: "His Arcadias and other scenes from the imagination, have not that originality and truth-telling force which his native pictures have. As a colourist or designer, Mr. Cole ought not to expect to rival Claude or Salvator Rosa; but as a true lover of his own native land, and as a faithful and bold delineator of all her wild scenery, he stands, and will, we think, continue to stand, unrivalled and alone."[31]

To meet the orders for the "New England Scenes, Pontusac Lakes, Ticonderogas, Lake Georges, etc." that a friend in Boston wrote "will sell more readily here than larger pictures,"[32] Cole had to fill his notebooks with sketches of "home scenes." His method, in general, was to work from his sketchbooks. The artist must "sit down amidst his sketches, make selections and combine them, and so have nature for every object that he paints."[33] He tried always to "get the objects of nature, sky, rocks, trees, etc., as strongly impressed on my mind as possible, and by looking intently on an object for twenty minutes I can go to my room and paint it with much more truth than I could if I employed several hours on the spot. By this means I become more intimately acquainted with the characteristic spirit of nature than I could otherwise do."[34]

What Cole sought was the "vivid" picture "in the mind's eye," which he found more valuable than sketches on the spot, "for the glare of light destroys the true effect of colour, and the tones of nature are too refined to be obtained without repeated paintings and glazings."[35] He made careful verbal color-notes on his drawings, thereby employing memory as an aesthetic component, a practice that allied him once more to Allston. His reference to the mind's eye is illuminating here, since it reveals the same belief in the superiority of the conceptual image noted earlier in Copley's American works. For Copley, however, thought could become thing. Cole complained bitterly that the American public wanted "things not thoughts," and he was right. At the base of Cole's ideal allegories was an essential abstraction far beyond an age tied to the naturalistic and nationalistic as well as to an enduring need for the palpable.

In seeking to extract a "characteristic spirit" from nature, Cole was anticipating a concept of synthesis, in which form clothes idea, that was to interest the Post-Impressionists and the proto-Abstractionists. Like Whistler,[36] Cole felt that nature was very rarely right. He embraced the idea of a characteristic or typical beauty, an essential truth hidden beneath the veil of vagaries of external nature:

That the true and the beautiful in Nature and Art are one and inseparable I have long been convinced. And that truth is the fixed and unchangeable standard of taste, that works of art, however they may tickle the fancy and amuse the eye of the multitude at the time—unless founded and built

upon truth will pass away like the breeze that for the moment ruffles the surface of the lake. Those founded on truth are permanent and reflect the world in perfect beauty. What I mean by true in Nature is the fulfillment in themselves, the consummation . . . of created things, of the objects and purposes for which they were created. . . . By true in art I mean imitation of true nature and not the imitation of accidents nor merely the common imitation that takes nature indiscriminately. All nature is not true. The stunted pine, the withered fig-tree, the flowers whose petals are imperfect are not true.[37]

Cole's ideal attitude can be traced back to Sir Joshua as well as forward to Whistler.[38] But it is Cole's relation to his own time that is most important here. Whether we consider him retrograde or in advance of his day, it is clear that, for the most part, he was not quite *of* his time—a time that sought not only an inner truth but an inner and outer truth that generally managed to have it both ways. As the *North American Review* put it: "In every kind of art, truth to nature is an imperative law. And under this law only can the imagination freely do its work, adding to carefulness power, to watchfulness truer insight, to love inspiration, to truth the spirit of prophecy. Truth-telling about nature, external nature and internal, the creation, in short, is the great end and aim of art."[39]

Cole's preference for the characteristic and the essential ran the constant risk of being criticized for lack of fidelity to the "truth" of nature's details.[40] Yet he strongly maintained that he always had "nature for every object," and even criticized Turner's later works for a "visionary, unsubstantial look about them that, for some subjects, is admirably appropriate; but in pictures representing scenes in this world, rocks should not look like sugar candy, nor the ground like jelly. . . . The standard by which I form my judgement is—beautiful nature; and if I am astray it is on a path which I have taken for that of truth."[41]

But the fact remains that Cole's patrons and critics largely distrusted his imaginative works. His philosophical cycles and Arcadian dreams were never as well received as his native scenes. By 1838, the *Mirror* was clearly nostalgic about "Mr. Cole's more early pictures, which to our taste, were always the best, from their truly American feeling."[42]

Throughout his career, then, Cole felt a pull between the public preference for specific views—which would transcend, nonetheless, "mere mechanical imitation"—and his heroic principles and philosophical ambitions, which had become succinctly involved with those painters whose philosophies coincided with his. It seems obvious, however, that though the public demanded specific locales, the specificity was essentially titular. Once he called a painting "The Catskills," the critics were satisfied; one even suspects that had he so labeled an imaginary Italian view, they would have been equally satisfied. The need for the specific also made it possible for critics to find

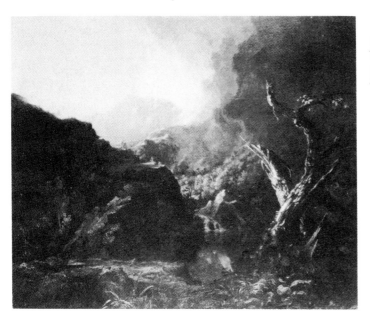

3-6 Thomas Cole: *Landscape with Dead Tree, ca.* 1827–28. Oil on canvas, 26½ x 32½ inches. Museum of Art, Rhode Island School of Design, Providence.

in the highly idealized eclectic compositions of "Course of Empire" and "Voyage of Life" "typical American scenery," and Louis L. Noble, Cole's biographer, reminds us that Cole's trip along the Genesee influenced "his mind and feelings" for "Voyage of Life."[43]

In a way, we can say that the public was fooled from the start, since Cole's

3-7 Thomas Cole: *Moonlight,* 1833–34. Oil on canvas, 24½ x 31¾ inches. Courtesy of The New-York Historical Society, New York.

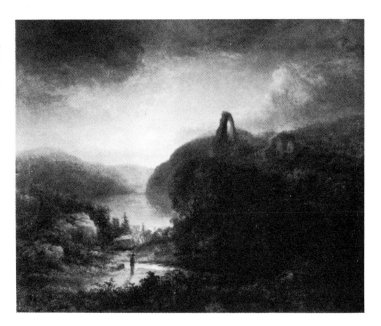

3-8 Thomas Doughty: *Tintern Abbey,* after 1836. Oil on canvas, 29½ x 36⅜ inches. In the collection of The Corcoran Gallery of Art; Gift of William Church Osborn.

views were never as uncomposed as the critical taste might have preferred. From the beginning, Cole tended to dispose nature's parts according to an *a priori* sense of composition. Using and re-using Salvator's gnarled trees and Claude's coulisses and glittering ponds, he deftly imposed details of American scenery upon formulae derived from earlier prototypes, or upon his own favorite compositional schema, which he would repeat whether the locale were the Catskills or the White Mountains.

Typical of such practice—containing the full repertory of devices—is the *Landscape with Dead Tree (Ill. 3-6).* The gnarled Salvatorian tree trunks dominate the right-hand portion of the painting, eloquent testimony to the "history of some storm." The strong system of diagonals, crossing first from top left to lower right, then back up from a central nexus capped by a mountain peak, is a favorite Cole formula for mountain landscapes. Added to these are other typical devices—the central pond, the Claudian coulisse. The essential flatness of this painting, with its abstract pull back to the surface plane, further emphasizes the basically synthetic character of the image. Cole has retreated to his studio and allowed time to draw a veil over the common details.

It is obvious that this approach was best suited to Cole's ideal Italianized compositions, in which time could not only draw a veil but remove the viewer to an elegiac world. As with Allston, one part of Cole's sensibility transmuted European romanticism into a tranquil dream, steeped in what he had called "the gigantic associations of the storied past." In his Arcadian dreams, he aspired, as he did in a picture "representing a ruined and solitary tower, standing on a craggy promontory, laved by the unruffled ocean," to "a stillness, a loneliness . . . that may reach the imagination."[44]

The mellow, subdued tone of twilight, the silvery lustre of the moon, the glassy ocean—the mirror of the scene—the ivy-mantled ruin, the distant ship, the solitary shepherd-boy, apparently in dreams of distant lands, and forgetful of approaching night, and of his flocks, yet straggling among the rocks, all these combined must surely, if executed with ordinary skill, produce, in a mind capable of feeling, a pleasing and poetic effect, a sentiment of tranquillity and solitude. This picture will probably remain on my hands. It is not the kind of work to sell.[45]

In paintings of this type (*Ill. 3-7*), Cole adds another chapter to the romantic iconography of moonlight in American painting (*Ill. 3-8*). And his largely unfulfilled yearning for a "storied past" reminds us of his own awareness that "American associations are not so much of the past as of the present and the future."[46]

The iconography—not only of moonlight but of nostalgia—in American art needs further probing. Such a longing for an ever-fugitive past time, for an only vicariously realized antiquity, annexed to the American experience through a deliberate expatriatism (*Ill. 3-9*), drew a whole generation of American painters and sculptors to Italy around the mid-century. These so-called Travelers in Arcadia, coupling European experience with their American sensibilities, require a separate study of their own (*Ill. 3-10*).[47]

As we might have expected, Cole's philosophical idealism grew increasingly synthetic as his art matured. Thus, in the development of his philosophical series, his last effort, "The Cross and the World," would have been (to judge from the studies for the unfinished series) (*Ill. 3-11*) the most two-dimensional and abstract; his earliest, "Course of Empire," the least so.

But in the development of his views from nature, these tendencies are curiously reversed. In the views, nature, in one of the nineteenth century's

3-9 Thomas Cole: *View of Florence from San Miniato,* 1837. Oil on canvas, 39 x 63⅛ inches. The Cleveland Museum of Art; Mr. and Mrs. William H. Marlatt Fund.

3-10 Thomas H. Hotchkiss: *Torre di Schiave,* 1864. Oil on canvas, 17 x 27 inches. Collection, Dr. and Mrs. Brian O'Doherty, New York.

most fascinating aesthetic quarrels, begins to wrestle with the imagination and inherited artistic conventions for its own rights. The impetus for this was provided by public opinion and the realistic taste of the time, and by the simple fact that Cole's constant communion with nature imposed upon him at a certain point irrefutable observations that time could not erase. Light, atmosphere, space—attributes generally captured more in on-the-spot views than in the studio—and an awareness of the subtleties of climate and weather, make their appearance by the mid-1830's in *The Oxbow (Ill. 3-12),*

3-11 Thomas Cole: *The Pilgrim of the Cross at the End of his Journey* (study for the series *The Cross and the World*), 1846–47. Oil on canvas, 12 x 18 inches. Courtesy of National Collection of Fine Arts, Smithsonian Institution, Washington, D.C.

a painting done at a time when, interestingly enough, Cole was fully engaged in the "Course of Empire" series. In this case, it was definitely a concession to public opinion that induced Cole to paint a view. As he said in a letter to Luman Reed:

I shall take advantage of your kind advice (and Mr. Durand's) and paint a picture expressly for the exhibition and for sale. The only thing I doubt in the matter is that I may be able to sell the picture. I think I never sold but 2 pictures in Exhibition in my life. . . . I have revolved in my mind what subject to take and have found it difficult to select such as will be speedy of execution and popular. Fancy pictures seldom sell and they generally take more time than views, so I have determined to paint one of the latter. I have already commenced a view from Mount Holyoke— it is about the finest scene I have in my sketchbook, and is well known. . . . You will perhaps think I have acted injudiciously in painting the scene as large as the largest picture in the series on account of selling—but I had

not altogether my choice for the only canvas I had was the one on which I made the first sketch of your large picture.[48]

Cole painted *The Oxbow* on a larger canvas than was usual for his views; the result was a monumental painting fully transcending the "mere view" to become "art," yet at the same time maintaining a freshness derived from the natural scene itself. The ubiquitous gnarled tree trunks still dominate the foreground at the left. But the observation of light and spatial volumes, as the "view" below stretches out into the distance, reveals a sensitivity to the immediate feel of the landscape experience that is rare in Cole's work up to this time.

This tendency appears to have grown in Cole's views of the 1840's, so that even in an Italian view, such as the *Vale and Temple of Segesta, Sicily* (*Ill. 3-13*), an expanded sense of the actual space of the natural scene is evident. It is especially apparent in Cole's *View of the Falls of Munda near Portage on the Genesee Falls, New York* (*Ill. 3-14*), one of the most singular works of Cole's career, which declares, in a startling way, the new development in his attitude to nature and to his art.

In this painting, which is dated 1847, we have evidence of a distinct change in Cole's whole approach to his subject. The *a priori* formula is nowhere to be seen. A few small, gnarled trees dotting the rocks are the last vestiges of Cole's Salvatorian sublimity. What we are confronted with is a painting that derives its composition and design not from an idea in the mind of the artist, not from a schema to which its parts conform, but rather from the

3-13 Thomas Cole: *Vale and Temple of Segesta, Sicily,* 1844. Oil on canvas, 44¼ x 66⅛ inches. Courtesy of The New-York Historical Society, New York.

77

configurations of nature itself—from the volumes created by the rock formations and from the spatial extensions of the landscape above the waterfall into the distance. The observations of light and weather conditions that characterized *The Oxbow* have been amplified even further in accordance with a fresh response to the actuality of nature. Though Cole had lamented that the public preferred "things not thoughts," this painting reveals a new

3-14 Thomas Cole: *View of the Falls of Munda near Portage on the Genesee Falls, New York (Mountain Landscape with Waterfall),* 1847. Oil on canvas, 51 x 39½ inches. Museum of Art, Rhode Island School of Design, Providence.

sense of the palpability of "things," a sense perhaps already signaled when he criticized Turner's rocks for being like "sugar candy."

Had Cole not died in 1848, shortly after its execution, *View of the Falls of Munda* might have been only one of many views in which his new awareness of nature could have manifested itself. For it seems, just at this paradoxical moment when his "Cross and the World" series drew as deeply as possible on his inner thoughts, that the dichotomy between the view and the composition had at last become clear to him. His compositions became even more synthetic, his views even more actual. The real and the ideal, which had so often conflicted in his art, seem to have separated out like oil and water.

In painting a view that finally abandoned artistic prototype and formula, he had placed himself not before his time or after his time but firmly in the vanguard of his time, looking forward to the brilliant nature studies of Durand in the 1850's. Had Cole lived longer, he might have made still more contributions to the development of landscape painting in America than he did.

Yet, despite his frustrations and regardless of the constant friction between his aims and the public taste, something in his ideal aspiration—perhaps its moralism—endeared Cole to the American public at large. There was little doubt that, though Americans would not follow him wholly into his Arcadian idyll, he was the leading landscapist of his time. Unfortunately, his successors perpetuated his compromises rather than the implications of his polarities, and it was through the popular success of the compromise Hudson River style that some of the more genuine answers to the dual needs of the age have become obscured.

Asher B. Durand

HUDSON RIVER SCHOOL SOLUTIONS

In the hands of Thomas Cole's successors, the development of an official Hudson River style seems to have been the natural result of the general public pressure for fulfillment of the hybrid aesthetic of the real-ideal. Some critics, such as Jarves, would have preferred the idealism of Cole:

> . . . in all his work we find the artist actuated rather by a lofty conception of the value of art as a teacher than by an ambition to excel in mere imitation. With him American landscape art began its career with high motives. Progress in this direction requires no ordinary degree of thought and imagination. It is, perhaps, on this account that he is not popularly estimated at his right value, and has left no followers to carry forward the beautiful significance and lofty suggestion with which he aimed to endow landscape art.[1]

Others, like Tuckerman, were more willing to accept the compromise style of the Hudson River men but searched out within its limitations peculiar American sensitivities to light and climate. Of Asher B. Durand (1796–1886), Tuckerman wrote:

> Among many other pictures which remain sweetly impressed upon our recollection, there is one representing a summer tempest. Whoever has watched the advent and discharge of a thunder cloud, in summer, among the White Mountains or the Hudson Highlands, will appreciate the perfect truth to nature, in the impending shadow of the portentous mass of vapor, as it falls on tree, rock, sward, and stream; and the contrasted brilliancy of the sunshine playing on the high ridge above; the strata of the latter, as well as the foliage and foreground of the whole landscape, are thoroughly and minutely American in their character. This we have long

4-1 Asher B. Durand: *The Babbling Brook,* 1851. Oil on canvas, 32 x 43¼ inches. Courtesy, Museum of Fine Arts, Boston; M. and M. Karolik Collection.

been accustomed to note and to admire in Durand; but seldom has he gone so near the atmospheric peculiarities of his native land.[2]

Jarves perhaps best evaluated the general character of the situation when he remarked of the most popular members of the Hudson River group, Church and Bierstadt, "Each composes his pictures from actual sketches, with the desire to render the general truths and spirit of the localities of

4-2 John F. Kensett: *White Mountain Scenery,* 1859. Oil on canvas, 45 x 36 inches. Courtesy of The New-York Historical Society, New York; Robert L. Stuart Collection.

their landscapes, though often departing from the literal features of the view. With singular inconsistency of mind they idealize in composition and materialize in execution, so that, though the details of the scenery are substantially correct, the scene as a whole often is false."[3]

As our understanding of the so-called Hudson River group grows, it becomes clear that the academic formula that yielded up this obvious mix of "idealizing in composition and materializing in execution" was only one of several forms of artistic statement. Within the development of each major Hudson River figure after Cole, we can, in fact, discern at least three distinct forms of expression.

When we investigate more carefully the nature of this tripartite division, further clues to the true character of the Hudson River school come to light. For the Hudson River formula, as practiced sometimes almost interchangeably by Durand, Kensett, Church, and Bierstadt—with bucolic sentiment, Claudian design, and "near-looking" detail—was only the most obvious and, probably for that reason, the most popular solution to the real-ideal dilemma (*Ills. 4-1 and 4-2*). That dilemma, which determined the course of American landscape painting, proscribed certain solutions to the landscape experience and resulted in others that are now finally emerging as more authentic, though less fully recognized or valued in their own time.

Thus, the same public taste that had pushed Thomas Cole toward the "real" pole of the real-ideal polarity pushed Asher B. Durand toward the "ideal." While Cole was alive, Durand had to endure being called "second

4-3 Asher B. Durand: *Head of a Roman,* 1840. Oil on canvas, 24½ x 19½ inches. Courtesy of The New-York Historical Society, New York.

4-4 Asher B. Durand: *Imaginary Landscape: Scene from "Thanatopsis,"* 1850. Oil on canvas, 39½ x 61 inches. The Metropolitan Museum of Art, New York; Gift of J. Pierpont Morgan, 1911.

only to Cole" in landscape painting. After Cole's death, he may be said to have assumed the mantle of dean of the Hudson River school. Young artists, such as Thomas H. Hotchkiss (*ca.* 1834–69), and older men, such as John W. Casilear (1811–93), John F. Kensett (1816–72), and Edward D. Nelson (?–1871), joined him on occasion in the 1850's on his travels to the White Mountains, North Conway, the Berkshires, and around the area near his home at Catskill Clove, and with him made those summer sketches from nature that would serve as model repertories for the winter months.

Durand actually lived through two substantial careers in one lifetime. Early in his life, he conducted (for some time with his brother Cyrus) an engraving business that specialized in banknotes and also included portraiture and landscapes. Probably under the influence of his close friend Cole, he became increasingly interested in landscape painting. By the 1830's, he was painting his "rambles around Hoboken,"[4] and the unhackneyed objectivity of these earliest sketches anticipated the fresh vision he would display in the 1850's.

In 1840, he made the grand tour (*Ill. 4-3*) with Casilear and Kensett. He copied and studied Rubens in Antwerp,[5] admired the English watercolorists in London,[6] was somewhat disappointed in Claude,[7] and wrote home that:

I can look with admiration and wonder on the beauty and sublimity of the scenes now before me; I can look with gratification and advantage on the great works of art, as I have done in England and on the Continent, and still expect to do in Italy; yet when all this looking and studying and admiring shall have an end, I am free to confess that I shall enjoy a sight of the signboards in the streets of New York more than all the pictures in Europe; and for real and unalloyed enjoyment of scenery, the rocks,

4-5 Asher B. Durand: *Sunset, 1838*. Oil on canvas, 25 x 34 inches. Courtesy of The New-York Historical Society, New York.

trees and green meadows of Hoboken will have a charm that all Switzerland cannot boast.[8]

Though Durand was in contact with the literary men of his time (several of his landscapes were inspired by contemporary poets, for example, the *Scene from "Thanatopsis"* [*Ill. 4-4*], based on William Cullen Bryant's famous poem), his letters are remarkably free of the literary references and allusions so common in Cole's correspondence. Durand's letters are objective, practical, concerned not only with climatic conditions for painting but whether there are trout to be caught nearby. He approached painting as an outdoor sportsman might, and it is precisely in this approach that his importance lies. For Durand was one of the first Hudson River men who was able, by temperament and inclination, to surrender the Claudian-derived cliché in his landscape compositions, and to assume a plein-air objectivity in which the inherent components of *landscape* determined design, while *weather* determined properties of atmosphere and light. Thus, his studies from nature in the 1850's are as vanguard in realistic observation as are Courbet's at the same time or slightly later in France.

This is not to say that Durand totally abandoned what may be called the salon Hudson River motif. Until his death, he continued to produce the cliché compositions for which the Hudson River artists have been both famed and damned up to the present (*Ills. 4-5 and 4-6*). But as a paradigm of the tripartite development mentioned earlier, his art also included—along

4-6 Asher B. Durand: *Sunset,* 1878. Oil on canvas, 25 x 37 inches. Courtesy of The New-York Historical Society, New York.

4-7 Asher B. Durand: *Kaaterskill Clove,* 1866. Oil on canvas, 39 x 60 inches. The Century Association, New York.

with the salon motif and the objective studies from nature—a *luminist* style, which in its poetic rather than analytic approach drew Durand closer to the indigenous solutions to problems of light and atmosphere of other Americans of the 1850's and 1860's (*Ill. 4-7*).

Initially, in the 1840's, Durand tried to meet the demand for some "ideal sentiment" veiling the naked truth by emulating Cole and making his own

4-8 Asher B. Durand: *Kindred Spirits,* 1849. Oil on canvas, 46 x 36 inches. Art and Architecture Division, The New York Public Library; Astor, Lenox and Tilden Foundations.

fairly successful attempts at allegory. By the time he had dedicated *Kindred Spirits (Ill. 4-8)* to Cole's memory (in 1849, a year after Cole's death, painting the artist and the poet Bryant gazing out over a deep gorge at an atmospheric distance), he was acknowledged in the press as the foremost American landscape painter. In 1853, *Gleason's Pictorial Drawing Room* could state: "Durand, a New York painter of very extended and favorable reputation, who is accounted the best painter of landscapes in America . . . is excelled perhaps by none in the world."[9]

By then, however, Durand had found his own direction, which was, in some respects, no more what the American public wanted than were the allegories of Cole. For in the 1850's, Durand executed that series of landscape studies from nature—free of contrived *a priori* compositions, spontaneously proto-Impressionist in handling—which are among the most remarkable group of plein-air studies in American nineteenth-century painting. Cole, one remembers, liked to absorb nature like a sponge and then

allow the veil of memory to erase the details. His conceptual approach was underscored by the way he made his on-the-spot color notations, not visually, in terms of tone and value, but verbally: green, blue, brown.

Durand, in the "Studies from Nature," was one of the earliest American painters to break with the conceptual mode and to respond to sensational impulses of light and air. He wrote to Edward D. Nelson:

> We are just settled down for the season in a situation that throws all others that I have ever found quite in the shade—with Mount Washington full in view from our window, with the intervening valley of woods and meadows, skirting away to the house, bounded on each side by . . . mountains and precipices, altogether forming a beautiful composition without need of change or adaption. In the immediate neighborhood are rocks and trees of great variety with streams and thin appendages that offer abundant material for every day and time, as the condition of the weather may be for consistent and profitable study. . . . Look from the top of the Hume house westward through the Franconia Notch—it is quite Alpine —the flies are so terrible about there that I could not work.[10]

When the flies were not biting, Durand executed such studies from nature, which, in his own words, formed "a beautiful composition without need of change or adaption." Compositional structure takes shape from the rocks and trees themselves, their weights and volumes and linear balances playing against one another within the limits of the picture (*Ill. 4-9*).

Courbet, in such paintings as *The Gour de Conches* (1864) (*Ill. 4-10*), achieved similar results, though I have found no evidence of influence in either direction. Rather, in a curious parallel of development proceeding simultaneously on both sides of the ocean, both Courbet and Durand achieve a classic ordering of form that looks forward to the famous legend of Cézanne "redoing Poussin after nature." The impetus is the same: the closest possible approximation on canvas of the artist's visual sensation, an objectivity that, finding its painterly equivalent, allows new laws of composition to grow from within the province of nature itself. Cole, it will be remembered, had reached this point at the end, in the *View of the Falls of Munda* of 1847.

Though the "Studies from Nature" seem to have offered Durand considerable satisfaction in themselves, they were also models for his winter labors, comprising a full color store of detail from which he could choose and select—and organize at winter's leisure—the finished salon pictures he continued to produce. There are some signs of a growing taste for the sketch: "I understand from Miss Durand that you might perhaps be willing to execute a study for me from nature in the coming summer. I wish for an American Landscape. I should rather prefer it without Buildings, as I think our buildings are rather angular, and am not desirous of many figures. . . .

On some accounts, I should prefer a sketch directly from nature to a more finished picture,"[11] and "I am very anxious to have an oil sketch by you— It matters not what, a single tree, or a rock."[12] But the demand for the spontaneous study was hardly sufficient to encourage large-scale abandonment of the official Hudson River style. Actually, in America, the problem of sketch versus finished picture was even more complex than that referred to by Delacroix from time to time in his *Journal,*[13] for behind it were still more subtle philosophical prohibitions.

Despite these, in the studies, Durand allows the pre-established formula of the Hudson River mode to give way to the immediacy of the happened-upon, where the closeness of the view establishes the spectator more directly on the spot. The suddenness of the moment is conveyed by the spontaneity of stroke, slickness is abandoned for the sketchlike and scumbled, and smooth finish is replaced by tactile pigment. Impastos of light, falling on rock forms, become at once sun and stone. Like Courbet, Durand takes advantage of the textural suggestions of rocks to indulge a taste for tactile pigment, loosely applied in the broken stroke of a proto-Impressionist. Unlike Courbet, however, who in *The Gour de Conches* uses a broken stroke

4-9 Asher B. Durand: *Study from Nature: Rocks and Trees, ca.* mid-1850's. Oil on canvas, 21½ x 17 inches. Courtesy of The New-York Historical Society, New York..

containing flecks of orange, pink, and purple along with green trees and brown-gray rocks, Durand never negates local color. We are reminded, through this coloristic distinction, that Courbet's painting is a step on the road to European Impressionism, while Durand's reaches toward an American Impressionism of the type practiced by Winslow Homer, a different brand entirely from the imported genre of Hassam and Twachtman later in the century.

Durand's example invites us to speculate again why an Impressionism similar to that of Europe did not develop in America. He was a plein-airist. He was able to abandon the *a priori* compositional formula for the close-up view. He was capable of painting with a spontaneous stroke, of using painterly rather than linear style (one of the few largely home-grown Americans who could develop this ability). He made observations in his famous "Letters on Landscape Painting," which were published in *The Crayon* in 1855 (v. 1 & 2), about "atmospheric space," its complexity "when considered under the influence of a variable sky, cloud shadows and drifting vapor . . . all the subtleties of light with color subject to the media through which it passes, and the intricacy of reflections from accidental causes,"

4-10 Gustave Courbet: *The Gour de Conches,* 1864. Oil on canvas, 29⅛ x 23⅝ inches. Musée des Beaux-Arts, Besançon.

4-11 Asher B. Durand: *Study from Nature: Stratton Notch, Vermont,* 1854. Oil on canvas, 18 x 24 inches. Courtesy of The New-York Historical Society, New York.

which call to mind the Impressionist concern with mist and changing light. In advising his imaginary pupil to study atmospheric changes "daily and hourly" because "the degrees of clearness and density, scarcely two successive days the same—local conditions of temperature—dryness and moisture—and many other causes, render anything like specific direction impracticable,"[14] he was, in effect, advising that same study of transitory effects that was formulated by the Impressionists into a working theory. The "Letters" also reveal that he was concerned with the neutralizing effect of light upon color, and with the variety of greens in nature when perceived in sunlight.

The clues lie in other comments in the "Letters"—as where he refers to sunlight as a color phenomenon, a type of the divine attribute, and an element that "imparts a cheerful sentiment to the picture,"[15] suggesting that his observations were not as analytically free from sentiment as were those of the Impressionists—and in other paintings of the 1850's, in which he achieves a hybrid style that incorporates sunlight "as a divine attribute" into the painting.

In *Study from Nature: Stratton Notch, Vermont (Ill. 4-11)*, Durand executes the dead tree trunk with impastos of paint that arouse our basic pleasure in paint as paint, with variations of paint thickness that create

luminosity and with a fresh painterly stroke that conveys the immediacy and directness of the Impressionist vision.

But the distant hills are covered with an even, sandlike impasto that acts as an equivalent for the softness of trees bathed in mist. Stroke (and the painter's correlative presence) vanishes, and the emanation of light and air, framed by the elegant twists of branches, leads us into that serene distance which is the province of the American luminist poet-painters.

Within the single painting, Durand has incorporated elements of his proto-Impressionist style and a concern for light closer in feeling to that of the luminists. If we say that Impressionism is the *objective* response to the *visual* sensation of light, then perhaps we can say that luminism is the *poetic* response to the *felt* sensation. There is much room here for speculation.

The indigenous development of Impressionism in America, which can be traced through the landscapes of such luminists as Heade and Lane into the works of Winslow Homer, unfolds under conditions not too dissimilar from those in Europe. The ideal, whether in neoclassic or romantic guise, gives way gradually to the real. In America, if anything, the taste for the real was stimulated by a national predilection for the specific and the recognitory and, above all, by the scenery that augmented the national pride—which was, of course, America's own. The ideal survived; too often, however, enmeshed in sentiment, a demure veil over the naked truth. Thus we can account for the postcard pinks of an occasional Bierstadt sky.

But the search for a sentimental *glow* could also heighten the artist's awareness of light, and the poetry of light was soon perceived. It is my feeling that the awareness of light at this moment could have led in several directions; the extraordinary coincidence between the specific paintings by Durand and Courbet suggests that it was, at this time, but a short step sideways from the lyric awareness of light to its analysis in paint. That step, however, was, as suggested earlier, virtually impossible for the American artist to take. The American necessity for the ideal, for "sentiment," which needs but a touch of profundity to become "lyricism," militated against an objective, analytic dissection of God's world. Sunlight, as a divine attribute, could hardly be broken down into the light rays of the spectrum. God's rocks could not be dissolved (the conceptual integrity of form had to be maintained), nor could they really lose their local color. The road to Impressionism as coloristic analysis and dissection was, despite all the atmospheric observations, blocked to American painters.

Yet a concern with weather and atmosphere had a long tradition in American art and criticism, paralleling similar concerns in Europe. For the American artist, atmosphere was as metaphysical as it was physical. It was natural that the artist interested in the sentiment and divinity of atmosphere should take the only path open to him. The path that most genuinely incorporated the real with this ideal was not the coloristic analysis of Impressionism but the poetry of light in luminism.

Luminism

AN ALTERNATIVE TRADITION

As I have suggested, Durand was not the only Hudson River artist who achieved a revelation of Emerson's "spirit in the fact" through the development of certain aspects of luminist style. A similar development can be seen even more markedly in the works of John F. Kensett, who, like Durand, painted in the Hudson River salon style (*see Ill. 4-2*), but who also produced pieces executed in a proto-Impressionist mode, such as *Bash-Bish Falls* (*Ill. 5-2*), and an even larger number of serene landscapes that fall into the general category of luminism (*Ills. 5-1 and 5-3*). Indeed, of all the Hudson River men, Kensett was the most clearly luminist in sensibility. In paintings such as *View from Cozzens' Hotel, near West Point* (*see Ill. 5-12*),

5-1 John F. Kensett: *Shrewsbury River,* 1859. Oil on canvas, 18½ x 30½ inches. Courtesy of The New-York Historical Society, New York; Robert L. Stuart Collection.

5-3 John F. Kensett: ▶ *Third Beach, Newport,* 1869. Oil on canvas, 11⅝ x 24¼ inches. Courtesy of The Art Institute of Chicago.

5-2 John F. Kensett: *Bash-Bish Falls, South Egremont, Massachusetts*, 1855. Oil on canvas, 29½ x 24¼ inches. Courtesy, Museum of Fine Arts, Boston; M. and M. Karolik Collection.

with its exquisitely subtle tonal modulations of golds, browns, and grays, proto-Impressionist scumble becomes a delicate equivalent for foliage, while vitrescent water confronts the spectator with no reference through stroke to the artist's presence. As Jarves wrote of Kensett's later works, "there is a phantom-like lightness and coldness of touch and tint, which gives them a

somewhat unreal aspect. But they take all the more hold on the fancy for their lyrical qualities."[1]

In Frederic E. Church (1826–1900) and Albert Bierstadt (1830–1902), the tripartite division initiated early in Hudson River practice persisted to its end. Church, as Cole's most illustrious pupil, carried the concept of landscape as history painting even further than his master. The large, symphonic paintings, with their all-encompassing light, are "better" than Cole, according to the morality of the Hollywood spectacular (*Ill. 5-4*). There is a rhetoric of grandeur here that has to do with a domestication of a kind of Wagnerian titanism for democratic purposes. The wish to astound and awe the beholder invites a study of rhetoric, and both Church and Bierstadt might be considered from this point of view without the irritation that we habitually feel in the presence of such emotional inflation. These pictures were, of course, popular art, and involved to some degree parodies of high-mindedness and a magnification of popular taste.

Jarves was probably justified in accusing both artists, at the height of their popularity, of idealizing in composition and materializing in execution (of achieving, in other words, the most superficial blend of the ideal and the real). Yet it may be premised that such works were simply the most logical fulfillment of the implications of the Hudson River compromise formula. What seems of larger importance, however, is that recent scholarship has noted in their works, concurrently with the production of exhibition pieces,[2] an interest in light and in plein-air fact that ties both men to the poetic and objective investigations in which all the Hudson River artists were engaged (*Ills. 5-5, 5-6, 5-7, and 5-8*).

Possibly for this reason, Flexner has chosen to see luminism as just another offshoot of Hudson River practice,[3] and Richardson takes it as "an intuitive search by American painters for a style of light, growing out of the tonal painting of the thirties and forties,"[4] pinpointing it along with naturalism as a major direction in landscape painting. Luminism is, of course, all these

5-4 Frederic E. Church: *The Heart of the Andes,* 1859. Oil on canvas, 66⅛ x 119¼ inches. The Metropolitan Museum of Art, New York; Bequest of Mrs. David Dows, 1909.

5-5 Frederic E. Church: *Study of a Forest Pool, ca.* 1860. Oil on paper (mounted on canvas), 12½ x 12½ inches. Collection Olana, Hudson, New York.

things, but it is even more, and to interpret it simply as another aspect of Hudson River practice, or merely as another way of painting light, is to ignore the full implications of this extraordinary style, which we have only begun to understand comparatively recently.

For luminism is one of the most truly indigenous styles in the history of American art, a way of seeing so intimately related to the artist's idea of world and his relation to it that it can be identified not only in landscape painting but also in still life, genre, and portraiture (*Ill. 5-9*). One of those modes of seeing that—like Surrealism—had few pure practitioners, it nonetheless touched upon and flavored the works of countless painters who worked ostensibly in other forms. Yet, as with Surrealism, it is precisely

5-6 Frederic E. Church: *Blue Mountains, Jamaica, B.W.I.,* 1865. Oil on canvas, 10⅝ x 17¾ inches. Collection Olana, Hudson, New York.

5-7 Albert Bierstadt: *Wreck of the "Ancon" in Loring Bay, Alaska,* 1889. Oil on paper (mounted on panel), 14 x 19¾ inches. Courtesy, Museum of Fine Arts, Boston; M. and M. Karolik Collection.

these widespread philosophical overtones that are important, for they are even larger than style, delving into fundamental attitudes toward being.

John I. H. Baur's pioneering essay on luminism, written in 1954,[5] is still the only plausible model for luminist definition. It is because Baur's definition is so all-inclusive that it is important. He sees luminism as an attitude not only to *light* but to *things* in nature; he reminds us of the artist's anonymous role as an Emersonian transparent eyeball and, mainly, that luminism is a mode of expression through a subjectivity so powerful that the artist's feeling is transferred directly to the object, with no sense of the artist as intermediary. It is thus a realism that goes far beyond "mere" realism, to be

5-8 Albert Bierstadt: *Indians,* n.d. Oil on academy board, 13½ x 19 inches. Courtesy of The New-York Historical Society, New York.

96

touched, in some instances, with super-real overtones and, in others, to register that magnified intensity that turns realism into a form of impersonal expressionism.

Baur suggests that we might apply to luminism Santayana's observation on Lucretius: "The greatest thing about this genius is the power of losing itself in its object, its impersonality. We seem to be reading not the poetry of a poet about things, but the poetry of things themselves. That things have their poetry, not because of what we make them symbols of, but because of their own movement and life, is what Lucretius proves once for all to mankind."[6] Throughout the history of American painting, from Copley to the present, aspects of this luminist vision have endured. The quality of artistic anonymity, the concern with the fact of the physical object, with its thingness and thereness, are continuous right up to the bland surfaces of much art in the 1960's.

In the mid-nineteenth century, the luminist vision lent itself to works that were of a piece with the most profound philosophic and literary developments of the time. For the luminist looked at nature, as Emerson did, "with a supernatural eye," and with a clarity that was for Thoreau "as if I touched the wires of a battery." In a luminist landscape, nature is presented on a smooth, mirror-like surface that shows barely a trace of the artistic hand. In removing his presence from the painting, the artist acts as a clarifying lens, allowing the spectator to confront the image more directly and immediately. Perhaps because of the absence of stroke, time stops, and the moment is locked in place—locked even more by a strong horizontal organization, by an almost mathematical ordering of planes in space parallel to the

picture surface, and by deliberately aligned vertical and occasional diagonal accents. All of these are the traditional tools of the classic artist, of a Giotto or a Poussin.

Such paintings raise all sorts of questions about the nature of their artistic invention. Admitting with Gombrich that all seeing is a form of knowing,[7] we can still say that some art draws more on the perceptual response to what the eye sees—to the sensational impulses of color and light, as does French Impressionism—while some is more wholly conceptual—controlled more by what the mind knows about the character or essence of an object.

The conceptual nature of the American vision is one of the most distinguishing qualities of American art. It is accompanied by a strong feeling for the linear, for the wholeness of objects that must not rationally be allowed to lose their tactile identity—to be lost or obscured by the flickering lights and shadows of the European painterly tradition. Yet luminist ultra-clarity sometimes shares the stage with dazzling light emanating from a distant core, enveloping detail in atmosphere. This polarity is not contradictory when we remember that facts and non-facts, things and non-things were for the transcendental philosophy of nature all part of the same divine presence. This light could become for the nineteenth-century American artist—as it was for the medieval artist—a visible material light "similar

to eternal spiritual light,"[8] as sunlight was for Durand a type of the "divine attribute." The lucidity of luminism raises the object to that even higher coefficient of reality that Berenson spoke of, making our awareness of the object more intense than if we were to confront it outside the painting. But the emanating light can also drown the senses in an intoxication of feeling. As Emerson wrote, "because all knowledge is assimilation to the object of knowledge, as the power or genius of nature is ecstatic, so must its science or the description of it be. The poet must be a rhapsodist—his inspiration a sort of bright casualty; his will in it only the surrender of will to the Universal Power."[9]

The methods of luminism remain for me curiously mysterious. One can get very close to these pictures. One can say knowledgeably that the effects are achieved by tonal handling and by virtual elimination of stroke—but it is very hard to explain their magic. A possible answer lies in still rarely investigated aspects of their relation to the primitive folk-art tradition in America. The linear clarity in the works of painters like Kensett or Lane has often been attributed to early training in graphic art. But late in his career, in 1869, Kensett produced a painting such as *Coast Scene with Figures* (*Ill. 5-10*), which offers a provocative comparison with an anonymous work, *Meditation by the Sea* (*Ill. 5-11*), by a primitive artist around 1860 or a bit earlier.

5-11 Anonymous: *Meditation by the Sea, ca.* 1850-60. Oil on canvas, 13½ x 19½ inches. Courtesy, Museum of Fine Arts, Boston; M. and M. Karolik Collection.

5-12 John F. Kensett: *View from Cozzens' Hotel, near West Point*, 1863. Oil on canvas, 20 x 34 inches. Courtesy of The New-York Historical Society, New York; Robert L. Stuart Collection.

The primitive work, obviously ideographic, has an appealing decorative sense of abstract rhythm, which caused the artist to repeat the curved motif of the water on the shore in the curling legs of the small figure, the rock behind him, and the plateau of dune at the left. As Jean Lipman has said, "extreme fidelity to the mental picture" involves "extreme perversion of reality" and freedom from realism results in a "free, unselfconscious ability to develop the purely aesthetic qualities of abstract design."[10]

The psychology of the folk artist demands further art historical investigation—as we learn more about the psychology of perception and art. It has always amazed me that the primitive can work directly in front of the object, aiming hard for realism, checking constantly back to the object as he works, and yet end up with something that is much truer to his mind's eye than to anything his physical eye has perceived. It is almost as though that outer eye were turned off, rendered oblivious to light and air. And the two-dimensionality of that inner image prevails. This is, of course, frequently explained by a reference to technical inabilities. We might say that the perspective in such a painting as *Meditation by the Sea* would have been more believable if the artist had had some lessons in perspective. But the technical aspect is

100

only one answer, and the problem is more complex, having to do with the nature of artistic vision and with points along a possible spectrum in the conditioned development of perception.

Kensett's painting is obviously more knowledgeable technically. He softens the line at the horizon, creating a degree of aerial perspective. His linear perspective at the left seems more believable—it doesn't turn up as sharply. Yet, like the primitive, Kensett offers a surface that remains essentially planar, and a mood, a feeling of almost fantastic space, that is oddly similar. Perhaps the closest tie between the two is Kensett's wave, poised like a jagged piece of cardboard. It has been stopped in motion and will never continue down to the shore. The extreme linearism of such a motif, really primitive in feeling, accents the conceptual tie between the folk artist and the luminist.

But distinctions exist, too, making of luminism an elusive and sophisticated mode of expression. In the change from the primitive to the sophisticated, there is an added sense of the weight and solidity of objects in space, a subtle differentiation of surface textures, which *become* the objects rather than painted representations of them. The airless space of the primitive gives way to a still, hermetically sealed space, in which, however, air exists, allowing volume to displace it.

The primitive *Egg Salad* (*Ill. 5-13*), by an anonymous painter, for instance, retains the texture of paint: the lettuce is paint, the hard-boiled eggs are

5-13 Anonymous: *Egg Salad, ca.* 1840. Oil on canvas, 8½ x 11 inches. Courtesy, Museum of Fine Arts, Boston: M. and M. Karolik Collection.

5-14 Fitz Hugh Lane: *Fresh Water Cove from Dolliver's Neck, Gloucester, ca.* 1849. Oil on canvas, 24 x 36 inches. Courtesy, Museum of Fine Arts, Boston; M. and M. Karolik Collection.

paint—only the fork seeks to free itself from the all-over texture of paint to become metal and wood, but its awkward position in space keeps it from achieving total freedom, and it remains bound to the two-dimensional surface. But consider Copley, the father of luminist vision, who places in Paul Revere's hand a silver pot (*see Ill. 1-10*) that gleams metallically, with fingers reflected on its surface and the cupped hand grasping its volume firmly in space. It is as if Copley, who himself grew out of a primitive, limner tradition, has added dimensions of weight and tactility to the bounded ideographic image of the object, making the object exist in space in a plastic realization of the process of perception, from idea to actuality. The table top in this painting glistens and reflects like the mirrored water in a luminist landscape.

Thus, the relation of the luminist vision to the American folk tradition remains challenging. Though the limner tradition from which Copley stemmed was, as noted earlier, essentially archaic, the primitive folk tradition continued with typical immutability clear through the nineteenth century up to the present time. It was always there, a constant alternative to the more sophisticated academic line of American art, and was sufficiently important for the compilers of the catalogue for the *M. and M. Karolik Collection of American Water Colors and Drawings 1800–1875,* to divide the collection into folk and academic works.[11]

Many of the artists who produced luminist works preceded them with highly primitive paintings (*Ill. 5-14*). Many primitive artists, as Baur has pointed out, often got quite close to luminist radiance in their endeavors to capture realistically the light effects that confronted them (*Ill. 5-15*). It could

5-15 Anonymous: *View of West Point from above Washington Valley, ca.* 1850. Oil on canvas, 14½ x 20 inches. Courtesy, Museum of Fine Arts, Boston; M. and M. Karolik Collection.

5-16 Martin J. Heade: *Storm over Narragansett Bay,* 1868. Oil on canvas, 32⅛ x 54¾ inches. Collection, Mr. and Mrs. Ernest T. Rosenfeld, New York.

be said that all untrained or self-trained artists begin with the ideography of the primitive, so that this is not necessarily unique or even significant. What seems more telling is that after attaining maturity, after European contact, training, and travel, sophisticated artists such as Kensett, for example, should reach for luminist expression and end with a mode so close to the primitive sensibility.

5-17 George Caleb Bingham: *Fur Traders Descending the Missouri*, 1845. Oil on canvas, 29 x 36½ inches. The Metropolitan Museum of Art, New York; Morris K. Jesup Fund, 1933.

Martin Johnson Heade (1819–1904), one of the purest and most important of the luminists, could, midway in his career, create a painting such as *Storm over Narragansett Bay (Ill. 5-16)*, in which, once more, the primitive flatness of the reflected sails in the water, which neither gleam nor radiate, reminds us of the very narrow line between the luminist and the folk artist. The tonal differences that transform the sharp painted edges of flat shapes into the piercing spatial definition of luminist form are painfully subtle. There are subtle changes, too, as noted above, that result in the transmutation of paint into object. And perhaps most important, there is a significant change in the relation to plane, which is very revealing for the development of luminist art.

As Wölfflin has observed in his analysis of the development of classic form in Italian Renaissance art, the primitive tendency to the plane is uncon-

scious, the classic, conscious.[12] The relation of luminist classicism to American folk art is not unlike that of Italian classic art to the earlier Italian primitive. Luminist space is achieved through a series of planes, parallel to the surface, which are never violated but proceed back in orderly, measured steps, like the lulls between the columns of a classical temple. There is little flow or sweep, but rather a containment of each part within its own spatial unit that arrests the moment in Emerson's "concentrated eternity."[13] Even when there is a hazy, atmospheric distance, in opposition to the controlled clarity of foreground alignments, the plane is affirmed by the very palpability of light, which becomes a wall, a finite termination that with frequent luminist paradoxicality suggests the infinite. This Emersonian blend of reason and faith in the single art form was also the most cogent American solution to the dual need for the real and the ideal.

That this American classicism of the mid-century occurs not only in luminist landscape but also in the genre and even portraiture of the period makes it possible to think in terms of a more all-embracing luminist vision, which emerged in the works of many artists at about the same time (*ca.* 1845 into the 1860's), linking them in their attitudes to light, space, time, and the object in nature. George Caleb Bingham's *Fur Traders Descending the Missouri* (*Ill. 5-17*) is one of the finest examples of luminist classicism—the ripples in the water extending parallel horizontal accents and stepping planar

5-18 William Sidney Mount: *Eel Spearing at Setauket,* 1845. Oil on canvas, 29 x 36 inches. Reproduced through courtesy of New York State Historical Association, Cooperstown, New York.

5-19 William Sidney Mount: *The Power of Music,* 1847. Oil on canvas, 17 x 21 inches. The Century Association, New York.

distinctions back in space. The boat is trapped, as it were, in a block of glass, in which reflections serve as only slightly hazed bilateral anchors to maintain the image in time and space. As in many luminist paintings, the light emanating from the core of the picture becomes palpable, uniting matter and spirit in the single image, and reaffirming a planar organization that is further fortified by the strong geometric angularities of the figures themselves.

At about the same time, 1845, William Sidney Mount painted *Eel Spearing at Setauket (Ill. 5-18)*, which manifests similar luminist classic qualities: the boat locked in place by the diagonal reflections of the oars, the vertical accents of the trees reflected in the pellucid water, the classic device of a foreground plane allocated to emptiness, except for the reflection of the boat with its figures. The slight diagonal shift of the boat away from the extreme

5-20 Piero della Francesca: *The Flagellation, ca.* 1455–65. Fresco, 23¼ x 31¾ inches. Galleria Nazionale delle Marche, Urbino.

planar horizontal breaks a totally static rhythm, as do the diagonal devices of such classicists as Poussin. But the planar clarity of the surface and the vertical reflections of the figures in the water once more reinforce classic organization.

That Mount was a classic designer, even in works that are not distinguished by luminist light and reflection, can be seen in a comparison of *The Power of Music* (*Ill. 5-19*) with Piero's *The Flagellation* (*Ill. 5-20*). If one disregards for a moment the superficial genre attributes of wrinkled and tattered overalls and barnyard detail in the Mount, one is left with a startling similarity of spatial and geometric organization—even to the placement of a figure (Mount) or figures (Piero) in the shallow plane of the right foreground, with the left area of the same plane empty, separated from an

107

interior to which more figures are assigned, and in which geometries of space are fortified by architectural detail: classical Renaissance for Piero, splintered boards for Mount.

The appearance of this classic sense of form in mid-nineteenth-century America is one of the most enigmatic aspects of our art. In it lies the key to artistic and philosophical attitudes that we must grasp more fully if we are really to understand the American vision. The awareness not only of classical surface attributes in Greek-revival details of architecture and classical imagery in sculpture—but of classic principles was voiced by the sculptor Horatio Greenough (1805–52) when he said, "The men who have reduced locomotion to its simplest elements, in the trotting wagon and the yacht America, are nearer to Athens at this moment than they who would bend the Greek temple to every use. I contend for Greek principles, not Greek things."[14]

Greenough's own sense, not only of the classic simplicity of what John A. Kouwenhoven would call "vernacular" technology, but of measure, was expressed in his observation, "I love the concrete, my brother; and I can look Sir Isaac Newton in the eye without flinching; I kneel to Willy Shakespeare, who guessed to a drop how much oil goes to a Lombard's salad."[15]

Greenough went on to object to "these transcendental theories of life because of their genesis. . . . I object to them more than all, because they threaten to pare down and clip the tendrils by which I cling to the concrete.[16] Yet he shared his awareness of measure with Thoreau, the Transcendentalist-surveyor, and his statement serves as a reminder of the delicate fusion of the concrete and the impalpable in the attitudes of the mid-century.

As early as 1821, John Quincy Adams (in a *Report Upon Weights and Measures*) had maintained, "measures of *length* . . . are the wants of individual man, independent of, and preceding, the existence of society."[17] Measure was one of the most important aspects of the luminist sensibility—not only for ordering the space of the picture, but also for controlling by careful degrees the tonal modulations whereby the object could emerge from ideograph to thing and then out into the palpable, radiating presence of luminist light.

In the development of the luminist vision, it also seems apparent that some direct recourse to the mechanical as a tool for measure came into play—a natural consequence in a country that Kouwenhoven has called the "only major world power to have taken form as a cultural unit in the period when technological civilization was spreading throughout the world."[18] Thus, Fitz Hugh Lane, perhaps the purest luminist, is believed to have used the camera obscura or the camera lucida to achieve his effects.[19] Eakins employed mechanical drawings for his essentially luminist boating pictures. Both used photographs and/or designer's plans as further aids, adding the certainties

of science to an already strong conceptual vision. The problems involved in investigating the luminist sensibility open the door to a new series of questions about the nature of American art, among them the importance to the American artist of the mechanical sciences as a correlative and parallel formulating activity and of the machine as a tool and as a model for the incorporation of certain mensurational exactitudes into the work of art. Kouwenhoven long ago stressed the importance of the machine for the understanding of the American sensibility. Leo Marx, in his essays in *The Machine in the Garden,* has added useful material to a growing bibliography of art and technology in America.[20] It is of the utmost importance to examine further the transformation of the awareness gained from the mechanical and the mathematical into aesthetic and formal principles. Interestingly, we can name as inventors and artists not only Robert Fulton and Samuel F. B. Morse but Charles Willson Peale, William Sidney Mount, Thomas Eakins, J. G. Chapman, and Thomas Cole. A further extension—to consider those artists who had architectural leanings: Cole, Cropsey, and even Lane, who helped build his own house—leads us into problems that deal with the "constructing" sensibility, which for Lane, especially, as a journeyman builder, seem particularly relevant.

To these questions of measure, mechanics, and mathematics must be added others involving not so much Emersonian reason, but faith. For the vast popular interest in spiritualism in mid-nineteenth-century America seems as pertinent to the spiritual and mystical properties of luminism as does measure to its concrete properties. Since the art of Lane is perhaps the most perfect example of the luminist interfusion of reason and faith, it is worth examining in further detail.

Fitz Hugh Lane

A PARADIGM OF LUMINISM

Standing on the bare ground—my head bathed by the blithe air, and uplifted into infinite space—all mean egotism vanishes. I become a transparent eyeball; I am nothing; I see all; the currents of the Universal Being circulate through me; I am part or parcel of God.

RALPH WALDO EMERSON

When Emerson wrote this famous statement, in *Nature,* in 1836, Fitz Hugh Lane (1804–65), a native of Gloucester, was in Boston serving as an apprentice to the lithographer William S. Pendleton. The following year, he worked with the Boston publishers Keith and Moore, and in 1845 formed his own business with John W. A. Scott. He returned to Gloucester about 1848. Shortly after, he built a stone house with a southeast studio and a view of the harbor, and he lived there until his death, apart from short trips to Maine, New York, Baltimore, and probably Puerto Rico.[1]

There is no direct proof that Lane knew Emerson's essays or that he ever heard him on any of the frequent occasions when Emerson visited Boston, and even Gloucester, to lecture, though on the evidence at hand, it seems unlikely that he could have escaped him.[2] Lane left no diary and few letters, and we still know too little about him. Yet his art is perhaps the closest parallel to Emerson's Transcendentalism that America produced: of all the painters of the mid-century, he was the most "transparent eyeball."

It is tempting, therefore, to try to get at the root of his style, in order to understand more fully the genesis of luminist vision. My contention has been that luminist vision, and, indeed, the conceptual mode of much indigenous American art, has derived in part from the tempering of a continuous primitive tradition that has run parallel to the mainstream of sophisticated art in America. But the linear bias of American art, as noted earlier,

has most frequently been ascribed to initial experience at printmaking. In Lane, both factors operate as formative elements for an early style. He was largely self-taught, and his first works can be read as primitive. His graphic experience began in the early 1830's, when he moved to Boston to work with Pendleton's lithographic firm.

I think, nonetheless, it is possible now to make a distinction between the contributions of the primitive and the graphic traditions to his art. From the lithographic experience, Lane could have developed an instinct for detail, a technique for intricate linear handling, and an awareness of value modulation that instructed the tonal nuances of his later paintings. But by and large, these benefits seem to me to have been primarily technical. What Lane appears to have taken from his primitive origins was more profound: a conceptual vision in which the painting illustrates and illuminates the *mind's eye*.

In an early watercolor of 1830, *The Burning of the Packet Ship "Boston"* (done after a sketch by the first officer, Elias David Knight, and one of the passengers, Charles Osgood) (*Ill. 6-1*), Lane's primitivism enables him to develop the abstract decorative potential of the picture. Ultimately, bound possibly by the topographical necessity of the graphic experience, he moved toward a closer accommodation to the realities of the world about him. The romantic abstraction of this exuberantly swirling design, like an Oriental scroll-painting, gives way to that kind of conceptual realism which embodies fact, as Emerson would have said, "as the end or last issue of spirit"—the visible creation as "the terminus or the circumference of the invisible world."[3]

6-1 Fitz Hugh Lane: *The Burning of the Packet Ship "Boston,"* 1830. Watercolor (after sketches by Elias D. Knight and Charles Osgood), 18¾ x 26⅝ inches. Cape Ann Historical Association, Gloucester, Massachusetts.

111

6-2 Fitz Hugh Lane: *Gloucester from the Outer Harbor,* before 1862. Pencil and watercolor, 9½ x 31½ inches. Cape Ann Historical Association, Gloucester, Massachusetts.

In such later but still developmental works as *Fresh Water Cove from Dolliver's Neck, Gloucester (ca.* 1849) *(see Ill. 5-14),* the topographical details contribute to an image that is more concrete than abstract. Yet we can observe the crystalline properties of luminism beginning to emerge precisely from those factors that are still the contribution of the primitive tradition: the burnished obliteration of stroke in some parts of the water, the mirror-like reflection of the central sail, the ruled-edge straightness of the distant shore line, like a taut wire affirming the planar inclinations of the image.

The Karolik catalogue notes that this painting is derived from a panoramic sketch and that the "use of a panoramic sketch as a preparation for more than one painting was evidently a usual procedure with Lane."[4] The extensive collection of Lane drawings at the Cape Ann Historical Association bears this out, for he drew on long, extended sheets pasted together to form panoramic views *(Ill. 6-2),* and then isolated sections for his finished paintings. The practice casts some light on the relationship between luminist landscapes and the popular panoramas of the day, for the horizontal expanses of luminist paintings often suggest, with their lack of accents at the lateral edges, that they are plucked from a more extensive panoramic view, like details halted and framed from a continuing classic frieze. (The panoramic views themselves sometimes manifested the classic, ordered serenity of luminist designs; but there was also a more romantic, even histrionic, panorama with which the luminist vision has few connections, except perhaps for a similar, though diversely expressed, interest in atmosphere—and the basic correlation of horizontal format.)

The relationship between the panorama and luminism requires further attention. As predecessors of modern cinema and cinerama travelogues, the moving panorama and its variations, such as dioramas, which stressed specific time and weather effects, are extensions of the propensity for the

machine and the mechanical that plays such a large part in American expression. The panoramas open up a number of speculations on the American artist's solutions to certain spatial problems; in some instances, they seem like naïve inventions by which to express America's wide-open spaces, a naïveté similar to the Hudson River school practice of such artists as Bierstadt and Church.[5] But where, in a kind of literalism of size, the panorama painters often tried to equate their vast canvases with the magnitudes of American space, the luminists were apt to create intimate canvases in which the potent space derived its amplitude, and often its surreal overtones, from the proportional relations and pull of parts within the picture structure. Entering these contracted spaces, we feel as though, like Alice, we have shrunk to size, to wander through the curiously finite and infinite world of luminist proportion.

The European contributions to Lane's vision must not be overlooked, though we have comparatively little to go on. We know that Robert Salmon (*ca.* 1775–*ca.* 1848–51), the English-born painter who was in Boston until 1842, had some influence on Lane; Salmon is, indeed, considered by Baur to have been a possible important founder of luminism in America (*Ill. 6-3*). Lane copied at least one painting by Salmon,[6] and John Wilmerding has recently placed both artists in Pendleton's at about the same time,[7] noting that "He [Salmon] is now definitely known to have had a pupil in Fitz Hugh Lane."[8] Yet the low horizons and high ratio of sky to ground, and the over-all horizontal proportions of luminist canvases, strongly raise the possibility of Dutch influence on luminist landscape (Salmon himself derived his style from Scottish-English variants on Dutch prototypes).[9]

We know that Dutch seventeenth-century landscape paintings were in American collections and could be seen.[10] There was, moreover, a certain amount of critical interest in Dutch landscape, despite official maintenance of neoclassic disdain for the realistic Dutch tradition as "mere" or "inferior"

6-3 Robert Salmon: *Harbor Scene,* 1842. Oil on panel, 16¼ x 24¼ inches. In the collection of The Corcoran Gallery of Art, Washington, D.C.

imitation. From Sir Joshua in the late eighteenth century, to Ruskin (whose admiration for the realism of the Pre-Raphaelites seems often to have been more moral than technical and whose writings, including a question-and-answer column in *The Crayon* in the mid-1850's, had an important influence on American art and taste of the time),[11] to James Jackson Jarves, one of the few eloquent American critical spokesmen of his day, the accepted aesthetic held to the manifest idealisms of the Claudian tradition. Jarves' judgment on Dutch art was largely negative.

> Intellectually, its choice was low and unrefined. It ignored moral significance, yet its feeling, although common, was not unsound at heart. I should say that it lacked both aesthetic and intellectual sensibility. . . . avoiding all thought and priding itself on its mechanical skill and infinite patience. There never was a more purely mechanical, commonplace school of painting, combined with so much minute finish and fidelity to the ordinary aspect of things, heedless of *idealisms* of any sort. If it labored for any special end, it was that of ocular deception. . . . They did not want art to teach them ideas, but to represent things.[12]

In the face of critical aversion to "mechanical" imitation, the intense realism of luminist art was sufficient to render it unacceptable to a large portion of official taste. Yet, just as luminism seems to have been, in some respects, a private art, there seems also to have been a private taste, and perhaps it is not too much to assume that in many ways private art and private taste

6-4 Fitz Hugh Lane: *Ships in Ice off Ten Pound Island, Gloucester, ca.* 1850–60. Oil on canvas, 12 x 19¾ inches. Courtesy, Museum of Fine Arts, Boston; M. and M. Karolik Collection.

6-5 Fitz Hugh Lane: *New York Harbor*, 1850. Oil on canvas, 36 x 60 inches. Courtesy, Museum of Fine Arts, Boston; M. and M. Karolik Collection.

coincided. Jarves had also noted: "But Dutch art is too well-liked and known for me to dwell longer on it. Those whose aesthetics are in sympathy with its mental mediocrity will not desert it for anything I may say."[13]

Earlier in the century, the critic John Neal had singled out "the warm air and silent skies" of Cuyp, and "Vandervelt's" "earlier sea pieces,"[14] but lamented that the public preferred poetry to prose. Yet one of the founders of the Hudson River style, Thomas Doughty (1793–1856) (*see Ill. 3-8*), had copied a Ruysdael, and Robert Gilmor, a major collector, had acquired quite a few Dutch paintings and had tried to shift Cole, it will be remembered, from the ideal to the real by suggesting that he study Ruysdael. Gilmor even went to Holland and sketched there himself.[15] It seems certain that further research will unearth more evidence of the importance of Dutch landscape to American painters in the early nineteenth century.[16] Thus, it is entirely possible that in their quiet way the luminists found justification for their own serene horizontal compositions in the works of Dutch artists like Van de Velde and Van Goyen.[17]

I use the word composition somewhat advisedly, since Baur has suggested that Lane "was not much interested in composition; indeed there is evidence to show that he scarcely composed at all except to choose, like a photographer, his place in the landscape and the extent of his view."[18] I think, however, that Baur had in mind the more elaborate *a priori* salon compositions, based on French prototypes, of the Hudson River school; and though Wilmerding sees some possibility not only of a Dutch influence but of a marine influence from Claude and Joseph Vernet,[19] it is true that Lane did not compose in this sense. But he *was,* certainly, deeply aware of design, order, and structure in his paintings, and his horizontal alignments of objects, people, or bits of nature within the picture can almost be plotted across with a ruler (*Ills. 6-4 and 6-5*). This deliberate orientation to the

plane, part of the inherent classic bias of the luminist sensibility, can be seen by comparing one of his most powerful paintings, *Brace's Rock, Eastern Point, Gloucester* (1863) (*Ill. 6-6*) with the drawing for it (*Ill. 6-7*).

The drawing, made on-the-spot as preparation for several painting versions, depicts a mid-shore projection of rocks that slants naturally along the edge of the sea. In the painting, however, the oblique slant is corrected and the rocks straightened out to establish a spatial plane parallel to the surface, related, as the columns in a peristyle, to the horizontals before and after it in space. Thus, like a true classicist, Lane carefully allocates a foreground plane, occupied only by grass and rocks and clearly delimited by a shore line, against which ripples of water are pulled taut. In the drawing, this foreground plane is barely suggested; in the painting, it is focused to an almost painful degree. The second plane stops at the juncture of the bow of the boat with the water, is delimited by a dark, horizontal ripple connecting the boat with the adjacent rock, and continues through the horizontal axis established by the promontory, now ominously darkened. The next plane terminates at the last rocky headland, gently straightened from the slight diagonal to a still stronger horizontal. A final plane is reached in the straight-ruled horizon, which is lower in the painting than in the drawing, as is often Lane's practice. In the drawing, the horizon was the most accented horizontal. In the painting, all the natural actualities of the scene have been manipulated into a more abstract planar order, from which

6-6 Fitz Hugh Lane: *Brace's Rock, Eastern Point, Gloucester*, 1863. Oil on canvas, 10 x 15 inches. Collection, Mr. John Wilmerding, Dartmouth, New Hampshire.

the painting derives much of its power, a power intensified by the hard focus on details, such as the water ripples, that are normally soft. As with Copley much earlier, we become aware of a curious animation of the inanimate. And, again, this animation is not obviously anthropomorphic, as were the trees of the late eighteenth-century picturesque painters, but rather reveals that awareness of spirit in matter which so concerned Emersonian Transcendentalism.

Hudson River school salon paintings, more expediently meeting the public need for the ideal and the real, arrived at a hybrid generally referred to as romantic realism. To separate the luminist vision from this all-embracing generic term, we might do better to call it a form of ideal or conceptual realism. For, as with Copley, the dominating feature would seem to be the concept, the idea in the mind's eye, which regulates, corrects, eliminates, and tempers sensation. In the most academic of Hudson River landscapes, this tempering often seems deliberately imposed from without—a sentimental dose of the ideal superimposed on the real. But luminist vision came from within. The ideal emanated from the core of the artist's sensibility, and out of that ideal core the real took shape. Actuality quietly encysted a nucleus of abstract idea. That luminism was the most genuine answer to the demands of the age for a synthesis of the real and the ideal is probably one good explanation for its lack of popular notice. (It must be said here immediately, however, that Lane enjoyed an excellent local reputation in

6-7 Fitz Hugh Lane: Study for *Brace's Rock, Eastern Point, Gloucester,* 1863. Pencil, 9¼ x 14½ inches. Cape Ann Historical Association, Gloucester, Massachusetts.

Gloucester, and in New England generally,[20] and that others of this sensibility also achieved a small amount of recognition in their time, though not much from the critics who fathered what Baur has called a "paternity of ideas" that has conditioned the writing of American art history for the past hundred years.)

The drawing for *Brace's Rock* poses another problem in considering Lane's art, for the boat in the painting does not appear in the sketch, and the Karolik catalogue notes, "it is not known whether the stranded boat, which appears in the Museum's picture, but not in the drawing, is in any of the other versions."[21] McCormick tells us[22] that, in order to add his boats, Lane occasionally used photographs, marking them off with coordinates for proper placement in space (*Ills. 6-8 and 6-9*).

6-10 Fitz Hugh Lane: *View in Gloucester Harbor,* n.d. Pencil, 8⅝ x 32 inches. Cape Ann Historical Association, Gloucester, Massachusetts.

Is the measure responsible for the expressive tone in so much luminist art an indication of the American respect for these certitudes, and for their practical utility in pursuing an end, even an artistic end? The list of those who have made aesthetic use of mechanical methods (especially photography) includes Lane, Mount, Church, Bierstadt, Homer, Eakins, and, in the twentieth century, ranges from Charles Sheeler to the artists of the 1960's. In the art of the 1960's, of course, photographic reproductions (used with various factual, ironic, or iconic attitudes) were often mobilized out of their paralysis into other relational systems. And in the mid-1960's, the industrial production of art objects, with its promise of mass production, signified the literal incorporation of idea into object.

Continuing research on preliminary drawings and unfinished paintings by luminist artists indicates that they measured their horizontal and vertical alignments very carefully, sometimes annotating proportions numerically (*Ill. 6-10*). Perspective studies by nineteenth-century American artists as a whole should be studied for what they reveal about the attitude to measure. It is not surprising that Lane's mensurational inclinations were early noted by his friend Benjamin Champney while he was still at Pendleton's: "He was very accurate in his drawing, understood perspective and naval architecture perfectly, as well as the handling of vessels, and was a good, all-round draughtsman."[23] Lane's "constructivist" instinct, his architectonic sensibility, is perhaps also indicated by his participation in the construction of his own home in Gloucester.

At Thoreau's funeral, Emerson remarked on "a natural skill for mensuration, growing out of his mathematical knowledge and his habit of ascertaining the measures and distances of objects which interested him, the size of trees, the depth and extent of ponds and rivers, the height of mountains and the airline distance of his favorite summits—this, and his intimate knowledge of the territory about Concord, made him drift into the profession of land-surveyor."[24] For Emerson, "every property of matter is a school for the understanding—its solidity or resistance, its inertia, its extension, its figure, its divisibility. The understanding adds, divides, combines, measures, finds nutriment and room for its activity in this worthy scene. Meantime,

6-11 Fitz Hugh Lane: *Owl's Head, Penobscot Bay, Maine,* 1862. Oil on canvas, 16 x 26 inches. Courtesy, Museum of Fine Arts, Boston; M. and M. Karolik Collection.

Reason transfers all these lessons into its own world of thought, by perceiving the analogy that marries Matter and Mind."[25]

It was this idea of matter as an extension of mind that distinguished the American vision. Its resolution of apparent contradictions lends to it its special flavor. Emerson stated, "we want the Exact and the Vast; we want our Dreams, and our Mathematics."[26] For Lane, too, there were dreams and mathematics. In a rare letter, he wrote of a picture suggested by a dream:

This picture, the property of John S. Webber, Esq., Colector [*sic*] of the Port and District of Gloucester, was suggested to the artist by a dream. Sometime last fall while lying in bed asleep a richly furnished room was presented to my imagination upon the wall, my attention was attracted to a picture which I have here endeavoured to reproduce. The dream was very vivid and on awakening I retained it in memory for a long time. The effect was so beautiful in the dream that I determined to attempt its reproduction, and this picture is the result. The drawing is very correct, but the effect falls far short of what I saw, and it would be impossible to convey to canvas such gorgeous and brilliant colouring as was presented to me. This picture however will give to the beholder some faint idea of ideal [*sic*].[27]

120

Thus, though Lane can be considered an intense realist, it appears that the dream could be as tangible and concrete to him as reality, perhaps even more so. Perhaps this would account for the frequent suggestions of a dreamlike surrealism overcasting the realities of the luminist world. There is a selection, in such paintings as *Brace's Rock,* of the moment in nature—early morning or sunset—when the world appears newborn or like some alien terrain. Even where man is present, as in *Owl's Head, Penobscot Bay, Maine (Ill. 6-11),* he is as much an object as the surrounding rocks, merely a coordinate for the picture's vertical and diagonal accents though he may also stand, his back toward us, for the spectator, immobilized.

The moment has been of utmost importance throughout American art. That luminists like Lane made occasional essays into the area of painterly proto-Impressionist atmosphere is evident from such paintings as *A Smart Blow* (1856), as Wilmerding has pointed out,[28] and from *Sea Shore Sketch (Ill. 6-12).* In America, however, interest has resided largely in the stopped moment, the frozen continuum, the fixation of becoming to being—the antithesis of the Impressionist transient moment. The hypothesis again arises that if the road to Impressionist analysis was blocked by an aversion to the fragmentation of actuality, perhaps the scientific interest in the specifics of time and climate could have been diverted to meet the specifics of mood and feeling that we find in luminism.

In the creation of this mood, space has played an enormous role. Constructed through the planar correspondences of classicism, on some occasions it has warped slightly against those correspondences to produce an unsettling effect of implicitly expressionist or surrealist feeling, suggesting Emerson's observation, "we now and then detect in nature slight dislocations which apprise us that this surface on which we now stand is not fixed, but sliding."[29] Often, this space is comprised of an ostensibly empty foreground and of a firm horizon line. Man, when he exists, seems oddly trapped by a vast

6-12 Fitz Hugh Lane: *Sea Shore Sketch,* 1854. Oil on canvas, 6 x 9 inches. Cape Ann Historical Association, Gloucester, Massachusetts.

spatial quicksand. This use of basically classic means for anticlassic ends signals an interior mood that can be traced from Lane and Heade through Eakins, Homer, La Farge, Dewing, and into Hopper, Shahn, and Wyeth as well (*see Ills. 15–19, 15–20, and 15–21*). (It is not surprising that Wyeth, whose favorite artist is Fitz Hugh Lane, and who spends his summers in Maine near Penobscot Bay, should own an Eakins of this type as well as work by Lane.)

It is, in fact, only within the context of the specific properties of luminist *space,* as defined by its classicism and its anticlassicism, and of luminist realism, that the nature of luminist *light* can be properly approached. For luminist light largely derives its special quality from its containment within clearly defined geometries and sometimes, too, from the opposition of its brilliance to the ultra-clarification of foreground detail. Though Baur has indeed emphasized the importance of tonal modulations in the creation of luminist effect, the nuances that create this light suggest an almost alchemical sleight of hand that defies technical analysis. Close up, the transitions of tone are almost imperceptible. Yet, from a distance, a painting such as Lane's *Off Mt. Desert Island* (*Ill. 6-13*) radiates, offering, from completely diverse means, a rather interesting parallel to the perception from a distance of a Monet, which also requires a certain amount of spectator withdrawal before it yields up its atmospheric effects. But light does not circulate in a painting by Lane. It does not unite with air and atmosphere to create, as with the painterly, a feeling of *action*. Rather, it produces a mirror-like plane that both disappears and assumes a glasslike tangibility. Thus, this light reminds us not only of the atmospheric realisms embraced by luminism but of its spiritual equivalences.

McCormick has noted the possibility that Lane was a "strong spiritualist."[30] If luminist light indeed stood for a spiritual and ideal feeling that transformed the real world into another manifestation of God, then a study of the whole problem of nineteenth-century spiritualism (as a popular manifestation of many of the century's more profound philosophical attitudes) might well yield important insights. At the peak of luminist development in the 1850's and 1860's, spiritualism in America was extremely widespread. Leading figures in arts and letters who attended séances around this time included James Fenimore Cooper, William Cullen Bryant, and William Sidney Mount. Swedenborgianism, which was to appeal strongly not only to the Brownings but to Inness, Page, and the sculptor Hiram Powers, was another important correlative experience.[31] Thus, our sense of the "spiritual" aspects of luminist light at the mid-century would appear to be strengthened by the possibility that more American artists than we now realize were involved in some way in spiritualist philosophies. That light was the natural artistic vehicle for such attitudes was an idea expressed, of course, by Emerson, in whom we seem able to find every attitude, contra-

6-13 Fitz Hugh Lane: *Off Mount Desert Island,* 1856. Oil on canvas, 23³⁄₁₆ x 36⁵⁄₁₆ inches. Courtesy of The Brooklyn Museum, New York.

dictory and confirming, that occupied his age, and for whom "a foolish consistency is the hobgoblin of little minds."[32] For Emerson, light was "the first of painters"[33] and there was "no object so foul that intense light will not make beautiful. And the stimulus it affords to the sense, and a sort of infinitude which it hath, like space and time, make all matter gay."[34] A "jet of pure light," he stated, was "the reappearance of the original soul,"[35] while "by the same fire, vital, consecrating, celestial, which burns until it shall dissolve all things into the waves and surges of an ocean of light, we see and know each other, and what spirit each is of."[36]

Fitz Hugh Lane's art concurs with Emerson's concept of light as the "reappearance of the original soul." For Lane, as for Emerson, "the universe becomes transparent, and the light of higher laws than its own shines through it."[37] Creating a "celestial geometry," Lane "turned the world to glass."[38] Emerson, writing of Thoreau, might have been describing Lane when he observed: "His power of observation seemed to indicate additional senses. He saw as with microscope, heard as with ear-trumpet, and his memory was a photographic register of all he saw and heard. And yet none knew better than he that it is not the fact that imports, but the impression or effect of the fact on your mind. Every fact lay in glory in his mind, a type of the order and beauty of the whole."[39]

With Stuart Davis long after him, Lane shared a special awareness of

the light of Gloucester, where Davis noted "the brilliant light of Province-town, but with the important additions of topographical severity and the architectural beauties of the Gloucester schooner."[40] Thus, the climate, geography, and topography of the *town* of Gloucester, which also seems to have contributed to certain architectonic luminist qualities in Homer's works, might possibly be considered as we examine the sources of Lane's style.

But these additional problems serve only to emphasize the complexities of Lane's luminism, for his art brings together many of the most provocative elements within the American experience. Hopefully, from a deeper under-standing of the empirical practicalities of his environment and situation and the climate of ideas that nourished his inner world, our knowledge of luminist style will continue to grow.

7.

Martin Johnson Heade

HAYSTACKS AND LIGHT

There is little evidence that Martin Johnson Heade (1819–1904) knew Fitz Hugh Lane or even that he was acquainted with his work.[1] Yet his painting *The Stranded Boat* (1863) (*Ill. 7-1*) is so similar in mood, feeling, and style to Lane's *Brace's Rock* of the same year (*see Ill. 6-6*) that it further substantiates the idea of luminism as an indigenous mode of seeing that characterized much pre-Civil War art without however, taking on the communal aspects of an acknowledged school or movement.

7-1 Martin J. Heade: *The Stranded Boat,* 1863. Oil on canvas, 22¾ x 36½ inches. Courtesy, Museum of Fine Arts, Boston; M. and M. Karolik Collection.

Lane's picture was executed in Gloucester. Heade's, it is believed, in the vicinity of Newport. Though both display the characteristic planar organization of luminism, it is less overt in the Heade. Only gradually are we made aware of the empty foreground plane, of the second planar division established by the careful alignment of rocks and foliage, of the strategic use of the smaller realistic details such as the pebbles on the beach to produce a rational space that, suffused with the light issuing from the depths of the picture, creates an unsettling image.

As in Bingham's *Fur Traders Descending the Missouri* (*see Ill. 5-17*), the foreground details have the familiar limpid focus, while the light, obscuring the more frequently accentuated horizon, is at once dazzling and palpable. Though a figure is suggested in the distance, perched at the tip of a promontory, he is no more important than the slightly oblique twig between the small rocks in the right foreground. Philosophically, then, he is a correlate of Emerson's concept of the unity of all matter in nature. Within the picture, he becomes little more than a tiny but essential vertical accent paralleling the verticals of the large tree on the horizon at his right and the small, hazy sailboats, and stabilizing the design to some extent by correcting in the viewer's mind the diagonal leftward thrust of the mast and the rightward tug of the foreground twig and the smaller branch of the background tree.

With Heade, even more than Lane, one is often conscious of the slight warpings of planar relationships that arrive, largely through classic means, at mannerist dislocations in space, time, and mood (*Ill. 7-2*). Heade shares such a sensibility with the surrealist de Chirico (though he appears not at

7-2 Martin J. Heade: *Rocks in New England,* 1855. Oil on canvas, 17 x 27¼ inches. Courtesy, Museum of Fine Arts, Boston; M. and M. Karolik Collection.

7-3 Martin J. Heade: *Approaching Storm, Beach near Newport, ca.* 1860–70. Oil on canvas, 28 x 58¼ inches. Courtesy, Museum of Fine Arts, Boston; M. and M. Karolik Collection.

all like him), who also made inscrutable use of space through deliberate distortions of classic planar relationships. Yet, technically, if we are to relate Heade to Surrealism, he has more obvious affinities with the detailed focus of Dali *(Ill. 7-4)*.[2]

Approaching Storm, Beach near Newport (Ill. 7-3) is an excellent display of all the various qualities of Heade's sensibility. His luminist planarism appears in the sharp edge of the horizon at the right and in the linear clarity of the ripples in the distance. A surrealist use of empty space is evident at the left, where a charged pull recalls again de Chirico's slanted perspectives— suspended between surface and distance at an angle that bars the viewer from entering onto the sliding plane. The sky and the foreground waves are handled softly and proto-Impressionistically, for in Heade's work, erasure of stroke and affirmation of stroke alternate and, as here, are often present in the single picture. Most compelling of all, the rocks at the left, perhaps more responsible than either storm or space for the ominous tone of the picture, are executed in relentless detail, each concavity and convexity wriggling with a curious presence. They are the rocks of fantasy. If we are to look for them somewhere in the history of art, we are most likely to find them in the late Gothic period. We are reminded of Cennino Cennini's advice on how to paint mountains: "If you want to acquire a good style for mountains, and to have them look natural, get some large stones, rugged, and not cleaned up; and copy them from nature, applying the lights and the dark as your system requires."[3] We are also reminded that this approach is fundamentally primitive and conceptual and that the

7-4 Martin J. Heade: *Lake George,* 1862. Oil on canvas, 26 x 49¾ inches. Courtesy, Museum of Fine Arts, Boston; M. and M. Karolik Collection.

luminist tie to the primitive sensibility is an important one. We need only consider the large sailboat at the right to find further evidence of the clear planarity of the primitive vision. The rocks at the left also relate to the primitive vision in their accumulation of equally emphasized detail.[4]

That I could call the same painter primitive, Gothic, Mannerist, and Surrealist (as well as classic and proto-Impressionist) may sound so all-inclusive as to appear meaningless. Yet elements of the late Gothic were precisely the latent continuities that survived into sixteenth-century Mannerism after the "classic interlude" of the High Renaissance.[5] The late Gothic sensibility of the fifteenth century has often been designated "primitive," and the Flemish ultrarealists of that period have been called *les primitifs flamands.*

The Surrealists can be linked with the Mannerists in their dislocations of the rational world of classicism and, technically, with the Flemish primitives in their ultrarealism. The classicism of the luminist has often been used, as noted earlier, for anticlassic ends. And the proto-Impressionism of stroke that exists here, as in many of Heade's paintings, is perhaps, as with Durand, a natural technical result of the American interest (exceptionally pronounced in Heade) in light, climate, atmosphere, and time of day—all luminist as well as Impressionist preoccupations. The very titles of Heade's paintings suggest that interest, though they may not all have originated with the artist:

Approaching Storm, Beach near Newport; Cloudy Day, Rhode Island; Dawn (Ill. 7-5); Sunset, Black Rock, Connecticut; Spring Shower, Connecticut Valley; Sunset on Long Beach.

The question why an Impressionism similar to that of the French did not develop here becomes even more challenging when raised in connection with Heade's work, because, like Monet in the 1890's, he chose the haystack as subject, treating it in a series of paintings under different conditions of light. For Monet, however, the problem was to capture the transient effect of light; under the assault of the multicolored strokes with which he stuccoed his surface, the haystack often dissolved, relinquishing its character as an object in space to become a shape on an abstract field (*Ill. 7-6*).

The problem is complicated by the fact that by the 1890's aspects of post-Impressionist synthesis and conceptualism were already present in Monet's work. These qualities certainly had something in common with the preeminence of idea in luminism. But Monet's dissolution of the object, though abstract and conceptual in result, was the logical end point of Impressionist analysis of the *thing* fragmented by light—an analysis that would, as we have said, have represented to American artists a basic disregard for matter. With analysis proscribed, only synthesis, which involved an interior method, a positive putting together, was open to them. Thus, when Monet's science of light gives way ultimately to the poetry of light, to the artist not as an eye but as a sensibility, he enters areas that parallel the moods of luminism.

Heade's attempts at the painterly sit on the surface and never fundamentally violate the integrity of object or of luminist space.[6] His haystack studies run the gamut from paintings in which the subject is treated in luminist terms—with smoothness of surface, ordered relations of forms, and preservation of object identity through shape and solidity—as in *Salt*

7-5 Martin J. Heade: *Dawn,* 1862. Oil on canvas, 12¼ x 24¼ inches. Courtesy, Museum of Fine Arts, Boston; M. and M. Karolik Collection.

7-6 Claude Monet: *Haystack at Sunset, Giverny,* 1891. Oil on canvas, 29½ x 37 inches. Courtesy, Museum of Fine Arts, Boston; Juliana Cheney Edwards Collection.

7-7 Martin J. Heade: *Sunset over the Marshes, ca.* 1863. Oil on canvas, 10¼ x 18¼ inches. Courtesy, Museum of Fine Arts, Boston; M. and M. Karolik Collection.

7-8 Martin J. Heade: *Twilight, Salt Marshes,* n.d. Charcoal and chalk, 11 x 21⅝ inches. Courtesy, Museum of Fine Arts, Boston; M. and M. Karolik Collection.

Marshes, Newport, Rhode Island (*Ill. 7-9*). to studies such as *Sunset over the Marshes* (*Ill. 7-7*), where his painterly handling comes closest to Impressionism. Here Heade relinquishes solidity and weight while preserving shape identity, and his flattened haystack bears similarities to some of Monet's flattened forms. But the stepped-back planes so characteristic of luminist space are retained, and the small impastos of stroke are carefully aligned so as not to disturb the mensuration. Impressionist transience rides precariously on luminist eternity. The moment, still arrested, relates to the space of a recognizable world, while for Monet, naturalistic ambience has given way to an abstract field, and the areas surrounding the haystack become shapes within the design.

The comparison with Monet was provoked by the similarity of interest in haystacks and light, a controlled test situation difficult for the art historian to ignore. Extended further, the synthetic conceptualism and classicism of Heade's approach can also be found in an artist like Seurat, whose conté drawings bear striking resemblances to some of Heade's graphic works (*Ill. 7-8*), But even earlier in French painting we can discover similarities of subject and sometimes of handling. The instances of proto-Impressionism that occur in Heade's work suggest corollaries, as do Durand's, with the art of Courbet. There are interesting points of juncture between Heade's *Off Shore: After the Storm* (*Ill. 7-10*), possibly of the later 1860's, and Courbet's

131

7-10 Martin J. Heade: *Off Shore: After the Storm, ca.* late 1860's. Oil on canvas, 30 x 50 inches. Courtesy, Museum of Fine Arts, Boston; M. and M. Karolik Collection.

The Waves (*Ill. 7-11*), of *ca.* 1870. But Heade's horizon is distinctly more linear, and even his waves adhere more closely to the planar, whereas Courbet's waves take on diagonal directions that release the fixity of the horizon. Most important, perhaps, is the handling of paint in the waves themselves. Heade's painterly intent seems conditioned by a desire to capture the frothiness of the water, while in Courbet, paint, and the autonomous texture of paint itself, begins to be more important than the theme. Heade's painterliness remains directed toward a specific thematic purpose. For Courbet, paint frees itself from subject and emphasizes its own expressive properties and, in a different way, the expressive activity of the artist. That both artists have so frequently been designated "realists" is simply a reminder of the constant necessity to qualify the context in which the word is used.

Heade's luminist organization of space was readily transferred from sea to land, even in paintings that included figures. While it might be claimed that the similarities between Courbet's *The Waves* and Heade's *Off Shore: After the Storm* were dictated by the necessities of coping with sea-and-sky relationships, there is an interesting distinction between Heade's *Hunters*

Resting (*Ill. 7-12*) and Courbet's *The Quarry* (*Ill. 7-13*).[7] Heade uses the now familiar luminist construction; Courbet, on the other hand, offers a more immediate close-up view, establishing a totally different relationship between the figures and the space surrounding them. Heade's effect is elicited by the ostensibly empty space, and by the inability of the figures to alter the space in any way other than to reaffirm its character. Courbet's rests again on the palpability of textural impastos, and on the figures' dramatic impact.

Perhaps such comparisons offer us a methodology of "comparative art history," in which we learn what American art is by distinguishing it from what it is not. Such comparisons have always been part of general art historical method but would seem to be of special use for those who would like to establish a locus for the American artist that relates him to the cultural environment on this side of the Atlantic and, at the same time, to Western art at large.

An understanding of the currents of ideas in contiguous disciplines is also becoming increasingly important to the historian of American art. Even Heade's flower paintings pose problems that draw us into considerations of

7-11 Gustave Courbet: *The Waves (Seascape), ca.* 1870. Oil on canvas, 12¾ x 19 inches. Philadelphia Museum of Art; The Louis E. Stern Collection.

7-12 Martin J. Heade: *Hunters Resting*, 1863. Oil on canvas, 12 x 24 inches. Courtesy, Museum of Fine Arts, Boston; M. and M. Karolik Collection.

the natural sciences in America in the nineteenth century (*Ill. 7-14*). On November 7, 1857, Asa Gray of Harvard, one of Darwin's early supporters in America, wrote to James Dwight Dana:

> But in reasoning from *inorganic species* to organic species, and in making it tell *where* you want it, and *for what* you want it to tell, you must be sure that you are using the word *species* in the same sense in the two— that the one is really an equivalent of the other. That is what I am not not yet convinced of. . . . Until I see further and clearer, I must continue to think that there is an essential difference between *kinds of animals or plants* and *kinds of matter.*[8]

That "essential difference" is what characterizes American flower painting from the early nineteenth century well into the twentieth. The indigenous nineteenth-century landscape tradition, with its close ties to prerelativistic mathematical and physical sciences, emphasized an inorganic and constant absolute. The flower painters intuitively grasped certain vitalistic properties to be found more readily in the organic preoccupations of the biological sciences. If there is any one place in American nineteenth-century painting where suggestions of flux, flow, and development make themselves felt, it is in the quiet biological stirrings of this humble tradition.

It is interesting that Heade, whose landscapes were so classically and mathematically controlled, should reveal in his flower painting, this suburb of his sensibility, the consciousness of organic vitalism that had also qualified Emerson's absolutism. Yet to look at this simply as two senses of time—the one adhering to an earlier Newtonian fixity, the other demonstrating organic awarenesses that, aided by Darwin at mid-century, prepared the way to some extent for the later acceptance of relativist ideas—is perhaps to misinterpret the signs. We can also read both attitudes as part of a continued American concern with the typical and characteristic, with *essences of kind,*

7-13 Gustave Courbet: *The Quarry*, 1857. Oil on canvas, 82 x 71 inches. Courtesy, Museum of Fine Arts, Boston; Henry Lillie Pierce Fund.

a concern that was voiced repeatedly in the periodical literature of the nineteenth century. Thus, if world, space, and time at large are controlled by inorganic laws, based in geometry, computed through mathematics, these are essentially best conveyed through the mathematical structure of luminism. But the essence of flowers is growth—bud, bloom, decay—and perhaps nowhere else does the artist find such an obvious paradigm of vitalism.

In this, it seems significant that there are parallels in Oriental painting. Benjamin Rowland has reminded us of the Chinese stress on "the presenta-

7-14 Martin J. Heade: *Magnolia Grandiflora,* 1880– 90 (?). Oil on canvas, 15 x 24 inches. Courtesy, Museum of Fine Arts, Boston; M. and M. Karolik Collection.

135

7-15 John J. Audubon: *Carolina Paroquet* (for Plate 26 of *The Birds of America*), *ca.* 1825. Watercolor, 29½ x 21¼ inches. Courtesy of The New-York Historical Society, New York.

tion of the essential aliveness appropriate to the species," and called attention, by comparing an Audubon parakeet and a Sung parakeet, to Audubon's ability to confer on birds "something of the personality peculiar to the species."[9] Like John James Audubon (1785–1851) (*Ill. 7-15*), Heade was sufficiently interested in birds, especially the hummingbirds of South America, to project an illustrated book on them that never saw completion. But his paintings of tropical foliage and birds were noted enough in his own time for the emperor Dom Pedro II of Brazil to make him a Knight of the Order of the Rose in 1864,[10] and for Tuckerman to comment, "As an accurate and graceful illustrator of natural history, Heade attained a special reputation; his delineation of birds and flowers is remarkable for the most faithful drawing and exquisite color."[11]

Paintings such as *Passion Flowers and Hummingbirds* (*Ill. 7-16*) form an interesting link between luminist landscape and the flower-painting genre. The polished light that gleams from the core of the composition, behind the discreetly winding stems, leaves and flowers, and dense foliation, is the radiant wall so often characteristic of luminist distance. The discreet asymmetry and careful decorative ordering of such a painting raises further analogies to the Oriental that go beyond formal considerations to coincidences of feeling and intent. Rowland speaks of the development in China of an attitude toward nature as "a revelation of a kind of invisible essence

7-16 Martin J. Heade: *Passion Flowers and Hummingbirds, ca. 1865 or ca. 1871.* Oil on canvas, 15½ x 21½ inches. Courtesy, Museum of Fine Arts, Boston; M. and M. Karolik Collection.

of divine being. . . . Nature could present at once a revelation of the divine and the vast serenity of emptiness in the contemplation of which, poet or painter could lose his identity."[12] Such a loss of self recalls Emerson's:

> Beauty through my senses stole;
> I yielded myself to the perfect whole.[13]

We may do well to explore further the coincidences between the Oriental attitude to landscape and Western attitudes as manifested by, say, Goethe and Emerson. Perhaps then we might have a clearer understanding of the occasional parallelisms of feeling, if not of technique, that reveal themselves in nineteenth-century American painting (*Ill. 7-17*).

7-17 James Hamilton: *Bayou in Moonlight,* n.d. Watercolor on paper (cut in a circle), 15½ inches in diameter. Courtesy, Museum of Fine Arts, Boston; M. and M. Karolik Collection.

137

William Sidney Mount

MONUMENTAL GENRE

Very expressive and clever are Mount's happy delineations of the arch, quaint, gay, and rustic humors seen among the primitive people of his native place; they are truly American.[1]

H. T. TUCKERMAN

As Tuckerman's comment indicates, William Sidney Mount (1807–68) was appreciated in his own time as a local genre artist of considerable merit, who satisfied further the need for "truly American" scenes that characterized the concurrent taste in landscape painting.

Mount was indeed "truly American," but he was hardly the provincial boor that Tuckerman's remark might lead us to suspect.[2] Today, from our vantage point, Mount is "American" not because of his American scenes but because of correlations and continuities with major figures within the American tradition. A close friend of Thomas Cole, whom he called the "high priest of the Catskill Mountains" and with whom he went out painting and playing music,[3] his art partook to some extent of the tripartite division already noted in the Hudson River development. Like Cole, Durand, and other members of that school, he could paint sentimental potboilers that pleased the lowest common denominator of public taste (*Ill. 8-1*). Yet, under the layers of sentiment, or apart from them, nineteenth-century artists were concerning themselves with serious artistic problems that are thoroughly integral to the development of art in any age.

Thus, Mount, like his Hudson River friends, had a sentimental public salon side and a private side. More important, there was, in the execution of some of his best works, an intense interest in formal problems, which now stands in sharp contradistinction to the thoroughly literary terms in which his art was discussed by contemporary critics. *The Power of Music* (*see Ill. 5-19*), with its black listener, for example, provoked this comment:

A brown jug and ax standing near inform us that he has been to dinner after chopping all the morning, filled his jug with blackstrap or a mixture of vinegar, water, molasses and ginger . . . and was about to resume his labor for the afternoon when he was arrested by the notes of the violin. He has got his 'stent' for the day, but thinks he can listen a little longer, work all the harder, and get through before sunset.[4]

Perhaps all these subject references applied, but to Mount they may well have been ancillary to the major problems of the picture, which were essentially architectonic. It was Mount who had written in his notebook a quote by "A Graduate of Oxford" (Ruskin): "Every architect ought to be an artist; every great artist is necessarily an architect,"[5] and another by "T. Paine":

The mere man of pleasure is 'miserable' in old age; and the mere drudge in business is 'but little better; whereas natural philosophy, mathematical and mechanical science are a continual source of tranquil pleasure' and in spite of the gloomy dogmas of priests and of superstition, the study of those things is the study of the true theology; it teaches man to know and to admire the creator, for the principles of science are in the creation, and are interchangeable and of divine origin.[6]

As Eakins did after him, Mount regarded mathematics as another route to a surer understanding of the structure of the world both inside and outside the picture. This respect for mathematics and measure seems also to have gone hand in hand with invention. Thus, the practical ingenuity that led Mount to invent a portable studio, a "Hollow-Backed" violin, and a device for the faster propulsion of steam vessels,[7] aligns him with the inventive

8-1 William Sidney Mount: *Dregs in the Cup (Fortune Telling)*, 1838. Oil on canvas, 42 x 52 inches. Courtesy of The New-York Historical Society, New York.

8-2 William Sidney Mount: *Book of Perspective,* 1836, page 3. Pen and wash, 9 x 12 inches. Suffolk Museum and Carriage House, Stony Brook, New York.

dispositions of such artist-scientists as Charles Willson Peale, Morse, Fulton, and Eakins, and adds further testimony to the importance of the interaction between machine, mathematics, and art.

Mount's scientific and mathematical interests are further borne out by an examination of his library, which included books on geography, spiritualism, phrenology, astronomy, and several volumes by Ruskin, as well as Frederick Emerson's *The North American Arithmetic, Part Second, Uniting Oral and Written Exercises,* Philadelphia, 1845; John Andrews' *Elements of Logick,* Philadelphia, 1825; and a volume on *The Electrical Theory of the Universe—or the Elements of Physical and Moral Philosophy,* Boston, 1846.[8]

On the cover of a book he gave his brother Robert Nelson Mount, inscribed May 10, 1848, he quoted "F. Emerson": "A knowledge of arithmetic tends to strengthen the power of comprehension, and leads to a habit of investigation, so indispensable to the formation of a sound mind, or judgment—and gives awareness and activity of thought"; and under this wrote, "By the study of arithmetic the mind is disciplined."[9]

His notebooks also referred to a *Treatise on Geometry and its application to the Arts,* by Dr. Lardner, and a *Treatise on Optics,* by Sir Daniel Brewster.[10] In a larger sense, Mount seems to have looked to the study of mathematics to instruct his approach to life. In practical terms, such interests manifested themselves in his approach to the construction of the picture.

Thus, the startling affinity mentioned previously between Mount's *Power*

8-3 William Sidney Mount: *Book of Perspective,* 1836, page 6. Pen and wash, 12 x 9 inches. Suffolk Museum and Carriage House, Stony Brook, New York.

of *Music* and Piero's *Flagellation* (*see Ills. 5-19 and 5-20*) turns out to be no happy coincidence but a direct result of Mount's own studies of perspective, as revealed by his perspective notebook of 1836 (*Ill. 8-2*).[11] Mount's perspective studies demonstrate an awareness of what he called the "parallel of the picture," a scientific control of measure and a complex ability to handle cubes of form abstractly that look not only back to Piero's classically ordered and measured form but forward to some geometrical projections in the art of the mid-1960's (*Ills. 8-3, 8-4, and 8-5*).

Mount's perspective notebook illuminates those questions of measure and classic form, which so often confront us when we delve beneath nineteenth-century sentiment. He augmented his experiments in placement and composition with detailed studies of the practices of the masters, compiling a lexicon of proportional references that he used as a guide. Thus, he wrote "Of Distance" in his perspective notebook:

> In the pictures of the great masters the distance greatly varies. Examples —In the Marriage of Cana by Paul Veronese, it is equal to three times the size of the picture. Leonardo da Vinci generally took it equal to three times the width between the point of sight and the side of the picture, and sometimes as much as twice the width of the largest dimension of his picture. In the school of Athens of Raphael the distance is equal to the base of the picture. In the compositions of Poussin it is equal to twice the width of the base.[12]

8-4 William Sidney Mount: *Book of Perspective,* 1836, page 1. Pen and wash, 9 x 12 inches. Suffolk Museum and Carriage House, Stony Brook, New York.

Despite some formal training, the sensibility Mount reveals in his note-
books is, like Lane's, that of the self-taught primitive (*Ill. 8-6*), who in true
empirical fashion painfully raises himself to a level of sophistication. He
began, in 1824, as a sign-painter's apprentice to his brother Henry (another
link to the primitive or vernacular tradition). He studied briefly (*ca.* 1826–
27) at the National Academy of Design in New York, and, after some traffic
back and forth between Long Island and New York City, settled in Stony
Brook, more or less for good, around 1837. He never went abroad, though

143

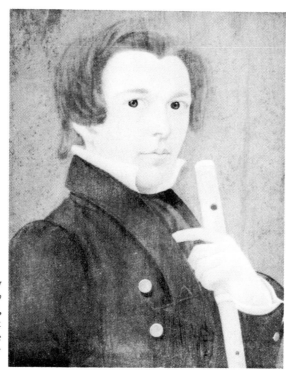

8-6 William Sidney Mount: *Self Portrait with Flute,* 1828. Oil on panel, 20 x 16 inches. Suffolk Museum and Carriage House, Stony Brook, New York.

friends continually urged him and patrons such as Jonathan Sturges would gladly have paid his way. On one occasion, Mount meditated:

> . . . a visit to Europe would be gratifying to me, but I have had a desire to do something in art worthy of being remembered before leaving for fear I might be induced by the splendor of European art to tarry too long, and thus lose my nationality. We have nature, it speaks to everyone, and what efforts I have made in art have been appreciated by my countrymen —Originality, thank God, is not confined to any one place or country and this makes it very comfortable for those who are obliged to stay at home.[13]

But though he did not have the advantage of European travel and study, Mount filled his notebooks with endless quotations on the techniques, primarily coloristic, of the masters. Like the primitive who carefully, and even unselectively, gathers and values every bit of knowledge, he tried vicariously, often through the written word, to learn coloristic formulae for his own purposes. This secondhand information he fortified during trips to the city, where he took careful notations from such original paintings as he could see on exhibition—either by friends, such as Cole, or by older

masters, often Dutch, such as Cuyp, who seems especially to have interested him.[14]

Mount's perspective notebook revealed his devotion to design problems of a geometric and conceptual nature. His color notes and quotations reveal his equal interest in the romantic tradition derived from Venetian color. Thus, there is much mention of Titian and Rubens, much careful attention to problems of thickness and thinness and of painterly effect,[15] though the golden tone he ultimately achieved in his own work was probably fortified by his study of Dutch art (*Ill. 8-7*).[16]

This dual interest can be seen in the paintings. Though the best of them are constructed with the logic of a geometer, the skin of paint is often freely transparent and gently glazed (glazing "is the flesh and blood of the art")[17] partaking of an over-all tonal unity. In his notebooks, Mount had written, "I believe in the broad style of painting. I must not have so many tints on my pallette—color more from feeling—five at the heap for my tints,"[18] and "a very minute and close imitation of nature without regard to the effect of the whole is apt to produce what is called the dry manner. The proper distribution of grey tints in a picture to lead the eye pleasantly over the work is important and must not be lost sight of. Hot and cold colours artfully arranged captivate the eye."[19]

What Mount could not learn about perceptual realism from his books and quotations, or from the few European and American originals he was able to see on visits to New York, he learned from nature. Even before Durand, he was a strong plein-airiste, and like Monet and Homer, with whom he shared an interest in Chevreul, he had a portable studio that enabled him to witness nature's effects in all climates and places:

> My best pictures are those which I painted out of doors—I must follow my gift to paint figures out of doors as well as in doors, without regard to paint room. The longer an artist leaves nature the more feeble he gets. He therefore should constantly imitate God—one true picture from nature is worth a dozen from the imagination. Remember the air tints. The skys as seen from [Stony Brook] Long Island away from the City are remarkable for clearness—also the water in the harbor and sound are clear and transparent.[20]

Mount's fundamentally pantheist view of nature, combined with his classic measure, his awareness of nuances of color and tonal unity, and his empirical observation of the specific moods of nature (the "clear" sky, the "transparent" water) are probably responsible for his execution of one of the luminist masterpieces of his time, *Eel Spearing at Setauket* (see *Ill. 5-18*). Mount's reference in his papers to a painting of 1845, which he calls "Fishing along Shore. Recollections of early days. With a View of the Hon. Selah B. Strong's

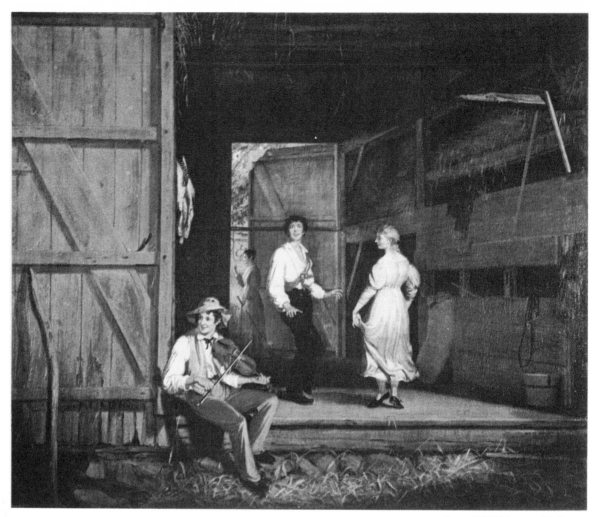

8-7 William Sidney Mount: *Dancing on the Barn Floor,* 1831. Oil on canvas, 25 x 30 inches. Suffolk Museum and Carriage House, Stony Brook, New York.

residence in the distance,"[21] is a mention of this painting; it was shown at the National Academy of Design in 1846 as *No. 131, Recollections of Early Days—"Fishing along Shore."* His use of the word "recollection" here is a reminder of the collaboration between thing and thought that produces luminism. Mount wrote as a luminist when he noted: "A painter should lose sight of himself when painting from nature—if he loves her—If a painter loves nature he will not think of himself—she will give him variety and raise him from insipidity to grandeur."[22] It is precisely this intense anonymity that makes *Eel Spearing* a perfect example of luminist vision.

Mount—perhaps even more than Lane—was interested in spiritualism and actively participated in séances where he inquired about his family. At

146

a séance on Wednesday evening, November 22, 1854, he was told that his mother was in the sixth sphere and his brother Henry in the fourth, on the verge of the fifth. Mount also attended a "circle held at Mr. Woolf's on Sunday, the 26th, 1854," at which he particularly inquired "how should we best worship God?"[23]

His library includes a spiritualist magazine *The Sacred Circle* (issue of May, 1854) and a volume called *Modern Spiritualism, its Facts and Fanaticisms, its Consistencies and Contradictions* (Boston, 1855), in which, interestingly enough, the stories of the Witch of Endor, the subject of one of his earliest paintings, and Belshazzar's Feast, Allston's famous theme, are found to be analogous to "hundreds of instances of modern spiritual manifestations."[24] His papers inform us that Mount contemplated painting "Three or four figures talking together about spiritualism";[25] and he chose, perhaps only half tongue-in-cheek, the spiritualist context of a "vision" in which to present to himself his well-known letter from Rembrandt of March 25, 1855.[26]

The importance of such spiritual interests on the part of American artists of the nineteenth century cannot in any way be passed over as quackery. The luminist vision, as noted earlier, was especially nourished in its approach to nature by attitudes that approximated "the identity of the spirit to all eternity."[27] The close ties between Transcendentalism, spiritualism, mesmerism or animal magnetism, and Swedenborgianism, and the wide popular appeal of all related aspects of spiritualism in America at the mid-century define another area of necessary research. Emerson seems to have been of two minds about Swedenborgianism, though he was moved on at least one occasion to write, "This age is Swedenborg's."[28] And Frederic Henry Hedge, in his review of the American edition of Swedenborg's *The True Christian Religion* in 1833, observed:

All that is marvellous in human life, occurs at such times of mystical experience, arising at the point of junction between the infinite and the finite, the possible and the actual of the human mind. To this place belong all kinds of portents, apparitions, and omens, fulfillments of dreams, coincidences, and the marvels of animal magnetism . . . and all those unclassed and unexplained phenomena which make up the world's book of wonders.[29]

Mount's interest in the tangibility of the unknown (Hedge's "point of junction between the infinite and the finite") is thus of significance for the luminist merger of fact and non-fact, as well as for the union of the real and the ideal in the nineteenth century. The dialectic of luminist sensibility is beautifully attested to by the combined concern with the factual certainty of mathematics and the factual unreality, or unfactual reality, of the world of the spirit.

Like the Hudson River men, then, Mount had a luminist style, which he

achieved, however, only rarely; an academic, or salon, genre style; and a proto-Impressionist style of plein-airisme, demonstrated more purely in small landscape sketches and, less obviously, in the frequent tonal effects of his rural genre pictures. He shared the typical American interest in atmosphere: "Paint atmosphere in all its effects. Paint from recollection of what you have seen. Great effects of storms. also, storms coming up—as I see now at this writing;"[30] and "Painting from nature in the open air will learn the artist at once the beauty of the air tints from the horizon to the foreground and how the dew on the foliage and the grass sparkles in the sunbeams early in the morning. How glorious it is to paint in the open fields, to hear the birds singing about you—to draw in the fresh air."[31]

He had, like Eakins, not only a deep feeling for mathematics, a respect for the machine and invention, and an interest in the unassuming aspects of everyday existence, but a concern with what "o'clock it is." His perspective studies seem to have occupied him most in the 1830's; his color notes in the 1840's and 1850's; but in the 1860's, his notebooks sound like the logs of a weather observer. In June, 1864, he noted:

> 23 was a hot day thermometer 88, 24th 32 degrees cooler—25th of June wind west at 2 PM 94 degrees—90 at 6 PM—June 26 at 6 AM 82 degrees at 7 AM 84 at 9 AM 88 at 10 AM 90 The thermometer hanging on the shady side of a large Black walnut tree and a strong west wind blowing upon it—at 11 AM 92 at 12 noon 94 at 2 PM 96 degrees at half past 2 to 3 97 de- 20 minutes to 4—91 degrees owing to a cloud and a few drops of rain it fell and rose at 4 PM to 93-½ after 4—93 degrees half after 5 PM 90 de-.[32]

One senses that what is important here is the *fixation* of a specific atmospheric effect. Thus, states of weather, rather than transitions, are catalogued, measured, made statistical and factual, and thereby removed to an area of permanency.

Mount's art represented a specific and concerted attempt to structure the transient perceptual experience with mind and idea, a process that by its nature establishes a kind of absolutism, as can be noted in the letter to himself from Rembrandt that was ostensibly materialized through spiritualism:

> With these few colors then, I dashed in my effects—after my design had been carefully drawn on the canvas or panel so that I had something certain to work upon, and I made it a very particular rule, to put as much effect and finish as was possible in at the first stage, taking care, however, to blend nothing definitely. But, all this could not be accomplished until the effect I intended to produce was so well developed in my mind by previous ideas, that, by closing my eyes, I could perceive, as it were, the picture I intended to create before me; and, by the constant observations

I made on peculiar effects daily submitted to my view, and which I was most careful to jot down on the spot, as the most precious relics, in a drawing book which I kept for that purpose, I, by degrees, accumulated a vast mass of treasure, of which, I made good use on various occasions in some of my best pictures.[33]

It would be all too easy to take a "modern" view of Mount, stressing his formal solutions and artistic attitudes and ignoring the fundamentally literary flavor of his genre pieces. The nineteenth century saw him largely in terms of story-telling, and delighted in spelling out the circumstances and plots of his narratives, reserving formal criticism largely for complaints when his coloristic experiments went awry.[34] He has since been judged perhaps too frequently as a provincial artist, a rural hayseed. As recently as 1962, Flexner described him as "in no way a profound artist . . . one of those minor but authentic creators who are justifiably beloved in the lands of their origin, but would be as lost as a gifted child in that international pantheon where the greatest artists of all time endure the shifting glare of centuries."[35]

It is important, therefore, to take the hayseed out of his hair, to reinstate him as a sophisticated designer, a thoughtful painter, whose best works can be measured formally against other works of quality in the history of art, as well as a genre painter who did indeed delineate "the arch, quaint, and rustic humors seen among the primitive people of his native place." If we then ask ourselves what special meaning this genre category had for Mount, the sophisticate, we can perhaps find an answer in his earliest works.

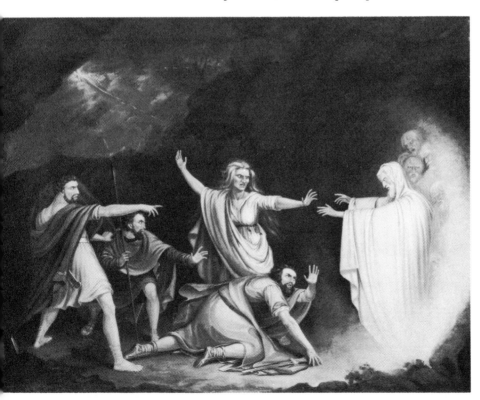

8-8 William Sidney Mount: *Saul and the Witch of Endor,* 1828. Oil on canvas, 35⅞ x 48 inches. Courtesy of National Collection of Fine Arts, Smithsonian Institution, Washington, D.C.; Gift of the International Business Machines Corporation.

8-9 William Sidney Mount: *Farmers Nooning,* 1836. Oil on canvas, 20 x 24 inches. Suffolk Museum and Carriage House, Stony Brook, New York.

Mount's early painting of 1828, *Christ Raising the Daughter of Jairus,* a primitive rendition of a Biblical theme, and his painting of the same year, *Saul and the Witch of Endor* (*Ill. 8-8*), a theme also treated by West and Allston (*see Ills. 2-7 and 2-8*), reveal from the outset his aspirations to the history-painting tradition that expired, it will be remembered, because "it had no root in the people."

Mount was inclined toward the Grand Manner, toward a venerable tradition that would allow him full scope to rehearse the formal problems of the masters. There is little doubt from his notebooks that he measured himself constantly against his great predecessors. But the need to present empirical reality was also strong. Thus, he followed the path laid out by Copley and West in making of the contemporary fact something monumental. West's *Death of Wolfe* (*see Ill. 1-25*) in modern dress and Copley's *Watson* (*see Ill. 1-27*) were precedents; yet though Mount had carefully absorbed the formal principles underlying classic composition, he was not constrained, as West had been, to justify himself through eclectic adaptations of pose. It was Horatio Greenough's "I stand for classical principles" all over again. Once Mount had learned these, he felt free to use them in reference to the nature and life he knew.

Mount was too transcendental in his reverence for nature's smallest details to share Sir Joshua's disdain for Dutch realism, though he read and quoted Sir Joshua extensively.[36] He was familiar with the great traditions of genre painting, not only with Steen and Van Ostade, but with Hogarth, whose comment "True painting can only be learned in one school and that is kept by nature" he had noted in his journal.[37] He had also read Van Mander and seems to have been at least theoretically aware of figures like Bruegel. The transformation of his history-painting intent into local-history reportage was totally in keeping with his vehement emphasis on originality, his Jacksonian democratic instinct to "paint for the many, not the few," and his allegiance to the fact:

A painter's studio should be everywhere; wherever he finds a scene for a picture in doors or out. In the blacksmith's shop. The shoe makers—The tailors—The Church—The tavern—or Hotel. the Market—and into the dens of poverty and dissipation. high life and low life. In the full blaze of the sun—in moon light and shadow. Then on the wave—the sea shine. in the cottage by fire-light and at the Theatre. See the Sun rise & set. Go and search for materials—not wait for them to come to you. Attend—Fairs, shows, Camp meetings and horse racings, Treasur up something in your mind, or on paper, or Canvass, wherever you may happen to be thrown—An artist should have the industry of a reporter. not be ashamed or afraid to plant his easel in the market place for figures or background or both. For painting is an honorable calling, and the artist will be respected let him sketch where he will (*Ills. 8-9 and 8-10*).[38]

8-10 William Sidney Mount: *California News*, 1850. Oil on canvas, 21⅛ x 20¼ inches. Suffolk Museum and Carriage House, Stony Brook, New York.

151

George Caleb Bingham

MISSOURI CLASSICISM

I had myself called with the four-o'clock watch, mornings, for one cannot see too many summer sunrises on the Mississippi. They are enchanting. First, there is the eloquence of silence; for a deep hush broods everywhere. Next, there is the haunting sense of loneliness, isolation, remoteness from worry and bustle of the world. The dawn creeps in stealthily; the solid walls of black forest soften to gray, and vast stretches of the river open up and reveal themselves; the water is glass-smooth, gives off spectral little wreaths of white mist, there is not the faintest breath of wind, nor stir of leaf; the tranquillity is profound and infinitely satisfying. . . . When the light has become a little stronger, you have one of the fairest and softest pictures imaginable. You have the intense green of the massed and crowded foliage near by; you see it paling shade by shade in front of you; upon the next projecting cape, a mile off or more, the tint has lightened to the tender young green of spring; the cape beyond that one has almost lost color, and the furthest one, miles away under the horizon, sleeps upon the water a mere dim vapor, and hardly separable from the sky above it and about it. And all this stretch of river is a mirror, and you have the shadowy reflections of the leafage and the curving shores and the receding capes pictured in it.[1]

MARK TWAIN

George Caleb Bingham (1811–79) was, like Mount, a local genre painter, not of Long Island farmers but of Missouri "men and manners." He merged in his art the now familiar elements of primitivism, classicism, and luminism. Like Mount, his attitude to picture-making as a constructive process transformed genre into a monumental art that became for Americans their only real equivalent for history painting in the grand manner. As the *Missouri Republican* put it: "Mr. Bingham has struck out for himself an entire new

field of historic painting, if we may so term it. He has taken our Western rivers, our boats and boatmen, and the banks of the streams for his subjects."[2]

Bingham's figures are rarely, if ever, as free in their movements as are those of Mount. Puppet-like, often wooden, they are reconstructed into the picture through a process that is in part an aspect of primitive "making" but has resemblances also to Cézanne's method of rebuilding nature into art. Despite the strong linear and planar control of their environment, Mount's figures—especially their contours—tend to move with the organic ease of the Dutch seventeenth-century genre tradition and of British artists such as Hogarth, and of Wilkie, with whom he was sometimes compared. But Bingham's figures are more conceptually conceived and subject to the restrictions imposed upon them by the geometric structure of the picture. This conceptualism, whereby the figure could be distorted according to formal needs, can be noted also in many of Bingham's figure drawings, offering telling evidence of the dual role of the figure in Bingham's art.

For there is no doubt that Bingham shared the nineteenth-century concern with narrative meaning, a concern with people and their actions that revealed itself in contemporary criticism to the almost total disregard of formal aspects. Of Bingham's *Raftsmen Playing Cards* (*see Ill. 9-2*), of 1847, a New York critic wrote:

It is truly American, (we always award this compliment with pleasure,) and decidedly original; and when we remember that the painter thereof is a statesman by profession, we think it a remarkable production. The scene represents a large plank [raft floating down the Mississippi] upon which the artist has placed a number of raftmen. Two of them are playing cards on a wooden bench, while two of the party are looking on watching the progress of the game, one individual is seated on a plank examining his injured foot, while another is in the rear, hard at work

9-1 George Caleb Bingham: *Stump Speaking (County Canvass),* 1854. Oil on canvas, 41 x 56 inches. The Boatmen's National Bank of Saint Louis.

153

9-2 George Caleb Bingham: *Raftsmen Playing Cards*, 1847. Oil on canvas, 28 by 36 inches. City Art Museum of Saint Louis; Ezra H. Linley Fund.

managing the raft. The great merit of the picture consists in the decided character which distinguishes each individual. One of the players, rather a young man, whom we should designate a "hard case," has just thrown his card and is awaiting the result; while his antagonist, a somewhat older person and evidently a novice in the gambling art, is hesitating and troubled at the appearance of the game. The young man looking over his shoulder appears a mean and cunning scamp, probably the black sheep of a good family, and a sort of vagabond idler. The other person who is watching the progress of the players is a middle aged man, industrious, frugal, and might be the respectable proprietor of the raft.[3]

Bingham's own rare comments about his work suggest that he, too, thought about the motivations of his protagonists, especially in his famous election pictures, since his political activities gave him, presumably, a first-hand insight.[4] Regarding *County Canvass* (later called *Stump Speaking*) (*Ill. 9-1*), he wrote to his friend Major James S. Rollins on December 12, 1853: "In my orator I have endeavored to personify a wiry politician, grown gray in the pursuit of office and the service of the party. His influence upon the crowd is quite manifest, but I have placed behind him a shrewd clear-headed opponent, who is busy taking notes, and who will, when his turn comes, make sophisms fly like cobwebs before the housekeepers broom."[5]

Yet his figures also served as modules to be disposed within his compositions; over and over again, he used—like so many permutational possibilities

—the various figure-studies from life recorded in his notebooks. In the same letter, he indicates as well that he was conscious of the formal necessities of ordered grouping:

> I have located the assemblage in the vicinity of a mill (Kit Bullards perhaps). The cider barrel being already appropriated in the Election, I have placed in lieu thereof, but in the back ground, a watermellon waggon [*sic*] over which a *darkie,* of course presides. This waggon [*sic*] and the group in and around, looming up in shadow, and relieved by the clear sky beyond, forms quite a conspicious [*sic*] feature in the composition, without detracting in the slightest degree from the interest inspired by the principal group in front.[6]

Such an awareness perhaps accounts for the interesting similarities between Bingham's *Raftsmen Playing Cards* (*Ill. 9-2*) and Cézanne's *The Card Players* (*Ill. 9-3*)—in the angulated faceting of arms and elbows, in the pyramidal groupings, and in the structured stabilizations of forms in space. But while geometric contour in Cézanne stabilizes form, the shifting films of stroke and pigment are already factors in the proto-analytical-cubist disintegration of form. Bingham differs sharply; the insistence on the integrity of the object prevails. Though Bingham's observation of light can be said to indicate a proto-Impressionist awareness, he turns it to luminist use, conceptualizes it, makes it not a scientific solution but a poem. With a transcendental as well as primitive anonymity, he erases stroke, leaving us to experience directly those radiant planes of light that emanate from his river pictures and reflect from the surfaces of his unruffled waters.

Bingham's use, in such pictures, of luminist classic space, his respect for the parallel of the picture plane, and his preservation of the potent emptiness of the foreground—which he accomplishes in *Raftsmen Playing Cards* by

9-3 Paul Cézanne: *The Card Players, ca.* 1892. Oil on canvas, 23½ x 28¾ inches. Courtauld Institute Galleries, London.

filling it only with still-life objects and in *Fur Traders Descending the Missouri* (*see Ill. 5-17*) with reflections that narrow the gap between illusion and reality—raises again the difficult question of classic structure in mid-century America. Historians of American art, many of whom have neglected evidence of classic order and mensuration in much nineteenth-century art, have nonetheless felt obliged to remark on its obvious presence in the works of Bingham.

Commenting as long ago as 1935 on Bingham's classicism, Arthur Pope suggested that: "If one were to consider merely the general arrangement of a picture like the *Verdict of the People,* one might say that it was done by some follower of Poussin. Bingham must have got his lessons in composition from engravings after Renaissance-Baroque masters, for there is constant use of pictorial forms derived from sixteenth and seventeenth century painting."[7]

E. Maurice Bloch, in his definitive study of Bingham, offers a more provocative thesis—that there was, behind Bingham's classicism, not only a carefully assembled portfolio of models (of old master engravings) and an interest (displayed as early as 1838) in casts from antique sculpture, but a heavy reliance on instruction books of the time for examples of procedure from the old masters.[8]

Unfortunately, there is little evidence in documents or library contents that Bingham actually knew the specific sources cited, and Bloch is forced to rely for the most part on comparisons between Bingham's works and the diagrams and descriptions in the instruction books. He makes, nonetheless, an interesting case for the way in which Bingham, in journeyman-like fashion, followed the do-it-yourself books.

Bingham might have been instructed and affected by such sources, just as Mount—whose library we still have and who kept, fortunately, a copious journal—was deeply touched by his own books on perspective and on geometry and art. But now a question arises that will have to be pressed further as we consider the problem of classic form in mid-century America, and the relation, as a necessary corollary, of the American artist to the great European traditions. For in pointing out the services of the instruction books to Bingham, Bloch stresses the idea of a classicism based almost exclusively on American adaptation of earlier classic examples. Such an emphasis on European paradigms tends to underplay the equally important—if not more important—idea of an American classicism arising naturally out of native attitudes to the object and to space, and to the problems presented by the picture plane.

Thus, what is posed in this volume is the idea of an art tempered often by certain conceptual attachments to the plane and conditioned always by a continuing folk tradition that was even more accessible than the European formulae. For most American artists, Bingham included, began within that tradition, which only grew slowly and painfully from the primitive's

"unconscious adherence to the plane" to the conscious adherence of the classic artist. Such classicism could, of course, have been served by the instruction books and by any other examples of art, native or European, contemporary or old master, that American artists could see and absorb. But what is of interest is the respect for the mensurational that drew them to such books—especially to the advice on perspective that could be found there —and led them to proceed like skilled technologists, carefully constructing the picture.[9]

In my opinion, access to the instruction books is not yet a sufficient explanation for the understanding with which Bingham handled the elements of classic form. As Pope perceptively noted, "what gives Bingham's painting particular interest is that he does not use these forms in a mechanical fashion; into the framework of his general scheme he masses and groups his figures with great skill, at the same time keeping the action convincing from a naturalistic point of view."[10]

Copley's American classicism, it will be remembered, was the result of a natural growth from a primitive root. In his European phase, direct contact with classic examples in the art of Raphael produced such neo-classic aberrations as the *Ascension of Christ* (*see Ill. 1-26*). For Benjamin West, too, classic examples were the route, more often than not, toward eclectic neoclassic violations of classic structure. It is hard to believe that the largely inept translations of classic composition (via picturesque etchings by the author) that were available in the instruction books could have offered Bingham such infallible advice as to insure his masterly rendering of classic form.

More than the diagrams and etchings, the textual comments on grouping and ordered composition might, as Bloch has proposed, have had their effect.[11] But since various *kinds* of order were presented, Bingham still had to exercise choice, and he would, I feel, have mainly found in this instruction fortification for an innate sense of classic space and form that he shared with some of the finest artists in America at this time.

If, indeed, Bingham did consult the instruction books, the idea becomes most stimulating, if we consider them, as Bloch suggests, as the "equivalents of today's 'do-it-yourself' books."[12] They would then join Bingham once again to the journeyman tradition that appears to have been the nest for fledgling classicists in America at the mid-century.

As with Copley and the luminists, Bingham's luminist genre seems to have derived from the injection of a strong element of empiricism into a conceptual and ideographic core. From apprenticeship to a cabinetmaker and some work as a sign-painter, he proceeded in the 1830's to paint primitive portraits as, for example, his *Self Portrait,* of 1835 (*Ill. 9-4*), in which, as in Copley's early *Mrs. Joseph Mann* (*see Ill. 1-6*), we can literally trace out the way the encounter with the form in reality swells the head to three-dimensional volume, while the body adheres ideographically to the surface plane.

Bloch seems to consider Bingham's three months' study in Philadelphia in 1838 pivotal for his development, since, among other things, it gave him the opportunity to acquire the instruction books from Philadelphia booksellers like Carey and Hart.[13] At The Pennsylvania Academy Annual in 1838, he could have seen works by a host of artists, including Allston, West, C. R. Leslie, Neagle, Stuart, Sully, Henry Inman, Charles Willson Peale, Charles Bird King, and Thomas Doughty.[14] Bloch points out that he could also have seen landscapes attributed to Salvator Rosa, interiors "said to be" by Van Ostade and Teniers, and a portrait by Sir Henry Raeburn.[15] At the exhibition of the Artist's Fund Society of Philadelphia, he might have encountered works by, among others, Joshua Shaw and John Gadsby Chapman.[16] A sale in Philadelphia that he could have attended "included works said to be by Ostade, Teniers, Van Dyke and Rubens; drawings attributed to Greuze, David, Watteau, Michelangelo, Rembrandt and Dürer; prints after Claude, Teniers, and Poussin."[17] Bloch also makes useful mention of picture dealers, galleries, artists' studios, and collectors as additional sources of study material for the young artist,[18] and considers the possibility of a visit to New York to the National Academy exhibition, where he might have seen Mount's *The Tough Story*.[19]

Yet not until around 1845—seven years after the exposure to the artistic and intellectual climate of Philadelphia, and after he had spent some time (1840–44) in Washington, D.C. painting mostly portraits—did Bingham produce paintings like *Fur Traders Descending the Missouri* and *The Concealed Enemy* (*Ill. 9-5*), paintings that epitomize his mature luminist vision.

9-4 George Caleb Bingham: *Self Portrait,* 1835. Oil on canvas, 28 x 22½ inches. City Art Museum of Saint Louis; Eliza McMillan Fund.

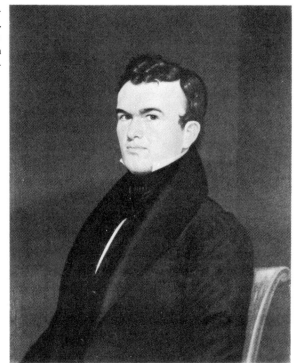

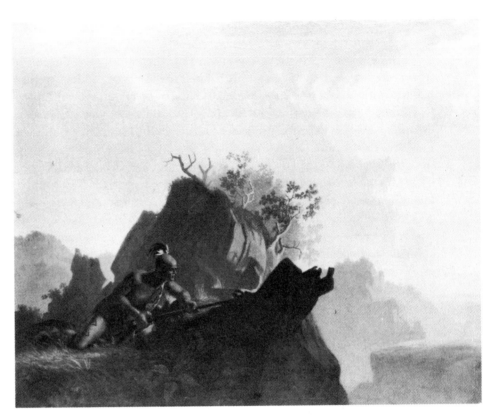

9-5 George Caleb Bingham: *The Concealed Enemy,* 1845. Oil on canvas, 28½ x 35½ inches. Peabody Museum of Archaeology and Ethnology, Harvard University, Cambridge, Massachusetts.

For Bloch, in *Fur Traders,* "the bright light that illuminates and brings the figures into such sharp focus that even the striped shirts are clearly defined is in direct conflict with the impression of the hazy atmosphere that hangs over the scene. The artist, still concerned with the study of light, was as yet unable to unite his figures and landscape in terms of an atmospheric light, a characteristic failing that was to dominate his work during this early period."[20] However, the sharply focused foreground and hazed distance represent to me the unique polarity of luminist vision; indeed, this polarity was rarely achieved again in Bingham's art after about 1850.

In this connection, some comments Bingham made at the end of his life, in his well-known lecture, *Art, the Ideal of Art, and the Utility of Art,* seem pertinent. Christ-Janer says of this statement: "Like many artists, Bingham wrote about an aesthetic which was far from the philosophy of art which he incorporated in his own work. Quite evidently, the artist had not thought seriously about putting into abstract conception his ideas of the 'ideals of art.' He borrowed too much, and not wisely enough."[21] Bloch refrains even from dealing with it.[22] Of recent biographers, only McDermott appears to have considered it as a genuine statement of Bingham's aesthetic.[23] To this I must add my own strong accord, for Bingham introduces

in this lecture an empirical response to nature that, infusing his classic order, accounts for the character of his art.

When he states, "Artists who expect to rise to anything like eminence in their profession, must study nature in all her varied phases, and accept her both as his model and teacher. He may consider every theory which may be advanced upon the subject nearest to his heart, but he must trust his own eyes and never surrender the deliberate and matured conclusions of his own judgment to any authority however high,"[24] he is again voicing that pragmatic dedication to nature observed, so often encountered in American art. That his observation included the tonal subtleties that characterize his finest luminist works is underlined by his comment: "Space and atmosphere, light and shadow, stamp their impress on all that we see in the extended fields which she opens to our view, and an omission to present upon our canvass a graphic resemblance of the appearances thus produced, makes it fall short of that truth which should characterize every work of Art."[25]

It seems revealing of Bingham the man (still a mysterious figure, whose letters show him often more as politician and statesman than as artist) that this final statement should be concerned with some of the most loaded and controversial words in the aesthetics of his time. Thus, he considers *imitation,* that word—with a pedigree extending back to Aristotle—which endlessly fascinated the American nineteenth century:

> But while I insist that the imitation of nature is an essential quality of Art, I by no means wish to be understood as meaning that any and every imitation of nature is a work of art.
>
> Art is the outward expression of the aesthetic sentiment produced in the mind by the contemplation of the grand and beautiful in nature, and it is the imitation in Art of that which creates this sentiment that constitutes its expression. The imitation is the word which utters the sentiment.[26]

In making allowances for artistic selection, in the isolation of "the grand and beautiful in nature" and the "sentiment" this produces in the mind, Bingham's concept of imitation followed the artistic credo of his age. The ideal enters naturally into this conception, yielding one of several midcentury solutions to the inevitable real-ideal dilemma.

> I cannot believe that the ideal in Art, as is supposed by many, is a specific mental form existing in the mind of the artist more perfect than any prototype in nature, and that to be a great artist he must look within him for a model and close his eyes upon external nature. Such a mental form would be a fixed and determined idea, admitting of no variations, such as we find in diversified nature and in the works of artists most distinguished in their profession. An artist guided by such a form would necessarily repeat in every work exactly the same lines and the same expression.[27]

In this, one senses something of Thomas Cole's defensive claim that he never painted from himself but "always had nature for every object." But one must recognize that Bingham, even more than Cole, was *in actual practice* strongly held by a formal ideal that, like Piero's, stamped his best works with a "fixed and determined idea." However, this is insufficient reason to discard his statement as a whole, for he tries further to qualify his comments, and perhaps we may allow him his qualifications:

All the thought which in the course of my studies, I have been able to give to the subject, has led me to conclude that the ideal in Art is but the impressions made upon the mind of the artist by the beautiful or Art subjects in external nature, and that our Art power is the ability to receive and retain these impressions so clearly and distinctly as to be able to duplicate them upon our canvas. So far from these impressions thus engraved upon our memory being superior to nature, they are but the creations of nature, and depend upon her for existence as fully as the image in a mirror depends upon that which is before it. It is true that a work of Art eminating from these impressions may be, and generally *is,* tinged by some peculiarity belonging in the mind of the artist, just as some mirrors by a slight convex in the surface give reflections which do not exactly accord with the objects before them. Yet any obvious and radical departure from its prototypes in nature will justly condemn it as a work of Art.[28]

In Bingham's emphasis, throughout this statement, on the *mind* of the artist, there is additional corroboration of the conceptualism at the root of much American art of his period. As a rebuttal to Ruskin's attacks on deceptive or illusionistic imitation, he suggests that art and nature can never be the same thing. "There are attributes of nature which the highest Art can never possess. . . . As the powers of man are limited so is Art necessarily limited in its domain."[29] A statement follows that can be read as a description of Bingham's own finest works and suggests that his strengths were the direct result of his knowledge of his limitations:

[Art] can faithfully present the human form in all its symmetry and beauty, but it cannot breathe into that form a living soul or endow it with speech and motion. It can give us the hue and forms of hills, mountains, lakes and rivers, or old ocean, whether in calm, sunshine or storm, but all that we see in these results of limited power is alike motionless and voiceless. There is no murmuring in their brooks as they seem to encounter the rocks in their passage. Their clouds are stationary in their skies, their suns and moons never rise or set. There is no sound of lowing coming from their flocks and herds. All is silent and still, and being so can never be mistaken for actual nature.[30]

The silence Bingham describes is not really art's inability to endow nature

with noise and motion. It is, rather, the classic silence of luminism. The parallels between this vision and the topographical description by Twain that opens this chapter suggest either a common source in a nature that was itself silent or a similar transformation through the "convex mirrors" of writer and artist into a moment of profound lyricism. As with Lane in Gloucester, it is sometimes hard to know whether we are dealing mainly with the artist's "annexation of world" or the world's annexation of artist.

Bingham's luminist vision did not endure steadfastly throughout his career. After about 1850, the glasslike clarity of light and form often gave way, even in the river paintings, to the more painterly handling that can be noted in *Wood-Boatmen on a River* (*Ill. 9-6*); and the interest in classic order bred itself out in the increased architectonic classicism of the election pictures of the mid-1850's (*Ill. 9-7*). His brief sojourn in Düsseldorf (1856–58) —"Düsseldorf is but a village compared with Paris or with our large American cities, yet I question much if there can be found a city in the world where an artist, who sincerely worships Truth and Nature, can find a more congenial atmosphere, or obtain more ready facilities in the prosecution of his studies"[31]—tended to dessicate his surfaces (*Ill. 9-8*), displacing even more the rutilant burnish of luminist modulation.

It is perhaps significant for our understanding of luminism that his most genuinely luminist works occurred early, at the first moment when he triumphed over primitive planarism, a moment when his vision was still closest to that of the primitive. Toward the end of his career, the primitive occasionally reasserted itself, as in *Order No. 11* (*Ill. 9-9*), where one senses a curious similarity to West's histrionic neoclassicism, and where, as Bloch has observed, eclecticism prevails.[32]

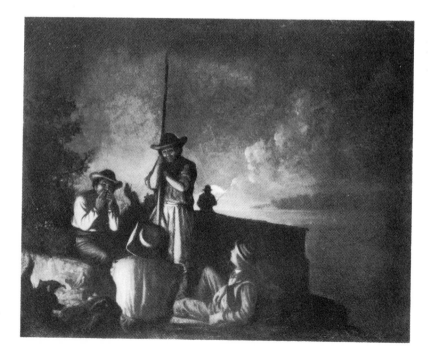

9-6 George Caleb Bingham: *Wood-Boatmen on a River,* 1854. Oil on canvas, 29 x 36 inches. Courtesy, Museum of Fine Arts, Boston.

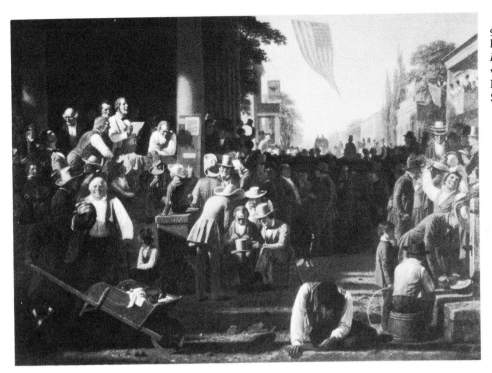

9-7 George Caleb Bingham: *The Verdict of the People*, 1855. Oil on canvas, 45½ x 64¼ inches. The Boatmen's National Bank of Saint Louis.

In occasional late pictures like *The Palm Leaf Shade,* (Ill. *9-10*), something of the effusive radiance of luminism returns. A reference by Fern Rusk to Bingham's interest in spiritualism after his wife's death in 1876 has been noted by Christ-Janer: "Bingham himself became somewhat interested a little later in the prevailing excitement over spiritualism. He declared at one time that he had seen and talked to his wife and she had kissed him."[33]

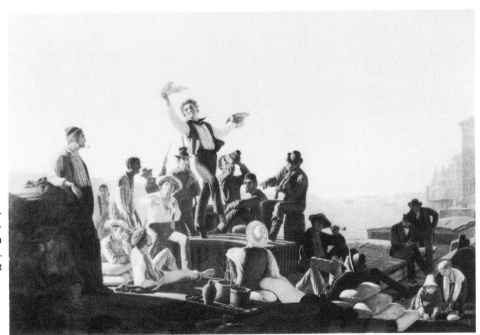

9-8 George Caleb Bingham: *The Jolly Flatboatmen in Port*, 1857. Oil on canvas, 46¼ x 69 inches. City Art Museum of Saint Louis.

9-9 George Caleb Bingham: *Order No. 11, ca.* 1865–69. Oil on canvas (transferred from a panel), 55½ x 78½ inches. Cincinnati Art Museum.

Yet later biographers have not carried this further. It would be presumptuous to claim that this very late evidence of an interest manifested also by Mount and Lane accounts for the otherworldly radiance of *The Palm Leaf Shade*. But in the light of our still fragmentary knowledge of the American nineteenth century and of the subtle and precarious balance that produced luminist style—primitivism, realism, classicism, and an idealism that took full cognizance of the spiritual—the question is at least, left tantalizingly open.

9-10 George Caleb Bingham: *The Palm Leaf Shade, ca.* 1877. Oil on canvas, 26¾ x 22½ inches. Collection Mrs. G. W. Stier, Lexington, Missouri.

Winslow Homer

CONCEPT AND PERCEPT

Mr. Homer goes in, as the phrase is, for perfect realism, and cares not a jot for such fantastic hairsplitting as the distinction between beauty and ugliness. He is a genuine painter; that is, to see, and to reproduce what he sees, is his only care . . . He not only has no imagination, but he contrives to elevate this rather blighting negative into a blooming and honorable positive. He is almost barbarously simple, and to our eye, he is horribly ugly; but there is nevertheless something one likes about him. What is it? For ourselves, it is not his subjects. We frankly confess that we detest his subjects—his barren plank fences, his glaring, bold, blue skies, his big, dreary, vacant lots of meadows, his freckled, straight-haired Yankee ur-chins, his flat-breasted maidens, suggestive of a dish of rural doughnuts and pie . . . He has chosen the least pictorial features of the least pictorial range of scenery and civilization; he has resolutely treated them as if they *were* pictorial, as if they were every inch as good as Capri or Tangiers; and to reward his audacity, he has incontestably succeeded.[1]

HENRY JAMES

When Henry James wrote this criticism of him in 1875, Winslow Homer (1836–1910) had already made major contributions to the development of art in America, and the first phase of his own development, which was to end in 1881 with his visit to Tynemouth, was nearing its close. During this period, from about 1862 to 1881, he had further transformed the art of genre from reportorial narrative into a kind of monumental contemporary history painting—as Mount and Bingham had done before him (*Ills. 10-1 and 10-2*).

As even James sensed, to read his early works by their "rural doughnuts and pie" is to miss Homer's contribution. Like his French Impressionist contemporaries, Homer utilized these local subjects largely as vehicles for the range of formal inventions that concerned him, inventions that were in some ways the culmination of the proto-Impressionist and luminist essays

of such artists as Mount, Durand, and Lane. Synthesized by Homer's broad sensibility, they led him to formulate what Baur has isolated as a native Impressionism.[2]

Homer's early experience, like that of Kensett, Lane, and many others, included printmaking. Apprenticed in 1854 or 1855 to the Boston lithographer John H. Bufford, he began submitting wood engravings to *Harper's Weekly* in 1857, but his first oils were not executed until 1862. Thus, again, the factor of graphic experience enters into the problem of the genesis of an artist's vision. This is further complicated in Homer's case by the contention of some scholars that he was strongly affected by Japanese prints.[3]

As Flexner has pointed out, Homer's own initial experience with the wood block could have given him insights parallel to those he might have gained from the Japanese,[4] though he might easily have been familiar with Japanese prints as well, having been introduced to them, perhaps, by his good friend John La Farge. It is a bit difficult to bear out Albert Ten Eyck Gardner's argument that he would have seen the prints when he attended the Paris Universal Exposition of 1867,[5] since none of the contemporary listings of the Exposition definitely show that prints were included in the Japanese offering.[6] He could, as Gardner has also suggested, have seen Japanese prints at the import shop that was such a rage with the French artists—La Porte Chinoise. But there are sufficient indications in Homer's work before 1867 that he was either already familiar with Japanese prints or had arrived, through his own printmaking experience, at similar formal solutions. The rather startling diagonal ramp that dominates *The Morning Bell (Ill. 10-3)*, a painting of about 1866, suggests Homer's familiarity with the Japanese predilection for abrupt diagonal perspectives. But again, Good-

◀ 10-1 William Sidney Mount: *Farmer Whetting his Scythe,* 1848. Oil on canvas, 24 x 20 inches. Suffolk Museum and Carriage House, Stony Brook, New York.

10-2 Winslow Homer: *Veteran in a New Field,* 1865. Oil on canvas, 24 x 38 inches. The Metropolitan Museum of Art, New York; Bequest of Miss Adelaide Milton de Groot, 1967.

10-3 Winslow Homer: *The Morning Bell, ca.* 1866. Oil on canvas, 24 x 38¼ inches. Yale University Art Gallery, New Haven; Bequest of Stephen Carlton Clark, B.A., 1903.

rich has written, "the Japanese parallels in his work seem less a result of conscious imitation, as with La Farge, Whistler and Degas, than of an underlying affinity between his vision of nature and that of the Oriental printmakers."[7]

Just as significant in *The Morning Bell* is Homer's treatment of sunlight dotting the flowers and rocks in the foreground, the bonnets of the young milkmaids at the right, and the body of the dog, and becoming palpable as it strikes the solid furniture of nature. This furniture, which here includes the man-made wooden ramp and houses, is treated with a respect for specific properties that recalls the detailed vision of the luminists and such genre painters as Mount. Yet already the strong sunlight is effecting a change: a face is blurred in contrasting shadow, the sunlit impastos of the left foreground unite the separate leaves in a glowing envelope, forms seem to partake at the same time of two and three dimensions, as does the central figure of the milkmaid. Even now a key duality is apparent in Homer's vision, one that combines the indigenous conceptualism with a perceptual realism that was developing with teleological authority in the Western world at that moment.

In other works at about this time, there are startling similarities between Homer and Monet, but the differences are sufficient to make a clear distinction between them. Homer's *Croquet Scene (Ill. 10-4)* and Monet's *Women in a Garden (Ill. 10-5)*, both of about 1866, share a plein-air preoccupation with the figure, but there is a fundamental difference in the

167

10-4 Winslow Homer: *Croquet Scene,* 1866. Oil on canvas, 15⅞ x 26⅟₁₆ inches. Courtesy of The Art Institute of Chicago.

10-5 Claude Monet: *Women in a Garden,* 1866–67. Oil on canvas, 100¼ x 81¾ inches. Musée du Louvre, Paris.

weight and solidity of the forms. Monet dances the eye about with flickers of light falling on detail or on passages that unite detail. Through effects of light and shade, an over-all multiplicity is created that looks forward to his later development, when the fragmented units are reduced to the size of a brushstroke. Homer, on the other hand, virtually blocks out the picture in large, ordered units that maintain their own situation in space and, more important, in time. Once more, we are confronted by a planar development of organized parallels stepped back into depth, by a geometry of solid shapes *containing* the spreading rays of sunlight that focus directly on the figures. In the Monet, the section of light on the garden path seems as palpable as the ladies' gowns. But Homer's light does not, through its own tangibility, challenge the fundamental integrity of shape and matter. Falling on the croquet lawn, light reaffirms its carpet-like function as a spatial support on which these figures stand. Falling on the figures, it firmly denotes their material structure.

Though here, as is often true in Homer, some forms, or parts of forms, flatten in the sunlight (as do the two ladies at the right), he always maintains the unbroken identity of individual shape. And curiously, even when flattened, his shapes weigh more than do those of his French Impressionist counterparts. The problem of *weight* is another challenging element in the precarious task of making distinctions between the American and the European vision. Monet's ladies are lighter, not by virtue of gastronomic self-denial but, since they are also flattened by sunlight, by virtue of their different spatial situation. While Homer preserves surface characteristics, he frequently does so in the manner of the luminists, consciously affirming a spatial development parallel to the plane. Homer's figures respond to a gravitational pull similar to that of our own three-dimensional world. Monet's figures are no longer grounded in our world. They float lightly like bubbles on the surface, subject only to the rhythmically winding demands of a new pictorial law. Homer's people are set like rocks, and this early absolutism, reached through a kind of Yankee feet-on-the-ground materialism, is a trait he rarely relinquishes.

The perplexing problem of Homer's stay in Paris and the possible influence on him of French Impressionism demands more research, if only to resolve the vast difference in scholarly contention. Goodrich notes "The influence of this trip on his art was not great. . . . Traces of any other artist's style are hard to discover; if anything, one feels that he might have been looking at the men of 1830. . . . what strikes one most is how little he changed abroad."[8] While noting the early parallels between Homer and Monet, he suggests that "Homer might have seen the Manet-Courbet show, but it is highly improbable that he could have seen the younger men."[9] He finds in the paintings of the next two or three years after Homer's return— *The Bridle Path, White Mountains (Ill. 10-6), Long Branch, New Jersey*

10-6 Winslow Homer: *The Bridle Path, White Mountains*, 1868. Oil on canvas, 24 x 38 inches. Sterling and Francine Clark Art Institute, Williamstown, Massachusetts.

(*see Ill. 10-10*), *High Tide: The Bathers* (*see Ill. 10-11*)—"a gayer and more fashionable note that may have reflected his French experience. They showed an increased awareness of sunlight and atmosphere, and were lighter and cooler than anything he had done before, or in fact was to do for some time, for he soon reverted to a darker key." Goodrich finds Homer's Impressionism "a matter of parallel development rather than influence . . . a natural development of his former preoccupation with outdoor light, doubtless stimulated by what he had seen abroad."[10] "The basic fact is that Homer, before he went abroad, had developed an independent brand of Impressionism based on first-hand observations of nature, and with affinities to Japanese art; and that the French experience merely confirmed and strengthened these tendencies."[11]

Gardner, on the other hand, has contended that Homer's ten-month stay in Paris was pivotal to his entire development:

It seems most improbable that the man who was to become "the greatest American artist" would spend such a long time in the very center of the art world and yet remain completely blind to and unaffected by the exciting new artistic currents of the day, currents which were then pulsing and flowing through the minds and conversations and writings of all the most sensitive critics, the boldest modern painters, most of them young men of just about the same age as Homer.[12]

Gardner places the emphasis of his thesis concerning Homer's development on Japanese influence during the Parisian trip and, secondarily, on familiarity with Manet as well. "Once the idea of Japanese influence on the art of Winslow Homer is accepted it becomes easy to find evidence of it in all

his work after 1867. . . . One feels that in all justice some credit must go to Hokusai and Hiroshige, and to Manet, for an important share in the development of the distinctively American art of Winslow Homer."[13]

Yet Homer's contacts and activities in Paris remain a mystery. We know from his famous print of artists copying the masters that he visited the Louvre. We don't know which, if any, of the Louvre masterpieces he himself studied or admired. La Farge reminds us: "He seems to have dealt little with the French artists . . . nor have I ever heard what he thought or said of the great masters' work. He might have been as silent upon that subject as on most."[14]

We know he painted the *Gargoyles of Notre Dame* and the same kind of rural farm scenes that might have interested him at home. (There is something of Courbet's strength in his *Girl with Pitchfork* of this date [*Ill. 10-7*].) We know he attended the Universal Exposition, that he did a portrait of a woman vendor there,[15] and in all probability paid a visit to his well-known Civil War painting, *Prisoners from the Front* (*Ill. 10-8*), and another painting, *The Bright Side,* which were shown in the American section. Most probably he did see the independent exhibition of works by Manet and Courbet at this time, but what could he have seen that did not fortify his own direction? Manet's flat areas of color and simplification of structure

◀ 10-7 Winslow Homer: *Girl with Pitchfork,* 1867. Oil on canvas, 24 x 10½ inches. The Phillips Collection, Washington, D.C.

10-8 Winslow Homer: *Prisoners from the Front,* 1866. Oil on canvas, 24 x 38 inches. The Metropolitan Museum of Art, New York; Gift of Mrs. Frank B. Porter, 1922.

and Courbet's visual realism are apparent in Homer's work prior to his European trip. If Manet's early works are not really Impressionist but partake of conceptual attitudes more typical of Post-Impressionism, that conceptualism already had a long tradition in America. Courbet's proto-Impressionism had, as this volume emphasizes, been paralleled and even presaged in the proto-Impressionist works of Hudson River men like Durand and Kensett, and in the plein-air attitudes of artists like Mount. Goodrich would seem, therefore, to be substantially correct in maintaining that "Certainly France left no such strong impress on him as on his younger and more suggestible fellow countrymen who were soon to begin flocking to Paris."[16]

This suggestion does not rule out the possibility of contact with the works of such Impressionists as Degas and Monet, though perhaps these were more difficult for him to see at that time. But even if one could discern specific influences, one would have to admit that Homer and the Impressionists were going in parallel directions anyway.

To say along with Goodrich that his color became lighter, blonder, and more atmospheric in a general way for a few years is, on the basis of present evidence, probably all one can say. Thus, the works of the next few years would seem to add new awarenesses of the possibilities of color as light to intuitions that Homer could have previously gained from the luminist and proto-Impressionist development. In *The Bridle Path, White Mountains,* of 1868, a lighter, bluer tonality implies some familiarity with the French

10-9 Winslow Homer: *Croquet Match,* 1868–69. Oil on academy board, 9¾ x 15½ inches. Private collection.

10-10 Winslow Homer: *Long Branch, New Jersey,* 1869. Oil on canvas, 16 x 21¾ inches. Courtesy, Museum of Fine Arts, Boston; Charles Henry Hayden Fund

palette. But the handling of the foreground rocks, with their painterly impastos, is fundamentally the same as that encountered in rocks by Durand and Kensett. And, as these painters frequently do, Homer incorporates along with this painterly realism a luminist distance that radiates a diffused glare quite different in character from the palpable sun that strikes upon the horse and rider.

In such a painting, we recognize the struggle between eye and idea that was to engage the American painter from the late 1860's on; for after the Civil War, the growing domination of painterly perception (augmented by the theories if not the practices of Impressionism) changed the character of the picture. For the American realist, with his indigenous allegiance to concept and the integrity of fact, the problem was one of resolution between plein-air empiricism and methods of observation and organization that were more essentially intellectual.

Even in those paintings of 1868 or 1869 that most obviously relate to the French adventure—for example, the later *Croquet Match* (*Ill. 10-9*), where

173

the flatness and, untypically, the lightness of the figures and ground again suggest parallels with Monet—there is an insistence on a geometry of spatial structure that subverts both the sharp diagonal of porch and ground and the flat ambiguities of a garden lawn that threatens to shift its reading, as in an early Manet, between two and three dimensions. The spatial order is one with which we are by now familiar. Derived from what may be called luminist classicism, it exerts a gravitational pull on the sharply angled skirt of the vertical figure to the right and extends across the horizontal alignment of floor boards to the angular form of the seated woman, behind whom a carefully grouped block of figures creates a vertical rectangle. The powerful porch column adds another vertical accent and, circled by the hands of the standing figure, once more provokes references to a three-dimensional world. The size relationships here are unsettling—the standing figure beside the porch column is an Amazon giantess, the figures on the lawn disproportionately small, yet curiously right.

Throughout his career, Homer produced paintings in which we find conflicts of size and proportion relating to planar and spatial problems, to problems of resolution between the two- and three-dimensional worlds. This is not surprising—it is frequently the dilemma of the artist caught between "making" and "matching," between the picture plane that resists entry and the demands of the world he walks in. During Homer's lifetime, we can see similar problems in Manet and Gauguin, to name only a few. They are problems that often occur when the conceptual and the perceptual collide. In the *Long Branch,* of 1869 (*Ill. 10-10*), these problems seem to be resolved. Maintaining the new blue lightness of tonality of the post-French period, *Long Branch* reverts to the solidly carved space of the American tradition, the charged emptiness of the sloping dune at the left looking forward (with the enigmatic blank wall of the beach house) to Edward Hopper. (A strong admirer of what he called "Homer's weight," Hopper also was heir to the nineteenth century's preoccupation with light.) Here, by the way, a rather direct and obvious reference to the Japanese can be distinguished in the sharp diagonal of the path, but, again, such a *Japonisme* is stabilized by the luminist horizon, by the geometries of the beach house, and by the vertical accent of the straight skirt-front of the figure at the right.

The hints of emotional content suggested by the spatial expressiveness in *Long Branch* are carried even further in another beach scene of the following year, *High Tide* (*Ill. 10-11*). In one of the most unsettling romantic paintings of the nineteenth century, Homer, like Hopper, achieves mystery through ostensibly prosaic subject matter—three lady bathers and a dog on the beach. As with Hopper, empty space becomes the carrier of wordless feeling.

It has already been noted that the use of space as an emotional vehicle

suggestive of imminent danger or simply to arouse vague fears of the unknown enters sporadically into American art, as part of a romanticism that is frequently tied to some form of realism. Less bizarre than orthodox Surrealism, less obvious than more overt romanticism, it gains its power through the *fact* of the real, often requiring just a slight shift of focus from thing (tree, person, house) to space, which then becomes the implicit theme of the picture. Space—and I speak here mainly of foreground space—occupies more of the design proportion than our "Gestalt" sense of "rightness" would accord it. People and things seem physically and even psychically dominated by it.

The space in Homer's *High Tide* is similar in feeling to that found in the anonymous *Meditation by the Sea* (*see Ill. 5-11*), Heade's *Approaching Storm* (*see Ill. 7-3*), Kensett's *Coast Scene with Figures* (*see Ill. 5-10*), and Hopper's *Nighthawks* (*see Ill. 15-19*). The anonymous painting is, however, overtly unreal; the space, tilted at a diagonal reminiscent of the foreground spaces of the Flemish fifteenth-century primitives or the contemporary Italian de Chirico, seems totally unenterable, creating a reassuring barrier of fiction between the spectator's space and that of the picture. In Homer, however, as frequently in Hopper, the diagonal tilt of the space is barely perceptible. It becomes somehow more enduringly threatening through its perfunctory relation to our real world.

The psychological tractions and distractions of *High Tide* are due to a syntax in which space subtly disorients the viewer's distinctions between "actuality" and pictorial fiction. There are, in addition, some *narrative* suggestions that this is not wholly a painting of sweetness and light, nor even

10-11 Winslow Homer: *High Tide: The Bathers,* 1870. Oil on canvas, 26 x 38 inches. The Metropolitan Museum of Art, New York; Gift of Mrs. William F. Milton, 1923.

175

simply the unrefined bathing picture greeted with reservations by some contemporary critics.[17] The dog seems unduly disconcerted by the dripping hair of the bending figure, whose face is masked by her falling hair, as is the face of the dark-cloaked figure turned away from us. The seated figure, startled, looks in the general direction of the barking dog, and beyond him, at something we cannot see. Like the figures of Edvard Munch twenty years later, these women, physically approximated, are psychologically estranged from one another. Like punctuations, they give emotional emphasis to a kind of wordless sentence—the space and silence that they help articulate.

This romanticism in Homer's art appears sporadically throughout his *oeuvre,* a pictorial concomitant to the final hermetic romanticism of his own withdrawal from society, as he lived out the icy winters at Prout's Neck, Maine: "Night before last it was twelve below zero. . . . My nearest neighbor is half a mile away—I am four miles from telegram & P.O. & under a snow bank most of the time."[18] Thus, to see the early works merely as rural genre is to underestimate the complexity of his art. The early works were, in addition, a natural culmination of some of the major currents of American art prior to the Civil War—of genre art made monumental, of plein-airisme, of respect for the fact and the thing, which constantly amended his developing visual realism. In this way, he summarized the best art that preceded him and, in this authoritative summary, added to it.

In other paintings of 1870, less emotionally loaded than *High Tide,* we can see how the mainstream of that development was synthesized with his luminist heritage. Though *On the Beach (Ill. 10-12)* is characterized by the strongly horizontal format and by a luminist interest in reflections of figures on the wet beach, these reflections are rendered suggestively, with soft, painterly touches, while the heavy impastos of the breaking waves recall

10-12 Winslow Homer: *On the Beach,* 1870. Oil on canvas, 16 x 25 inches. Canajoharie Library and Art Gallery, Canajoharie, New York.

again the contemporary waves of Courbet, whose objective vision Homer shared on several occasions.

By 1871, however, Homer's works reveal a more deliberate, even calculated interest in the classic organization of the picture. The version of *The Country School* of that year is not only a study of sunlight penetrating an interior. It is an essay in grouping, an experiment in order and organization, with that familiar, vacant, and measured foreground plane arresting the attention. By 1872, this interest in order had led Homer to *Snap the Whip* (*Ill. 10-13*), in which angulated figures are strung across a horizontal space as in an orderly Poussin bacchanal (*Ill. 10-14*). One need only note the

10-15 Winslow Homer: *Waiting for Dad*, 1873. Oil on panel, 9 x 13¾ inches. From the collection of Mr. and Mrs. Paul Mellon.

measured correlation of feet and knees, which, plotted on horizontals and diagonals, suggests that Homer might well have had in his library, as did Mount, some of the current volumes on geometry and art. One wonders, too, with such paintings, how carefully he observed the Poussins in the Louvre.

But Poussin may not even have been necessary at this point in Homer's development; it seems obvious that his abilities as a constructor, a maker of pictures, were innate and remain dominant throughout his *oeuvre*. Again, it is too easy to misread this picture, as has often been done, as rural genre, to be deceived by the indigenous respect for each blade of grass and wrinkled trouser. In the best constructivist sense, Homer was a designer, working (who knows how empirically?) to achieve that "good Gestalt" noted by Herbert Read in Cézanne.

This tendency may have been fortified in 1873, when Homer spent June and July in Gloucester, Fitz Hugh Lane's home town, and in the backyard of luminism painted his most obviously luminist painting, *Waiting for Dad*

10-16 Winslow Homer: *Boys Wading*, 1873. Watercolor, 9½ x 13¼ inches. The Harold T. Pulsifer Memorial Collection, Colby College Art Museum, Waterville, Maine.

(*Ill. 10-15*). The "health" of the Emersonian "eye" is insured by a taut horizon; a clarion pellucidity of light and color recall Piero, as does the contained figure of the motionless mother, babe in arms. As Piero's painting was directly affected by the subtle tonalities of the hills of Urbino, so Gloucester itself surely had its effect on Homer. We may well recall here Stuart Davis' later comment on the "brilliant light" and "topographical severity" of Gloucester. Thus, it is not surprising that Homer's eye for detail, clarified perhaps not only by the atmosphere but by the examples of Lane's particularized realism that he must have seen in Gloucester, should isolate pebbles and fronds of grass and magnify the crack in the fallen log

10-17 Winslow Homer: *Boys in a Pasture*, 1874. Oil on canvas, 15⅔ x 22⅔ inches. Courtesy, Museum of Fine Arts, Boston; Charles Henry Hayden Fund.

179

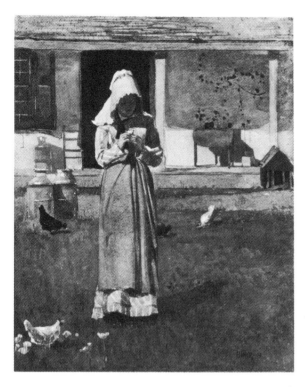

10-18 Winslow Homer: *The Sick Chicken,* 1874. Watercolor, 9⅜ x 7⅜ inches. The Harold T. Pulsifer Memorial Collection, Colby College Art Museum, Waterville, Maine.

on which the boat is propped. This family, columnar and still, inhabits the emotional compound of Lane's *Brace's Rock.*

Here, and in the watercolors of this year, as in *Boys Wading (Ill. 10-16),* Homer's development reaches its closest point of contact with the earlier luminist tradition of Lane. The strong tendency toward classic organization continues in other paintings of 1873, in *Morning Glories,* with its grid of window panes and flower pots, and in the paintings of the following year, such as *Boys in a Pasture (Ill. 10-17),* where carefully disposed space gains power through the added component of weight. In *The Sick Chicken (Ill. 10-18),* of 1874, a coy title momentarily obscures an American Hera of Samos, measured against the geometries of a farmyard porch.

After about 1875, Homer synthesized the classicism of this period with other tendencies he wished to pursue. Although one can isolate later works that are largely classic in organization, they are never quite as pure. But the annexation into his sensibility of a classic absolute, heavily weighted in time and space, endured into his most mature works, and made Impressionism, in the ephemeral French sense, impossible for him. The debt he owed to the classic phase was not, however, immediately evident.

In 1876, the year of *The Cotton Pickers,* the early classicism gave way to a more natural movement of forms in space. The women picking cotton are still monumental, but the weight is organic rather than geometric. They

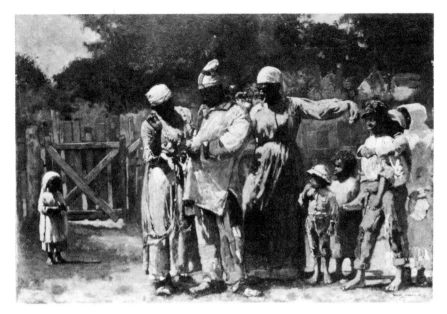

10-19 Winslow Homer: *The Carnival,* 1877. Oil on canvas, 20 x 30 inches. The Metropolitan Museum of Art, New York; Lazarus Fund, 1922.

are flesh and blood, and they move with ease in a field of cotton that only perhaps at the left horizon reveals the stringent control of luminist line. By 1877, when Homer painted *The Carnival (Ill. 10-19)*, he was concerning himself primarily with light striking colorfully costumed forms. Both represent, in addition, a genuine attempt to rescue the black from Uncle Tom status in American art. Thus, like Mount in paintings such as *The*

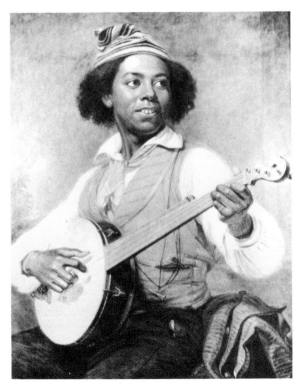

10-20 William Sidney Mount: *The Banjo Player,* 1856. Oil on canvas, 36 x 29 inches. Suffolk Museum and Carriage House, Stony Brook, New York.

181

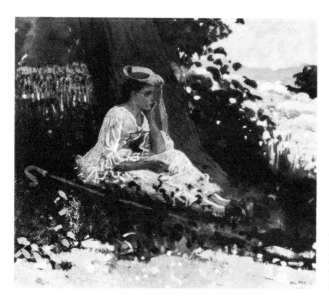

10-21 Winslow Homer: *Bo-Peep,* 1878. Gouache, 6⅞ x 8½ inches. Courtesy, Museum of Fine Arts, Boston; Bequest of John T. Spaulding.

Banjo Player (*Ill. 10-20*), Homer added to the iconography of the black as a human being rather than as a cliché.[19]

The years 1875–81 saw various trips to Virginia (the source of many black themes from 1875 to 1879) and Maine (1875); to Houghton Farm, Mountainville, New York (1878); West Townsend (1879) and Gloucester, Massachusetts (1880); and to the Adirondacks, which Homer had begun to visit in 1870 and continued to visit intermittently throughout his life. From the first Gloucester visit, he had devoted an increasing amount of summer time to watercolors, and at Mountainville he indulged a nostalgia for the eighteenth century by occasionally painting farm girls in eighteenth-century shepherdess costume. Goodrich has suggested that in doing so, "perhaps

10-22 Winslow Homer: *The Green Dory,* 1880. Watercolor, 13¾ x 19¾ inches. Courtesy, Museum of Fine Arts, Boston; Gift of Mrs. Arthur T. Cabot.

10-23 Winslow Homer: *Hark, the Lark!*, 1882. Oil on canvas, 36 x 31 inches. Layton Art Gallery Collection, Milwaukee Art Center.

Homer, like other Americans of the time, was showing the effect of the great Centennial Exhibition of 1876, which had revived interest in everything Colonial and had also spread a craze for decorative art throughout the homes of America. It is noteworthy that even Thomas Eakins, most drastic of realists, was essaying Colonial subjects in these same years."[20] Goodrich comments, too, that "these Mountainville watercolors have a delicacy and grace unique in all his work" (*Ill. 10-21*).[21]

Two years later, the watercolors dating from his second visit to Gloucester (*Ill. 10-22*) return to the linear calm of the earlier Gloucester works. But the bucolic phase of young boys and pubertal girls was drawing to a close. When Homer visited the fishing port of Tynemouth, England, in 1881 and 1882, he seems to have changed fundamentally, not only his work but his life-style.

There he consummated a marriage to the sea that would last until his death, reinforcing an artistic and personal concern with the obdurate and obstinate, with survival in the face of elemental dangers, a Darwinian concept that underscores a new attitude to nature by the 1880's. If nature was a source of wonder to the landscapists up to the mid-century, to Homer it was a worthy antagonist to be taken on, a challenge to be met day by day. Nature had achieved an intimacy of scale that permitted human engagement in the struggle, something that would not have been possible earlier.

183

10-24 Winslow Homer: *Fisher-folk on the Beach at Tynemouth,* 1881. Watercolor, 13 x 18¼ inches. Addison Gallery of American Art, Phillips Academy, Andover, Massachusetts.

Yet the struggle at first was undertaken by human beings endowed with superhuman strength. The women of the Tynemouth period are Amazons. If they bear any resemblance to classic form, it is not to Homer's earlier Piero-like columns but to Picasso's classicism of the early 1920's. Strength derives from physical size and weight. This is true not so much of the watercolors of 1881, in which the figure types are more directly observed, as of the works of 1882 and the consciously designed pictures done later from on-the-spot sketches. In *Hark, The Lark!* of 1882 (*Ill. 10-23*), the conceptual intermediary of memory fortifies the statuesque solidity of the

10-25 Winslow Homer: *The Life Line,* 1884. Oil on canvas, 28¾ x 44⅝ inches. Philadelphia Museum of Art; George W. Elkins Collection.

184

10-26 Winslow Homer: *Undertow,* 1886. Oil on canvas, 30 x 48 inches. Sterling and Francine Clark Art Institute, Williamstown, Massachusetts.

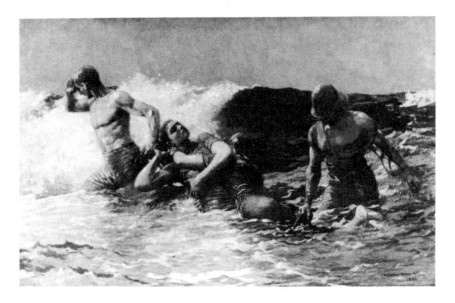

fisherwomen. Though Homer is still concerned with light in this period, as in the *Fisherfolk on the Beach at Tynemouth* (*Ill. 10-24*), his tonalities are grayed and muted, and the rich brilliance of color of his first phase gives way to the oceanic palette that is by and large characteristic for the rest of his career—excepting the luminous excursions into highly saturated color that mark the watercolors of his later trips to the Bahamas and Cuba.

He returned from Tynemouth in 1882 and the following year settled in Prout's Neck, Maine, to continue in seclusion his contest with the sea, and to flourish like some hardy seaweed in conditions that would have withered more delicate plants. The grit of his personality is transferred to his art. Shortly after his return, while he still maintained his New York studio, he posed some models on the roof of the Tenth Street building, drenching them with water, and executed a painting based partly on a recent observation of lifesaving in Atlantic City, *The Life Line,* which he exhibited at the National Academy in 1884 (*Ill. 10-25*). That he combined the posed studio situation and simulated rooftop conditions with on-the-spot observation indicates again his continued effort to synthesize concept and percept. (Eakins, too, often climbed to a sunlit rooftop with small figure models, trying to duplicate actuality through synthetic reformulation.)

The Life Line was one of Homer's most successful efforts of this type, a fortunate resolution of two-dimensional design and three-dimensional space. Another painting, of 1886, *Undertow,* deriving from the same Atlantic City experience in 1883, was less successful precisely because these problems were not resolved (*Ill. 10-26*), and thus is extremely instructive as an indication

10-27　Winslow Homer: *Eight Bells,* 1886. Oil on canvas, 25 x 30 inches. Addison Gallery of American Art, Phillips Academy, Andover, Massachusetts.

10-28　Winslow Homer: *The Gulf Stream,* 1899. Oil on canvas, 28⅛ x 49⅛ inches. The Metropolitan Museum of Art, New York; Wolfe Fund, 1906.

10-29　Winslow Homer: *The Turtle Pound,* 1898. Watercolor, 14¹⁵⁄₁₆ x 21⅜ inches. Courtesy of The Brooklyn Museum, New York.

of Homer's constant dilemma. Here the plastic properties of the picture are in conflict with the element that in the 1880's assumed brief dominance in Homer's work: a narrative representation that at its worst could border on the illustrative. Thus, while three-dimensional space and naturalistic light characterize the right portion of the picture, the left portion pulls abstractly to the surface plane, the figure at the left is affixed to the surface, and both flesh and foam share the same homogenized local texture, forecasting the tough-skinned paint of the later sea paintings.

In other paintings of the 1880's, such as *The Herring Net,* illustrative narration predominates. At times, as in *Eight Bells (Ill. 10-27),* firm verticals and strategic diagonals rescue the painting from illustration. Related to this group is one of the most famous but least plastically satisfying of Homer's paintings, *The Gulf Stream* (1899) *(Ill. 10-28),* whose illustrative deficiencies are clearly revealed if compared with companion watercolors of about the same time *(Ill. 10-29).* But by the 1890's, the problems of narrative were, with few such exceptions, resolved, and Homer's development until his death was in the direction of further consolidation and synthesis.

In one sense, his later development can be conceived of in terms of a constellation in which formal and thematic tendencies, inclinations, and attitudes continually redispose themselves. Narrative observation, perceptual vision, the world outside the picture, so to speak, come to terms with the world of the picture—with ordered design in terms of large, simple units, utilizing either the classic symmetries of horizontals and verticals parallel to the picture plane, as in *Searchlight, Harbor Entrance, Santiago de Cuba (Ill. 10-30),* or the more asymmetrical decorative diagonals that again suggest

10-31 Winslow Homer: *West Wind,* 1891. Oil on canvas, 30 x 43½ inches. Addison Gallery of American Art, Phillips Academy, Andover, Massachusetts.

10-32 Winslow Homer: *Cape Trinity, Saguenay River, Moonlight, ca.* 1904. Oil on canvas, 28¾ x 48⅜ inches. Alastair Bradley Martin Collection, Glen Head, New York.

affinities to the Oriental, as in *The Fox Hunt* (1893).[22] The romanticism hinted at earlier in such paintings as *High Tide* manifests itself even more strongly in paintings like *West Wind* (Ill. 10-31)—or *Cape Trinity, Saguenay River, Moonlight* (Ill. 10-32), where Homer shares with Ryder the earlier spirit of Allston. In the late watercolors of the Bahamas, light and color are synonymous, but never at the expense of solid form, which becomes, like the space itself, even more concrete.

But the synthesis that Homer achieved in the sea pictures of those last years at Prout's Neck is perhaps his most resonant attempt at epic quality —a quality attained by fulfilling the implications of his abdication from all but a minimum of human congress. The figure is rarely included in these

188

10-33 Winslow Homer: *Driftwood*, 1909. Oil on canvas, 24 x 28 inches. Collection, Dr. and Mrs. S. Emlen Stokes, Moorestown, New Jersey.

pictures—just rocks, sea, wind, and weather. When in the last of them, *Driftwood* (1909) (*Ill. 10-33*), a figure finally appears, it is as an observer, passively watching the ceaseless dialectic between elements, not in any way involved in the dream of mastery.

The synthesis in these pictures is between Homer's classic instincts and his sense of observation, his perceptual awareness of plein-air light. Homer developed a professional sea-watcher's precision of observation and a sense of the *specifics* of time that recalls Mount's meteorological concerns and Eakins' famous "what o'clock it is." "People never see that early morning effect," Homer wrote of *Early Morning after a Storm at Sea* (*Ill. 10-34*),

10-34 Winslow Homer: *Early Morning after a Storm at Sea*, 1902. Oil on canvas, 30¼ x 50 inches. The Cleveland Museum of Art; Gift from J. H. Wade.

189

"They don't get up early enough."[23] And of *West Point, Prout's Neck* (*Ill. 10-35*), he wrote:

> The picture is painted *fifteen minutes* after sunset—not one minute before —as up to that minute the clouds over the sun would have their edges lighted with a brilliant glow of color—but now (in this picture) the sun has got beyond their immediate range & *they are in shadow*. The light is from the sky in this picture. You can see that it took many days of careful observation to get this, (with a high sea & tide just right.)[24]

In *West Point,* Homer calcifies water and foam into a tundra that obviates fluid progression. These last sea pictures represent his ultimate way of reifying ephemerals. "Why," he wrote, "I hang my pictures on the upper balcony of the studio and go down by the sea seventy-five feet away, and look at them. I can see the least thing that is out, I can then correct it."[25] No wonder the summary forms of these pictures, subjected to this telescopic eye, achieve such an authority of placement. Nothing more clearly points up Homer's fixation of a single moment than this withdrawal to a distance. From this distance, the moment yields up not its transience, but its quotient of eternity.

10-35 Winslow Homer: *West Point, Prout's Neck,* 1900. Oil on canvas, 30 x 48 inches. Sterling and Francine Clark Art Institute, Williamstown, Massachusetts.

11.

Thomas Eakins

SCIENCE AND SIGHT

When Thomas Eakins (1844–1916) visited the Universal Exposition in Paris in 1867, he was more interested in the locomotives and machinery than in the art.[1] This curiosity about mechanism, with its concomitant respect for fact, led him into serious anatomical studies—like the Renaissance masters who dissected to use knowledge as an instrument of truth. With Eakins, this desire for knowledge—an almost obsessive one in his case—extended to the use of the machine as tool (photography) and into mathematics. His art thus belongs, in many of its aspects, to the mensurational, machine-connected aesthetic that characterizes much American art before and after him.[2] In his grave attempts to reconcile knowledge with art, he was perhaps the most philosophical and conscientious of American artists.

Like Homer, Eakins continued to monumentalize the genre tradition of Mount. And Philadelphia became for him, as did Stony Brook for Mount, a locus for complicated perspective studies. Eakins was as aware as Mount and Homer of the challenges of plein-air observation, and he sometimes went up to the roof with rag models, using actual sunlight, as Homer did, to reconstruct scenes observed elsewhere. Occasionally, for boating pictures, Eakins advised that the student set the boat into place by simulating its position with a brick.[3] Thus, direct observation, secondary re-creation through the model, and mathematical (sometimes mechanical drawing) aids were all brought to bear on a single picture.

It is not surprising that at times his pictures lack easy resolutions and authoritative syntheses. Within the same painting, the mathematical and the visual could coexist without reconciliation. Yet the outcome often has an odd conviction, deriving precisely from this combined process, declaring a cousinship to similarly compounded works within the American tradition. This is especially obvious in the superb boating pictures of the early 1870's. Eakins' most famous statement recognizes the components of this process:

11-1 Thomas Eakins: *Max Schmitt in a Single Scull,* 1871. Oil on canvas, 32¼ x 46¼ inches. The Metropolitan Museum of Art, New York; Alfred N. Punnett Fund and gift of George D. Pratt, 1934.

In a big picture you can see what o'clock it is, afternoon or morning, if it's hot or cold, winter or summer and what kind of people are there, and what they are doing and why they are doing it. . . . If a man makes a hot day he makes it like a hot day he once saw or is seeing; if a sweet face, a face he once saw or which he imagines from old memories or parts of memories and his knowledge, and he combines and combines, never creates—but at the very first combination no man, and least of all himself, could ever disentangle the feelings that animated him just then, and refer each one to its right place.[4]

Such a statement is a reminder that Eakins, like the luminists, was deeply aware of specifics of time and weather. But, more important, it shows that he understood that his art was a "combination" of the known, seen, and remembered—though, as Fairfield Porter has aptly commented, "he trusted his head more than his hand and knowledge more than appearance."[5]

192

Eakins was correct in observing that no man could "disentangle the feelings" of the artist and "refer each one to its right place." But Eakins' combining *process* can be "disentangled" and referred to points of origin in his complicated sensibility. Thus, in his early masterpiece, *Max Schmitt in a Single Scull* (1871) (*Ill. 11-1*), one can isolate sections that seem to have drawn on immediate plein-air response, that were probably painted on the spot, as, for example, the trees at the left, where the stroke is lighter and more spontaneous. But the figure of Schmitt himself is so sharply focused that it is more likely a studio portrait, too heavy in its plastic assertiveness for the fragile, ideographic boat. One senses that boat, man, and water were not all apprehended and painted simultaneously but put together out of different aspects of the painter's experience and sensibility. The burnished portions of the painting, the quiet detail near the boat in the left background, and the studied still-life observation of the oars in the foreground recall that particular conjugation of memory and knowledge peculiar to luminism.

In fact, these boating pictures continue luminism's attitude to time. Being has not yet given way to becoming, though luminist anonymity has been displaced by a more obviously painterly process that quietly establishes the artist as intermediary between the work of art and the spectator. In pre-Civil War art in America, this use of tactile, opaque pigment—away from descriptive to more visual ends—is largely found in the proto-Impressionist studies of the Hudson River men. After the war, of course, the general trend of American art, and, indeed, of Western art, was toward the painterly. But the importance of this for American art is in the way artists such as

11-2 Thomas Eakins: *Starting out after Rail,* 1874. Oil on canvas, 24 x 20 inches. Courtesy, Museum of Fine Arts, Boston; Hayden Collection.

193

11-3 Thomas Eakins: *John Biglen in a Single Scull*, 1873–74. Watercolor, 17⅛ x 23 inches. The Metropolitan Museum of Art, New York; Fletcher Fund, 1924.

Eakins and Homer utilized the new perceptual possibilities of plein-airisme and integrated them with their indigenous conceptual bias. It is this integration, this resolution of the vision of their period (time style) and their American proclivities (national style) that makes for the uniqueness of their contribution.

11-4 Thomas Eakins: *Whistling for Plover*, 1874. Watercolor, 11 x 16½ inches. Courtesy of The Brooklyn Museum, New York.

194

11-5 Thomas Eakins: Perspective study for *John Biglen in a Single Scull,* 1873–74. Pen, pencil, and wash, 27⅜ x 45³⁄₁₆ inches. Courtesy, Museum of Fine Arts, Boston; Gift of Cornelius V. Whitney.

Eakins' boating pictures (*Ill. 11-2*), then, offer us a vision tempered by science, by the abstraction of mathematics, by the study of reconstructed models of parts of the scene observed,[6] and by a discreet painterly plein-air response. In *John Biglen in a Single Scull* (*Ill. 11-3*), despite the assertion of painterly stroke, a luminist mood prevails, deriving primarily from the measured containment whose logic is clarified by the perspective study (*Ill. 11-5*). The empty foreground plane, the scull marking off a dominant horizontal (slightly angled into space in a typically luminist escape from rigidity), the jutting edge of an adjacent scull at the left, and the careful placement of the scull near the horizon all recall luminist parallelism. As with *Max Schmitt,* the relation of the figure to the calibrated empty space seems profoundly charged.

In some of the hunting scenes of the same period, such as *Whistling for Plover* (*Ill. 11-4*), this grave spatial locution, exaggerated still further, becomes the real theme. In *The Artist and his Father Hunting Reed-Birds* (*Ill. 11-6*) space also is given the dominant expressive role. It is psychologically plausible that the action of the figures in the boat be arrested; the action is slowed and checked by the tangled marsh grasses. Yet it seems significant that this halt of time and motion partakes of the same general character as that of the presumably more "fluid" boating pictures. In Eakins' hands, as often in Homer's, the ephemeral signatures of water and air are replaced by

195

11-6 Thomas Eakins: *The Artist and his Father Hunting Reed-Birds, ca.* 1874. Oil on panel, 17⅛ x 26½ inches. Collection of Mr. and Mrs. Paul Mellon.

material densities. If we look at the water in *Max Schmitt*, we find that its surface has been carefully demarcated. The passage of the distant sculler (Eakins himself) is marked by pairs of interrupted lines that have replaced the pockets of water out of which the oars have been lifted. Schmitt's course is denoted by similar lines. Such lines, though they arise from movement, do not give an idea of movement. They are used by Eakins to measure and fix location in space more clearly.

The question of stopped motion again raises the problem of a distinctive American attitude toward a "fixed" reality and the use of the machine as a tool to stabilize and verify physical certainties. Though artists like Mount and Eakins used complex mathematical perspectives to determine placement of things in space, they also used another mechanical device whose immense effect on much nineteenth-century painting has had insufficient attention. "It is surprising," Beaumont Newhall has remarked, "that today's art historians with their delight in probing into the prototype of every artist's work, should so generally fail to recognize that photography has been ever since 1839 both a source and an influence to hosts of painters."[7]

Photography has long been recognized for its role in liberating the painter from the necessity for realistic representation to concentrate on the autonomy of the picture. But little attention has been given to the early use of the daguerreotype and subsequently of the photograph as a tool to make the studies of "reality" that the artist could then use in his studio to freeze and

196

capture effects of light and dark and, mainly, to fortify conceptual knowledge.

Art historical investigation of the problem might go at least as far back as Leonardo's diagram of the camera obscura (if not as far back as Euclid, who seems to have known its principles), would include consideration of Vermeer's now well-established use of the instrument and extend in nineteenth-century America to artists like Fitz Hugh Lane. When Daguerre transformed the concept of the camera obscura into the magical sun-wrought process of the daguerreotype (happily proclaimed in America as an instrument of Nature),[8] he may have made a larger contribution to art history than has yet been dreamed of. We may ask whether it is a coincidence that the startling luminist paintings of Bingham and Mount around 1845 (*see Ills. 5-17 and 5-18*) occurred at the same time as the widespread introduction of the stopped eye of the daguerreotype,[9] with its long exposures to a subject sometimes literally held motionless in a vise.

The camera, of course, had its effects on both sides of the ocean. In France, Delacroix was extremely enthusiastic: "Let a man of genius make use of the Daguerreotype as it should be used, and he will raise himself to a height that we do not know."[10] Ingres admired photographs for an "exactitude that I would like to achieve."[11] Courbet used photographs as sources, as did Manet, whose etching of Edgar Allan Poe (a strong influence on French Symbolists) has been "linked directly to a well-known American daguerreotype."[12] Seurat was interested in Jules-Étienne Marey's photographic gun, which was related to inventions for motion study by Muybridge and Eakins in America. Degas was famous for using instantaneous stereo-camera shots to discover new attitudes to composition. But he was also aware of Muybridge's studies of movement and after 1880 "made clay studies and charcoal sketches of horses based on Eadweard Muybridge's chronophotographs,"[13] another link between Eakins and developments in France. Eakins, whose association with Muybridge's researches at the University of Pennsylvania in 1884 resulted in the invention of a camera with two disks in front of the

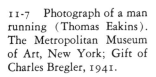
11-7 Photograph of a man running (Thomas Eakins). The Metropolitan Museum of Art, New York; Gift of Charles Bregler, 1941.

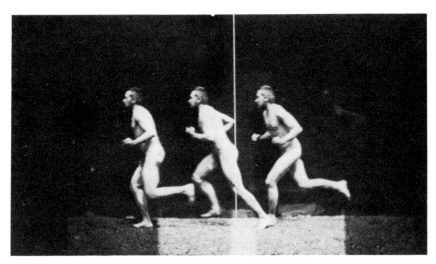

11-8 Thomas Eakins: *The Gross Clinic,* 1875. Oil on canvas, 96 x 78 inches. Courtesy of The Jefferson Medical College of Philadelphia.

lens, one revolving eight times faster than the other, has been credited by some scholars with anticipating the motion picture camera.[14]

Ultimately, the European artist seems to have benefited from the camera in a somewhat negative way. Once the photograph had "fixed" reality, the artist, liberated from that obligation, could become increasingly concerned with the reality of the picture. In America, however, given an indigenous conceptual and realistic bias, we can expect that the camera would and did have a different effect, functioning in a machine technology as another instrument to certify the outside world.

From the inventor and painter Morse, to whom the daguerreotypes were not "copies of nature, but portions of nature herself,"[15] through Poe, who called the daguerreotype "only a more absolute truly more perfect identity of aspect with the thing represented,"[16] Americans were enchanted by the veracity of the camera. The romantic Cole was one of the few painters who voiced strong reservations, considering the daguerreotype "a mechanical contrivance," although even he felt the daguerreotype would have the virtue of revealing the insincerities of the superficial "painter of views."[17] But Mount, Lane, Homer, Page, Healy, Church, Remington, Harnett, and

Bierstadt (who especially used stereoscopic views) all seem to have made some use of the photograph not only as a study but as a model for paintings. The fundamental American attitude was perhaps best voiced by Theodore Robinson at the end of the century when he wrote, "Painting directly from nature is difficult as things do not remain the same, the camera helps to retain the picture in your mind."[18] It was probably this devotion to the "picture" in the mind that first drew Eakins to photography as another device contributing to the clinical verism on which his art was founded (*Ill. 11-7*).

The same instinct had attracted him earlier to the science of anatomy; his first studies after graduation from Central High School in 1861 were in drawing at The Pennsylvania Academy of the Fine Arts and in anatomy at Jefferson Medical College. He went to Europe in 1866 to study with Gérôme, and "continued to dissect cadavers in Paris at the Beaux Arts."[19]

After a trip in the winter of 1869 to Spain, where he admired Ribera and that other master of realism, Velázquez,[20] he returned home in July, 1870, and again took up his anatomical studies at Jefferson Medical College.

One important result of this interest was the famous *Gross Clinic* (*Ill. 11-8*), a genre painting (in the best "contemporary-history" sense) as well as a portrait of Dr. Samuel D. Gross, the celebrated surgeon, in the operating amphitheater. Rejected by the art jury of the Philadelphia Centennial Exhibition in 1876, it was finally hung in the medical section, a rather apt though probably unintentional tribute to the integrity of the painter's observation. Family-minded contemporary critics, for whom it was not a painting

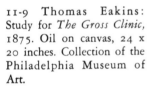

11-9 Thomas Eakins: Study for *The Gross Clinic*, 1875. Oil on canvas, 24 x 20 inches. Collection of the Philadelphia Museum of Art.

for "togetherness," voiced outrage that "society thinks it proper to hang [it] in a room where ladies, young and old, young girls and boys and little children, are expected to be visitors. It is a picture that even strong men find it difficult to look at long, if they can look at it at all."[21]

Yet, in the tradition of Copley's *Death of Chatham*, Eakins had taken a contemporary event and made it—as the same critic also suggested—heroic, executing actual portraits of all the protagonists: Dr. James H. Barton, Dr. Daniel Apple, Dr. Charles S. Briggs, Dr. W. Joseph Hearn, Dr. Franklin West; looking on, the surgeon's son, Dr. Samuel W. Gross, Hughie the janitor, and, face hidden by her hand, the patient's mother.

As in *Max Schmitt,* the artist's method of combining the scientifically analyzed and the perceptually realized results in spatial discontinuities. The patient's thigh and part of the buttock seem literally disjointed from the body. Sufficient space is not allotted for the physical existence of a trunk between leg and anesthetized head. As in many of Eakins' works, however, this *seems* right, as well as curiously wrong, emphasizing the paradox implied by his method—mathematical fidelity to the realities of three-dimensional space and form *outside* the picture transferred to the two-dimensional pictorial space by multiple conceptual and perceptual means.

The picture thus runs a gamut of styles from conceptual realism to visual realism, from the *trompe l'oeil* of the doctor's knife and hand, wet with blood (a Copley-like illusionism), to the painterly impastos of the doctor's head, especially of his hair and beard, and the suggestive handling of the spectators in the amphitheatre. The sketch for this painting is as freely and thickly painted as an early Cézanne, an indication, perhaps, that such extreme painterliness was possible for the American artist but not preferable (*Ill. 11-9*).

The subject interested Eakins enough for him to essay a similar one later in life. *The Agnew Clinic,* of 1889 (*Ill. 11-10*), shows Dr. Hayes Agnew of

11-10 Thomas Eakins: *The Agnew Clinic,* 1889. Oil on canvas, 74½ x 130½ inches. School of Medicine, University of Pennsylvania, Philadelphia.

200

11-11 Thomas Eakins: *William Rush and his Model,* 1907–8. Oil on canvas, 35¼ x 47¼ inches. Collection of the Honolulu Academy of Arts.

the University of Pennsylvania Medical School and his students and assistants officiating at a breast-cancer operation (and includes, at the extreme right, a portrait of Eakins painted by Mrs. Eakins). But this work, somewhat freer in over-all execution, lacks the dramatic, almost Rembrandtesque focus of light and dark of *The Gross Clinic.* The structure is more lax, the loss in power marked. The critical reception was again not aesthetic but moralistic, and the directors of The Pennsylvania Academy refused to allow it to hang in the 1891 annual exhibition.

The disappointments Eakins suffered over the reception of his American "Anatomy Lessons" were not isolated incidents in his life. Rather, they were signs of a continued fall from grace endured throughout his career and climaxed in 1886 by his resignation as head of The Pennsylvania Academy school, after the directors censured him for acquainting female students with the facts of male anatomy. He allegorized contemporary prudery by returning four times to the theme of the sculptor William Rush and the scandal Rush had created early in the nineteenth century when he carved his *Nymph of the Schuylkill,* using as model a young Philadelphia girl who agreed to pose nude, accompanied by a chaperone. In one of Eakins' last versions, around 1908, we are confronted with a provocative ambivalence of meaning, as the artist eliminates both chaperone and statue from the picture and shows only the sculptor, perhaps Eakins himself, helping the model

201

11-12 Thomas Eakins: *The Fairman Rogers Four-in-Hand,* 1879. Oil on canvas, 24 x 36 inches. Collection of the Philadelphia Museum of Art.

down from the stand, as though the statue has become his Galatea (*Ill. 11-11*).[22] The statue comes to life; that is, the statue is eliminated and replaced by nature. In the gesture of the sculptor helping down the living figure, we witness a moment when art and life literally touch.

Eakins objected to any surrogates that interposed themselves between the artist and reality, and he disliked the contemporary practice of teaching from plaster casts.[23] Like Greenough, he would have maintained that he

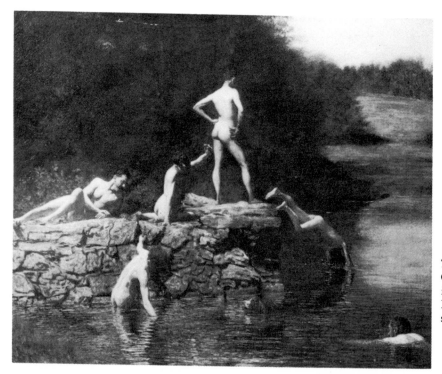

11-13 Thomas Eakins: *The Swimming Hole,* 1883. Oil on canvas, 27 x 36 inches. Collection of the Fort Worth Art Center Museum, Texas.

contended only for Greek principles. He shared the Greeks' admiration for the nude, and his admiration was not only aesthetic but functional. His anatomy classes at The Pennsylvania Academy and his photographic studies of athletes in motion served as tools to demonstrate what a machine the body was.

Even these instruments had to be checked against one another for accuracy. As Fairfield Porter has pointed out, Eakins had a "sensitive appreciation of the limitations of the camera as an instrument for discovering fact," and he did a gray copy of his famous study of horses in action, *The Fairman Rogers Four-in-Hand (Ill. 11-12)* "to be photographed in place of the original in full color, since before the invention of the panchromatic film photography translated color values inaccurately."[24] This recognition of the photograph as a convention like painting itself was an interesting insight on Eakins' part at this time. But he was nonetheless rightly convinced of the importance of this new convention in analyzing motion. He fixed the physiology of motion in his photographs and analyzed the anatomy of motion on the dissecting table, thus studying both the exterior and interior mechanisms of living things. When he delivered his paper on horses before the Philadelphia Academy of Sciences, *On the Differential Action of Certain Muscles Passing more than One Joint,* he was merely demonstrating once again how his anatomical and photographic interests supported each other.

It was probably his extreme scientism that made of paintings like *The Swimming Hole (Ill. 11-13)* (1883) more a laboratory for research on the various poses of the human form than a unified work of art. He deliberately attempted to re-create outdoors the poses in which Phidias might have

11-14 Thomas Eakins: *The Crucifixion,* 1880. Oil on canvas, 96 x 56 inches. Collection of the Philadelphia Museum of Art.

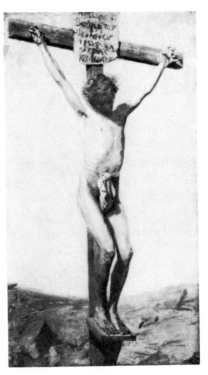

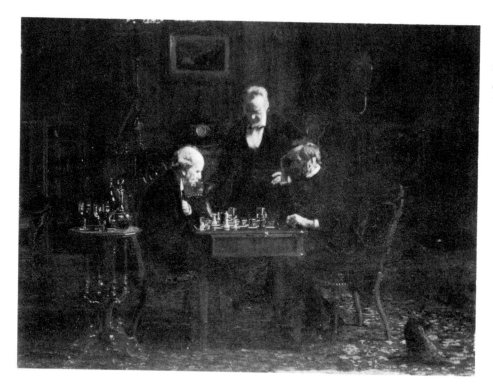

11-15 Thomas Eakins: *Chess Players*, 1876. Oil on panel, 11¾ x 16¾ inches. The Metropolitan Museum of Art, New York; Gift of the artist, 1881.

placed his live models. As he said: "The Greeks did not study the antique; the Theseus and Illysus and the draped figures in the Parthenon pediment were modelled from life undoubtedly. And nature is just as varied and just as beautiful in our day as she was in the time of Phidias. . . . Our business is distinctly to do something for ourselves, not to copy Phidias."[25] Thus, setting models in these "Greek" poses was not a matter of imitation but of discovering what the original logic of the pose was before the Greeks had turned it into a convention. His re-creation here was to see nature as the Greeks had seen it—with the possibility of finding a different result—rather than seeing nature through what the Greeks had made of it. Typically, the poses in *The Swimming Hole* are recovered by Eakins in a factual, nonideal way. But they are very definitely "posed" figures, and set as they are in a more spontaneously perceived outdoor setting, assume a curious artificiality, despite the immediacy of the image of Eakins himself, with his setter Harry, swimming toward them. (Eakins' desire to reconstruct or discover reality apart from artistic convention also prompted such stratagems as strapping his friend J. Laurie Wallace—painter, pupil, and demonstrator of anatomy at The Pennsylvania Academy—to a cross outdoors. The result, *The Crucifixion* [*Ill. 11-14*], is unemotional and blatantly naked—rather than conventionally nude—realism as defined by confronting the truth, ugly or not.)

204

Eakins was highly disappointed in the reception of his often brutal realism. The public tended to see the brutality—we can guess that Eakins himself saw mainly the truth. Yet perhaps the disappointment added to the psychological resources of his later art. In the later years, his analytic genius became intensely reflective, and the change was from a measured classicism to a more romantic and humane preoccupation. That romanticism was present in his portraits from the beginning, as though the friends and family who modeled for him (even in the genre scenes) (*Ills. 11-15 and 11-16*), submerged his scientism in an introspective sympathy. The personal and the impersonal were thus oddly contiguous in his early career. The clinical objectivity that produced the rather unpalatable nakedness of the masked nude drawing of 1866 (*Ill. 11-17*) is roughly concurrent with the tender mood of the study of a girl's head, of 1867–69 (*Ill. 11-18*). At the same time that Eakins could see the human animal with almost cruel

11-16 Thomas Eakins: Perspective study for *Chess Players,* 1876. Pencil and ink on cardboard, 24 x 19 inches. The Metropolitan Museum of Art, New York; Fletcher Fund, 1942.

11-17 Thomas Eakins: *Masked Woman Seated*, 1866. Charcoal, 24 x 18 inches. Collection of the Philadelphia Museum of Art.

11-18 Thomas Eakins: *Study of a Girl's Head*, ca. 1867–69. Oil on canvas, 17¾ x 14½ inches. Collection of the Philadelphia Museum of Art.

11-19 Thomas Eakins: *Home Scene*, ca. 1871. Oil on canvas, 21¾ x 18 inches. Courtesy of The Brooklyn Museum, New York.

11-20 Thomas Eakins: *Miss Van Buren, ca.* 1889–91. Oil on canvas, 45 x 32 inches. The Phillips Collection, Washington, D.C.

detachment, he could recognize it through feelings of a generous amplitude, indeed nobility. These feelings seem to have been released in direct ratio to the sitter's role in his life, for with intimates, the psychological penetration was generally more profound. In the *Home Scene,* of about 1871 (*Ill. 11-19*), his sister Margaret, whose early death grieved Eakins deeply, turns thoughtfully from the piano to observe the child drawing on her slate. In other studies of Margaret, which isolate her from the genre environment and which are conceived as portraits, as in *Marguerite in Skating Costume* (1871), the contemplative mood is even more intense.

Portraits became his major preoccupation from around the late 1870's on, and he carried into them a judicious gravity that precluded the trivializing of sentiment. Eakins' portraits celebrate a sympathetic bond of deep feeling between artist and sitter, in which the *process* but not the *content* of the

sitter's introspection is revealed. As with Rembrandt, we may ask whether the poignant quality of many of Eakins' portraits is a property of the artist's own sensibility projected onto the sitter, resides in the sitter's personality, or partakes of both.

The quietism of such portraits, with eyes averted from the spectator or gaze turned inward (*Ill. 11-20*), is in one sense another aspect of that contemplative romanticism expressed earlier in American art by Copley, in portraits like *Mrs. Richard Skinner* (*see Ill. 1-21*), and by Allston in such paintings as *The Spanish Girl in Reverie* (*see Ill. 2-13*). But it is even more a part of the art historical moment in which Eakins was painting. A new subjectivism in the presentation of the individual was developing internationally. In America and Europe, the figure lost in thought, usually female, often became a motif for the artist's tone poem on the impenetrability of reverie. At the same time, by the late 1880's, early Expressionist portraiture displaced reverie and revealed alienation. Many of Eakins' portraits lie between reverie and alienation. Thus, his sensibility was in some ways more

◄11-21 Thomas Eakins: *The Thinker: Louis N. Kenton*, 1900. Oil on canvas, 82 x 42 inches. The Metropolitan Museum of Art, New York; Kennedy Fund, 1917.

11-22 Thomas Eakins: *Letitia Wilson Jordan Bacon*, 1888. Oil on canvas, 59⁷⁄₁₆ x 40⅛ inches. Courtesy of The Brooklyn Museum, New York.

11-23 Thomas Eakins: *Portrait of Mrs. Edith Mahon,* 1904. Oil on canvas, 20 x 16 inches. Smith College Museum of Art, Northampton, Massachusetts.

genuinely of its time than was that of the popular John Singer Sargent, whose bravura brushstroke beguiled the eyes of a chic social world that clamored for his attention. Eakins' attempts to meet psychological truth, whether in himself or in the sitter, again led to difficulties, for the portraits were sometimes rejected even by the sympathetic friends who sat for them.

Eakins learned, as had Manet, from Velázquez, to use the limbo of empty space around a figure, making it function as surface and depth. In their full-length portraits, Sargent and Whistler, too, were aware of this spatial potential. But, more than they, Eakins could utilize the gestural attitude of the entire body as a psychological comment. Thus, in *The Thinker: Louis N. Kenton* (*Ill. 11-21*), it is the arabesque of the suit against the surrounding space, rather than the face, that reveals the mood of the man. And in the asymmetric displacement of the gown over the shoulders, the inclined arms and tilted fan—indeed, in the way the posture is identified as much by the surrounding space as by its own silhouette—*Letitia Wilson Jordan Bacon* (*Ill. 11-22*) suggests parallels with such a stylistically diverse work as Lautrec's *Yvette Guilbert.*

209

But it is the bust-length portraits that are most psychologically potent. In portraits like *Addie* (1900), and especially in *Portrait of Mrs. Edith Mahon* (*Ill. 11-23*), the sitter is brought into still closer intimacy with the surface plane and, consequently, with the viewer. The reflective eyes leave little doubt as to the dual origin of thought in both sitter and artist; a doubled life-experience is projected behind self-entranced pupils. With such portraits, thought itself becomes a theme. No longer a logical instrument of the artist's creative process, thought becomes a hermetic reverie. The reality of fact is replaced by the reality of dream. It is the other side of the American coin, not as frequently upturned, but ever present.

12.

Albert Pinkham Ryder

EVEN WITH A THOUGHT

Thomas Cole had complained that the American public wanted "things, not thoughts." Albert Pinkham Ryder (1847–1917) can be said to have made thought into a thing, into a substance built up of innumerable layers of paint. In his awareness of the expressive potential of paint, Ryder recalls the romanticism of Allston earlier in the century. Both artists have links to the coloristic tradition of European art, from the Venetians through Rubens, into Delacroix's romanticism, Impressionism, and ultimately into Expressionism.

But if Ryder's "expressionist" use of paint to materialize and fuse ideas and feelings belongs to a distinct Western painterly tradition, his emphasis on contour, on circumscribed forms, can be seen as relating to the linear ideographs with which the American tradition began, as does his reduction of the picture to a few large unbroken shapes. Even the surface inclinations of his art (two-dimensional in its representation of external space, though three-dimensional through accumulation of paint) relate as much to the conceptual planarism of the American tradition as to similar inclinations in late nineteenth- and twentieth-century European art.

In his intuitive grasp of the painting as a self-contained structure, an autonomous object, Ryder was more genuinely a part of the international developments of his age (of Post-Impressionism and early Expressionism) than any other American of his time, with the possible exception of Whistler, whose formal experiments were so knowledgeably attuned to decorative abstraction. Thus, his art comes into clearer focus at a point of many intersections, a focus that is, however, difficult to preserve when dealing with it (*Ill. 12-1*).

Ryder materialized his ideas very slowly, and there was even an extensive pre-natal process of conceptual germination: "I've carried the idea for some of my pictures around in my mind for five years before I began to put them

on canvas."[1] Indeed, it is difficult to avoid the biological metaphor in dealing with his art: "An inspiration is no more than a seed that must be planted and nourished."[2] With Klee, whom he resembles in telescoping cosmic ambitions into a few square inches, Ryder might have said: "Art does not render the visible, but makes visible."[3]

Like most genuine romantics, Ryder was in search of the "impossible and the unattainable."[4] It is tempting to identify this search with his technique and his subjects—with his interminable process of painting, and with the voyages of those lonely boats under moonlit skies. Though some of his pictures emphasize process, others have the perfect Gestalt of an absolute idea, a point of arrival fully recognized. He himself spoke of the difficulty of distinguishing process from the point of arrival, the difficulty, as he put it, of knowing when "to cry 'halt.'"[5] This is, again, a romantic's problem, and one, it will be remembered, that consumed Allston as he struggled with *Belshazzar's Feast*.

Like Allston and Cole, Ryder was a poet, producing verses that sometimes had a distinct Emily Dickinson quality:

> Who knows what God knows?
> His hand He never shows,
> Yet miracles with less are wrought
> Even with a thought.[6]

And, like Allston, Cole, and Delacroix, he enjoyed working from the Bible and from literary themes such as Shakespeare's. His romanticism could, like theirs, assume on occasion a Gothick mood of dread, as in *The Race Track* (or *Death on a Pale Horse*) (*Ill. 12-2*). He also shared with Whistler

12-1 Albert Pinkham Ryder: *Moonlit Cove, ca.* 1890–1900. Oil on canvas, 14 x 17 inches. The Phillips Collection, Washington, D.C.

212

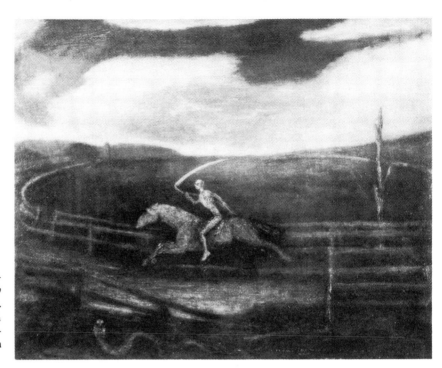

12-2 Albert Pinkham Ryder: *The Race Track (Death on a Pale Horse), ca.* 1910. Oil on canvas, 28¼ x 35¼ inches. The Cleveland Museum of Art; Purchase from the J. H. Wade Fund.

and, interestingly enough, Homer an admiration for Wagner, a culture hero of the latter part of the century.

Ryder's interests in literature, music, and Gothick mood, then, can perhaps be associated with Western romanticism at large. But he was very American in his frequent cultivation of the aspects of his work that reveal a dreaming contemplation, a metaphysical lyricism that extended beyond the European *Sturm und Drang* toward a serenity suggestive of Taoism and Oriental mysticism. It was this aspect of his romanticism that tied him to the Transcendentalism of his New England forebears, so that he could write: "Have you ever seen an inch worm crawl up a leaf or a twig, and then clinging to the very end, revolve in the air, feeling for something to reach something? That's like me. I am trying to find something out there beyond the place on which I have a footing."[7]

In the mid-century, as we have seen, external reality was revered as the outward manifestation of a spiritual inner reality, and the various solutions to the real-ideal dilemma were aesthetic embodiments of that belief. By the late nineteenth century, however, the moralistic adherence to naturalism was largly an outdated aesthetic, and Ryder was free to create something that was "better than nature, for it was vibrating with the thrill of a new creation."[8]

To some extent, this concept of the artist as a new creator takes us back to the romantic ideas held earlier in the century by Cole and Allston, before the mid-century dictum requiring art to depict both internal and external

nature made such frank romanticism virtually impossible. Allston would have agreed with Ryder that "Imitation is not inspiration, and inspiration only can give birth to a work of art. The least of a man's original emanation is better than the best of a borrowed thought."[9]

But while Allston spoke at length of originality, he was frequently eclectic in utilizing neoclassic conventions and in borrowing freely from such earlier artists as Michelangelo. Ryder felt that "Modern art must strike out from the old and assert its individual right to live through Twentieth Century impressionism and interpretation. The new is not revealed to those whose eyes are fastened in worship upon the old."[10] Even Thomas Cole, that champion of the imagination, had cautioned the artist against relying too exclusively on himself. But to Ryder, the inner reality was paramount and natural forms just the means to an end: "The artist should fear to become the slave of detail. He should strive to express his thought and not the surface of it. What avails a storm cloud accurate in form and color if the storm is not therein?"[11]

That "inner reality" has enveloped our idea of Ryder's life to the point where we find it surprising that he stirred out of his studio at all. But there are glimpses of him communing with nature for his own purposes, looking at the moon on frequent walks along the Battery or, in Bronx Park, studying the trees that eventually became *The Forest of Arden* from "As You Like It."[12] Though there has always been evidence to the contrary, Ryder has been seen as a recluse nurturing his thoughts and pictures in solitude, cut off from human congress. This is largely true, but one might be a little suspicious of so comfortable a legend.

Ryder was pure, but not simple; innocent, but not necessarily unsophisticated. He had a small circle of valuable friends that included Daniel Cottier, the art dealer, J. Alden Weir, the painter, and John Gellatly, the collector. On occasion, he visited New York exhibitions, and such excursions suggest some interest in the paintings, but we know little of what he admired.

He rarely spoke of other artists, though he admired Corot and the Dutch artist Matthew Maris, whose studio he probably visited when he was in Holland in 1882. During the same European journey, he went to England, France, Italy, Spain, and Tangier. He had previously been to London for a month in 1877, and it is presumed that the later trips he made in 1887 and 1896 on his friend Captain Robinson's boat were to study the sea and moonlight on the way over and back. When one considers how generations of American artists have undertaken that journey with trepidation in the face of the great European traditions, Ryder's relegation of Europe to a port of call between two voyages is marvelously quixotic. It is indeed hard to avoid the conclusion that to Ryder painting was primarily a way of externalizing his thoughts and feelings, and that the history of art was of as little concern to him as the future of his own paintings.

That future has obliterated many of his works, probably because they were kept "ripening" for so many years in his studio: "The canvas I began ten years ago I shall perhaps complete today or to-morrow. It has been ripening under the sunlight of the years that come and go."[13] This concept of "ripening" is one of his most telling attitudes and suggests a reciprocal existence shared by Ryder and his work, in which the painting's continued progress comes to represent the inner life of the artist. Thus, the decision to halt (the birth of the picture for others) could be seen as the death of the picture for the artist and so, to a degree, of himself.

This process is different from a painting that has simply taken a long time to execute. Walter Pach has written that after the picture was laid in directly, without a preliminary sketch, there followed "a process of small or large changes that frequently extends over a period of years. The position of clouds in a sky, the contour of a hill, or the movement of a figure undergo infinite modifications until the stability and harmony of masses is attained that the artist's astonishing sense of their beauty demands." Ryder told Pach: "I think it is better to get the design first before I try for the color. It would be wasted, much of the time, when I have to change things about."[14] Trial and error continued until he recognized—or failed to recognize—the perfection of his idea, and by that time, as Lloyd Goodrich has remarked, "even a tiny canvas weighs heavy in the hand."[15]

Unfortunately, Ryder, ignorant of technical problems, painted over wet surfaces and used a bitumen that discolored. This ended literally in the "death" through decay of some of his pictures, and we do not see them now as Ryder intended. Yet the crackled amber surfaces have a patina of age that may have pleased him, though in some cases further deteriorations have frustrated modern observers (*Ill. 12-3*). It is not surprising that another

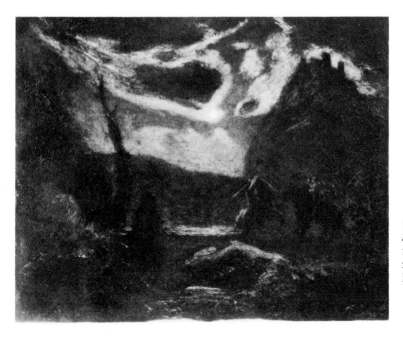

12-3 Albert Pinkham Ryder: *Macbeth and the Witches,* 1890–1908. Oil on canvas, 28¼ x 35¾ inches. The Phillips Collection, Washington, D.C.

215

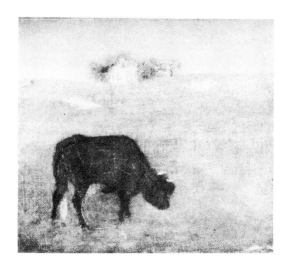

12-4 Albert Pinkham Ryder: *Evening Glow, the Old Red Cow, ca.* late 1870's, early 1880's. Oil on canvas, 7⅞ x 9¹⁄₁₆ inches. Courtesy of The Brooklyn Museum, New York.

artist who has "seen" with the inner eye, Morris Graves—for whose work Ryder's *Dead Bird* is an important precedent—should have deliberately crackled his paper surfaces to give them a sense of age. In both cases, we are confronted with an interesting materialization of romantic nostalgia. Time is not the theme of the picture, but, in a curious, nostalgic literalism, the entire picture itself is aged. But though in Ryder's case the aging, as mellowing, was in a sense intentional, the decay was surely not so.

Ryder's works, mostly undated, do not reveal a clear formal development. To some extent, we can approximately date the earlier paintings by subject. The simple studies of cows and sheep, occasionally thinly painted, as in *Evening Glow, the Old Red Cow (Ill. 12-4)*, seem to date from the late 1870's and early 1880's. Goodrich calls them "reminiscences of the country around New Bedford, with its secluded stony pastures, old stone walls and

12-5 Albert Pinkham Ryder: *Jonah, ca.* 1885. Oil on canvas, 26½ x 33½ inches. Courtesy of National Collection of Fine Arts, Smithsonian Institution, Washington, D.C.; Gift of John Gellatly.

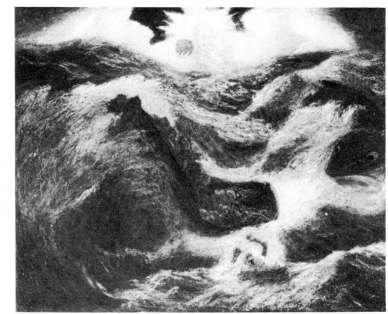

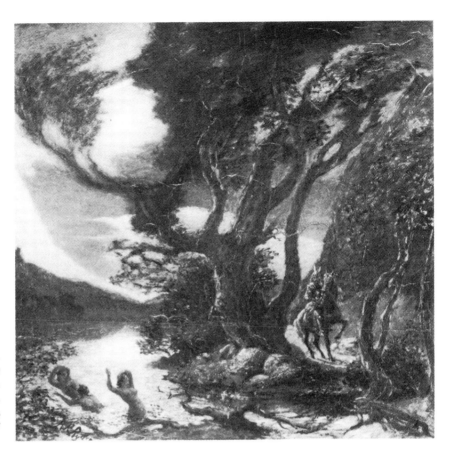

12-6 Albert Pinkham Ryder: *Siegfried and the Rhine Maidens,* 1888–91. Oil on canvas, 19⅞ x 20½ inches. National Gallery of Art, Washington, D.C.; Andrew Mellon Collection.

wood lots."[16] Like the luminists, Ryder often chose specific quiet moments in the day—twilight or sunset hours. Even this early, the moonlight that has come to stand for his special "annexation" of the world made its appearance.

His most important works, often based on heroic themes from opera and literature, belong to the mid 1880's and 1890's. "I am in ecstasys over my Jonah," he wrote in April, 1885, "such a lovely turmoil of boiling water and everything."[17] This is not the language of quiet meditation but of baroque vision, of the senses caught up in a dizzying religious experience, over which the rather naïve figure of God the Father presides, orb in hand (*Ill. 12-5*). Thomas Cole, who, like Ryder, associated painting with prayer, was also inclined to place symbolic figures in the sky. The Guardian Spirit and demon forms inhabit the heavens of Cole's *The Voyage of Life: Manhood* (*see Ill. 3-5*). But while "The Voyage of Life" today is little more than religious soap opera, Ryder's tiny *Jonah* is a convincing universe of feeling perfectly approximating mind and form.

There may be some connection between Ryder's exposure to the baroque conventions of the operas he saw in New York and the centrifugal expansiveness of the *Jonah* and those pictures directly inspired by Wagner—

217

Flying Dutchman (see Ill. 14-19) and *Siegfried and the Rhine Maidens,* based on Götterdämmerung *(Ill. 12-6).* Of the *Siegfried,* Ryder said: "I had been to hear the opera and went home about twelve o'clock and began this picture. I worked for forty-eight hours without sleep or food, and the picture was the result."[18] In all these paintings, the subject, or even knowledge of it, is relatively unimportant. To use Ryder's phrase, the storm is therein. The insistent rhythms, especially in the *Siegfried,* are fixed into the "good Gestalt" of the perfect design. *Siegfried* belongs, like El Greco's *View of Toledo,* to that small group of masterpieces that stamp themselves on our minds with instantaneous—indeed, almost violent—authority.

That *Siegfried* suggests associations with Greco's *Toledo* is not surprising. Ryder, like El Greco, was a visionary, and his entire *oeuvre,* religious or secular, might be seen as an act of devotion. The Gothic sensibility at the root of Greco's Mannerism was precisely Worringer's "ceaseless melody of northern line," the whorling, convoluted rhythms that worked their way into Baroque religious art and ultimately through the expansive forms of Rubens into the romantic color of Delacroix. It was this sensibility, intensified emotionally, that informed the Expressionism of Munch and the Germans in the late nineteenth and early twentieth centuries. In such paintings as *Siegfried, Jonah,* and *Flying Dutchman,* Ryder shared this sensibility. They have a Gothic visionary aspect, a romantic amplitude, and an Expressionist intensity.

Yet Ryder seems to have experienced a polarization in his modes of expression in which we can distinguish at least two types of religious experience. On the one hand, the traditional Western projection of the self into

12-7 Albert Pinkham Ryder: *Toilers of the Sea,* before 1884. Oil on panel, 11½ x 12 inches. The Metropolitan Museum of Art, New York; George A. Hearne Fund, 1915.

an anthropomorphic baroque ecstasy, a form of appropriating the world. On the other, a serene, almost Oriental absorption of the self into cosmos, an annihilation of the self. For the latter, as we have seen, there was already a strong American precedent in Transcendentalism and in the works of those painters who erased their own artistic presence in the attempt to realize the life of things. In Ryder's pictures of a lonely boat under a moonlit sky, his most popular image, we can find this alternative (*Ill. 12-7*).

If we study some of the most remarkable of these—*Under a Cloud, Moonlight Marine, (Ill. 12-8) Marine (Ill. 12-9)*—we are struck, as Roger Fry was, by how limited their components are. An enumeration would repeat boat, sky, moon, cloud, sea, each as summary and bare as the language of his best poems. These elements are stabilized and "named," as it were, by his way of distinguishing them. They are distinguished by their shapes and edges but bound together by a somewhat impersonal uniformity of paint. And when, as so often before in American painting, we encounter that distinct horizon, we realize that these pictures recall luminist modes. The ships do not move. They are shapes imprinted on and becalmed in this stillness. The constant subject of the "lonely boat" becomes ideographic and neutral, and sea and sky some abstract void that Ryder wished to invent.

Perhaps it is not until Mark Rothko, another absolutist, that we come across the kind of perfect equivocation of which Ryder was here capable. Ryder's shapes, and Rothko's, are not geometry or formlessness; they are neither—or both. Though the artist's hand is still suggested by the presence of stroke, the hand does not indicate a subjective projection but becomes a *medium* of something larger and less than self. Before an abstract picture

12-8 Albert Pinkham Ryder: *Moonlight Marine,* 1870–90. Oil on panel, 11⅜ x 12 inches. The Metropolitan Museum of Art, New York; Samuel D. Lee Fund, 1934.

12-9 Albert Pinkham Ry-
der: *Marine,* n.d. Oil on
board, 13½ x 10 inches. Col-
lection, Mr. and Mrs. Leo M.
Rogers, New York.

had been painted, Ryder had performed a task of almost impossible sophis-
tication in these reductive images. By limiting himself to a few simple forms,
he assimilated them completely into his thoughts and resolved romantic
antinomies that had troubled Allston at the beginning of the century. In
resolving them, Ryder was anticipating abstract paintings not yet painted.
In privately bringing one romantic dream to a conclusion, he was uncon-
sciously pressing against the future.

In their impersonality, their restriction to a few silhouettes and shapes,
and their contemplative fixity, such paintings are iconic. They suggest that
Ryder's interminable process of painting and repainting, which has dom-
inated his legend, was an attempt to realize his *idea,* just as Cézanne's
repeated attempts were to realize his *sensations.* If Cézanne tried to preserve
himself while reconciling observed nature with history, Ryder used the
memory of nature to discover an *idea,* and this process, as we have seen in
the moonlit marines, often meant eliminating himself. We are reminded
once more of the American artist's oddly tenacious devotion to concept.

13.

William Harnett

EVERY OBJECT RIGHTLY SEEN

We learn nothing rightly until we learn the symbolical character of life. Day creeps after day, each full of facts, dull, strange, despised things, that we cannot enough despise—call heavy, prosaic and desert. The time we seek to kill; the attention it is elegant to divert from things around us. And presently the aroused intellect finds gold and gems in one of these scorned facts—then finds that the day of facts is a rock of diamonds; that a fact is an Epiphany of God.[1]

RALPH WALDO EMERSON

The respect for the fact, whether object or place, that characterizes so much American art might easily be mistaken for the famous—or infamous—American materialism. But Emerson, like the medieval thinkers, saw the fact as the "end or last issue of spirit," and one may speculate, therefore, on the reasons why conceptual realism in America should resemble the late Gothic painting of Jan van Eyck. Originating with Copley, this conceptual mode was inherited by the luminist landscape painters and by a still-life tradition extending almost without interruption or change from Raphaelle Peale (1774–1825) (*see Ill. 1-9*) at the beginning of the century to William Michael Harnett (1848–92) at the end (*Ill. 13-1*). Much American art of the late eighteenth century and of the nineteenth century can in fact be seen as still life, whether a portrait by Copley or a landscape by Lane.

In discussing Vermeer's *View of Delft,* Étienne Gilson has referred to its "actionless existentiality." This quality is precisely what we find in Harnett's works. Alfred Frankenstein has noted, "Place a Harnett still life of the middle 1870's . . . next to a Raphaelle Peale of 1815 . . . and it is impossible to believe that they are separated by two generations, that the one belongs to the era of James Madison and the other to that of U. S. Grant."[2]

Though Harnett was working at a moment when the more painterly cosmopolitan style was prevalent, his still lifes, in their intense apprehension of objects, hermetic containment, and displacement of the artist, further support the idea of a luminist mode of vision that escapes the restrictions not only of subject but also of period style—while falling, however, into the smaller category of individual style and the broader category of national style.

In its constant attitude to the object, we might say that the luminist mode is an American variety of a conceptual realism that is a recurring state of mind in Western painting from the fifteenth century to the nineteenth century. One can trace it from van Eyck in Flanders, through seventeenth-century Dutch and Spanish still life, and into Ingres in nineteenth-century France (particularly in such paintings as the *Comtesse d'Haussonville*). This is in distinction to an alternative mode that goes as far back as Pompeian frescoes, and embraces such artists as Chardin and Cézanne within a painterly tradition in which the object becomes a vehicle for the artist engaged primarily in formal solutions.

Sometimes the two traditions can come exquisitely close to each other, as in aspects of Zurbarán, Heda, Chardin, and, in America, John F. Francis.

But, for the most part, American still life, as represented by the Peale-Harnett tradition, falls within the category of conceptual realism—in which the presentation of the object is controlled by a knowledge of its properties that is tactile and intellectual, rather than optical or perceptual. The still life, in its indifference and monumental inertia, represents existence "out there" and becomes a challenge to the artist's capacity to realize and apprehend it. This existential urgency is what makes Harnett's so-called *trompe l'oeil* so relentless, almost moral, and, quite apart from the obvious elimination of brushstroke, so self-canceling.

For the objects in Harnett's pictures are so fully realized that they begin to add a problematic quotient to their own existence. This quotient brings us into the area of symbolism, well expressed by Giorgio de Chirico's reference to "the double life of a still life, not as a pictorial subject, but in its supersensory aspect."[3] In de Chirico, the element of surprise is in the startling juxtaposition of still life and arcaded square. In Harnett, it is in the technique itself, a supreme fiction masquerading as "reality." Instead of solving the object's phenomenal presence, the technique simply re-presents it in a way that summarizes its enigmas. We are reminded of Emerson's reference, "every object rightly seen, unlocks a new faculty of the soul."[4] Thus, in exposing the "Eleusinian mysteries" beyond the "stark common sense" of fact,[5] Harnett's art suggests kinships between such diversities as Emersonian Transcendentalism and de Chirico's symbolism. This is not surprising, for still life of this "existential" mode has the capacity to pose philosophical problems that recur in entirely different civilizations and contexts, and we are as likely to find ourselves pondering Meister Eckhart's such-ness and is-ness as the essence of Victorian memorabilia.

There is little doubt that we encounter here an invitation to philosophize that many writers have found difficult to avoid. Étienne Gilson has written:

Whether its origin be Dutch or French, the things that a still life represents exercise only one single act, but it is the simplest and most primitive of all acts, namely, to be. . . . Always present to that which is, this act of being usually lies hidden, and unrevealed, behind what the thing signifies, says, does, or makes. Only two men reach an awareness of its mysterious presence: the philosopher, if, raising his speculation up to the metaphysical notion of being, he finally arrives at this most secret and most fecund of all acts; and the creator of plastic forms, if purifying the work of his hands from all that is not the immediate self-revelation of the act of being, he provides us with a visible image of it that corresponds, in the order of sensible appearances, to what its intuition is in the mind of the metaphysician.[6]

This reference to the correspondence of visible image and mind is a reminder of the strongly ideographic nature of such art. We have often

13-2 Richard Caton Woodville: *Waiting for the Stage,* 1851. Oil on canvas, 15 x 18½ inches. In the collection of The Corcoran Gallery of Art, Washington, D.C.; purchase and through the gifts of Mr. and Mrs. Lansdell K. Christie and Orme Wilson.

found it profitable in this volume to notice how conceptual realism was tempered by the parallel folk tradition. To compare a painting by Raphaelle Peale with the previously encountered primitive *Egg Salad* (*see Ill. 5-13*) is to witness once more the transmutation of paint into object texture, and concept transformed, literally before our eyes, into thing. The illusion of the fork in the primitive work underscores again the narrow line—technical and tonal as well as philosophical—dividing primitive vision from conceptual realism. This closeness to the ideographic (Emerson's "fact in nature as

13-3 Charles Bird King: *Poor Artist's Cupboard, ca.* 1815. Oil on panel, 29¾ x 27¾ inches. In the collection of The Corcoran Gallery of Art, Washington, D.C.

224

13-4 Thomas Eakins: *Between Rounds,* 1899. Oil on canvas, 50¼ x 40 inches. Collection of the Philadelphia Museum of Art.

the noun of the intellect") may be another reason why the *word* seems to have played such an important part in American still life.

If the integrity of the object has tended to be maintained in American art, we are justified also in speaking of the integrity of the idea. This relationship between thing and thought has provided us throughout the nineteenth century with many varieties of realism. Even earlier, it will be remembered, Jonathan Edwards had favored the thing as intermediary between word and idea. And Emerson, of course, had joined words and things. So it would not be surprising if within the American tradition we found the word becoming a thing, objectified as visual fact, and so becoming potentially subject to the ideographic imperatives of that tradition.

In a superficial sense, we can simply point to the ubiquity of the word in America. Between the earliest colonial sign-painting and the advertising of today, it gains in frequency in genre painting and still life—in Woodville (*Ill. 13-2*), Mount (*see Ill. 8-10*), Blythe, and in Charles Bird King (*Ill. 13-3*) or Harnett. We notice ourselves *reading* in Eakins' prize-fight scenes (*Ill. 13-4*), in Reginald Marsh's Bowery paintings, in Demuth's poster portraits (*see Ill. 15-13*), and in the work of artists as diverse as Ben Shahn and Stuart Davis (*see Ill. 15-17*). More recently, the word has been an intimate component of the syntax of such artists as Rivers, Asher, Johns, Indiana, and Lichtenstein, while Kaprow has composed an entire environment called WORDS.

Mere distribution, however, no matter how widespread, is hardly significant. But in nineteenth-century America, we repeatedly find that the integrity

of the word or the sign or notice is preserved, often where we would expect it to be perceptually blurred. If the respect for the fact militated against its disruption, perhaps words within a picture, where the criterion was legibility, could also be expected to survive other pictorial necessities, as indeed they did, on many occasions. It is a short step to words themselves becoming pictorial subjects, and thus we may see Demuth's numbers and letters in a very different context than one derived from Cubist practice. It can of course easily be maintained that in the European tradition, too, words have played a substantial role, entering modernism in Cubist collage, through a very complicated rationale, as emblems of the real world subjected to new pictorial laws, and in Dada, contributing to the invention of a new language.

But in America, language, so vigorous in its vernacular, had a long pictorial history and was quoted in full in nineteenth-century genre and still life. And, insofar as writing was a fact of the external world, it remained as legible as any object. We are perhaps justified in suggesting that the written and printed word in America shared a privileged position with the object, and that behind its ubiquity and apparent banality there is a moral force derived, however indirectly, from the integrity of nature and natural fact that dominated the aesthetics of the mid-century. Indeed, it was this force that led to the endless debates throughout the nineteenth century about problems of imitation.

Given the persistence of these arguments, it is not surprising that Harnett's miraculous imitative powers were seen in the light of attitudes persisting from the mid-century. For the layman, Harnett's skill was occasion for betting on what was "real" over the bar of the saloons where his paintings sometimes hung. But that skill prompted a different reaction in the critic, usually a negative one. So the perceptiveness of the unknown critic who wrote the following about Harnett's *After the Hunt* (*Ill. 13-5*) was highly unusual:

> The artist shows the highest skill in the representation of textures. The wood *is* wood, the iron is iron, the brass is brass, the leather is leather. The fur of the rabbit and the feathers of the birds tempt the hand to feel their delicate softness. The extreme care which reason convinces the beholder must have been constantly exercised in finishing all the exquisite details of such a painting is entirely concealed. We see not the artist nor his method of working. The things themselves only are seen.[7]

Usually, the magical absence of the artist from his work aroused the censure of the sophisticated critic. And as luminist landscape seems not to have been as much appreciated in its own day as now, so *trompe l'oeil* still life could be dismissed as "mere imitation." In reviewing Harnett's *The Social Club* at the National Academy of Design Exhibition, an anonymous critic

13-5 William Harnett: *After the Hunt,*
1885. Oil on canvas, 71 x 48 inches. California Palace of the Legion of Honor, San Francisco.

for the *New York Tribune* wrote in 1879: "This imitative work is not really so difficult as it seems to the layman, and though there are degrees of it, yet when we come down to works like this of Mr. Harnett, it is evident that only time and industry are necessary to the indefinite multiplication of them."[8] The same critic also made the interesting observation that:

Just as there are scores of people who look at and admire Mr. Heade's picture (*Tropical Flowers*) while comparatively few either look at or admire Mr. Sargent's picture (*Little Wanton Boys*) hung just beneath it, so there are many who stop and look with delight at Mr. W. M. Harnett's *The Social Club* . . .

Last year Mr. William M. Harnett had several pictures in the exhibition of the same general character as this *Social Club,* and they attracted the

attention that is always given to curiosities, to works in which the skill of the human hand is ostentatiously displayed working in deceptive imitation of Nature.[9]

The critic passed off the attention given to Harnett as the layman's attraction to "curiosities" of "deceptive imitation." But, at the same time, he noticed that people responding to Heade were also attracted to Harnett. That the layman, without prior prejudices in any direction, might have been responding to the stylistic clarity of Heade and Harnett did not occur to him. Imitation, to satisfy the critics, needed more intervention by the artist —an intervention that had to be qualified, as we have seen, by the utmost discretion. He must neither be the ape of nature nor usurp God's creative function. These simple proscriptions were, however, highly deceptive, since they required complicated definitions of the artist's creative role and of nature, definitions to which the mid-century devoted much energy. At the center of these definitions was the problem of imitation:

> . . . *imitation,* the thing easiest of accomplishment, is really the meanest purpose the artist can devote himself to, and is, in fact, no legitimate object of his labors. The province of painting, then, is not to imitate, but to suggest, not to reproduce, but to represent to the mind, or appeal to the moral faculties, and in proportion as Art tends to the imitative, it is base though excellent, and as it aspires to the intellectual and thence to the moral, it is noble, though imperfect in its attainments of the results it aims at.[10]

> The art which merely presents to us a copy of nature, provided it be really a copy, has its value, a high value, because it excites in us the emotions of the actual scene; but the art which, by means of the forms of nature truthfully rendered, tells us a story, either of fact or fancy and puts us in sympathy with the emotions and visions of genius, has a far nobler significance and value. This is accomplished by selection and idealization, which last consists not in the improvement of nature (for the works of God cannot be improved by man) but in catching the real, yet the highest and most spiritual expression of natural objects.[11]

Such meditations give us an idea of the confusion and restrictions that surrounded the idea of imitation. One doctrine that held strong sway throughout the nineteenth century in America was a form of "selective imitation,"[12] which involved a certain amount of choice of details in nature or isolation of the fragment of nature to be represented. Once selected, nature had to be depicted according to truth, since it could not be improved upon (to do so would be a criticism of God). Neither could it be slavishly imitated, for this would abdicate the artist's role as creator. Such words as "real" or "truth" were often entirely ambiguous, depending on whether

inner or outer truth or, more usually, a combination of both, was implied. Imitation often raised the question "Imitation of *what?*" Selective imitation then, could frequently represent a compromise between alternatives so close together that they were liable to continual confusion.

Selective imitation, however, was exactly what Harnett himself felt he was practicing. His *New York News* interview of about 1889 or 1890 reminds us that he was not a slavish imitator:

> In painting from still life I do not closely imitate nature. Many points I leave out and many I add. Some models are only suggestions. . . .
>
> I always group my figures, so as to try and make an artistic composition, I endeavor to make the composition tell a story. The chief difficulty I have found has not been the grouping of my models, but their choice. To find a subject that paints well is not an easy task. As a rule, new things do not paint well. New silon does not look well in a picture. I want my models to have the mellowing effect of age. For instance, some old and most new ivory paints like bone. From other pieces I can get the rich effect that age and usage gives to it—a soft tint that harmonizes well with the tone of the painting.
>
> New models selected without judgment as to their painting qualities, would be utterly devoid of picturesqueness, and would mar the effect of the painting beyond all hope of reparation.[13]

Harnett's statement is remarkably clear about his intentions, and we can see that selective imitation for him included the isolation of a certain aspect of nature, the elimination (or addition) of details, and "making an artistic composition." Harnett had, in addition, not only design ambitions, which Frankenstein and Baur among others have singled out, but the literary aim of telling a story and the romantic motive of including the nostalgic "histories" of the objects themselves, his version of the venerable concept of the picturesque.

Harnett, the ultrarealist, was therefore a romantic both superficially and profoundly—profoundly, insofar as the intensity with which he represented objects brings into play existential speculations on the mysterious nature of reality. And this, one feels, would be true whether his still-life objects were old or new, whether they told a story or not. But, in adding to the narrative strain and, further, in invoking the picturesque, Harnett linked himself with the more obvious romantic tradition of Thomas Cole, who also wanted to tell a story,[14] but for whom the picturesque took the form of an antique ruin.

Nostalgia is a way of civilizing the past, especially interesting in America, a country "without a past," since it involves inventing that missing past. Initially, as with Cole, nostalgia took the conventional form of grafting onto the limited repertory of American subjects the traditions of Greece and

Rome. Ultimately, that nostalgia transferred itself to America's own past. Homer and Eakins briefly practiced a form of archaism—Homer in his eighteenth-century milkmaids, and Eakins in his passing concern for spinning in grandmother's day. But, less specifically, the taste for the picturesque eventually extended from the antique ruin to the ruined *thing,* so that a whole syntax of nostalgia was available for still life and, ultimately, for assemblage. Harnett's mellowed objects, splintered doors, and torn labels thus have an interesting relation to the rehabilitation of the discard which has extended from Cubist collage and Dada to the junk sculpture of the late 1950's and early 1960's. Quite apart from similar European practices, the ruined object seems especially at home in an American tradition within which the thing has always held a privileged position.

Yet Harnett makes clear that the aging of objects was not simply a matter of nostalgic sentiment but a formal idea. His deliberate choice of objects apparently depended on that "soft tint" that harmonized well "with the tone of the painting." If the ivory handle of the sword in *After the Hunt* had a "different tint the tone of the picture would have been ruined."[15] This "mellowing effect of age" was the model for his perfect modulations of tone, modulations as consummate as those that Fitz Hugh Lane had applied to landscape. The perception of objects is similarly intense, the hermeticism invokes a similar silence, the removal of the artist is as radical and complete. The distant wall of light in luminism is replaced in Harnett's work by the boards and doors from which the objects hang. But the mode of vision, in its tonal sophistication, is similar enough to speak of a constant style.

13-6 John F. Peto: *Still Life with Lanterns,* after 1889. Oil on canvas, 50 x 30 inches. Courtesy of The Brooklyn Museum, New York.

13-7 John F. Peto (formerly attributed to William Harnett): *Old Time Letter Rack (Old Scraps),* 1894. Oil on canvas, 30 x 25⅛ inches. Collection, The Museum of Modern Art, New York; Gift of Nelson A. Rockefeller.

It is worth remarking that Harnett depended so literally on his models, not only for their value as objects but for their tone. This gives us some ideas of the exquisite judiciousness that he exercised in choosing his objects. The chief difficulty, as he said, was not in the grouping but in the choice. But the subtlety of his arrangements should in no way escape us. Though there is a long tradition of hanging still-life objects, Harnett used this device in a very individual way. Their gravitational dependence becomes an aesthetic force that gives formal consistency.

Indeed, this idea of gravity as a formal concept allows us to make distinctions between Harnett and some of his contemporaries. When John Haberle (1856–1933) suspends objects, they are fixed in place by design rather than by gravity. In *Still Life with Lanterns* (*Ill. 13-6*), by John F. Peto (1854–1907), the light cascades down over objects carefully tilted to receive it, and in that flicker of light, the sense of weight, of gravitational pull, somehow disappears. This is understandable, since Peto (whose works were for a long time confused with Harnett's) (*Ill. 13-7*)[16] at times tended to place design, light, and color factors above object reality, and in this picture, the feeling for paint never gives way to the alchemistic transmutation into literal texture that characterizes Harnett's work. As Baur has said,

From early in his career, Peto was sensitive to the new impressionist vision which was gradually seeping into American painting at about this time. . . . It caused him to relax that intensity of observation which the *trompe*

13-8 William Harnett: *A Study Table,* 1882. Oil on canvas, 39⅞ x 51⅜ inches. Collection of Munson-Williams-Proctor Institute, Utica, New York.

l'oeil group had used to create a sense of preternatural significance, and to abandon the exact description of texture, weight and density. The object, with Peto, is no longer paramount; it is bathed in palpable light and atmosphere, half lost in shadow and wholly transformed by the conditions of seeing.[17]

But Harnett's sense of the object and its weight was always acutely present. In *A Study Table* (*Ill. 13-8*), weights are experienced in fully understood systems of checks and balances. Books rest against one another in series, a page is twisted and crushed under an open book placed face down, the pages of another book fan out lightly and are motionless in an absolutely still atmosphere; a book cover dangles over the table's edge, a repeated motif that, like a plumb line, can be seen as a demonstration of gravity. Later, of course, most of Harnett's objects are suspended or rest within clearly defined niches. Gravity is intimately experienced in terms of its potential for giving consistency to his arrangements, and this almost architectural understanding contributes to Harnett's seemingly "casual" arrangements and gives them that sense of rightness, that magical authority, which we immediately recognize.

232

In *Old Models (Ill. 13-9)*, for instance, we are informed on the very texture, substance, and weight of the brass bugle, so that the point at which it is suspended from the nail is experienced acutely, and its slight tilt fully understood. Such estimations of weight and pressure are sometimes brought to discreet areas of risk; the violin is not tilted securely into the niche but rests against a nail. The introduction of the idea that it might somehow fall suggests also its fragility. The base of the vase overlaps the book on which it stands. The tilted book beside it is similarly casual and insecure. Yet such insecurities, elicited by a precise apprehension of centers of gravity, build up a perfect formal system.

Harnett's constant style makes it almost superfluous to search for orthodox art historical evolution in his work. Frankenstein has suggested that after Harnett went abroad in 1880 there was some Meissonier influence toward miniaturism, and that, paradoxically, the slightly more painterly and lively touch in his works of the Munich period was also derived from Meissonier, rather than from the Leibl group.[18] But Frankenstein finds "no trace of the miniaturistic manner" in the *After the Hunt,* of 1885.[19] Even the change in subject that, during Harnett's European sojourn, briefly led to more

13-9 William Harnett: *Old Models,* 1892. Oil on canvas, 54¹⁄₁₀ x 28 inches. Courtesy, Museum of Fine Arts, Boston; Charles Henry Hayden Fund.

233

cluttered arrangements of Victorian bourgeois objects (*see Ill. 13-8*) gave way, after his return to America in 1886, to the simplicity of objects and elements with which he began.

The early inclinations of his art—toward few clear units and broad planar organization—are crystallized and reduced still further. The splintered boards that act as field for the object take on greater significance. The outcome is a refinement of purpose and amplification of means. *The Old Violin,* of 1886, and *Old Models,* of 1892, recall the full-blown control of Copley in the last years of his American period.

The new amplitude of Harnett's late pictures also seems to derive from a change in size and ratio. In such paintings as *Old Models* there is less of a tendency to the horizontal format in which objects crowd toward the picture edge. The vertical pictures, dealing with the subtle dialectics of gravity already mentioned, are read not only in and out, in terms of shallow illusionistic inflections, but up and down, in terms of surface organization. The objects relate to each other and to the surrounding edges across the planar fields of wood that contribute so substantially to the Gestalt of the picture. One is reminded of Matisse's essay of 1908: "The whole arrangement of my picture is expressive. The place occupied by figures or objects, the empty spaces around them, the proportions, everything plays a part."[20]

We started by distinguishing two forms of still life: one in which the object is subsidiary; the other in which the object's existential presence is acutely experienced. Harnett, we said initially, belongs in the latter category. But by this time it should be clear that this judgment should be modified. For Harnett does something quite extraordinary. He so exactly superimposes reality and abstraction that they obscure one another. A formalist might be so struck by Harnett's design that he never sees the objects; another might see the objects and not the design. Harnett, it seems, achieved a complete reciprocal system, in which his objects depend for their reality on abstraction, and abstraction depends for its perfection on objects. This is another way of saying that he made such distinctions irrelevant, and speaking of his pictures in terms of either reality or abstraction does them violence. They are both and neither; that is, at their best, they are perfect pictures.

14.

The Painterly Mode in America

If the dominant indigenous mode of expression in America was linear and conceptual, it would be an oversimplification to deny the existence of an ancillary painterly mode that was largely the result of European contact, training, and influence. To follow the many variations on this painterly theme requires another, separate volume, but perhaps a few ideas can be advanced here.

The painterly mode appears primarily in the works of those artists who either were almost total expatriates (spending large and significant portions of their lives abroad) or were cosmopolitan and international in sensibility, like John La Farge (1835–1910), of whom Henry Adams was moved to write: "Although I thought him quite the superior of any other artist I ever met,—and I have no special reason for limiting the remark to artists alone,—he was so 'un-American.'"[1] Perhaps we are justified in assuming that for many American artists the painterly signified Europe—and thus, by inference, sophistication, grace, aristocracy, and vigorous traditions. Significantly, the period (1825–65) in which the painterly was least prevalent was one of national confidence and relative self-sufficiency. Though, in this period, the painterly mode could still modify indigenous characteristics— loosening primitive fixity, introducing atmospheric sophistication, and making a certain translucency of color possible. Even when held at a distance, then, the painterly made valuable contributions.

The painterly alternative was introduced at the very beginning of the American tradition. Gilbert Stuart, in reaching for the truth of what he saw ("paint what you see, and look with your own eyes"),[2] sought a visual realism based on a sensational response to light and color that few of his countrymen shared. For most of them, the image was concept made concrete. For Stuart, it was the indefinite perception made definite. As he told

his pupil Jouett, "in the commencement of all portraits the first idea is an indistinct mass of light & shadows, or the character of the person as seen in the heel of the evening, in the grey of the morning, or at a distance too great to discriminate features with exactness."[3]

Further information about Stuart's approach to the sitter and the picture comes to us from subjects like Horace Binney, who sat for Stuart in about 1800:

Stuart led off in one of his merriest veins and the time passed pleasantly in jocose and amusing talk. At the end of the hour I rose to go, and, looking at the portrait, I saw that the head was as perfectly done as it is at this moment, with the exception of the eyes, which were blank. I gave one more sitting of an hour, and in the course of it Stuart said: "Now, look at me one moment." I did so. Stuart put in the eyes by a couple of touches of the pencil and the head was perfect. I gave no more sittings.[4]

Our awareness of the fundamental impressionist—even expressionist[5]—immediacy of Stuart's method might well be tempered by Gombrich's useful distinction between "making" and "matching." Just as Copley's process sought an absolutism of "making" that might require as many as ninety-six sittings, Stuart's spontaneous reaction to the sitter not only was a kind of empirical visual realism but also involved, as Gombrich has made clear, a "matching" achieved through the application of a learned painterly formula. Though Stuart's first works were as primitive as those of any young untrained American artist, his early exposure to the British scene—which included not only Reynolds and Gainsborough but (perhaps more important for Stuart) Romney, Hoppner, and Raeburn—determined his artistic direction.

The influence of the British tradition on Copley was, as we have seen, something of a disaster; he assumed the painterly mode more from provincial inadequacy than from any feeling for the open stroke. With Stuart, however, it struck a genuine chord. Thus, despite frequent lapses into recognizable British conventions in the handling of hair or hands, Stuart's natural freshness saved him from applying the British formula simply as formula. At his worst, of course, he applied all the conventions of the aristocratic portrait tradition—of pose and setting as well as of technique. But at his best, interested not at all in stuffs and objects—in contradistinction to most of his American colleagues ("I don't want people to look at my pictures and say how beautiful the drapery is; the face is what I care about"[6])—he became, as Allston called him, "a *philosopher* in his art."[7]

Allston especially noted Stuart's "faculty of distinguishing between the accidental and the permanent, in other words, between the conventional expression which arises from *manners,* and that more subtle indication of

14-1 Gilbert Stuart: *Mrs. Perez Morton, ca.* 1802. Oil on canvas, 29⅛ x 24⅛ inches. Worcester Art Museum, Massachusetts.

the individual mind."[8] Thus, we might premise that, just as the awareness of flux did not stop Emerson from probing for the constancies beneath, the transient painterly stroke became a route to the essentials of character and expression that were Stuart's main interest. We have an example here of a way in which the largely expatriate artist could transform a European mode into an American idiom, into the quest for the essential and the permanent that is a dominant American concern. That quest, as we have seen, was at least twofold, and the painterly mode was adapted to meet this dichotomy. On the one hand, it was crystallized to offer a more stable presentation of forms in space, relating to American realist traditions. On the other, it was diffused into an amorphousness that transcribed abstract

"essences" of feeling and emotion, becoming part of a sparse tradition of American romantic reverie, which, in the context of this book, can be called the American dream.

Stuart contributed to both traditions, and we need only compare the more solidly realized *Mrs. Richard Yates* (*see Ill. 1-19*) with the diaphanous *Mrs. Perez Morton* (*Ill. 14-1*)[9] to recognize the range of his sensibility, which always remained, however, within the context of the painterly mode.

Unlike most of his American colleagues, Stuart was able to achieve "breathing" flesh tones through an understanding of the luminous potential of color applied in transparent glazes that seems closely related to the approach of Rubens and the Venetian colorists. Neagle told Dunlap:

> He told me that he thought Titian's works were not by any means so well blended when they left the easel, as the moderns infer from their present effect. He considered that Rubens had a fair perception of color, and had studied well the works of the great Venetian, and that he must have discovered more tinting, or *separate tints,* or distinctness, than others did, and that, as time mellowed and incorporated the tints, he (Rubens) resolved not only to keep his colors still more distinct against the ravages of time, but to follow his own impetuous disposition with spirited touches. Mr. Stuart condemned the practice of mixing a color on a knife, and comparing it with whatever was to be imitated.—"Good flesh coloring," he said, "partook of all colors, not mixed, so as to be combined in one tint, but shining through each other, like the blood through the natural skin."[10]

Stuart was also conversant with another aspect of the painterly that has less to do with color than with value. Hence, his comments about the suitability of starting with "the character of the person as seen in the heel of the evening, in the grey of the morning," and his reference to "Fog colour preferable to any other as a ground for painting. This the opinion of Da Vinci & the reason because being of no colour it receives any colour well."[11] Such comments to some extent ally him to the late nineteenth-century tradition of "dark impressionism" that had its roots in the value painting of Velázquez and Hals.

But it was most probably Stuart's assimilation of the coloristic tradition of Rubens and the Venetians that led Allston to comment: "I learned much from him in my art."[12] For Stuart, "Flesh is like no other substance under heaven. It has all the gaiety of a silk-mercer's shop without the gaudiness or glare and all the soberness of old mahogany without the deadness or sadness."[13] Yet, though Stuart eschewed "blending, 'tis destruction to clear and beautiful effect," his results did sometimes approximate the conventional formula for flesh tones. In theory, Allston was even more daring. As he told Henry Greenough:

The modern Italians mix their pearl tints with the palette-knife, which is death to all brilliancy of color. It makes mud of the tints at once. They no longer sparkle to the eye, but become flat as stale beer. By mingling them lightly with the brush, you make a neutral tint of ten times the force of one ground up with the knife, and if you were to take a magnifying-glass and examine the tint you would find small particles of pure color which give great brilliancy.[14]

Though, as noted earlier, Allston's "small particles of pure color" could have led to the development of Impressionism in America, they did not. Even with Allston, the discoveries of the light and color potentials of painterly glazing were not directed to the more objective end of perceptual truth but diverted, as were most such developments in American art, to areas of feeling and emotion—in short, to romanticism. If sensation could not be an acceptable gauge of naturalistic truth, it could at least stir the imagination to dream.

But after Allston, the dream was, to a large extent, suspended until the last quarter of the century. The mid-century would hardly accept the ideal, even in this ephemeral disguise. Nonetheless, the painterly lightly touched the surface of much mid-century art, though gauging the significance of its presence becomes a matter of very fine discrimination. It rarely challenged the solidity of objects or ruptured the precise control of time and space. Frank painterliness survived most readily within the sporadic romantic

14-2 John Quidor: *The Money Diggers*, 1832. Oil on canvas, 16¾ x 21½ inches. Courtesy of The Brooklyn Museum, New York.

tradition. We find it in the art of John Quidor (1801–81), the fantastic genre artist, whose paintings are visual accompaniments to Washington Irving (*Ill. 14-2*), and whose technique, the derivation of which we know too little, is reminiscent in golden tonal unity of the Dutch seventeenth century. William Page (1811–85) (*Ill. 14-3*) spent his life combining a painterly technique derived from the Venetians with an American concern for measure and spirit that, in turn, united canons of proportion with Swedenborgianism.[15]

In landscape painting, as we have seen, the Hudson River men made use of the perceptual and atmospheric potentials of the painterly. Even in luminist landscape, the real sometimes extended into a transcendental distance, an atmospheric haze that had its connections to the painterly tradition. In the works of artists like Sanford R. Gifford (1823–80) (*Ill. 14-4*), the painterly tempered luminist measure. The lines of fluting on the columns of Gifford's *Ruins of the Parthenon* are carefully ruled; the artist also had painstakingly measured the actual intercolumniations. But, in the atmospheric distance, an understated stroke plays a more cosmopolitan variation on the American luminist theme.

Thus, when American artists after the Civil War entered an international phase, there were already painterly precedents and European connections

14-3 William Page: *Self Portrait,* 1860. Oil on canvas, 60¼ x 36¼ inches. Courtesy of The Detroit Institute of Arts.

14-4 Sanford R. Gifford: *Ruins of the Parthenon,* 1880. Oil on canvas, 27⅛ x 53⅜ inches. In the collection of The Corcoran Gallery of Art, Washington, D.C.

behind them. For all the increased emphasis on touch and stroke in their works, Homer and Eakins remained firmly bound to the indigenous conceptualism. But the European-influenced painterly mode dominated the majority of American artists, and its absorption is a major theme of this period.

For John Singer Sargent (1856–1925), one of the most cosmopolitan and painterly of American artists, it was not so much a problem of absorption as of the fortuitous coincidence of his own sensibility with the internationalist and painterly inclinations of the art of his time. Though his earliest works of any importance resulted, like Stuart's, from European influence, we cannot claim in either case that it was *only* this expatriate experience that made them painterly. National style and period style, influence, training, and environment can account for just so much in the development of an artist. Ultimately, there is always the question of individual style, and both Stuart and Sargent seem to have perceived their world in terms of atmosphere, stroke, and fluid space.

That Sargent singled out Hals and Velázquez to admire and copy indicates his affinity to their painterly vision. Eakins and Manet had also greatly admired Velázquez. Eakins' attraction to the Spanish painter lay in the cool objectivity of Velázquez' approach to reality; Manet's, in the control of values stated flatly on a two-dimensional surface with ambiguous allusions to a third dimension. Sargent seems to have been interested in Velázquez' subtle control of values within an atmospheric space.

At his best, Sargent was able, within the painterly convention, to match the psychological depth of Eakins' portraiture, but fashionable success could also divert his natural facility to superficial ends. Sargent's reputation, which has suffered extraordinary inflations and depressions, will perhaps stabilize

241

14-5 John Singer Sargent: *The Wyndham Sisters: Lady Elcho, Mrs. Tennant, and Mrs. Adeane,* 1900. Oil on canvas, 115 x 84¼ inches. The Metropolitan Museum of Art, New York; Wolfe Fund, 1927.

14-6 John Singer Sargent: *Asher Wertheimer,* 1898. Oil on canvas, 58 x 38½ inches. The Tate Gallery, London.

14-7 John Singer Sargent: *Portrait of Paul Helleu, Sketching, and his Wife*, 1889. Oil on canvas, 25⅝ x 31¹³⁄₁₆ inches. Courtesy of The Brooklyn Museum, New York.

itself when he is excused for paintings like *The Wyndham Sisters* (*Ill. 14-5*), remembered by the Eakins-like profundity of *Asher Wertheimer* (*Ill. 14-6*), and valued for his exquisitely handled atmospheric watercolors, the fruits of his most subjective painterly inclinations.

Though Sargent could often utilize in masterly fashion a form of dark impressionism of Hals-Velázquez derivation, he had significant difficulty in applying the colorful palette of the French Impressionists to the same objective purpose. In the watercolor medium he had no such problem, using light and color with authority to arrive at a kind of suggestive and highly abstract nature romanticism. But when, in oils, he attempted the sensational objectivity of the Impressionists, he gave away his American proclivities, revealing his inability to dissolve form and local color. In the *Portrait of Paul Helleu, Sketching, and his Wife* (*Ill. 14-7*), impressionist stroke and plurality of color merely cosmeticize a resistant structure.

This adherence to the integrity of local color and unfractured shape characterizes most American attempts at French Impressionism in the last decades of the nineteenth century. The works of that other famous expatriate, Mary Cassatt (1845–1926), give ample confirmation. Even if we recognize that Cassatt's mentor, Degas (who did not want to be called an Impressionist), was the most linear and conceptual of the Impressionists, the fact remains that Cassatt made Impressionism weightier and more solid, rarely allowing light and color to disintegrate form. Indeed, contemporary French

243

14-8 Mary Cassatt: *Woman with a Dog, ca.* 1880. Oil on canvas, 39½ x 25½ inches. In the collection of The Corcoran Gallery of Art, Washington, D.C.

critics were astute enough to recognize that "she remains exclusively of *her* people."[16] As with so many American artists of her time, the respect for form and the dominance of the conceptual mode relate her work both to the continuing American tradition and to the Post-Impressionist attitudes of the late 1880's and the 1890's (*Ill. 14-8*).

The same sense of form integrity distinguished the works of Childe Hassam (1859–1935) from those of the French Impressionists, and the attitude is perhaps best summed up by quoting again the comment of another American drawn to Impressionism, Theodore Robinson (1852–96), like Sargent a good friend of Monet: "Painting directly from nature is difficult, as things do not remain the same, the camera helps to retain the picture in your mind."[17]

It would seem, then, that when the intent was analytical objectivity, Americans were still reluctant to trust appearances and sensations, tending to crystallize form and add a conceptual element that negated the announced perceptual purity of Impressionism. When, however, the intent was romantic or lyrical, it was easier for them to adapt the painterly mode as an alterna-

tive route to diaphanous conceptualism. The poetry of John Twachtman's landscapes (1853–1902), therefore, relates both to French Impressionism and, in its delicacy and suggestiveness, to American luminist hazes (*Ill. 14-9*).

Earlier, George Inness (1825–94), under the influence of the Barbizon painters, abandoned his Hudson River style and spoke at length of memory and feelings: "What is art anyway? Nothing but temperament, expression of your feelings."[18] Yet, despite his attachment to the Barbizon group, he could never actually ally himself to Impressionism, one of the historical end-products of Barbizon activity, regarding it as "a mere passing fad." Though he often spoke of "impressions," for him, "impression" meant "feeling." He combined his sense of the emotional fabric of art with an emphasis on spirit (fortified by Swedenborgianism)—and on mind:

> . . . we tend eventually to ideas of harmonies in which parts are related by the mind to an idea of unity of thought. From that unity of thought mind controls the eye to its own intent within the units of that idea; consequently we learn to see in accord with ideas developed by the power of life, which also leads us through our own affections. Hence everyone sees somewhat differently.
>
> The art of painting is the development of the human mind.[19]

14-9 John H. Twachtman: *Hemlock Pool,* 1902. Oil on canvas, 30 x 25 inches. Addison Gallery of American Art, Phillips Academy, Andover, Massachusetts.

Through such control of "feeling" by "mind," within the framework of the painterly tradition,[20] the work of Inness (*Ill. 14-10*) correlates with that of such a lesser-known figure as Thomas Dewing (1851–1939) (*Ill. 14-11*) as part of the atmospheric romanticism with which we are now familiar. Perhaps it is this persistent mental component that explains the traces of

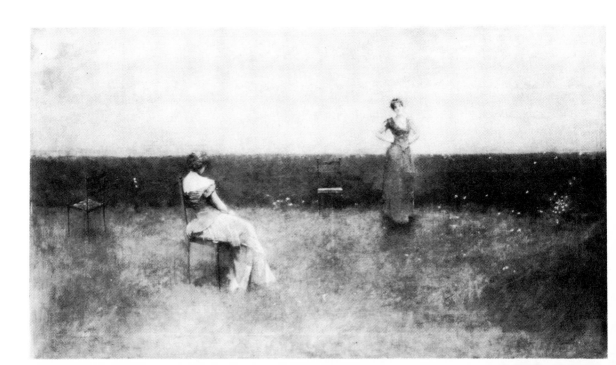

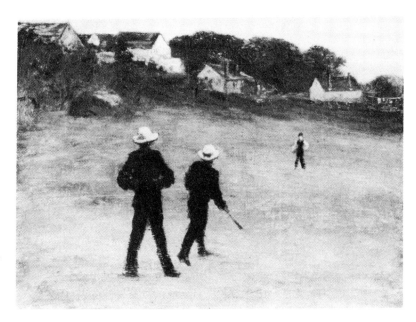

14-12 William Morris Hunt: *The Ball Players, ca.* 1874. Oil on canvas, 16 x 24 inches. Courtesy of The Detroit Institute of Arts.

luminist construction and the unsettling space discernible in the art of Inness and Dewing as well as in the works of the great Boston teacher William Morris Hunt (1824–79) (*Ill. 14-12*). Hunt was also much affected by the Barbizon painters, especially Millet, and counted among the "very few great painters: Velázquez, Tintoretto, Paul Veronese,"[21] though Titian "had not the grandeur of the others."[22]

Curiously enough, it is in the art of James A. McNeill Whistler (1834–1903)—so much an internationalist and expatriate that the English have claimed him—that the conversion of the painterly to an indigenous romantic conceptualism is most clearly demonstrated. Whistler's art was primarily an art of memory and synthesis. Like Copley, he made his portrait subjects sit through agonizing hours. Unlike Copley, he did not use these encounters to re-create the substances of reality within a three-dimensional space, but to arrive at that synthesis of two-dimensional contour which would be decoratively expressive within the painting.

His conceptual, synthetic approach had correspondences on both sides of the Atlantic, and the Pacific as well. His interest in Japanese art is famous, even infamous, if one thinks of the extent to which he carried it in the decoration of the Peacock Room (repainting the expensive leather with which the artist Tom Jeckyll had decorated Frederick Leyland's dining room at 49 Prince's Gate, Hyde Park, thereby driving poor Jeckyll into the mad-

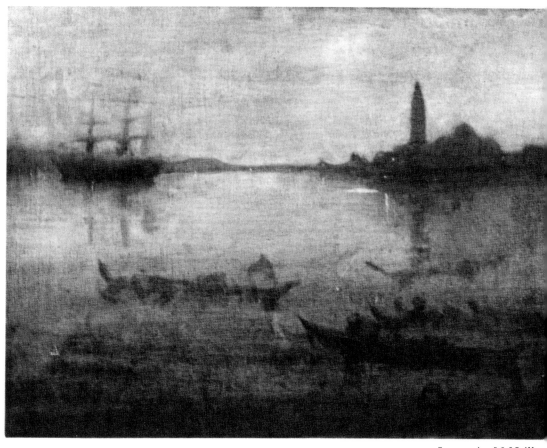

14-13 James A. McNeill Whistler: *The Lagoon, Venice: Nocturne in Blue and Silver,* 1879–80. Oil on canvas, 19¾ x 25⁹⁄₁₀ inches. Courtesy, Museum of Fine Arts, Boston; Emily L. Ainsley Fund.

house). Along with Sargent and Eakins, Whistler was early instructed by Velázquez, whose handling of values and spatial ambiguities affected Whistler's full-length figures even more profoundly than those of his contemporaries. One of his closest contacts among the French Impressionists was Degas, of whom he said, "So far as painting goes, there's only Degas and myself."[23] This was, as in Cassatt's case, a relationship with one of the most conceptual members of the group. Thus, it is not surprising that Whistler should have arrived at the well-known statement of the 1878 trial, in which he claimed £1,000 damages for Ruskin's criticism (and was ultimately awarded one farthing). In answer to the question "What is your definition of a Nocturne?" he replied:

I have perhaps meant rather to indicate an artistic interest alone in the work, divesting the picture from any outside anecdotal sort of interest

which might have been otherwise attached to it. It is an arrangement of line, form and colour first; and I make use of any incident of it which shall bring about a symmetrical result. Among my works are some night pieces, and I have chosen the word Nocturne because it generalizes and simplifies the whole set of them.[24]

Such an attitude in 1878 presages by twelve years the statement by Maurice Denis that has become such a cliché of modernist theory: "It must be recalled that a picture—before it is a picture of battle-horse, nude woman, or some anecdote—is essentially a plane surface covered by colors arranged in a certain order."[25]

Yet perhaps the important point here is not that Whistler, an American expatriate, was one of the first to practice as well as to voice an "art for art's sake attitude"[26] before it took effective hold and changed the course of Western art, but that his emphasis was on the interior role of the artist. The nocturnes (*Ill. 14-13*) were not only, as the artist called them, artistic "arrangements," they were distillations of memory. They might, in fact, have been done under cover of that same "veil of memory" of which Cole had spoken, and the similarity, mentioned earlier, between the aesthetics of Sir Joshua, Cole, and Whistler is not a coincidental one. In each instance, we are dealing with a form of interior idealism in which the artist, rather than nature, controls the primary judgments. Thus, Whistler stated in the famous Ten O'Clock lecture of 1885:

Nature contains the elements, in colour and form, of all pictures, as the keyboard contains the notes of all music.

But the artist is born to pick, and choose, and group with science, these elements, that the result may be beautiful—as the musician gathers his notes, and forms his chords, until he brings forth from chaos glorious harmony.

To say to the painter, that Nature is to be taken as she is, is to say to the player, that he may sit on the piano.

That Nature is always right, is an assertion, artistically as untrue, as it is one whose truth is universally taken for granted. Nature is very rarely right, to such an extent even, that it might almost be said that Nature is usually wrong; that is to say, the condition of things that shall bring about the perfection of harmony worthy [of] a picture is rare, and not common at all.[27]

For Whistler, nature offered "hints for his own combinations," and the artist would look "at her flower, not with the enlarging lens, that he may gather facts for the botanist, but with the light of the one who sees in her choice selection of brilliant tones and delicate tints, suggestions of future harmonies. . . . Through his brain, as through the last alembic, is distilled

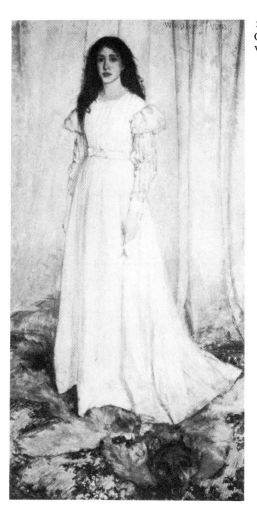

14-14　James A. McNeill Whistler: *The White Girl*, 1862. Oil on canvas, 84½ x 42½ inches. National Gallery of Art, Washington, D.C.; Harris Whittemore Collection.

14-15　James A. McNeill Whistler: *Head of an Old Man, Smoking, ca.* late 1850's. Oil on canvas, 16¼ x 13 inches. Musée du Louvre, Paris.

14-16　James A. McNeill Whistler: *Coast of Brittany: Alone with the Tide*, 1861. Oil on canvas, 34¹⁵⁄₁₆ x 45⁹⁄₁₆ inches. Courtesy, Wadsworth Atheneum, Hartford.

the refined essence of that thought which began with the Gods, and which they left him to carry out."[28]

Thus, to Whistler, as to Cole, artistic thought was, in a sense, divine, connected for him more probably to pagan gods than to Cole's Christianity, but no less ideal. When, in his nocturnes, he used the sketchy stroke that outraged Ruskin, it was not in the service of an objective Impressionism but for a delicate lyricism.

But the opportunity to develop an objective response from his own encounters with nature was there for Whistler, as it is for any artist, and it was fortified by his earlier friendship with Courbet (to whom he had lent the services of his mistress-model, Jo Heffernan [*Ill. 14-14*]). Whistler's *Head of an Old Man, Smoking* (*Ill. 14-15*), of the late 1850's, is painted in heavy impastos in a rich, Courbet-like palette of browns, reds, and grays. In 1861, when Whistler executed *Coast of Brittany: Alone with the Tide* (*Ill. 14-16*), Courbet's influence could still be seen in the heavy impastos of sea and beach and in the solidity of the rocks, though the rocks are thinly painted in a way that is less perceptually realized than synthesized.

But by 1865, when Whistler and Courbet went to Trouville to do a series of seascapes, comparisons yield more differences than similarities. Parallels to Courbet, it will be remembered, already existed in American art at this time, in seascapes by Heade and, even earlier, in the rocks and trees of Durand and Kensett.

But just as these proto-Impressionist tendencies were diverted into lyrical expression, so in Whistler's case the painterly instinct was quickly tempered by mood, memory, and "refined essence of thought" (*Ill. 14-17*). Indeed, that refined painterly essence was one aspect of a duality within Whistler's art that revealed itself almost from the outset. The other was a tendency

14-17 James A. McNeill Whistler: *Crepuscule in Opal, Trouville, ca.* 1867–70. Oil on canvas, 13½ x 18 inches. The Toledo Museum of Art, Ohio; Gift of Florence Scott Libbey.

toward linear pattern and surface design sustained, above all, by his interest in Oriental art (*Ill. 14-18*), though one should not discount the effects of Velázquez, the linear example of Pre-Raphaelite figures, and the memory training of his early teacher, Lecoq du Boisbaudran. This tendency crystallized in the 1870's in the abstract *Arrangement in Grey and Black, Nos. I* (*Ill. 14-20*) and *II*. His art thus represented both the linear and the painterly components of synthesis, derived from intellect and idea on the one hand, and reverie and introspection on the other. Both have a common stem in the conceptualism of that American tradition which claims the cosmopolite Whistler as a leading expatriate.

Along with Ryder, he contributed substantially to the iconography of moonlight in American art. Like the luminists, he chose his moment of quietude, waiting until the "evening mist clothes the riverside with poetry, as with a veil, and the poor buildings lose themselves in the dim sky, and the tall chimneys become campanili, and the warehouses are palaces in the night, and the whole city hangs in the heavens, and fairyland is before us."[29] Unlike Lane and Heade, however, he transformed realism not through ultra-lucency but through dissolution into dream.

That dream, as we know, had already manifested itself in the art of Allston earlier in the century. Emerson had allowed room for it beside the American taste for the specific when he said "We want our Dreams and our Mathematics." The lineage of the dream can be traced back across the Atlantic from Poe to Baudelaire, who quotes Poe's "It is a happiness to dream,"[30] and thence into the French Symbolist poets, who in Whistler discovered Poe's natural heir. (Whistler himself had indicated his interest in Poe in an attempt at a painting of *Annabel Lee*.)

14-18 James A. McNeill Whistler: *Caprice in Purple and Gold No. 2: The Golden Screen,* 1864. Oil on panel, 19¾ x 27 inches. Courtesy of the Smithsonian Institution, Freer Gallery of Art, Washington, D.C.

14-19 Albert Pinkham
Ryder: *Flying Dutchman,*
1887. Oil on canvas, 13¾
x 16½ inches. Courtesy of
National Collection of Fine
Arts, Smithsonian Institu-
tion, Washington, D.C.;
Gift of John Gellatly.

It was not just Poe, however, but the ephemeral, fleeting stuff of the dream that linked Whistler to the Symbolists. If the emphasis on memory and idea was indigenous to an American tradition, it finally found European correlates in the art and literature of the 1880's and 1890's. Both Ryder and Whistler would have agreed with the Symbolists' goal as stated by Gustave Kahn and Jules Laforgue: "The essential aim of our art is to objectify the subjective (the externalization of the Idea) instead of subjectifying the objective (nature seen through the eyes of a temperament)."[31] Such an order of preference had often been basic to an American approach. Ryder, too, could have joined with the founders of the *Revue Wagnérienne* in their admiration for Wagner (*Ill. 14-19*),[32] though it is questionable whether he

253

14-20 James A. McNeill Whistler: *Arrangement in Grey and Black No. 1: The Artist's Mother,* 1872. Oil on canvas, 56 x 64 inches. Musée du Louvre, Paris.

would have been as intellectually aware as they of Wagner's special position as the creator of a new aesthetic.

But Whistler, always the voluble theoretician, did share the Symbolists' interest in the aspiration of other disciplines to the state of music, and when Verlaine, in *Art Poétique,* spoke of "music above all else," and wrote:

> For we seek the nuance
> Not color, just the nuance
> Oh! the nuance alone
> Joins dream with dream and flute with horn[33]

he was composing verbal parallels to Whistler's veiled nocturnes. It is not surprising, then, given Whistler's emphasis on the interior experience and on the syntax of painting, that later in his life he should have formed such a strong friendship with Mallarmé and perhaps influenced, with his interiors, Mallarmé's protegé Vuillard. Mallarmé's "Paint, not the thing, but the effect that it produces,"[34] might well have been Whistler's dictum for that diffusion of the painterly mode in the *Nocturne in Black and Gold: The Falling Rocket (Ill. 14-21)*, that so provoked Ruskin's displeasure.[35] Whistler's art was sufficiently admired by the Symbolists for them to reproduce his works beside those of Redon, Seurat, Signac, and Renoir when they took over the *Revue Indépendante* after 1886.[36] Historically, then, in one sense, it could be said that the art of the Western world had "caught up" with American conceptualism.

The amorphous dream was expressed also by other artists as an ephemeral veil, glaze, stain, or mist of color that was the antithesis of indigenous clarity, though of course it had a place within the American tradition, at least from Allston on. American conceptualism, however, had always been more heavily weighted in favor of mathematics than the dream, and it remains to examine why, suddenly, in the late nineteenth century, solid things were able to give way to evanescent thoughts—a state that no doubt would have delighted Thomas Cole, who had always been prone to gaze prophetically into the future. The fact is, a good part of the world was

14-21 James A. McNeill Whistler: *Nocturne in Black and Gold: The Falling Rocket, ca.* 1875. Oil on panel, 23¾ x 18⅜ inches. Courtesy of The Detroit Institute of Arts.

255

14-22 John La Farge: *The Last Valley,* 1867. Oil on canvas, 32 x 41½ inches. Private collection.

dreaming, and America, now fully entered into an international phase after the Philadelphia Centennial of 1876, no less than anywhere else. Industry and technology, which had tempered American art from the outset, were finally beginning to have a stronger psychological impact. The arts were withdrawing to an ideal, interior world.

Just as earlier in the century, however, some artists found themselves caught in the real-ideal conflict. The public taste had veered sharply once more toward the ideal and, enjoying those fruits of industrialism, wealth, and leisure, was again seeking a sense of past by annexing other cultures— Ancient, Medieval, Renaissance—in what Larkin has rightly called "The Renaissance Complex."[37] As society at large gradually became aware of the new psychic threat of the technology it had nurtured so lovingly, there was a quickening of interest in religion, both in America and abroad, which resulted in more churches for decoration and strengthened those currents of mysticism and spiritualism that had always had their followers and their effect on the arts.

256

John La Farge's return to earlier cultures for inspiration was in part an attempt to avoid an industrialism that now seemed to artists and intellectuals to be threatening their very humanity. In his version of the English Arts and Crafts movement—in concert with the architect Henry Hobson Richardson and the sculptor Augustus Saint-Gaudens in the decoration of Trinity Church, Boston, or with McKim, Mead and White in the decoration of the Church of the Ascension, New York—La Farge attempted to use the cooperative efforts of artists and craftsmen, as the Middle Ages and the Renaissance had done, to create public monuments that would be great works of art.

Although this union produced ensembles that are among the most impressive monuments to their age, La Farge's own work, in both stained glass and painting, was often trapped in an unfortunate eclecticism. His efforts perfectly illustrate the unresolved merger of American and international modes; beneath the romantic painterly stroke culled from the Delacroix-Chassériau lineage was the stolid American specific, refusing to dissolve (*Ill. 14-22*), yet sometimes insufficiently dominant to complete an act of artistic resolution. Thus, one might say that, despite his internationalism, he could not escape his American need to *know* and, caught between intellect and sensation, became a casualty of his dual heritage.

Like Whistler, whom he quotes in *Considerations on Painting*,[38] La Farge thought the artist's sensibility was a product of memories, the accumulation of a lifetime: "We can consider all that we record in our brains as memories composed of many other memories. We can, therefore, see nothing without the use of the memory of sight—or we should not know what it is."[39] And, like Whistler, he appreciated the uniqueness both of the artistic personality and of style, which he described as "a living form which the live spirit wraps around itself,"[40] a definition that would probably have pleased Allston. Indeed, La Farge emerges as the logical American heir to Allston, the New England cosmopolite, as well as a cousin to Delacroix and Chassériau.

As spiritual heir to Allston and, to some extent, to Cole, La Farge had literary inclinations that may have further hindered his painting, though they led him, as they had Allston, to remarkably acute theoretical observations (framed in his *Considerations on Painting*). Royal Cortissoz wrote of him, paraphrasing Anatole France on Gavarni: " 'He thinks, and that is a cause of wonder in the midst of all this world of artists who are content with seeing and feeling.' "[41] Cortissoz found this *thinking* both a "check" and a "fertilizing influence,"[42] and quotes La Farge's comment to him: "Painting is, more than people think, a question of brains. A really intelligent man would not have to *see*, if he could only find his place, any more than a musician is obliged to hear the music he writes. Of course the actual execution modifies the more intellectual view within which the artist works."[43]

Though it brought him to a sophisticated understanding of the vanguard

14-23　Paul Gauguin: *The Brooding Woman,* 1891. Oil on canvas, 35⅞ x 27 inches. Worcester Art Museum, Massachusetts.

14-24　John La Farge: *Maua, Our Boatman,* 1891. Oil on canvas, 47 x 38 inches. Addison Gallery of American Art, Phillips Academy, Andover, Massachusetts.

ideas of his age, perhaps the self-consciousness of his superbly educated intellect also hindered him. One of the first Americans to admire Japanese art, he was also aware of the latest optical discoveries of the scientists O. N. Rood and Charles Henry. He wrote brilliantly on the relative perceptions of artist and spectator and made acute observations on the psychology of repetition. His inquiries into the nature of motion anticipated Futurist theory.[44] But, obligated equally to the worlds of nature and of art, both of which he understood through a deliberate application of intellect, which he then hoped to filter through feeling, he sometimes could not give to art the ultimate commitment it required. Thus, if one compares his South Seas studies with those of Gauguin (*Ill. 14-23*), who visited "our Islands" a year or two later,[45] only two or three, as, for example, *Bridle Path, Tahiti* and *Maua, Our Boatman* (*Ill. 14-24*), have enough formal strength to bear comparison. The others remain illustrations, pleasant on-the-spot narrations, touched with a few exotic passages of intense color that leave the observer with a sense of what might have been.

In two areas his art clearly escaped his dilemma: in the evanescent flower paintings, to which he gave himself totally, allowing feeling to carry form and color without too much damaging intervention of intellect (*Ill. 14-25*);

14-25 John La Farge: *Flowers on a Window Ledge, ca.* 1862. Oil on canvas, 24 x 20 inches. In the collection of The Corcoran Gallery of Art, Washington, D.C.

14-26 John La Farge: *The Wolf Charmer, ca.* 1866–67. Watercolor, *ca.* 6¾ x 5 inches. Formerly in the collection of William C. Whitney, New York (present whereabouts unknown).

and in such Gothick conceits as *The Wolf Charmer* (*Ill. 14-26*), in which fantasy and the desire to pin down the essence of a poem freed his sensibility from its habitual restrictions. In such paintings, along with his friend Elihu Vedder (1836–1923) (*Ill. 14-27*) and his teacher William Rimmer (1816–79) (*Ill. 14-28*), he added to the small chapter of American Gothick that had originated with Allston.

One must remember, too, that in placing La Farge in the tradition of Allston (and of Cole), we are relating him to others of his kind, aesthetically displaced persons who found their artistic nourishment in the European traditions. Yet, in this, La Farge was a product of his time, for the indige-

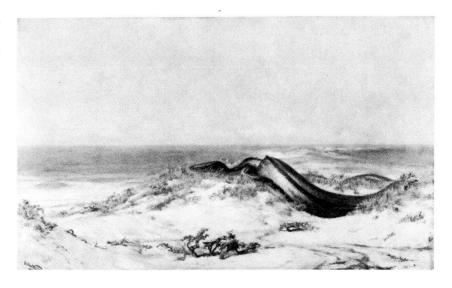

nous, almost pure American qualities still visible in the Homer-Eakins tradition could hardly be found elsewhere in America in the last quarter of the century. International qualities dominated, international traditions and training were paramount. Perhaps only in retrospect, having grown more aware of indigenous factors as the structure of American art history continues to settle, can we find the native qualities and their transformations under the veneer of European modes.

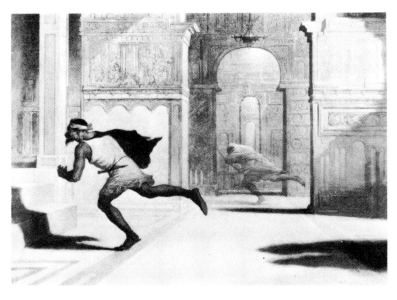

Epilogue

THE TWENTIETH CENTURY

It seems obvious from the foregoing chapters that America brought into the twentieth century an art that exhibited specific tendencies and continuities. From the limners on, American artists had held, in one way or another, to the adamant control of idea. Enlisting measure, mechanics, and technology as aids toward a certainty that was often as ideal as it was real, American artists guarded the unbroken integrity of the objects or things of this world, which became, very often, vessels or carriers of metaphysical meaning. Tempered by the dual planar inclinations of a continuing folk tradition and a classic mensuration, matter, in American nineteenth-century art, was often stable, fixed, weighted, the pictorial parallel of an age still dominated by Newtonian physics. Dissolution of matter, when it occurred, was rarely scientific or analytical, but emotive and lyrical, becoming part of a quietistic tradition and reaching through memory to another area of Mind. Through it all, the *thing* dominated, amounting, in fact, to a preoccupation with *things,* amplified by concerns with light, space, weather, and time that were often additional routes to the character of an environment shaped by things, as well as extensions from the world at large to the thing.

All these properties were manifested in American art in various ways: threading through the sometimes linked and sometimes separate traditions of realism and idealism; ignoring—as, unfortunately, the historian with his necessity for labels often cannot—the art historical categories; grouping, so that sometimes all could be found in the art of a single artist; then spreading, to link, through isolated characteristics, artists of a totally different kind.

To this wealth of native diversity the twentieth century added the impact of an age of mechanized speed and power, in which the Newtonian world was, as we are so frequently reminded, replaced by Einsteinian relativity, and the world of the picture fundamentally changed by new attitudes to

form. The American artist assumed, along with America's own emergence as a world power, a new international role. We can well ask ourselves what indigenous properties remained and how they were affected by the major revolutions in art and science.

It may be objected that the twentieth century is so radically different from the nineteenth that the grounds for such an enterprise are suspect. And a case could be made that the art of the two centuries is so different as to preclude any such attempt. But I think it is possible to take those forms and habits of mind that continually defined the art of the nineteenth century and make an attempt to discern them in the new conditions. Such a view will, of course, dispose twentieth-century art according to its own perspectives. What was the fate of the American attitude to the object, to conceptualism, to the painterly in the twentieth century? What of the machine and mathematics and of that anonymity so frequently encountered?

The first group of American artists chronologically of importance was the Eight,[1] and especially those members who became known as the Ash Can School: newspaper and magazine illustrators like Luks, Glackens, Sloan, and Shinn, who, counseled by Robert Henri (1865-1929) adapted the American genre tradition to the city and its fast-growing slums. Their style, though derived largely from Frank Duveneck's (1848–1919) importation (via Munich) of dark impressionism,[2] could also be called a discreet expressionist extension of earlier romantic realism.[3] The Ash Can group won the first "revolution" of the century, a revolution, as Baur has rightly called it, of subject rather than form.[4] However traditional and conservative the paintings of this group may look to us today compared to the radical innovations of the formalists working in America and abroad at the same time, the revolution in subject itself, with the hindsight gained from the Pop art

15-1 John Sloan: *Backyards, Greenwich Village,* 1914. Oil on canvas, 26 x 32 inches. Collection of Whitney Museum of American Art, New York.

263

of the 1960's, seems of importance. The rejection of escapist themes, of the "Renaissance complex" and pseudoclassical iconography that concerned La Farge, Abbott H. Thayer (1849–1921), George de Forest Brush (1855–1941), and others was an outright declaration of the thematic validity of the artifacts and banalities of the twentieth century. Snob preconceptions of subject could be erased in 1914 by a painting of a Greenwich Village back yard (*Ill. 15-1*), just as many artists of the 1950's and 1960's, through their junkyard sculpture and Coca-Cola icons, attempted to dismiss the snob "subject" of modernism—abstraction itself.

Those American artists who were more anxious to participate in a revolution in form did not wait for the Armory Show of 1913 to do so. By 1910, the list of vanguard artists who had made their way abroad included some of the most prominent figures—Dove, Sheeler, Marin, Weber, and Demuth. What was rejected, assimilated, and transformed when they returned is very instructive. Just as in the nineteenth century, even the most internationally oriented artists translated the European formal vocabulary into an American idiom. But now, the over-all conceptualism of European art from Post-Impressionism on made it easier for Americans to accept. In this sense, as noted earlier, we might even say that Europe had finally caught up with the "provinces." A tradition that was mainly conceptual and that had, moreover, a long and powerful folk tradition could not really find the "primitivism" of Henri Rousseau, so much admired by the French vanguard, radical or strange.

What Americans did find hard to accept and, in fact, virtually rejected, was the "analysis" of Cubism; for perhaps the crucial point in the adaptation of European vanguardism to an American mode lay in the attitude to the

15-2 Max Weber: *Chinese Restaurant*, 1915. Oil on canvas, 40 x 48 inches. Collection of Whitney Museum of American Art, New York.

264

object. The reluctance to analyze, fracture, or disassemble the *things* of God's world persisted, though shorn of nineteenth-century pietism and sentiment. Americans were as reluctant as they had been with Impressionism to dissect the object scientifically. The objectivity of Analytical Cubism seems to have been impossible for them.

Synthetic Cubism, on the other hand, coincided with a long American tradition of synthesis of putting things back together and reinstating the essential object in accordance with idea. Max Weber (1881–1961), one of the most interesting of the eclectic vanguard modernists, held on to the object by merging Picasso's Analytical Cubism with African primitivism and aspects of Matisse's synthetic Expressionism. He returned to America in 1909 and around 1915 arrived at a form of Synthetic Cubism that paralleled similar experiments by Picasso at the same time. Slightly earlier, Weber had tried to adapt Futurist concepts to an American interest in environment. *Chinese Restaurant* of 1915 (*Ill. 15-2*), in which he tried to capture the mood of the city, activates Synthetic Cubism with Futurist devices. Of this painting, he wrote:

> On entering a Chinese restaurant from the darkness of the night outside, a maze and blaze of light seemed to split into fragments the interior and its contents, the human and inanimate. For the time being the static became transient and fugitive—oblique planes and contours took vertical and horizontal positions, and the horizontal and vertical became oblique, the light so piercing and so luminous, the color so liquid and the life and movement so enchanting! To express this, kaleidoscopic means had to be chosen.[5]

The surprising American predilection for Futurist motion in the twentieth century requires more study. It is not enough simply to say that American technology, rapidly advancing, was naturally attuned to an aesthetic of speed and power. This is only one part of the answer. It is possible that America's traditional love for the mechanical had become in some ways a mystique of the machine and could share with Futurism certain mystical and intuitive aspects that were clearly linked to our romantic traditions. Analytical Cubism could be rejected, but Futurism could enter into those romantic precincts to which the European painterly mode, with its implicit idea of relative time, had often been diverted in the nineteenth century. Futurist *energy,* as it was adapted by the pioneers of modernism in America and, later, possibly, by the Abstract Expressionists was, in fact, not purely mechanistic; it quickly overflowed into areas of feeling and metaphysics, with expressionist and surrealist overtones that again recall American nineteenth-century romanticism.

When further adapted to American use, even Futurism ran into conflict with the object. John Marin (1870–1953), like Weber, tried to capture the life of the American city:

15-3 John Marin: *Region of Brooklyn Bridge Fantasy,* 1932. Watercolor, 18¾ x 22¼ inches. Collection of Whitney Museum of American Art, New York.

15-4 John Marin: *Maine Islands,* 1922. Watercolor, 16¾ x 20 inches. The Phillips Collection, Washington, D.C.

15-5 Marsden Hartley: *Portrait of a German Officer,* 1914. Oil on canvas, 68¼ x 41⅜ inches. The Metropolitan Museum of Art, New York; The Alfred Stieglitz Collection, 1949.

15-6 Marsden Hartley: *Smelt Brook Falls,* 1937. Oil on composition board, 28 x 22 inches. City Art Museum of Saint Louis: Eliza McMillan Fund.

If these buildings move me they too must have life. Thus the whole city is alive; buildings, people, all are alive; and the more they move me the more I feel them to be alive . . .

I see great forces at work; great movements; the large buildings and the small buildings; the warring of the great and the small; influences of one mass on another greater or smaller mass. Feelings are aroused which give me the desire to express the reaction of these "pull forces."[6]

In his urban paintings, however, Marin was frequently unable to disintegrate objects sufficiently under Futurist lines of force, and these clichés of Futurist form often sit on the surface of unshattered worlds (*Ill. 15-3*). He found the Maine landscape more tractable, integrating Futurism more successfully with an indigenous nature romanticism (*Ill. 15-4*).

Another painter of Maine landscapes, who dreamed of being *the* Maine painter, presumably contending with Lane, Homer, and Marin, was Marsden Hartley (1877–1943). After contact first with the expressionism of Ryder, then with the expressionist abstraction of the Blaue Reiter group, he ultimately returned to Maine to produce solid, heavy paintings that combined the Ryder tradition with folk primitivism and something of Homer's late classicism. The same rhythms that inform his *Portrait of a German Officer* series (*Ill. 15-5*)—in which flags and symbols are an early focus of invention and variation—characterize his later *Smelt Brook Falls* (*Ill. 15-6*). Whether

15-7 Arthur Dove: *Sand Barge,* 1930. Oil on panel, 30 x 40 inches. The Phillips Collection, Washington, D.C.

15-8 Arthur Dove: *Life Goes On,* 1934. Oil on canvas, 18 x 24 inches. The Phillips Collection, Washington, D.C.

these were a temperamental predilection, or gifts from the central European source brought back for assimilation, is open to question. Certainly the vanguard movements abroad freed American art to speak more openly in a new formal vocabulary.

But there was little in the Blaue Reiter tradition quite like Hartley's art, and there was little, too, in European Futurism or Expressionism quite like the forms of another pioneer modernist, Arthur Dove (1880–1946). An excellent case could be made, however, for affinities of *intent* and *content,*

especially with the mystic overtones of the Blaue Reiter group. Both the Germans and the Americans had behind them long traditions of nature feeling with a common philosophical origin, and it is important to remember how deeply Emerson and the Transcendentalists had drunk from the fountains of German thought. As we have seen, in nineteenth-century America nature was usually approached modestly, latent immanences gradually revealing themselves through contemplation. Only within the more official romantic tradition did American artists explicitly express nature's *terribilità,* as in Cole's more exaggerated and theatrical pieces and in similar works by

Church and Bierstadt. In the art of Ryder, later, as in the works of these artists, one could find both the overt dynamics of natural forces and the contemplative quietism that approached the self-negation of the luminist tradition.

In Dove's art, one finds a similar polarity (*Ill. 15-7*), and the dynamic ultimately expressed itself in an organic vitalism (*Ill. 15-8*). Such paintings by Dove, along with the flower paintings of Heade and, occasionally, of La Farge (*see Ill. 14-25*) in the nineteenth century, and those of Charles Demuth (*Ill. 15-9*), Charles Sheeler, and Georgia O'Keeffe (*Ill. 15-10*) in the twentieth, append a small footnote of vitalism to an American tradition that was predominantly mathematical. As noted earlier, this organicism probably had to do with the need to pursue essences. If the essence of inanimate matter was mineral inertia, the essence of living matter was growth. Thus, in the flower paintings, a vitalistic metaphor could be approximated.

Such a sense of *élan vital* could be related both to the international influence of Bergsonian concepts and to a transcendental tradition that left ample room for organic growth within its all-embracing scheme. To Thoreau, grass was a "symbol of perpetual youth, the grass-blade, like a long green ribbon, streams from the sod into the summer, checked indeed by the frost, but anon pushing on again, lifting its spear of last year's hay with the fresh life below."[7] Emerson, it will be remembered, had recognized process when he found beauty in the

> moment of transition, as if the form were ready to flow into other forms . . . to this streaming or flowing belongs the beauty that all circular movement has; as the circulation of waters, the circulation of the blood, the periodical motion of planets, the annual wave of vegetation, the action and reaction of nature; and if we follow it out, this demand in our thought for an ever onward action is the argument for the immortality.[8]

But Emerson's process always ended in this timeless immortality. Thoreau, too, felt that human life, like the blade of grass "dies down to its root, and still puts forth its green blade to eternity."[9] In the same way, we may speculate as to whether vitalism in American art aspires to some teleological goal of ultimate rest. For especially at its appearance early in the twentieth century, vitalism occurred in the works of artists who were in some way allied to the luminist tradition.

That tradition found its first genuine twentieth-century heirs in the group known as the Immaculates, or Precisionists, which included Dove, Demuth (1883–1935), Sheeler (1883–1965), O'Keeffe (b. 1887–), Preston Dickinson (1891–1930), and some aspects of Stuart Davis. Dove, Demuth, and Sheeler were members of the first wave of international modernists (all of them abroad before 1910).

Both Dove and Demuth created works in the second decade of the century

that were closely related to international trends. Dove's early nonobjective art, dealing with biological energies, was more directly stamped with futurist angularity than his later, more organic work. Demuth adapted romantic expressionism, with references to Rodin and Toulouse-Lautrec, into an art of suggestion, coding veils of watercolor with a quavering line. A cosmopolitan like Henry James, whom he admired, Demuth reconverted the European painterly tradition into American currency, as so many Americans had done before him. Thus, he illustrated Poe in a style uniting European romanticism with American transcendental tradition. In his moving illustrations for James's *The Turn of the Screw* (*Ill. 15-11*), he confronts us with ectoplasmic forms and diaphanous washes that recall the nineteenth-century American concern with spiritualism.

The suggestiveness of this early romanticism continued in Demuth's flower studies after about 1920 as part of the subcurrent of vitalism mentioned above. But from 1920 on, his art contributed mainly to the development of the precisionist aesthetic. Despite the American stamp placed by the pioneer vanguardists on all the forms they took from Europe, the first wave of modernism, from about 1908 to 1920, was undoubtedly eclectic and international in character. On the other hand, the particular blend of the real and the ideal that the Precisionists applied to the new subject of the machine was more native and familiar than anything that had gone before. They might have agreed with Oscar Wilde, when he said earlier:

There is no country in the world . . . where machinery is so lovely as in America. I have always wished to believe that the line of strength and the line of beauty are one. That wish was realized when I contemplated American machinery. It was not until I had seen the waterworks at

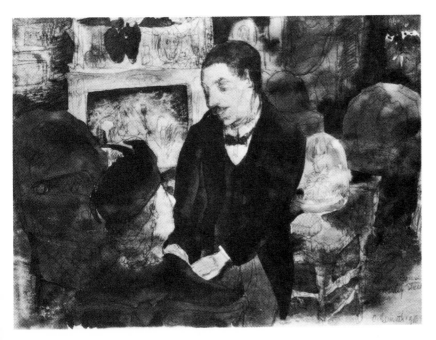

15-11 Charles Demuth: *At a House in Harley Street* (illustration for *The Turn of the Screw*, by Henry James), 1918. Watercolor, 8 x 10 inches. Collection, The Museum of Modern Art, New York; Gift of Abby Aldrich Rockefeller.

271

Chicago that I realized the wonders of machinery; the rise and fall of the steel rods, the symmetrical motion of great wheels is the most beautifully rhythmic thing I have ever seen.[10]

The cult of nature had given way to the cult of the machine, grain elevators and factories had replaced the deserted beach. But an art that had always tended toward the measured and planar, toward the smooth-surfaced and anonymous, toward the timeless and contained, tempered in its character by a technological society with a long-standing admiration for the Platonic simplicity of machine forms, could easily accommodate itself to this new landscape.

As Leo Marx has pointed out, even Emerson had been optimistic about the fast-growing power of the "machine in the garden," confident that "in Young America mechanical power is to be matched by a new access of vitality to the imaginative, utopian, transcendent, value-creating faculty, Reason."[11] Though the cosmopolitan Henry Adams had been deeply disturbed by the conflict between the Virgin and the Dynamo America was, from the beginning, the natural land of the machine. Not only had the inventing, making, constructing instinct always dominated America, but, as Marx has noted, *inventors* were the intellectual heroes.

15-12 Georgia O'Keeffe: *Abstraction*, 1926. Oil on canvas, 30 x 18 inches. Collection of Whitney Museum of American Art, New York.

15-13 Charles Demuth: *I Saw the Figure Five in Gold,* 1928. Oil on composition board, 36 x 29¾ inches. The Metropolitan Museum of Art, New York: The Alfred Stieglitz Collection, 1949.

But God's nature had to be replaced by man's nature, by the industrial landscape, before the artists could make the iconographic switch to the machine as theme. When the change came, prefaced at home by the city themes of the Ash Can school and abroad by Futurist exaltations of technological power and by diverse manifestations that included Léger's development of a machine aesthetic, the Precisionists found international justification for their mode of expression. Though Demuth rarely abandoned the futurist lines of force that, from about 1916 on, worked their way into his paintings as mathematical counterparts of his earlier mystical energy, they did not actually interfere with the integrity of the industrial object that was the modern counterpart of luminist nature.

Even when the futurist diagonal thrust was retained (as it was in the nature- rather than the machine-derived art of O'Keeffe and Dove during this period, related more by style than subject to the Precisionist group [*Ill. 15-12*]), it did not so much suggest relative time as some frozen absolute. It functioned not very differently from the slight angular subversions of classic frontality found in some luminist works, achieving the mannerist distortions of meaning that had, for the luminists also, extended beyond the real and the rational to controlled areas of intuition and feeling.

Within his precisionist style, Demuth's cosmopolitan sophistication continued to fuse the indigenous mode with elements not only of European Futurism but of Dada and Surrealism as well. The use of letters and numbers in such paintings as *Business,* or in such poster portraits as *I Saw The Figure Five in Gold* (*Ill. 15-13*)—a portrait of his friend, the poet William Carlos Williams—joined the factual American devotion to the printed word with a European concern found in Cubism and Dada.

Charles Sheeler's work, on the other hand, was more clearly indigenous, though it alternated between a rather extreme form of abstract purism and a photographic realism (*Ill. 15-14*) that was, in effect, a kind of purism of the specific. Both styles were dominated, however, by the precision that earned the group its name. The closest approximation to luminist classicism occurred, as one might expect, between the two extremes, in the paintings of about 1930, when Sheeler's fusion of the real and ideal struck the same balance that had produced luminism. Thus, the glaring similarities between Sheeler's *American Landscape* (*Ill. 15-15*) and George Tirrell's luminist-primitive *View of Sacramento, California, from across the Sacramento River* (*Ill. 15-16*) need little elaboration. The sources of this parallel lie in Sheeler's interest in the American folk tradition that had always tempered luminist vision (in Sheeler's case, specifically the Shaker tradition), in his consuming involvement with photography (which may have conditioned the frozen time of nineteenth-century luminism), and in his shared respect for measure, order, and the integrity of the object.

Leo Marx has said of Sheeler's painting:

On closer inspection, we observe that Sheeler has eliminated all evidence of the frenzied movement and clamor we associate with the industrial scene. The silence is awesome. The function of the ladder (an archaic implement) is not revealed; it points nowhere. Only the miniscule human figure, the smoke, and the slight ripples on the water suggest motion. And

15-14 Charles Sheeler: *Rolling Power,* 1939. Oil on canvas, 15 x 30 inches. Smith College Museum of Art, Northampton, Massachusetts.

15-15 Charles Sheeler: *American Landscape,* 1930. Oil on canvas, 24 x 31 inches. Collection, The Museum of Modern Art, New York; Gift of Abby Aldrich Rockefeller.

the very faintness of these signs of life intensifies the eerie, static, surrealist quality of the painting. This "American Landscape" is the industrial landscape pastoralized.[12]

We might also call it the pastoral landscape industrialized, for man-made nature now occupies the place of God's nature. The luminist vision is applied to an environment even better suited to an aesthetic dominated by intellect and measure. And in this strangely benign machine world, wiped clean of

15-16 George Tirrell: *View of Sacramento, California, from across the Sacramento River, ca.* 1860. Oil on canvas, 27 x 48 inches. Courtesy, Museum of Fine Arts, Boston; M. and M. Karolik Collection.

all dirt, disorder, and extraneous detail, this American mode seems totally at home.

The machine continued to exert its iconographic and formal impact in the works of other artists, but with a less fundamentally ideal purism. If Precisionism, as Sheeler practiced it, was in some ways the perfect merger of Henry Adams' Dynamo with a Virgin ideal, for Stuart Davis (1894–1964), who used similar hard-edged forms and anonymous surfaces to handle frequent technological and environmental concerns, the Dynamo dominated. The color and rhythms of Davis' works often disrupted the planar classicism of the luminist-precisionist tradition. He called one of his pictures *Colonial Cubism,* and, indeed, his work may be seen as a locus of conflict between Synthetic Cubism and the American vernacular. That vernacular now included not only the severe simplicities of nineteenth-century architecture and modern skyscrapers but also jazz, and the speed and motion of the city. Responding to some of the same elements in the American environment that had intrigued nineteenth-century artists (for instance, the light in Gloucester), he joined these to his idea of contemporary America, sharing with the earlier pioneers, Marin and Weber, a desire to capture the total "feel" of urban environment in a single work:

> . . . all my pictures have their originating impulse in the impact of the American scene. Some of the things that have made me want to paint, outside of other paintings, are: American wood and iron work of the past; Civil War and sky-scraper architecture; the brilliant colors on gasoline stations, chain store fronts and taxicabs; the music of Bach; synthetic chemistry; the poetry of Rimbaud; fast travel by train, auto and aeroplane which brought new and multiple perspectives; electric signs; the landscapes and boats of Gloucester, Mass.; 5 & 10 cent store utensils; movies and radio; Earl Hines' hot piano and Negro jazz music in general, etc. In one way or another the quality of these things plays a role in determining the character of my paintings. Not in the sense of describing them in graphic images, but by predetermining an analogous dynamics in the design, which becomes a new part of the American environment.[13]

Davis' reconciliation of Synthetic Cubism with the vernacular rejected easy solutions insofar as he allowed disruptive energies into his art. He attempted to experience a contemporary American dilemma more unguardedly than perhaps anyone before the Abstract Expressionists. Where they seem to have found Cubism an irksome problem, Davis adapted it to his own solutions, solutions that drew on properties of the American environment that have had a constant influence on its art.

For Davis, a first-class painting was an object, as indeed were the letters and numbers in his pictures, which stand out with the clarity of objects in a luminist landscape (*Ill. 15-17*). The economy of individual forms. their

276

15-17 Stuart Davis: *Owh! In San Pāo,* 1951. Oil on canvas, 52¼ x 41¾ inches. Collection of Whitney Museum of American Art, New York.

boundedness of shape, the unwillingness to take apart fully any object included, are more American than Cubist, much more than the chauvinist "American Scene" painting of the 1930's, which had, interestingly, some painterly bias.

The attitude to the city—the "new nature"—has been a distinguishing factor in much twentieth-century American art. Edward Hopper (1882–1967), situated in the same luminist-classic tradition as the Precisionists, emphasized

overtones of luminist mystery still further in dealing with the almost de-populated city. Into the silent world of luminism, now transposed to grim urban architecture, he introduced the weighted geometries of Homer and the unsettling spatial shifts from classic parallelism found throughout the nineteenth century. He also shared luminism's concern with unbroken light (quickly rejecting *pointillisme* during a youthful visit to Paris) and with the atmosphere of early morning and evening, when few people stir (*Ill. 15-18*). These are Hopper's American qualities, not to be confused with the "American Scene" context that still is occasionally attached to his work. It would be a mistake, however, to refer Hopper's vision exclusively to the city, since landscape was a part of his *oeuvre* to the end. But it is a landscape painted with the same neutrality and indeterminacy as the city; the landscape is "urbanized" without a trace of idealism.

Hopper's compositions have been compared to Mondrian, his emotional effects to de Chirico, who was also concerned with the character of architecture, silence, and waiting. A comparison with de Chirico shows how Hopper's paintings gain their particular emotional status through his desire to experience the phenomenal weight of reality (*Ill. 15-19*), while de Chirico's are more frankly theatrical and two-dimensional.

Hopper also exchanged the isolation of man in nature—a recurring theme in luminist modes—for the more pathetic isolation in a man-made environment. The single figure immobilized within a prosaic urban space is a frequent theme in the works of other artists who, from the 1930's on, dealt in realist-expressionist terms with the city. Generally, the voice of social

15-18 Edward Hopper: *Early Sunday Morning*, 1930. Oil on canvas, 35 x 60 inches. Collection of Whitney Museum of American Art, New York.

15-19 Edward Hopper: *Nighthawks,* 1942. Oil on canvas, 33⁹⁄₁₆ x 60⅛ inches. Courtesy of The Art Institute of Chicago.

protest is not too far distant. In *Vacant Lot,* by Ben Shahn (1898–1969) (*Ill. 15-20*), this reproach is submerged in those lonely extensions of space so familiar within the American tradition. In Shahn's paintings, too, the iconography of posters, of letters and numbers, establishes itself further across the stylistic divergencies of twentieth-century American art.

An alternative to the city and to the machine environment was, of course, escape to nature, or to that interior reverie noted at the end of the previous

15-20 Ben Shahn: *Vacant Lot,* 1939. Watercolor and gouache on paper (mounted on panel), 19 x 23 inches. Courtesy, Wadsworth Atheneum, Hartford; Ella Gallup Sumner and Mary Catlin Sumner Collection.

15-21 Andrew Wyeth: *That Gentleman*, 1960. Tempera on composition board, 23½ x 47¾ inches. Dallas Museum of Fine Arts.

century. But recourse to a nature ever more limited and circumscribed can hardly be called escape, and Andrew Wyeth's (b. 1917–) solution has an air of calculated anachronism—of theme and of technique. Wyeth paints nature, the nature of nineteenth-century art, at a time when landscape art, and even landscape itself, seems vestigial. One can question how much of Wyeth's response is calculated or primitive, but the latter seems more likely. The intensity of the commitment commands respect, though the lack of irony makes it vulnerable.

Wyeth's program could have been written by Fitz Hugh Lane: "to escape from the medium with which I work. To leave no residue of technical mannerisms to stand between my expression and the observer. To seek freedom through significant form and design rather than through the diversion of so-called free and accidental brush handling."[14] We can also notice in Wyeth's paintings those spatial conventions so frequent in Homer and Eakins (*Ill. 15-21*), along with an interest in odd angles prompted by the camera eye, which often provides his idea of modern design.

His art, which began with fluent and painterly watercolors, is a kind of reconstruction of the primitive mode, for the purpose of growing out of it, so that he rehearses the luminists' halted progressions out of the primitive. At its best, Wyeth's patient concern with the thing is also a twentieth-century extension of luminist transcendentalism, of that Emersonian juncture of the real and the ideal.

Morris Graves' (b. 1910–) escape from the machine, for which his *Bird Maddened by the Whir of Machinery in the Air* becomes an effective symbol, has taken on the aspect of a pilgrimage, which led him from the West Coast to Ireland and was resumed when the calm of his Georgian mansion near Dublin was disrupted by the ubiquitous air traffic. But though a satisfactory physical removal from technological sound has thus far eluded him (he has since returned to America), Graves surely found some psychic escape through recourse to the *Little Known Bird of the Inner Eye* (*Ill. 15-22*), which, deriving from Oriental sources, leads into the mystical and contemplative precincts that in America were always a part of the transcendental ideal.

Perhaps we might at this point re-acquaint ourselves with certain nineteenth-century modes that appear to persist in the twentieth, not so much as conventions of *form* as conventions of *attitude*. The Hudson River salon picture had orchestrated sentiments that culminated in part in the rhetoric of artists like Church. A concomitant mode, practiced by many Hudson River men, as well as by such luminists as Lane and Heade, was quietistic, precise, and conceptual. By the end of the century, the quietistic mode had found an alternative expression in the amorphousness of that American dream to which we have referred. It is remarkable how these attitudes persist in the twentieth century, though disguised under new styles and associated with different ambitions and intentions. As we have said, Ryder's art signified these distinctions through his baroque excess and his quietistic reverie.

It seems appropriate to the protean nature of Abstract Expressionism in the late 1940's and 1950's that it should have rehearsed these persistent states

15-22 Morris Graves: *Little Known Bird of the Inner Eye*, 1941. Gouache, 20¾ x 36⅛ inches. Collection, The Museum of Modern Art, New York.

of mind. In the late 1940's, Jackson Pollock (1912–1956) (*Ill. 15-23*), like Ryder, one of his early heroes, replaced his rhetorical expressionism (perhaps as much a local translation of the Grand Style as the Hudson River salon practice) with a transcendent quietude, a quietude maintained even when the paint itself can be read as active or moving.[15] It may be significant that Pollock's mature success was achieved at a moment when European influences in his work were subsumed in a self-transcendence for which there were clear precedents in the American tradition. Indeed, we might speculate on how persistent the transcendental strain is in America, how diverse and subtle its transformations.

We have seen, too, how in America, artists, and especially the luminists, initiated those painful progressions from the primitive to the classic by which they achieved, through a process that had strong elements of empiricism, not so much a style as an *appearance*. With this in mind, one might advance the idea that Abstract Expressionism met the European idea of "style" with a solution that eliminated the connotations of a word that had become a cliché. Many of the best Abstract Expressionist pictures, like luminist pictures, seem to have been painted *against* style. Though this is more obvious in a de Kooning than in a Rothko, it becomes abundantly clear when the art of the first generation is compared with that of the second generation, where style predominated.

Though such a judgment on the appearance rather than style of Abstract Expressionism emphasizes the empirical, it does not imply any lack of

sophistication in artists who were, indeed, superbly educated, drawing on many sources—Cubism, Expressionism, Surrealism, and even, I believe, Futurism. In the context of this book, it simply suggests an American—that is, empirical—way of coping with sophistication.

In its method, Abstract Expressionism relates to the American painterly tradition and to European modes that go as far back as the Venetians. But, as in the nineteenth century, it is possible to distinguish attitudes in the adaptation of the painterly. Thus, Abstract Expressionism differs from Expressionism in America—from the East European-derived Expressionism represented by the art of Hyman Bloom (b. 1913–) and Jack Levine (b. 1915–). Paint, in their hands, is very different from the paint of Willem de Kooning (b. 1904–) or Philip Guston (b. 1913–), who conduct an inquiry into the assumptions of the painterly mode, assumptions that Bloom and Levine accept.

And even between de Kooning and Guston there are clear distinctions. De Kooning (*Ill. 15-24*), undoubtedly the most European of the group, often recalls his countrymen—Hals, Rembrandt, and Van Gogh. While he anthologizes nearly every modern movement from Cubism on (he is the most inclusive and thus the most obviously ambitious of his contemporaries), it is the vitality of the American locus, indeed, its vulgarity, that gives his art its particular character. Guston's later works, though very painterly, seem to reject painterliness in favor of an insistent inquiry that is quietistic

15-24 Willem de Kooning: *Door to the River*, 1960. Oil on canvas, 80 x 70 inches. Collection of Whitney Museum of American Art, New York.

15-25 Mark Rothko: *Number 10*, 1950. Oil on canvas, 90⅜ x 57⅛ inches. Collection, The Museum of Modern Art, New York; Gift of Philip C. Johnson.

in mood, in search of a transcendence that never quite arrives and that may, in fact, be hindered by the paint itself. In de Kooning, we can perhaps identify aspirations often sought through excess; in Guston, aspirations toward repose. Franz Kline's (1910–62) art seems to experience this dichotomy. His later, romantic works again recall some of the ambitions of the previous century. The black-and-white paintings, though surrounded by a similar

rhetoric of power and energy, seem to settle frequently into the calm that results when a "spontaneous" vernacular appearance is firmly disciplined.

The quietistic mode can be traced from the late 1940's in the work of William Baziotes (1912–63) and Theodoros Stamos (b. 1922–), who, in the context of this book, relate to Dewing and Whistler. It was a mode that Milton Avery (1893–1964) practiced with a more ordered and intellectual emphasis, and that endured in the second-generation work of Helen Frankenthaler (b. 1929–) and the stain paintings of Morris Louis (1912–62).

Mark Rothko (b. 1903–) (*Ill. 15-25*) brings this American dream into an art that is as carefully measured, in its amounts of light, color, and geometry, as that of the luminists. Thus, Rothko in the twentieth century perfectly resolves two American modes. The diaphanous conceptualism of the dream is made compatible with exact quantification and measure. What results is an abstract equivalent of the transcendental ideal, an ideal no less powerful in that it is gently stated. As with Ryder, his images satisfy the American need for the concrete through the actual materialization of idea. The ideal becomes *physically* real in another of those infinitely various American mergers of the ideal and the real. As Rothko himself has said: "The progression of a painter's work, as it travels in time from point to point, will be toward clarity; toward the elimination of all obstacles between the painter and the idea, and between the idea and the observer."[16] Emerson would have agreed.

Barnett Newman's (b. 1905–) expanses of canvas, too, often glow in a way reminiscent of those walls of light so familiar in luminist distances; like luminist horizons, now vertical, his pillars exactly dispose every inch of surrounding space. It is as if the luminist vocabulary—sky, light, and horizon—were adapted to make, by very different means, similar transcendental statements.

In the 1960's, one could point to much art that seemed to relate to nineteenth-century attitudes of measurement and conceptualism. But such confidence had to be qualified by the realization that irony and "distancing" often made forms equivocal. Measurement and geometry, now sometimes highly conditional and relativistic, were, in some instances, no longer sure evidence of a search for certainty.

Nonetheless, the emphasis of American art was once more on the geometric and the conceptual, and painterliness was, in the 1960's, under attack. Colorism as sensation and perceptual appearance, another apparent derivation of the painterly mode, found brief scientific justification in Optical art, but it simply put into physical and concrete form what Americans had always maintained—that optical sensations are not to be trusted. It did not last long, and beyond Richard Anuskiewisz (b. 1930–) did not gain any important American adherents.

15-26 Robert Rauschenberg: *Canto XXXI* (illustration for Dante's *Inferno*), 1959–60. Transfer drawing, red pencil, gouache, and pencil, 14½ x 11½ inch sheet. Collection, The Museum of Modern Art, New York.

The Pop art of the early 1960's, however, reintroduced such a battery of familiar characteristics that its American status could hardly be in doubt; the smooth surfaces and sharp edges of the previous mid-century, the vernacular iconography—print, advertising, comic strips, photographs (*Ill. 15-26*), and, inevitably, objects—were all apotheosed on a grand scale carried over from Abstract Expressionism. This art, though tempered by irony, could be included within the well-established American realist-genre tradition. The use of the banal in American Pop art, particularly in the work of artists like Roy Lichtenstein (b. 1923–) and Andy Warhol (b. 1931–), has a rawness already encountered in American art, especially in Eakins' early naked-figure studies. This quality is different from similar European uses of the object, which as a rule seem filtered through the protective screen of art. Even after it was expressed or aborted out of an Abstract Expressionist context by Robert Rauschenberg (b. 1925–) and Jasper Johns (b. 1930–), the American object preserved its vernacular pungency as well as, in Johns's case, its metaphysical overtones. Indeed, Claes Oldenburg's (b. 1929–) very painterly hamburgers (*Ill. 15-27*) use the freedom of that mode to qualify what is essentially a fixed idea. He discovers in his soft exaggerations an infinitude of form, always illuminated

by this single idea—hamburger, typewriter, toothpaste tube—thus providing a precedent for the amorphous conceptualism at the end of the decade.

The emergence of Minimal art in the mid-1960's sometimes allows us to speak of abstract Pop or abstract vernacular. Whatever its sources, it was a form of ideational materialism in which the American search for an art that makes idea concrete was realized. Johns' target and flag paintings had already pointed in this direction, as had Frank Stella's (b. 1936–) conversion of the painting into an unequivocal object.

Though Minimalism, like most developments, often belies its name (rhetorical interests were also disguised in its forms), its strict conceptualism, "making" aspects (though without mathematical idealism), and neutral surfaces have, at their most astringent—as in the art of Donald Judd (b. 1928–) and Sol Lewitt (b. 1928–) (*Ill.* 15-28)—that integrity of an idea followed to its fullest implications, even when, as in nineteenth-century art, it leads to occasional awkwardness. As the sculptress Tina Matkovic (b. 1943–) has stated:

> It is first of all strictly conceptual, not a reworking and rearranging of parts with the "artist's hand"—its form is determined before actual handling of the work begins. . . . It makes its presence felt in a room. There is no illusion or fiction as to what it is, yet fantasy still plays a part in its unexpected positions and colors, in the unreal and unnecessary fact that it exists; and is then existential, has 'thingness' and demands of itself to be acknowledged.
>
> The forms used in this manipulation are fundamental units of artistic knowledge—geometric forms, flat planes, angles—and are used as vehicles in a search for which posture or structure or juxtaposition will make that ordinary form become a thing never before seen in that way, with that ease, intensity, or mute stubbornness of the particular piece, demanding that much attention of itself.
>
> . . . The artist is now only the mechanic, the maker, the stage manager, not the star.[17]

15-27 Claes Oldenburg: *Dual Hamburgers,* 1962. Painted plaster, 7 x 14¾ x 8⅝ inches. Collection, The Museum of Modern Art, New York; Philip Johnson Fund.

For this kind of art, the inventing, constructing sensibility of the American tradition provides ample precedent. It does not need the European constructivist pedigrees that have been provided for it. American artists have always been makers. The artist now stands behind, as generating idea, his aim to have technology render his idea concrete and tangible. As in luminist classicism, the idea becomes the palpable thing.

It is hard to avoid the conclusion that this kind of methodology and logic, though it results in objects that are perceived, emphasizes the conceptual to the detriment of the perceptual. This suspicion is strengthened by the disappearance of the object in the conceptual art of the late 1960's, which replaced the object with verbal methods and prescriptions; in our context, the *thing* becoming, as Jonathan Edwards had held, simply the mediator between *word* and *idea*. This prescriptive art preserves the thought, however amorphous or "painterly" its means—sand, stones, pebbles, and so on. Common to both structured and destructured means is this integrity of idea.

What emerged in the 1960's, then, in one short decade from Pop to conceptual art, was a way of dealing with the American environment, from appropriating banal objects to colonizing and re-forming the landscape itself through idea—often through maps, plans, and diagrams even more ambitious in their scale than the nineteenth-century panoramas. It is tempting to accept this conceptualism as our point of exit from the investigation of a tradition that began with the ideographs of the limners, contemporary with the first colonization of the American landscape.

15-28 Sol Lewitt: *Untitled Cube (6),* 1966–68. White painted metal, 15¼ x 15¼ x 15¼ inches; grid system, 45¾ x 45¾ inches. Private collection.

Notes

NOTES TO CHAPTER ONE

1. The limner style was rooted not only in an indigenous craft tradition, which included such skills as sign-making, but in the linear traditions of Tudor and Jacobean England, in late sixteenth- and seventeenth-century Dutch art, and in the English seventeenth- and eighteenth-century courtly tradition, which perpetuated an increasingly rigid painterly convention through Van Dyck to Sir Peter Lely and Sir Godfrey Kneller, reaching the colonies largely via the mezzotint.

2. See E. H. Gombrich, *Art and Illusion* (New York: Pantheon, 1960), Bollingen Series XXXV, 5; especially chapter 9, "The Analysis of Vision in Art," pp. 291 ff.

3. Perry Miller, *Errand into the Wilderness* (New York: Harper, 1964), "The Rhetoric of Sensation," p. 177.

4. *Ibid.*, "From Edwards to Emerson," p. 185. See also p. 195, where, on the issue of mystical tendencies in Edwards, Perry Miller observes, "assuming as we have some right to assume, that what subsequent generations find to be a hidden or potential implication in a thought is a part of that thought, we may venture to feel that Edwards was particularly careful to hold in check the mystical and pantheistical tendencies of his teaching because he himself was so apt to become a mystic and a pantheist."

5. *Ibid.*, p. 202. Quoting Professor George Whicher.

6. Ralph Waldo Emerson, *The Basic Writings of America's Sage,* ed. Edward C. Lindeman (New York: New American Library, Mentor Books, 1947), "Beauty," p. 114.

7. *North American Review,* LXXXI (1855), 221.

8. James Jackson Jarves, *The Art-Idea* (Hurd and Houghton, 1864; ed. Benjamin Rowland, Jr., Cambridge, Mass.: The Belknap Press of Harvard University Press, 1960), p. 86.

9. *Copley-Pelham Letters,* letter of August 4, 1766 (Massachusetts Historical Society Collections, 1914), LXXI, p. 44.

10. *Ibid.,* letter of November 12, 1766, p. 51.

11. *Ibid.*

12. *Ibid.,* letter from Copley to West or Captain R. G. Bruce, *ca.* 1767, pp. 65, 66.

13. *Ibid.,* p. 301.

14. *Ibid.,* letter from Rome of March 14, 1775, pp. 302–3, 306–7.

15. James Thomas Flexner, *Gilbert Stuart* (New York: Knopf, 1955), p. 63.

16. William Dunlap, *A History of the Rise and Progress of the Arts of Design in the United States* (1834; rev. ed. by F. W. Bayley and C. E. Goodspeed, 1918; ed. Alexander Wyckoff, New York: Blom, 1965), I, pp. 253–54.

17. *Ibid.*, p. 255.

18. John Hill Morgan, *Gilbert Stuart and His Pupils* (New York: New-York Historical Society, 1939), p. 83.

19. Charles Willson Peale (1741–1827) arrived in London in 1767; Stuart, in 1775; John Trumbull (1756–1843), in 1780 and again in 1784.

20. Chateaubriand, "Voyage en Amérique," *Oeuvres* (1836), XII, 18; quoted in Hans Huth, "The American and Nature," *The Journal of the Warburg and Courtauld Institutes,* January, 1950, XIII, 127.

21. *Copley-Pelham Letters,* letter of August 17, 1774, p. 241; see also letter of March 14, 1775, p. 299: "I hope you will procure Sir Josh: Reynolds's Lectures; they are the best things that have yet appeared of the kind."

22. Sir Joshua Reynolds, *Discourses on Art* (New York: Dutton, 1928), VI, p. 81.

23. *Ibid.,* VI, p. 82.

24. *Ibid.,* IV, p. 41.

25. Jules David Prown, *John Singleton Copley* (Cambridge, Mass.: Harvard University Press, 1966), II, 269, and notes 20 and 21.

26. Reynolds, *op. cit.,* Discourse V of December 10, 1772, p. 68. The seeds of romanticism were already present in England in the growing taste for the Gothic and the picturesque. In Germany, in 1772, the young Goethe had shown his early interest in the Gothic, in his essays on Gothic architecture in honor of Strassburg Cathedral. See Lionello Venturi, *History of Art Criticism* (New York: Dutton, 1964), pp. 169–70.

27. Reynolds, *op. cit.,* Discourse XV, p. 264.

28. E. P. Richardson, *A Short History of Painting in America* (New York: Crowell, 1963), p. 103. Prown, *op. cit.,* II, 280, points out, in addition, that "West's influence has long been recognized as seminal in the development of French neo-classicism."

29. Reynolds, *op. cit.,* Discourse IV of December 10, 1771, p. 59.

NOTES TO CHAPTER TWO

1. Nathaniel Hawthorne, *The Marble Faun* (New York: Dell, 1960), Preface, p. 23.

2. Sarah Tytler, *Modern Painters and Their Paintings* (5th ed.; London: 1886), p. 336.

3. E. P. Richardson, *Washington Allston, A Study of the Romantic Artist in America* (Chicago: University of Chicago Press, 1948), p. 28; see also Jared B. Flagg, *The Life and Letters of Washington Allston* (New York: Scribner's, 1892), p. 8.

4. Richardson, *ibid.,* p. 47.

5. *Ibid.,* pp. 47–48. Precisely which study Allston saw remains in some doubt. Richardson notes: "This painting of Death on the Pale Horse which roused such admiration in Allston was either the admirable small study now in the Philadelphia Museum of Art or the study at Petworth." (The Philadelphia Museum owns two studies, an earlier one of the 1780's and the 1802 version.)

6. Eugène Delacroix, *Journal,* ed. Hubert Wellington, trans. Lucy Norton (New York: Phaidon, 1951), p. 311.

7. Allston's aesthetic is eloquently expressed in his *Lectures on Art and Poems,* ed. Richard Henry Dana, Jr. (New York: Baker & Scribner, 1850), published posthumously. See Allston, *Lectures,* p. 75, "by Originality we mean anything

(admitted by the mind as *true*) which is peculiar to the Author, and which distinguishes his production from that of all others." See Delacroix, *op. cit.* (September 30, 1855), p. 301, "One must learn to be grateful for what one discovers for oneself; a handful of naïve inspiration is preferable to everything else. They say that Molière closed his Plautus and Terence one day and remarked to his friends: 'I have had enough of such models; from now onwards I look within and around myself.'" See also Allston (quoted from Flagg, *op. cit.*) in Richardson, *op cit.*, p. 174: "Trust to your own genius, listen to the voice within you, and sooner or later she will make herself understood not only to you, but she will enable you to translate her language to the world, and this it is which forms the only real merit of any work of art," and Delacroix, *ibid.* (October 12, 1853), p. 196, "the beautiful is created by the artist's imagination precisely because he follows the bent of his own genius." See also Allston, *op. cit.*, p. 106, "the several characteristics, Originality, Poetic Truth, Invention, each imply a something not inherent in the objects imitated, but which must emanate alone from the mind of the Artist," and *op. cit.*, p. 87, "It is enough for him to know that there is that within him which is ever answering to that without, as life to life—which must be life, and which must be true," and Delacroix, *op. cit.* (October 17, 1853), p. 200, "I firmly believe that we always mingle something of ourselves in the emotions that seem to rise out of objects that impress us."

8. Jared B. Flagg, *op. cit.,* p. 380, publishes an extract of a letter from an unknown American artist from Freywalden, Austrian Silesia, September 23, 1844, which suggests that Allston's work had an influence on the German art of his time: "Were I in Italy I might obtain details for you from the brothers Riepenhausen who occupy a prominent position in the German school, both as painters and as writers on art. I am not personally acquainted with them, but know that Allston was well known to them, and that they still possess a work of his hand.

"If Mr. Leslie will consult Mr. Severn who knew Allston when in London, and who was afterward intimate with his German friends in Italy, he could scarce fail to get valuable information on the subject that interests you. I am the more certain of this as I had a long conversation about Allston at Mr. Severn's house in London a year since, and he spoke of Allston's influence on the German school as a thing well known to him." William H. Gerdts offered a paper on "Washington Allston and the German Romantic artists in Rome" at the General Session of the College Art Association meeting, January 1968, providing further evidence of Allston's contact with and influence on the German group, and especially on Joseph Anton Koch (see abstract of lecture).

9. Stanley M. Vogel, *German Literary Influences on the American Transcendentalists* (New Haven, Conn.: Yale University Press, 1955), p. 103, states: "Although Emerson read Goethe before the publication of *Nature,* he found in the writings of this German not so many new ideas as the confirmation of those already long established in his mind." The issue of German influence on the American Transcendentalists has been open to endless discussion and subject to the same problems of disentangling native American inclinations from influences absorbed through contact with European (here German) sources that we find in the art. Vogel notes, *ibid,* "I side with those persons who believe that much in Emerson's thought and philosophy which may appear German is merely Yankee," but the problem remains provocative and extends to parallelisms in painting.

10. Richardson, *Allston,* p. 74; quoting from Allston, *Lectures,* p. 94.

11. Flagg, *op. cit.,* p. 160, quotes a letter from Allston to C. R. Leslie from Boston, November 15, 1819: "so familiar is the image of Sir Joshua to me, his manners, habits, modes of thinking, and even of speaking, created by the description of him, that I feel almost persuaded at times I had actually been acquainted with him."

12. *Ibid.,* p. 408; see also p. 407 for another poem, "On a 'Falling Group by Michael Angelo."

13. Richardson, *Allston,* p. 71, quotes Washington Irving's reminiscence of Allston: "I well recollect the admiration with which he contemplated the statue of 'Moses' by Michael Angelo." The references to Michelangelo's Moses in the Jeremiah are obvious.

14. Allston, *op. cit.,* p. 139.

15. Oliver W. Larkin, *Samuel F. B. Morse and American Democratic Art* (Boston and Toronto: Little, Brown, 1954), pp. 31–32.

16. A study still remains to be written of the frustrated attempts of various American artists to work with religious themes. West's project for Revealed Religion, Mount's earliest efforts, and even Quidor's attempts at a Biblical series would be logical inclusions. (See John I. H. Baur, *John Quidor* [New York: Brooklyn Institute of Arts and Sciences, 1942], and Baur, *Quidor,* catalogue of an exhibition at Munson-Williams-Proctor Institute, 1965–66.) When Allston corresponded in 1830 with Gulian C. Verplanck, chairman of the Committee of the House of Representatives on Public Buildings, who wanted him to paint two panels in the Rotunda of the Capitol, he suggested in a letter of March 1, 1830 (Flagg, *op. cit.,* p. 233): "There is another class of subject . . . in which, were I permitted to choose from it, I should find exciting matter enough, and more than enough, for my imperfect skill, that is, from Scripture. But I fear this is a forlorn hope. Yet why should it be? This is a Christian land, and the Scriptures belong to no country, but to man." Verplanck's answer of March 9, 1830 (*Ibid.,* p. 235), was: "To Scripture I fear we cannot go in the present state of public opinion and taste."

17. See John I. H. Baur, *M. and M. Karolik Collection of American Paintings 1815–1865,* published for the Museum of Fine Arts, Boston (Cambridge, Mass.: Harvard University Press, 1949), p. xiv.

18. Flagg, *op. cit.,* p. 229, suggests in reference to Verplanck's offer above, "we are inclined to think that had it not been for the unfinished condition of 'Belshazzar' he would have overcome his objections and undertaken at least one of the panels," and quotes him (p. 345), "I can paint under affliction . . . but to paint under debt!" See also Flagg, *op. cit.,* pp. 334 ff., for the condition of *Belshazzar* immediately after Allston's death.

19. Richardson, *Allston, op. cit.,* p. 125, states it best, when he suggests "The fact is simply that Allston had grown into another period of his life, in which the tranquil and meditative element of his art, reinforced by the introspective atmosphere of his new environment, displaced the grandiose and dramatic interests predominant in the preceding fifteen years. As a result, although he worked at the 'Belshazzar' doggedly he never could recapture the feeling which he had begun to express so many years before."

20. Quoted in Richardson, *op. cit.,* p. 138. Flagg, *op. cit.,* p. 57, quotes Allston from *Lectures on Art,* "to give the whole truth in the midnight as well as in the daylight belongs to a master."

21. Richardson, *op. cit.,* p. 92.

22. See Suzanne Latt Epstein, "The Relationship of the American Luminists to Caspar David Friedrich" (unpublished Master's Essay, Columbia University, 1964), written under the author's direction, where such problems are considered in depth.

23. It would be interesting to know more about the little-known influence of Rubens on American painters of the nineteenth century. Henry Greenough quoted Allston's remark (Flagg, *op. cit.,* p. 185): "Rubens was a liar, a splendid liar, I grant you, and I would rather lie like Rubens than to tell the truth in the poor, tame manner in which some painters do. His pictures are like the sophistical reasonings of a liar, to whom you have only to grant his premises and he will thereon erect a gorgeous fabric, but deny these premises and it all falls to the ground." See also *ibid.,* pp. 409–10, for a sonnet by Allston on Rubens. Although Allston criticized

Rubens' "method of painting flesh, as described in Field's work on color," as "faulty" for thinness of shadows and for "streaks of separate colors which always remind me of a prize-fighter, who has been bruised black and blue" (*ibid.*, pp. 184–85), he was fascinated with the whole problem of painterly color that belonged to the Venetian-Rubens tradition. Durand was later to make copies of Rubens' works during his visit to Belgium in 1840. See Barbara Novak, "Asher B. Durand and European Art," *College Art Journal*, XXI, No. 4 (Summer 1962), 254. It seems likely that further research might make a strong case for the influence of Rubens on the painterly tradition in nineteenth-century America.

24. Quoted in Richardson, *op. cit.*, pp. 59–60. See Delacroix, *Journals* (June 22, 1863), p. 414: "The first quality in a picture is to be a delight for the eyes. This does not mean that there need be no sense in it; it is like poetry which, if it offend the ear, all the sense in the world will not save from being bad. They speak of *having an ear* for music: not every eye is fit to taste the subtle joys of painting. The eyes of many people are dull or false; they see objects literally, of the exquisite they see nothing."

25. Flagg, *op. cit.*, p. 186.

26. *Ibid.*

27. Richardson, *op. cit.*, p. 61.

28. Nathaniel Hawthorne, *Hawthorne's Short Stories,* ed. Newton Arvin (New York: Random House, Vintage Books, 1960), "The Artist of the Beautiful," pp. 282–83.

29. *Ibid.*, p. 290.

NOTES TO CHAPTER THREE

1. Rev. Louis L. Noble, *The Course of Empire, Voyage of Life and Other Pictures of Thomas Cole, N.A.* (New York: Cornish, Lamport & Co., 1853), p. 116.

2. See Hans Huth, *Nature and the American* (Berkeley, Calif.: University of California Press, 1957), for an intensive investigation of the relation of the American to nature.

3. Noble, *op. cit.*, p. 202.

4. James Jackson Jarves, *The Art-Idea* (Hurd and Houghton, 1864; ed. Benjamin Rowland, Jr., Cambridge, Mass.: The Belknap Press of Harvard University Press, 1960), pp. 177, 151.

5. *The Crayon,* I, No. 6 (February 7, 1855), 81.

6. *North American Review,* LXXXI (1855), 221.

7. Quoted *ibid.*, p. 223.

8. *North American Review,* XXXI (1830), 309.

9. Jarves, *op. cit.*, p. 86.

10. *North American Review,* LXXXI (1855), 220.

11. See Ms. Cole papers, The New York State Library (Ms. NYSL), photostat copies in The New-York Historical Society, November 3, 1839.

12. Noble, *op. cit.*, p. 248.

13. *Ibid.*, p. 117.

14. William Gilpin, *Forest Scenery,* ed. Francis G. Heath (London: 1879), pp. 18 ff. First published in 1791 under the title *Remarks on Forest Scenery and Other Woodland Views (Relative Chiefly to Picturesque Beauty).*

15. Quoted in Noble, *op. cit.*, p. 119.

16. *Ibid.*, p. 107.

17. Sir Joshua Reynolds, *Discourses on Art* (New York: Dutton, 1928), Discourse XIII, pp. 217–18.

18. Noble, *op. cit.*, pp. 294–95.

19. Ms. NYSL, December 13, 1826.

20. Ms. NYSL, December 25, 1826. Noble, *op. cit.*, edits and publishes, dates it 1825, pp. 93–94.

21. *Ibid.*

22. *Ibid.*

23. Shearjashub Spooner, *Biographical and Critical Dictionary of Painters, Engravers, Sculptors and Architects* (New York: Putnam's, 1853), p. 213.

24. Ms. NYSL, March 6, 1836. Noble, *op. cit.*, edits and publishes, dates it March 26, 1836, pp. 216–17.

25. *New York Mirror,* XII, No. 42 (April 18, 1835), 330.

26. *Ibid.,* XIV, No. 17 (October 22, 1856), 135.

27. Perhaps one of Cole's most difficult experiences was with Ithiel Town, the architect for whom he executed the famous *Architect's Dream.* The correspondence (Ms. NYSL) indicates that Cole had almost literally pushed Town into commissioning a larger and more elaborately allegorical painting than he had wanted. Town's letter of May 20, 1840, admonishes Cole for an "almost exclusively architectural subject of large size [that] . . . much less suits my fancy, nor would it please my friends. I like the mixture of different ages and styles in the same imaginary picture, but I wish the landscape to predominate—the Architecture, History, etc. to be various and subservient or mainly to enrich a very bold and richly various landscape: in this union you have generally succeeded and have truly acquired your great and very just fame as a landscape painter." Cole replied (Ms. NYSL, May 25, 1840) that: "The picture which I have painted for you was, as far as lay in my power, executed in such a manner as to meet your expressed desire—I have taken utmost pains with it and it is one of immense labor. . . . The picture that I have painted is one of the best I have ever painted, it has been as much admired as any single picture of mine. . . ." Town ultimately wrote, after some discussion about "litigation" (Ms. NYSL, July 4, 1840), that: "The subject is not at all what I described—it cannot be termed a landscape—neither myself or friends can possibly like it, either with other light, long acquaintance or by any explanation possible to be given. . . . Were I to put my own value on it as you suggest, it would not at most exceed $250, and to me not at all desirable at such a price. . . . It is worth much more, to those who like the subject. . . . You must admit that I have never wanted so large or so high-priced a picture, and have stood out against it, but you have urged me so strongly to it, that after a long time, and against my wish and judgment, and in offering it at half of your common price etc. I did at last agree for one of your larger and richest landscapes. . . . You painted this picture for me, it is peculiar etc. in consequence of what you conceived to be my desire— if you entirely misconceived my desire, taste and directions, or understood them different from many others, who heard the same expressions etc. from time to time, then how would the case stand in strict justice."

William P. Van Rensselaer, for whom Cole did his *Departure* and *Return,* seems at first not to have been entirely in accord with the artist's aims, having requested two landscapes representing Morning and Evening (Ms. NYSL, December 10, 1836). An undated draft of Cole's reply states his feelings (Ms. NYSL, *ca.* December 15, 1836): "The subjects Morning and Evening afford wide scope for selection or invention—Your silence as to the particular kind of scenery, whether Italian or American or whether the scene be real or ideal implies that you leave the choice to me, which supposition is gratifying to me, and is a surety for my working con amore." On October 15, 1837 (Ms. NYSL), Cole wrote again about the two paintings, now called *The Departure* and *The Return:* "The story, if I may so call it, which will give title, and I hope, life and interest to the landscapes is taken neither from history nor poetry: it is a fiction of my own, if incidents which must have occurred very frequently can be called fiction. It is supposed to have date in the 13th or 14th century." Noble, *op. cit.,* publishes this, p. 244. Van Rensselaer replied on October 19, 1837 (Ms. NYSL), "My first impression on

reading your letter was that I did not like the 13th century and the knight. Upon reflection I am much pleased with the general idea . . . and I know I shall not be disappointed." On November 1, 1839 (Ms. NYSL), Van Rensselaer wrote again to reassure Cole that he was not dissatisfied with the subject. Cole was always concerned about the reactions of his patrons to his subjects, but the paintings, according to a letter from Cole to his wife (Ms. NYSL, December 6, 1837), brought $1,000 apiece.

28. To Samuel Ward, Jr., who asked for a release from the commission, he wrote (Ms. NYSL, December 7, 1839): "My dear sir, the request would seem to call upon me for a sacrifice that cannot be merely pecuniary but one of cherished hopes and objects. . . . I know that you are capable of feeling how hard a thing it is to give up the dearest object of artistic life just on the eve of accomplishment."

29. See Noble, *op. cit.*, p. 277: "November—Mr. Ward who gave me the liberal commission for the Voyage of Life is dead. There would seem almost a fatality in these commissions. Mr. Reed died without seeing his series completed. Mr. Ward died soon after his was commenced."

30. An engraving of *Youth* from "Voyage of Life" became an Art-Union dividend—which is rather like being a Book-of-the-Month Club dividend—in 1849, shortly after Cole's death had immortalized him. In the Minutes of the American Art-Union, Committee of Management, June 1, 1848, p. 160 (Ms. The New-York Historical Society), the Committee listed as one of the reasons for this choice: "It will enable us to take advantage of the interest attached by the public to the memory of Mr. Cole." The engraver, James Smillie, subsequently engraved the whole series for the Spingler Institute, which acquired the paintings in 1849 and published the engravings, along with an essay by Rev. Gorham Abbott stating that: "The name of the Series has become familiar as 'household words' all over our country. . . . As a work of lofty and refined imagination, of artistic skill, of pure moral and Christian sentiment, it has scarcely a rival. . . . It were difficult to find in the Whole World of Art, a more interesting, appropriate and valuable series of truly Family Pictures." Thus, Thomas Cole was accepted, in true American style, because he fostered Togetherness. See Rev. Gorham D. Abbott, *Cole's Voyage of Life, A Series of Allegorical Pictures entitled Childhood, Youth, Manhood and Old Age, painted by the late lamented Thomas Cole of Catskill, New York.* (Engraved in the Highest Style of Art by James Smillie of New York. From the originals in Possession of Rev. Gorham D. Abbott), Spingler Institute, New York, New York, S. N. Gaston, 1860. See also, for records of the Art-Union, *American Academy of Fine Arts and American Art-Union,* ed. Mary Bartlett Cowdrey (2 vols.; New York: 1953), and an interesting chapter on various Art-Union activities in Neil Harris, *The Artist in American Society* (New York: Braziller, 1966), "The Pattern of Artistic Community," pp. 254 ff. James Thomas Flexner, *That Wilder Image* (Boston: Little, Brown, 1962), also offers an important chapter, "Artist Life, Merchant Amateurs, Artistic Lotteries, and Athletic Painters," pp. 103 ff.

31. *New York Mirror,* XV, No. 49 (June 2, 1838), 390.

32. Ms NYSL, November 3, 1839.

33. *Ibid.,* December 25, 1826, Cole to Gilmor.

34. *Ibid.,* undated, to person unknown.

35. *Ibid.*

36. James McNeill Whistler, *The Gentle Art of Making Enemies* (1890; New York: Putnam's, 1943), pp. 142–43: "That nature is always right is an assertion artistically as untrue, as it is one whose truth is universally taken for granted. Nature is very rarely right, to such an extent even, that it might almost be said that nature is usually wrong."

37. Ms. NYSL, "Thoughts and Occurrences," undated, *ca.* 1842.

38. Reynolds, *op. cit.,* Discourse III, p. 35: "All the objects which are exhibited to our view by nature, upon close examination will be found to have their blemishes

and defects." Reynolds here elaborates the idea of the "perfect state of nature," or Ideal Beauty, which the artist will create by forming an "abstract idea of their forms more perfect than any one original."

39. *North American Review,* CII (1866), 21–22.

40. Charles Lanman, one of Cole's strongest admirers, felt obliged to criticize such later works as "Voyage of Life," though he admired "the high and rare order of poetic power," maintaining that "with regard to the mechanical execution of these paintings, I consider them not equal to some of the earlier efforts of the same pencil. They are deficient in atmosphere, and have too much the appearance of paint." See Charles Lanman, *Letters From a Landscape Painter* (Boston: J. Munroe and Co., 1845), p. 79 and *ibid.,* p. 73, where Lanman admires the first, second, and last paintings of "Course of Empire" because the style is more varied and has less the appearance of paint than in many of his late productions." Of *The Departure* and *The Return,* Lanman wrote: "As these are among the artist's early pictures, they are distinguished for their truth and unmannered style." (*Ibid.,* p. 75.) In his funeral oration at the occasion of Cole's death in 1848, William Cullen Bryant observed that "a certain negligence of detail has been objected to in some of Cole's works, produced in the maturity of genius" and noted that Cole's first trip to Italy was "regretted by many who preferred the gentle beauty of his earlier style, attained by repeated and careful touches." See W. C. Bryant, *A Funeral Oration—Occasioned by the Death of Thomas Cole,* delivered before the National Academy of Design, New York, May 4, 1848 (New York: Appleton, 1848), pp. 33, 21. (Bryant did not share this view, but his reference suggests that a good number of people did.) Gilmor, too, had early protested against the growing "mannerism" he detected as Cole's art matured. See Gilmor correspondence, Ms. NYSL.

41. William Dunlap, *A History of the Rise and Progress of the Arts of Design in the United States* (1834; rev. ed. by F. W. Bayley and C. E. Goodspeed, 1918; ed. Alexander Wyckoff, New York: Blom, 1965), III, 153. Though Dunlap maintained "I feel that I should do injustice to my reader and my subject if I did not give his communication as received" (*ibid.,* p. 150), Cole was evidently distressed that Dunlap had published words written in confidence. A manuscript letter from Cole to C. R. Leslie reads in part: "With respect to Turner, I have expressed myself perhaps too strongly—and had I expected my remarks would be published—I should certainly of spoken somewhat differently, although I do not join you in that unlimited admiration of him which is held by many of his friends—and I know that many persons eminent for critical taste agree with me." Ms. NYSL, undated, probably June, 1835.

42. *New York Mirror,* XV, No. 49 (Saturday, June 2, 1838), 390.

43. Noble, *op. cit.,* pp. 275–76. Following a letter from Cole to his wife of August 3, 1839, Noble notes: "He was on his way to the Genesee River for the purpose of studying, and taking sketches of its very beautiful and picturesque scenery. The Voyage of Life, which he was now mentally composing, exhibits here and there, in the fine verdure of its banks and groves, and in its delightful atmospheric effects, the influence upon his mind and feelings of this pleasant and refreshing excursion."

44. Noble, *ibid.,* p. 263.

45. *Ibid.,* pp. 263–64.

46. Thomas Cole, "Essay on American Scenery," 1835, reprinted from *The American Monthly Magazine,* New Series, I (January, 1836), 1–12, in *American Art 1700-1960, Sources and Documents,* ed. John W. McCoubrey (Englewood Cliffs, N.J.: Prentice-Hall, 1965), p. 108.

47. An excellent museum catalogue dealing with this problem is E. P. Richardson and Otto Wittmann, Jr., *Travelers in Arcadia: American Artists in Italy 1830–1875,* The Detroit Institute of Arts and The Toledo Museum of Art, 1951. Van

Wyck Brooks touched on the problem in *The Dream of Arcadia: American Writers and Artists in Italy 1760–1915* (New York: Dutton, 1958), but didn't really investigate sufficiently the wealth of material dealing with American artists in Rome. Among artists who require independent study are figures like Sanford R. Gifford—see unpublished doctoral dissertation by Ila Weiss (Columbia University, 1968)—and Thomas H. Hotchkiss—see Barbara Novak O'Doherty, "Thomas H. Hotchkiss, An American in Italy," in *Art Quarterly,* XXIX, No. 1 (Spring 1966), 2–28.

48. Ms. NYSL, March 2, 1836.

NOTES TO CHAPTER FOUR

1. James Jackson Jarves, *The Art-Idea* (Hurd and Houghton, 1864; ed. Benjamin Rowland, Jr., Cambridge, Mass.: The Belknap Press of Harvard University Press, 1960), pp. 171–72.

2. H. T. Tuckerman, *Book of the Artists* (1867; New York: James F. Carr, 1966), p. 189.

3. Jarves, *op. cit.,* p. 191.

4. See Ms. Durand papers, The New York Public Library (Ms. NYPL), letter to Durand from James Gibbs, Jr., Bloomfield, July 28, 1819: "You inform me in your last . . . of your rambles at Hoboken, the various scenes of nature 'in her flowering and smiling aspect, rocks and precipices—groves and fields arrayed in all the verdant glories of exhilarating summer' pleasing scenes for the contemplative mind." See also John Durand, *The Life and Times of Asher B. Durand* (New York: Scribner's, 1894), pp. 80–81.

5. He considered Rubens' *Marriage of St. Catherine,* in the Church of St. Augustine, Antwerp, "one of his most extraordinary productions" (entry of August 16, 1840) and returned a second time (on August 17) "to reexamine the painting and take some memorandums of its composition and colour." He then proceeded "for the third and last time to the Museum in order to [do] a more thorough examination of Rubens' chef d'oeuvre of the Crucifiction as well as others of his works there, and those of Vandyck etc." He noted: "The Crucifiction appears to me the grandest conception and most powerful in execution of all the works of this Giant in art, for daring boldness, richness and depth of colour, simplicity of design, truth in drawing and expression in short—originality and consummate skill throughout, this picture is indeed a work of art." Ms. Journal, NYPL.

6. Ms. NYPL, June 28, 1840, letter to John Durand: "If I have been disappointed in some degree with the Royal Academy, on the other hand, I was agreeably surprised with the watercolor exhibitions. . . . I have been so much pleased with them, that I am resolved to practice this mode of painting at such times as I can spare, for the purpose of availing myself of its usefulness in sketching from nature." See John Durand, *op. cit.,* p. 147. On July 1, 1840, Durand wrote in his journal: "Made some unprofitable attempts at the use of the moist watercolors preparatory to their application in sketching from nature and from pictures. Am a little doubtful of my success in this business." Ms. Journal, NYPL.

7. On June 22, 1840, he wrote in his journal (*ibid*), after a visit to the National Gallery in London: "I may now say more emphatically I have seen the Old Masters, several of them undoubtedly fine specimens of three [word illegible] schools and first and foremost in my thought is Claude, who if not in all his glory here—at least is gloriously represented—There are 10 of his works in this collection, some of them esteemed his very best, I may therefore venture to express my first impressions of Claude—On the whole, then, if not disappointed, at the least, I must say he does not surpass my expectations. . . . I will not express an opinion in detail until further examination, yet what I have seen of them is worth the passage of the Atlantic." In a letter to his wife of the same date, as well as one to

his son John dated June 28, 1840, he elaborates further (*ibid*): "The pictures of Claude (of which I have seen a dozen or so) do not astonish me although there are parts in some of them of surpassing beauty, but there is not one of his works in which I cannot see some faults and in several of them a great many. I will venture to say, there are several of them, which if placed in Clinton Hall without name or notice, would be passed by as indifferent affairs, by many a would-be connoisseur and wise-acre in our community—there is generally a cold green and blue appearance about them and no particularly striking effects in colour or light and shade, still on a careful examination, they evince that knowledge of Nature for which Claude is celebrated, particularly in atmosphere, the character and softness of foliage, and more especially in the water as seen in some of his seaport subjects —It is in this class of subjects indeed, that his great superiority is most manifested, at least so far as I have yet seen him—on the whole I am somewhat disappointed in Claude, or at most, I see but 2 or 3 of his works which meet my expectations, and in no respects do they surpass my preconceived notions, yet to me, they alone are worth the passage of the Atlantic." See John Durand, *op. cit.,* p. 147. In another letter, written to Cole and published by John Durand, *ibid.,* p. 160, Durand remarked: "it may be hopeless to expect more perfect light and atmosphere than we find in the seaports and occasionally, other scenes by Claude. Still, I have not felt in contemplating them that I was so completely in the presence of Nature, so absorbed by her loveliness and majesty, as not to feel that the portrait of her might be at least, in some important feature, more expressive of character. But one result I found in all, as well in landscape as in figures: those which approach nearest to the desired perfection bear indisputable marks of deep, unceasing study and proportionate toil. In the latter, Paul Veronese and Rubens appear to me to have accomplished more with less labour than any others."

8. John Durand, *op. cit.,* p. 165.

9. *Gleason's Pictorial Drawing Room* (1853), p. 240.

10. Ms. The New-York Historical Society, July 25, 1855, from North Conway, New Hampshire.

11. Ms. NYPL, letter from J. G. Gray, June 11, 1854.

12. *Ibid.,* letter from R. S. Chilton, Washington, D.C., March 5, 1857. Not infrequently, such sketches were requested by other artists. Minor B. King wrote in 1856 asking for "a few of your studies from nature, Beech, Birch, Oak and Maple tree, and a few rocks, on canvas 12 x 16, I wish them for foreground studies." *Ibid.,* January 10, 1856.

13. See Eugène Delacroix, *Journal,* ed. Hubert Wellington, trans. Lucy Norton (New York: Phaidon, 1952), pp. 202–3: "Here we come back, as always, to the question of which I have spoken before: the finished work compared with the sketch —the great edifice when only the large guiding lines are visible and before the finishing and coordinating of the various parts has given it a more settled appearance and therefore limited the effect on our imagination, a faculty that enjoys vagueness, expands freely, and embraces vast objects at the slightest hint." See also George P. Mras, *Eugène Delacroix's Theory of Art* (Princeton, N.J.: Princeton University Press. 1966), for a consideration of Delacroix and the sketch.

14. *The Crayon,* I, No. 10 (March 7, 1855), 145 ff.

15. *Ibid.,* I, No. 14 (April 5, 1855), 210.

NOTES TO CHAPTER FIVE

1. James Jackson Jarves, *The Art-Idea* (Hurd and Houghton, 1864; ed. Benjamin Rowland, Jr., Cambridge, Mass.: The Belknap Press of Harvard University Press, 1960), pp. 192–93. That Kensett's luminist qualities were valued in his own time, though not defined as such, becomes clear from other contemporary criticism.

H. T. Tuckerman, *Book of the Artists* (1867; New York: James F. Carr, 1966), p. 512, remarks that "His coast scenes are so popular that they find purchasers before they leave the easel," and (p. 511) "In some of his pictures the dense growth of trees on a rocky ledge, with the dripping stones and mouldy lichens, are rendered with the literal minuteness of one of the old Flemish painters. It is on this account that Kensett enjoys an exceptional reputation among the extreme advocates of the Pre-Raphaelite school, who praise him while ignoring the claims of other American landscape-artists. But this fidelity to detail is but a single element of his success. His best pictures exhibit a rare purity of feeling, an accuracy and delicacy, and especially a harmonious treatment, perfectly adapted to the subject." It is interesting for our understanding of the general reception of luminist realism that Tuckerman was reluctant to admire Kensett only for his "literal minuteness" and "fidelity to detail." Much more important to him were Kensett's "rare purity" of feeling, "accuracy," "delicacy," and "harmonious treatment." He was especially attuned to Kensett's "local character" and "atmospheric effects": "His landscapes would charm even a man of science, so loyal to natural peculiarities are his touch and eye. Equally felicitous in the transfer of atmospheric effects to canvas, and with a genius for composition, scenery is illustrated by his fertile and well-disciplined pencil with rare correctness and beauty" (p. 513).

2. Even Jarves (p. 192) had commented of Bierstadt: "In the quality of American light, clear, transparent and sharp in outlines he is unsurpassed." See David C. Huntington, *The Landscapes of Frederic Edwin Church,* (New York: Braziller, 1966), a study that has reconsidered Church's entire *oeuvre,* his position and reputation, and restores his importance as a painter who (p. 60) "accepted the demands of American society which were both mystical and utilitarian."

3. James Thomas Flexner, *That Wilder Image* (Boston: Little, Brown, 1962), p. 280, notes "That Baur classed some of Kensett's work under luminism reveals that the movement was actually one aspect of the normal practice of the school Kensett led." See also *Luminous Landscape: The American Study of Light 1860–1875,* catalogue of an exhibition at the Fogg Art Museum, April 18–May 11, 1966, pp. 3–4, where the contention is made that "Luminism was the major concern of the Hudson River School in the period 1860–1875." The authors tend to see luminism more exclusively as "A style through which the painter studied the effects of light."

4. E. P. Richardson, *A Short History of Painting in America* (New York: Crowell, 1963), p. 159.

5. John I. H. Baur, "American Luminism," *Perspectives USA,* No. 9 (Autumn 1954), pp. 90–98.

6. *Ibid.,* p. 98.

7. E. H. Gombrich, *Art and Illusion* (New York: Pantheon, 1960), Bollingen Series XXXV, 5; especially chapter 9, "The Analysis of Vision of Art," pp. 291 ff.

8. See Wolfgang Schoene, "On Light in Painting" (1954), in *Art History: An Anthology of Modern Criticism,* ed. Wylie Sypher (New York: Random House, Vintage Books, 1963), p. 139.

9. Ralph Waldo Emerson, in Perry Miller, *The American Transcendentalists, Their Prose and Poetry* (New York: Doubleday, Anchor Books, 1957), p. 62. It is interesting that there are pictorial correlates between some mid-nineteenth-century luminist paintings and Oriental art that suggest similar philosophical and religious attitudes to nature and the universal power, possibly resulting from the Oriental aspects of Transcendental philosophy. See Perry Miller, *Errand into the Wilderness* (New York: Harper, 1964), where we are reminded at several points in the essay on "From Edwards to Emerson" of the eclectic merger of East and West embodied in Transcendentalism. On p. 187, Miller notes "We are impatient with an undiscriminating eclecticism which merges the Bhagavad-Gita, Robert Herrick, Saadi, Swedenborg, Plotinus, and Confucius into one monotonous iteration."

10. Jean Lipman, *American Primitive Painting* (New York: Oxford University Press, 1942), p. 5.

11. *M. and M. Karolik Catalogue of American Water Colors and Drawings 1800–1875* (Boston: Museum of Fine Arts, 1962). Vol. I: "Academic Artists." Vol. II: "Visiting Foreign Artists, The Civil War, and Folk Artists."

12. Heinrich Wölfflin, *Principles of Art History* (New York: Dover, 1932), p. 109.

13. *Emerson: A Modern Anthology,* eds. Alfred Kazin and Daniel Aaron (Boston: Houghton Mifflin, 1958), p. 122. The idea I am stressing, of an American sense of time stopped, embodied in an essentially classic space-form relationship, has, of course, its scholarly antithesis. Several scholars have recently put forth the idea of *flux* as the essentially American quality. See, then, for the point of view opposite to the one I elaborate in this volume, John W. McCoubrey, *American Tradition in Painting* (New York: Braziller, 1963), who emphasizes "restlessness and change" in American art, and John A. Kouwenhoven, in *Beer Can by the Highway* (New York: Doubleday, 1961), in an essay called "What's American about America," who says "America is process" (pp. 66 ff.) and quotes Emerson's statement (p. 66) that the universe "exists only in transit," and that man is great "not in his goals" but "in his transitions." In the same essay, however, Kouwenhoven, citing the skyscraper and the Manhattan skyline as models of American qualities, refers to the "fluid and everchanging unity" that comes about from the cage construction and gridiron ground plan, which for me are further examples of the frequent American reliance on mathematical absolutes. It is precisely the imposition of measure on the horizontal expanse of the luminist landscape that gives it for me its specifically "American" flavor. See also Russell Blaine Nye, *The Cultural Life of the New Nation: 1776–1830* (New York: Harper, Harper Torchbooks, 1960), who observes, p. 96, that Emerson perceived nature as "flux and development" and pinpoints this attitude, voiced in 1833, as signaling the arrival of the new science. Perry Miller has justly observed, in *Errand into the Wilderness,* p. 188, that "to take Emerson literally is often hazardous." It is certainly true that he can be all things to all men, and we can all find supporting quotes in Emerson's papers. He was indeed aware of relative and absolute properties in nature, and had a consciousness of the organic, evolutionary processes that Darwin's discoveries were to reinforce. But he could also state, *Emerson,* eds. Kazin and Aaron, p. 131: "Genius detects through the fly, through the caterpillar, through the grub, through the egg, the constant individual, through countless individuals the fixed species, through many species the genus; through all genera the steadfast type, through all the kingdoms of organized life the eternal unity. Nature is a mutable cloud which is always and never the same." If a dominant American quality is, as I maintain, not flux but an absolute in time and space that fortifies the constant existence of both thing and thought, it is perhaps because we have indeed had an awareness of flux that has engaged us even more intensely in a search for the underlying absolutes, for the clear, the measurable, the palpable. For Emerson, the task seems to have been to find that unity beneath the flux. Certainly, properties of process manifest themselves in American art—largely through the expatriate-based painterly tradition (see below, Chapter 14)—but the determination of what is American would seem to me to be a subtle process of discrimination in which the frequency of certain formal and expressive continuities and the weight of their importance within the history of American art are valuable measuring tools. To rule out polarities would be to run the strong risk of discrediting any useful observations that we may make. "Pure" examples are very rare. Latencies, tendencies, hybrids are more the rule. Nonetheless, at the risk of generalizing, we must try to synthesize. What is American will ultimately be determined by the weight of evidence that certain attitudes, coexisting with others, were dominant, hence culturally, perhaps, more revealing.

14. Quoted in John A. Kouwenhoven, *Made In America* (1948; New York: Doubleday, Anchor Books, 1962), p. 82.

15. Quoted in Baur, *M. and M. Karolik Collection of American Paintings 1815–1865,* p. xx, from *The Crayon,* I (1855), 372. Baur also quotes, p. xix, Samuel Atkins Eliot's comment: "Mathematics and machinery are not usually enumerated among the fine arts, properly so called; but . . . extremes meet and the lines and figures drawn by the scientific engineer often show the very curves which the artist calls lines of beauty, and the proportions which he loves to delineate. . . . Certainly our bridges over rivers and valleys, and from mountain to mountain, are among the finest specimens of *fine arts* which the world has to show." (From *North American Review,* LXXXIII [1856], 91-92.) Baur notes, *ibid.,* that "these were voices in advance of their times," but the artists seem to this author to have shared such feelings, at least implicitly, in many instances. Emerson, as usual, adds to the iconography of the mathematical in America when he writes of Plato (*The Selected Writings of Ralph Waldo Emerson,* ed. Brooks Atkinson [New York: Modern Library, 1940 and 1950], p. 495), "This second sight explains the stress laid on geometry. He saw that the globe of earth was not more lawful and precise than was the supersensible; that a celestial geometry was in place there, as a logic of lines and angles here below; that the world was throughout mathematical; the proportions are constant of oxygen, azote and lime; there is just so much water and slate and magnesia; not less are the proportions constant of the moral elements."

16. Baur, *op. cit.,* p. xx.

17. Quoted in *Quest for America 1810–1824,* ed. Charles L. Sanford (New York: Doubleday, Anchor Books, 1964), p. 194.

18. Kouwenhoven, *Made in America,* p. 5.

19. See Gene E. McCormick, "Fitz Hugh Lane, Gloucester Artist, 1804–1865," *Art Quarterly,* XV, No. 4 (Winter 1952), 298.

20. See Leo Marx, *The Machine in the Garden: Technology and the Pastoral Ideal in America* (New York: Oxford University Press, 1964).

NOTES TO CHAPTER SIX

1. See John Wilmerding, *Fitz Hugh Lane, 1804–1865, American Marine Painter,* (Salem, Mass.: Essex Institute, 1964), p. 16, where he notes: "The number of paintings of New York Harbor reinforces the belief that he took a trip there, but his oil painting of Saint John's Porto Rico raises quandaries." See also *M. and M. Karolik Collection of American Paintings, 1815–1865,* published for the Museum of Fine Arts, Boston (Cambridge, Mass.: Harvard University Press, 1949), p. 396. Wilmerding also notes that Lane went to Baltimore and to Norwich, Conn., and possibly to Washington, D.C., and to New Brunswick, Canada, as well (letter of June 21, 1968).

2. Wilmerding, *op. cit.,* p. 12, notes that "Emerson was surely nearby while Lane was studying and practicing painting under Pendleton, and even visited Gloucester to deliver lectures. Beyond this, however, any personal contact between Lane and local literary figures is unknown." See, however, Suzanne Latt Epstein, "The Relationship of the American Luminists to Caspar David Friedrich" (unpublished Master's Essay, Columbia University, 1964), pp. 47 ff., where we are reminded that: "Between 1833 and 1881, Emerson gave 1,469 lectures in the United States and was considered one of the most popular lecturers of his day." (From William Charvat, *Emerson's American Lecture Engagements, A Chronological List* [New York: New York Public Library, 1961], pp. 5 ff.) Mrs. Epstein notes, *op. cit.:* "Between 1832 and 1848 Lane was a resident of Boston. During that time Emerson delivered several lectures in Boston which would have appealed to Lane and would have acquainted him with the basic principles of Emerson's philosophy," and cites

not only such lectures as "Uses of Natural History," 1833, "The Relation of Man to the Globe," 1834, "The Principles and History of Art," 1836, but "The Doctrine of the Soul," 1838, "The Relation of Man to Nature," 1842, and, most especially, "Swedenborg or the Mystic, 1845," which "would have also appealed to the sensitive young man with spiritualist inclinations." After Lane moved to Gloucester, Emerson lectured there almost every year.

3. *Emerson: A Modern Anthology,* eds. Alfred Kazin and Daniel Aaron (Boston: Houghton Mifflin, 1958), p. 111.

4. *Karolik Collection of Paintings, op. cit.,* p. 400.

5. I am aware that the argument can go both ways. The exaggeration of space can be tied to a desire to involve the spectator as environmental and envelopmental art might today. Nonetheless, there seems at base to have been an artistic naiveté that disregarded formal solutions to problems of spatial representation in favor of physical duplication of spatial equivalences.

6. See Wilmerding, *op. cit.,* p. 29, "While Salmon was in this country Lane occasionally painted the same scenes, and in one case executed an oil after a sketch by Salmon of the *Yacht 'Northern Light' in Boston Harbor,* now in the Shelburne Museum."

7. See Wilmerding "A New Look at Robert Salmon" in *Antiques* (January, 1965), p. 92.

8. *Ibid.* See also Wilmerding, *Lane,* p. 29, where he notes: "Salmon as a young man had studied Turner, Vernet and the other prominent European Romantics. Their taste[s] for heavy atmospheric effects and addiction to contrasts of value and to moody but dramatic compositions were moderated by Salmon and transmitted to Lane."

9. Wilmerding, while emphasizing Salmon's influence (see *Robert Salmon, The First Major Exhibition,* catalogue of an exhibition at the De Cordova Museum, Lincoln, Massachusetts, 1967), also is one of the few recent scholars to give attention to the problem of Dutch influence in American art. See Wilmerding, *Lane,* p. 7, where he notes, "Other strains appearing in Lane's art are traceable to Dutch seascapes, which made an indirect impression on several artists of this generation" and, *ibid.,* "By the early nineteenth century the effect on American painting of the longstanding landscape tradition of Holland is clear."

10. See especially Lois Engelson, "The Influence of Dutch Landscape Painting on the American Landscape Tradition" (unpublished Master's Essay, Columbia University, 1966), written under the author's direction. The appendix offers a germinal listing of nineteenth-century collections, auctions, and exhibitions, where Dutch seventeenth-century paintings and prints might have been seen. The Gilmor Collection alone included such artists as Backhuysen, Van de Velde, Van der Neer, Jacob Ruysdael, Cuyp, Van Goyen. Cuyp begins to emerge as a significant figure for his handling of light, while Van de Velde, Van der Neer, and Van Goyen offer striking prototypes for luminist marine compositions. Some other private figures who acquired Dutch paintings were: Michael Paff, Thomas J. Bryan (whose collection is still in The New-York Historical Society), William A. Colman, Nathaniel Delvalletooth. The Pennsylvania Academy of the Fine Arts, The American Academy of Fine Arts, the Apollo Gallery, the American Art-Union, The Boston Athenaeum all exhibited Dutch landscapes in the first half of the nineteenth century. The transmission of Dutch compositional prototypes through English eighteenth-century sources with painterly atmosphere already converted into a more linear style is noted by Miss Engelson in a comparison between paintings by such Englishmen as Charles Brooking and Peter Monamy (Plates 62, 63, 64) and those of Lane. One striking compositional comparison is Fitz Hugh Lane's *Southwest Harbor, Maine* and Cuyp's drawing "River Landscape" (Plates 66 and 67). Miss Engelson calls attention, moreover, to Dutch nineteenth-century artists working in America during and shortly after the first half of the nineteenth century, for example, W. S. Starken-

borg, F. H. de Haas, J. M. Culverhouse, who exhibited at The Boston Athenaeum in 1851, the National Academy of Design in 1852, and The Pennsylvania Academy of the Fine Arts in 1852 and 1867 (See pp. 32 ff.). See also Wilmerding: "Rediscovery: Fitz Hugh Lane," *Art in America*, No. 1 (1965), 66, where it is suggested that Lane was aware of Dutch marine painting "during his apprenticeship in Boston."

11. See, for example, *The Crayon*, I, No. 26 (June 27, 1855), 409, where Ruskin, in answering questions from artists, stresses the selective and moral role of the artist: "The artist . . . is, when good, a telescope not only of extraordinary power, but one which can pick out the best stars for you to look at." See also Roger B. Stein, *John Ruskin and Aesthetic Thought in America, 1840–1900* (Cambridge, Mass.: Harvard University Press, 1967), which came to the author's attention after completion of this book and which offers a good account of Ruskin's impact.

12. James Jackson Jarves, *Art Thoughts* (New York: 1869), pp. 181, 180. Engelson *op. cit.*, quotes on p. 39.

13. Jarves, *ibid.*, pp. 181–82.

14. See *Observations on American Art: Selections from the Writings of John Neal (1793–1876)*, ed. Harold Dickson, Pennsylvania State College Studies, No. 12 (1943), pp. 47, 49.

15. See Engelson, *op. cit.*, p. 9, plates 3, 31, 35.

16. E. Maurice Bloch, in *George Caleb Bingham, The Evolution of an Artist, A Catalogue Raisonné*, 2 vols. (Berkeley and Los Angeles: University of California Press, 1967), has called attention to Bingham's possible recourse to instruction books such as J. Burnet's *A Practical Treatise on Painting. In Three Parts. Consisting of Hints on Composition, Chiaroscuro and Colouring. The Whole Illustrated by Examples from the Italian, Venetian, Flemish and Dutch Schools . . .* (1826; London: James Carpenter & Son, 1828). Such books were filled with engravings of compositions by Cuyp, Potter, Van de Velde, and Rembrandt, and could readily have offered a convenient compositional storehouse for those American artists who had access to them.

17. As to influences and continuities within the American tradition, there is an excellent possibility that Allston's *Coast Scene on the Mediterranean* and *Moonlit Landscape* were more than simply artistic predecessors for Lane and Heade, but may well have been direct progenitors of the luminist vision. Both paintings might have been seen by Lane when they were on exhibit in Chester Harding's studio in Boston in 1839, or at the Athenaeum in 1850, in the same year that Lane himself exhibited there. Heade, too, might have seen the two paintings in 1857, when he exhibited for the first time at the Athenaeum, where they were shown again in that year. See Epstein, *op. cit.*, pp. 37, 38.

18. Baur, "American Luminism," *Perspectives USA*, No. 9 (Autumn 1954), 92.

19. Wilmerding, *Lane*, p. 8.

20. Wilmerding, *ibid.*, p. 17, 18, notes: "His artistic popularity prompted invitations to lend his works to several large and well known art galleries outside the periphery of Gloucester. As early as 1841 and 1844 he exhibited at the Massachusetts Charitable Mechanics Association." He also cites exhibits at the Albany Gallery of Fine Arts in 1850, "the American Art Union in New York in 1849, the New England Art Union in Boston in 1851, The Boston Athenaeum throughout the 1850's, the Harding Gallery in Boston, the Leonard Gallery, and the National Academy of Design, both of New York, in 1859. This highly favorable recognition that was paid him by his own generation was ironically to be eclipsed and nearly extinguished in the century following his death."

21. *Karolik Collection of Paintings, op. cit.*, p. 412.

22. Gene E. McCormick, "Fitz Hugh Lane, Gloucester Artist, 1804–1865," *Art Quarterly*, XV, No. 4 (Winter 1952), 298, 301: "by running lines from a segment of the coordinate to the vanishing point on the horizon, he achieved

precise placement of objects in space." For a drawing of 1863, *Looking Up Portland Harbor*, he used a professional photograph of the steamer "Harvest Moon," "and by ruling on it coordinates to a ⅜ inch scale and numbering them, he could transfer the ship to the painting with utmost precision."

23. Quoted in Wilmerding, *Lane*, p. 12.

24. Ralph Waldo Emerson, *Selected Writings*, ed. Brooks Atkinson (New York: Modern Library, 1940, 1950).

25. *Emerson*, eds. Kazin and Aaron, p. 114.

26. *Ibid.*, p. 23.

27. Wilmerding, *Lane*, p. 31.

28. *Ibid.*, p. 40. See also McCormick, *op. cit.*, p. 297.

29. *Emerson*, ed. Atkinson, p. 286.

30. McCormick, *op. cit.*, p. 295.

31. For studies of spiritualism in America, see J. Arthur Hill, *Spiritualism, Its History, Phenomena and Doctrine* (New York: George H. Doran Co., 1919), and Frank Podmore, *Mediums of the Nineteenth Century* (2 vols.; New York: University Books, 1963), especially *Early American Spiritualism*, I, 179 ff. See also Epstein, *op. cit.*, p. 66, who comments, referring to connections between luminism and Friedrich: "Friedrich once admitted to his friend Carus that he had developed his extraordinary skill at rendering light from knowledge provided to him by a dream," and, p. 44, where she notes that Swedenborg was one of Schelling's major sources. For a comparison of some aspects of Schelling's philosophy with Emerson, see *ibid.*, pp. 51 ff.

32. *Emerson*, eds. Kazin and Aaron, p. 97.

33. *Ibid.*, p. 26.

34. *Ibid.*

35. *Emerson*, ed. Atkinson, p. 309.

36. *Ibid.*, p. 271. See also Epstein, *op. cit.*, pp. 54–55, quoting Emerson.

37. *Emerson*, eds. Kazin and Aaron, p. 111.

38. *Emerson*, ed. Atkinson, p. 329: "the poet turns the world to glass and shows us all things in their right series and procession."

39. *Ibid.*, p. 906.

40. Stuart Davis, *Stuart Davis*, American Artists Group 6, New York, 1945 (unpaged).

NOTES TO CHAPTER SEVEN

1. John Wilmerding, *Fitz Hugh Lane, The First Major Exhibition*, catalogue of an exhibition held at the De Cordova Museum, Lincoln, Massachusetts and the Colby College Art Museum, Waterville, Maine, 1966 (unpaged), suggests that "there is good reason to believe their paths crossed" and locates Heade and Lane in the Newburyport vicinity at about the same time. He adds, "whether or not actual reciprocation can be documented, it would seem that these artists were closer than the sharing of common sympathies. The suggestion has even been raised that it was Lane who introduced Heade to Frederic Church, a natural outcome of their similar interests in painting the Maine coast." My own feeling, however, is that "the sharing of common sympathies" is the most profound link between them, with or without evidence of counterinfluence, for the attitude and mood manifested by their paintings goes beyond pictorial influence into fundamental attitudes to nature and to art that are of significance for our "reading" of the American sensibility.

2. It is not surprising that when Heade's *Approaching Storm* was shown in London several years ago, a British critic characterized it, according to the late Maxim

Karolik, as "the most surrealist painting showing in London today" (conversation with the author).

3. Cennino D'Andrea Cennini, *The Craftsman's Handbook,* trans. Daniel V. Thompson, Jr. (New Haven, Conn.: Yale University Press, 1933; New York: Dover, 1954), "The Way to Copy a Mountain from Nature," p. 57.

4. Heade was not only born and raised in Lumberville, Pa., where he could have been exposed to the Pennsylvania Dutch folk art tradition, but also, according to his biographer, Robert G. McIntyre, *Martin Johnson Heade,* (New York: Pantheon Press, 1948), p. 67, "began to earn his living as a carriage painter."

5. For the idea of the High Renaissance as an interlude or "intermezzo," see Wilhelm Worringer, *Form in Gothic* (New York: Schocken Books, 1964), p. 116.

6. Nonetheless, Heade may have had early contact with the European painterly mode. It should certainly be noted that Heade's endless peregrinations included an early visit to Italy "while still in his teens" (McIntyre, *op. cit.,* p. 7), staying, according to McIntyre, perhaps a year in France and England and two years in Rome and returning home in about 1840, at the age of about twenty-one (*ibid.,* pp. 8–9). Thus, very close to the beginning of Heade's development we can assume exposure not only to a Pennsylvania Dutch folk art tradition and to the efforts of his earliest teacher, Thomas Hicks—who was himself four years younger than Heade—but to a still undocumented European and especially Roman experience, a fascinating and mysterious chapter that demands further scholarly exploration, placing Heade abroad very close to Durand's trip in 1840 with Kensett, Casilear, and Rossiter. McIntyre's description of Heade's travels gives some idea of the complexity of his movements: "We have now followed Heade from his birthplace in Lumberville, to Italy, France, England, back home, presumably first to Lumberville, to New York, to Brooklyn, again to New York; to St. Louis, Chicago, Trenton, Philadelphia, Providence; to Newport, Boston, Newburyport, Brazil; again to London; to Nicaragua, Jamaica, Colombia, Porto Rico, British Colombia; to Florida, Lake George, Lake Champlain, Thousand Islands, California, Vermont, Washington, D.C.; to Maine and, finally, again to Florida, there to live and die. From the letters of Church and Darley, we learn of visits to still other places in the East for such diversions as shooting and fishing" (*ibid.,* p. 23). Heade's biography in the *M. and M. Karolik Collection of American Paintings 1815–1865,* published for the Museum of Fine Arts, Boston (Cambridge, Mass.: Harvard University Press, 1949), p. 302, theorizes from an exhibition label that Heade "may have visited Holland and Belgium." See also McIntyre, *op. cit.,* p. 16: "June 1865 finds him in London, at 16 Douro Place, and exhibiting 'Salt Meadow in America' at the Royal Academy, and 'Brazilian Forest Scene' (Price £60) at the British Institution. At some time he also exhibited in The Hague and Brussels."

7. The Courbet made its way to America in 1866 and was first acquired by the Allston Club, under the leadership of William Morris Hunt.

8. *Science in Nineteenth-Century America, A Documentary History,* ed. Nathan Reingold (New York: Hill and Wang, 1964), p. 193. The reconstruction of nineteenth-century attitudes to the mechanical and the biological is still inadequate. The matter is complicated by the fact that each frequently uses the other as a metaphor to discuss itself.

9. Benjamin Rowland, *Art in East and West* (Cambridge, Mass.: Harvard University Press, 1954), pp. 103, 105.

10. McIntyre, *op. cit.,* p. 15.

11. H. T. Tuckerman, *Book of the Artists* (1867; New York: James F. Carr, 1966), p. 542.

12. Rowland, *op. cit.,* p. 90.

13. Emerson, quote from "Each and All," in Perry Miller, *The American Transcendentalists, Their Prose and Poetry* (New York: Doubleday, Anchor Books, 1957), p. 225.

1. H. T. Tuckerman, *Book of the Artists* (1867; New York: James F. Carr, 1966), p. 421.

2. Though he spent the greater part of his life in the country at Stony Brook, Long Island, Mount was a man of ideas and intellect who could write (July, 1847): "A painter of pictures must lead almost a monastic life—For my part I am getting tired of it. This quiet country life—this loneliness hangs heavy upon me. Too heavy to stand a great while longer. In hours of relaxation we should associate with those who have a kindred spirit, or visit a gallery of choice pictures that will stimulate the mind—There does not appear anything noble and generous in the country but the scenery, and the pure atmosphere—The City should be the home of the artist. He can sally out in search of the picturesque when he pleases." Journal, Ms. Stony Brook. (The Mount papers in the collection of the Suffolk Museum and Carriage House at Stony Brook were examined on microfilm copies at The New York Public Library and at Stony Brook, and are hereinafter cited as Ms. Stony Brook.) And again (September 20, 1847), "The City in the winter for study to hear lectures upon various subjects," and on August 29, 1848: "The City is the place to stimulate an artist—He is compelled to work—There is more character—more dirt—and consequently more color." (*Ibid.*)

3. Letter from Mount to brother Nelson from Catskill, October 1, 1843, Ms. Stony Brook: "My violin has been the source of a great deal of amusement. . . . I have played two evenings at Mr. Cole's. He is fond of Music and plays the flute—I don't let music interfere with my painting—I shall give my whole attention to painting—practice is very important to me just now." In a journal note of April 12, 1848, he wrote: "Cole used but five colors and passed them under the muller every morning before painting. He made a hasty sketch with pencil of every interesting sun set or sun rise with remarks as regards color and effect. I have sketched and painted with him in the open air and scambled [*sic*] about the mountains after the picturesque. He was delighted with an original artist but despised a copyist. In skys and sun sets Durand in comparison seems to lack color." (*Ibid.*)

4. Quoted in James Thomas Flexner, *That Wilder Image* (Boston: Little, Brown, 1962), p. 32.

5. Journal, Ms. Stony Brook, undated, following entry of November 9, 1846.

6. *Ibid.*, following entry of July 31, 1847.

7. Ms. Stony Brook, copy of letter from Mount to the Commissioner of Patents, May 5th, 1857: "The first of July 1849 I thought of a plan to propel a boat with great rapidity, she being partly sustained by the aid of large cylinder (or drum) wheels—air tight. The paddles on the outside of the rim, and fastened to the arms which lead from the shaft thus (accompanied by drawing) to have from three, or two to six wheels on a side and to be driven by steam." Mount wanted to take out a patent with Nathan Oakes, who had the same idea.

8. Mount's library at Stony Brook.

9. *Ibid.* A note (Ms. Stony Brook) of August 29, 1848, reads: "arithmetic, geometry, and mechanicks—should be studied—not so much to make us mathematicians as to make us reasonable creatures."

10. Ms. Stony Brook, entry after March 19, 1846.

11. Ms. Stony Brook. A notation in the notebook indicates that Mount referred to *A Practical Treatise of Perspective on the principles of Dr. Brook Taylor* by Edward Edwards, Associate and Teacher of Perspective in The Royal Academy (Printed 1806).

12. *Ibid.*

13. Draft letter, undated, Ms. Stony Brook. Bartlett Cowdrey and H. W. Williams, Jr., *William Sidney Mount, 1807–1868: An American Painter* (New York:

Columbia University Press, 1944), pp. 4–5, quotes a similar letter to Charles Lanman published in Lanman, *Haphazard Personalities* (Boston: 1886), pp. 170 ff.

14. In an undated entry following a note of May 4, 1848, he wrote (Ms. Stony Brook): "—Some of Cole's figures and [illegible word] have the finish of the Dutch masters. . . . He had a flowing mind and painted from feeling. . . . In some of his skys he destroyed the marks of the brush, by touching gently all over the sky with the end[?] of a large brush—one way of blending—"

15. A note (Ms. Stony Brook) following the entry of March 19, 1846, mentions Veronese, Rubens, Reynolds, "Vandyke," and quotes Sir Joshua's comment: "A picture should have a richness in its texture as if the colours had been composed of cream or cheese." It includes as well a drawing of the French chromatic scale from Mérimée and notes from Field on color. In this entry, too, Mount includes notes on Gilbert Stuart's palette as well as Sir Joshua's, though a footnote of July 13, 1847, contains the self-admonition: "We may as well be a little carefull how we listen to the mixtures of these great men. They could very easily have color on their palettes they did not use." A note after an entry of October, 1844, states: "The only copy I ever made from a portrait was of a Lady by G. Stuart." Mount's interest in Allston's color is recorded in a note of December 29, 1848. On May 13, 1846, he referred to Titian and recorded the following quote: "The splendor of the Venetian school was produced by laying on every color in its native purity on white grounds without mixing, never losing the effect of the ground in the dark portion and bringing the whole into harmonious glory, by glazing with transparent tints, which lowered the gaudiness without loosing the power of the original painting." On the reverse of a page dated January 12, 1847, he noted: "Rubens regarded white as the nourishment of light and the poison of shadow. . . . Rubens says, Begin by painting in your shadows lightly, taking particular care that no white is suffered to glaze[?] into them; it is the poison of a picture, except in the lights, if once your shadows are corrupted by the introduction of this harmful colour, your tones will be no longer warm and transparent, but heavy and leady. It is not the same in the lights. They may be loaded with (opaque) colour as much as you may think proper, provided the tones are kept pure—you are sure to succeed in placing each tint in its place, and afterwards by a light blending with the brush or pencil, melting them into each other without tormenting them, and on this preparation may be given those decided touches which are always the distinguishing marks of the great master."

16. Undated. (Notebooks of 1844–50.) Ms. Stony Brook. "The simplest arrangement and treatment of colours will be found in the style of Cuyp and Both; objects in shadow are relieved against a warm, sunny sky, and do not present much variety of tint. The whole aspect or general tone of the picture is warm." The problem not only of Dutch influence but of Dutch parallels arises here again, for Mount's so-called democratic art, with its genre themes, has its parallels in artists like Steen and Van Ostade, to whom Allston, in a famous letter, had early directed him. We can also consider certain general cultural parallels between the nineteenth-century American democratic society and the seventeenth-century Dutch republic, which would explain a similar concern with the subject categories, also found in abundance in Dutch art, that were deemed inferior by Sir Joshua, such as still life, landscape, and genre. Like the luminists, Mount's paintings betray special formal debts to Dutch painting in general, and his notes are full of references to Ruysdael, Hobbema, Cuyp, Rembrandt, Teniers.

17. Ms. Stony Brook, November 11, 1848.

18. *Ibid.,* April 7, 1848.

19. *Ibid.,* entry after June 6, 1848.

20. *Ibid.,* entry after November 9, 1846. See also, about the same time, his notation of the following quotation: "The character of extreme distance (mountains etc.) is always excessive sharpness. If you soften your outline you [illegible

word] put mist between you and the object and in doing so diminish your distance and destroy the effect of clear air."

21. *Ibid.,* undated draft of a letter (to Lanman?) in answer to a request for material, listing all his pictures and noting that he "gave up history painting for bread" (portraits).

22. *Ibid.* Undated. After entry of November 9, 1846.

23. Ms. Stony Brook.

24. Mount's library at Stony Brook, p. 11.

25. Undated notebooks of 1844–50. Ms. Stony Brook.

26. Cowdrey and Williams, *op. cit.,* pp. 8–9.

27. *Modern Spiritualism,* p. 354.

28. Ralph Waldo Emerson, *Journals* (Boston: Houghton Mifflin, 1909–14). VIII (1849–55), entry of 1854, 477.

29. *Christian Examiner,* XV (November, 1833), 193 ff. I am indebted to Miss Carol Gordon for this quote.

30. Ms. Stony Brook, June 6, 1864.

31. *Ibid.,* May 4, 1848.

32. *Ibid.,* June, 1864.

33. Cowdrey and Williams, *op. cit.,* p. 9.

34. *Ibid.,* p. 22, quote a comment in *Literary World,* II (May 27, 1848), 328, about Mount's *Boys Caught Napping in a Field:* "Mr. Mount's pictures are characteristic portraitures of American rustic life, and though they exhibit the scenes of the most homely and familiar nature, they never offend by grossness or vulgarity. . . . This picture is well drawn, and in character and expression is excellent, but very inferior in its coloring. We hardly can conceive how any man, especially one whose observation of nature seems to be so acute as that of Mr. Mount, can live in the midst of it and do such injustice to the colors in which it is arrayed."

35. Flexner, *op. cit.,* p. 38.

36. A quote in his notebook at Stony Brook (1844–50) reads: "I can easily imagine that if this extraordinary man, Jan Steen had been happy in Italy instead of Holland and been blessed with Michael Angelo and Raffaelle for his masters, instead of Brouwer and Van Goyen, the same sagacity and penetration which distinguished so accurately the different characters and expression in his vulgar figures would, when exerted in the selection and imitation of what was grand and elevated in nature, have been equally successful, and he now would have ranged with the great pillars and supporters [of] our art."

37. Ms. Stony Brook, after March 19, 1846.

38. Ms. Stony Brook, follows entry of August 30, 1847.

NOTES TO CHAPTER NINE

1. Mark Twain, *The Favorite Works of Mark Twain* (New York: Garden City Publishing Co., 1939), *Life on the Mississippi,* pp. 140–41.

2. Quoted in John Francis McDermott, *George Caleb Bingham* (Norman, Okla.: University of Oklahoma Press, 1959), p. 62, from *Missouri Republican,* November 27 and 28, 1847.

3. Albert Christ-Janer, *George Caleb Bingham of Missouri* (New York: Dodd, Mead, 1940), p. 42, quoting from *New York Express,* as noted in *Jefferson City Metropolitan,* August 17, 1847.

4. The *New York Express* critic also remarked (*ibid.,* p. 43): "If Mr. B. designs to distinguish himself as a painter, he ought to give up politics, about which he knows but little, and for which his peculiar temperament wholly unfits him." For a thorough documentation of Bingham's political activities see E. Maurice Bloch, *George Caleb Bingham, The Evolution of An Artist, A Catalogue Raisonné,* 2 vols.

(Berkeley and Los Angeles: University of California Press, 1967), pp. 301 ff. Bingham was elected to the State Legislature in 1848, was State Treasurer 1862–65, was a candidate for Congress from the 6th District in June 1866 (not appointed), was originally a Whig but joined the Democratic party after the Civil War, served as Adjutant-General of State 1875–77. I am indebted to Professor Bloch for kindly making the proofs of his book available to me so that the benefits of his research could be incorporated into this volume.

5. Quoted in Bloch, *op. cit.*, pp. 158–59.

6. *Ibid.*, p. 158.

7. Quoted in John Francis McDermott, *op. cit.*, p. 186, from Arthur Pope, "Bingham's Technique and Composition" in Meyric R. Rogers, James B. Music, and Arthur Pope, *George Caleb Bingham, the Missouri Artist, 1811–1879* (New York; Museum of Modern Art, 1935), p. 15.

8. Bloch, *op. cit.*, pp. 37–38, quotes a letter from Bingham to his wife written in Philadelphia, June 3, 1838: "I have just been purchasing a lot of drawings and engravings, and also a lot of casts from antique sculpture, which will give me nearly the same advantages in my drawing studies at home that are at present to be enjoyed here." See also p. 90, where Bloch states his thesis: "It might be well to observe at this point that Bingham, in the obviously sincere and painstaking approach to what he had come to consider proper form was, in fact, only following a procedure that had already been laid down by the classicists more than a century earlier. They had attempted to synthesize the heritage of the past, much as the Carracci and their school had done before them, as a means of achieving 'correctness' of form and harmony of composition. The instruction books of the nineteenth century, which Bingham apparently referred to, simply continued the tradition by repeating most of the old recipes. There can be little question that Bingham sought to develop a system of rules which he could readily adapt in his work. Once they were found and assimilated with his style, they were always to be closely obeyed."

9. If one considers the instruction books to which Bloch refers, the most interesting sections from the point of view of conceivable effect on Bingham are the parts on perspective, which Bloch does not stress, though he notes (p. 43) J. Burnet's *The Principles of Practical Perspective*.

10. McDermott, *op. cit.*, p. 186, quoting Pope, *op. cit.*, p. 16.

11. See Bloch, *op. cit.*, p. 88, quoting J. Burnet, *An Essay on the Education of the Eye with Reference to Painting. . . .* (London: J. Carpenter, 1837), p. 41: "groups of figures without some appearance of geometric form apparent to the eye, would produce a confused effect upon the spectator," and also (p. 82), quoting Samuel Prout, *Hints on Light and Shadow, Composition. . . .* (London: M. A. Nattali, 1848; first published in 1838; listed in Carey and Hart, 1839), p. 11: "*Triangular* or *pyramidal* composition, has been selected . . . as exemplifying a principle easily misunderstood. It is applicable to almost every variety of subject, and is perhaps, hardly ever unpleasant to the eye; it may be adapted to advantage where the subject will admit of it."

12. Bloch, *ibid.*, p. 254.

13. See Bloch, p. 43.

14. *Ibid.*, p. 44.

15. *Ibid.*

16. *Ibid.*, p. 45.

17. *Ibid.*

18. *Ibid.*, pp. 45–46.

19. *Ibid.*, p. 47.

20. *Ibid.*, p. 82.

21. Christ-Janer, *op. cit.*, p. 120.

22. See Bloch, Preface, ix,: "Bingham's intention was to appeal to an intellectual audience, and he therefore employed notions of an art or aesthetic philosophy which were obviously derived from the writings of others. Although this reveals the artist as an avid reader and even as a thinker along such lines, any extended consideration of the published lecture has been eliminated from this study, chiefly because it offers no evidence in support of the purely stylistic discussion that is the main concern of the present book."

23. See McDermott, *op. cit.*, pp. 168–70.

24. Quoted in Christ-Janer, *op. cit.*, p. 122.

25. *Ibid.*

26. *Ibid.*, pp. 122–23.

27. Christ-Janer, *op. cit.*, pp. 124–25.

28. *Ibid.*, p. 125.

29. *Ibid.*, p. 123.

30. *Ibid.*, pp. 123–24.

31. Quoted in Christ-Janer, *op. cit.*, pp. 90–91, letter of November 4, 1856.

32. Bloch, *op. cit.*, p. 221.

33. Quoted in Christ-Janer, *op. cit.*, p. 118.

NOTES TO CHAPTER TEN

1. Quoted in Lloyd Goodrich, *Winslow Homer,* published for the Whitney Museum of American Art (New York: Macmillan, 1944), pp. 53–54.

2. See John I. H. Baur, *M. and M. Karolik Collection of American Paintings 1815–1865,* published for the Museum of Fine Arts, Boston (Cambridge, Mass: Harvard University Press, 1949), pp. liii ff.

3. Albert Ten Eyck Gardner, *Winslow Homer, A Retrospective Exhibition,* catalogue (copyright, The Metropolitan Museum of Art, the National Gallery of Art) of an exhibition at the Museum of Fine Arts, Boston, 1959, p. 42: "From 1868 to 1910 every drawing and painting produced by Homer shows in some degree the results of his profound study and sympathetic understanding of Japanese prints."

4. James Thomas Flexner, *That Wilder Image* (Boston: Little, Brown, 1962), p. 336.

5. Gardner, *op. cit.*, p. 33: "This is said to have been the first large public showing of Japanese prints in Europe (but the artists of Paris had been studying and collecting them for some years before this). That Homer saw this exhibition and that he was powerfully affected by it is to be plainly seen in all his subsequent work."

6. See John J. Walsh, Jr., "Winslow Homer: Early Work and the Japanese Print," (unpublished Master's Essay, Columbia University, 1965), written under the author's direction, p. 15: "However satisfying and convenient it may be to imagine a stunning exhibit of Japanese prints, after which none of the artists were quite the same, the evidence shows that there were no prints at the 1867 fair at all." Walsh's study, based on official catalogues and first-hand reports of the exhibition, concludes that the Japanese pagoda inside the Palais des Arts et Industries contained "porcelains, swords, fans, lanterns, paper goods, a collection of various objects from the Ryukyu Islands, a showcase of 'unusual knick-knacks' lent by Philipe Burty, and some religious objects and decorated screens lent by the Duke of Morny. In the Maison Japonaise there was a teashop, costumed mannekins, a bell and some 'marchandises.'" He notes (p. 16), "There is no mention in any official or unofficial source of paintings or prints from Japan, whether sent by the Japanese commissioners or lent by private owners."

7. Goodrich, *op. cit.*, p. 39.

8. *Ibid.*, p. 40.

9. *Ibid.,* p. 41.

10. *Ibid.,* p. 41–42.

11. Lloyd Goodrich, *Winslow Homer* (New York: Braziller, 1959), p. 19.

12. Gardner, *op. cit.,* p. 30. (However, Edward Hopper, an artist of similar temperament, once remarked to this author that art in Paris in the early twentieth century had little interest for him, though he was in Paris during the pivotal and stimulating years of 1906–7 and again in 1909 and 1910.)

13. Gardner, *op. cit.,* p. 41.

14. Quoted in Goodrich, *Homer,* Whitney Museum, pp. 39–40.

15. Walsh, *op. cit.,* p. 82, footnote 13, refers to Goodrich's notes on the painting, an unfinished portrait in the collection of Colby College, Waterville, Maine.

16. Goodrich, *Homer,* Whitney Museum, p. 42.

17. *Ibid.,* p. 51, quoting a "writer in *Harper's Weekly* who said of *High Tide* and other works in the Academy show of 1870: 'The pictures are not wholly pleasing; perhaps the bathing scene—like another which he has in the east room— is not quite refined.' "

18. Goodrich, *Homer,* Braziller, p. 24.

19. Though even at the very outset of the American tradition, Copley had treated the black as a distinctive individual in *Watson and the Shark.*

20. Lloyd Goodrich, *Winslow Homer in New York State,* catalogue of an exhibition at the Storm King Art Center, Mountainville, New York, June 29– August 22, 1963, p. 8.

21. *Ibid.*

22. These paintings and others, such as *West Wind,* look forward to later paintings by Andrew Wyeth, who shares in the twentieth-century Homer's awareness of the stark cruelty of nature, of the eloquent possibilities of the figure-space relationship, and who often chooses low-slanting vantage points similar to that in *West Wind.*

23. Goodrich, *Homer,* Whitney Museum, p. 177.

24. Goodrich, *Homer,* Braziller, p. 25.

25. Goodrich, *Homer,* Whitney Museum, p. 177.

NOTES TO CHAPTER ELEVEN

1. See Lloyd Goodrich, *Thomas Eakins, His Life and Work,* (New York: Whitney Museum of American Art, 1933), p. 21: "Even when Courbet and Manet, having been refused at the Universal Exposition of 1867, caused a furore by showing their work in a wooden shed outside the grounds, Eakins' letters about the Exposition did not mention them; most of his space was devoted to the machinery, particularly the great American locomotive, 'by far the finest there; I can't tell you how mean the best English, French and Belgian ones are alongside of it.' "

2. Certain architectonic properties in Eakins' art seem to demand deeper investigation as they connect to attitudes throughout the American tradition. Goodrich observes, in *Thomas Eakins, A Retrospective Exhibition,* catalogue of an exhibition at the National Gallery of Art, The Art Institute of Chicago, and the Philadelphia Museum of Art, 1961, p. 15: "In his early pictures the perspective was worked out in preliminary drawings as exact as those of an architect, using logarithms." Fairfield Porter, in *Thomas Eakins* (New York: Braziller, 1959), p. 20, notes that for his painting of *The Concert Singer,* Eakins "posed the model in exactly the same position every day relative to a grid placed vertically behind her, with a place on the wall in front for her to look at. He attached colored ribbons to salient points of the dress corresponding to the points on the grid. The canvas was perpendicular to the floor and at right angles to the eye of the painter. The painting became a projection of the figure on a vertical plane, like an architect's elevation."

There would seem to be a good case, in fact, for a study of the connections between the measured architectonic order of some American art and actual practical experience with the building art. Lane's mensurational sense may well have derived in part from the practical architectural instincts that enabled him (along with his brother-in-law) to build his own home. Even within the Hudson River group, Jasper F. Cropsey did architectural drawings. See *M. and M. Karolik Collection of American Water Colors and Drawings 1800–1875* (Boston: Museum of Fine Arts, 1962), I, 123, which notes: "At the age of twelve he showed mechanical skill and by using miniature home-made tools, constructed an elaborate model of a house on a platform three feet square, surrounded by a picket fence. Exhibited in 1837 at the Mechanics Institute Fair, it won him a diploma and brought him to the attention of Joseph Trench, an architect, who arranged to take him into his office for five years." See *ibid.*, plate 62, *City House, Front Elevation* (cat. 219), and plate 63, *Design for Gilbert Elevated Railway* (cat. 227). Cole's concern with architectural projects, as with the Ohio State Capitol, is well known.

3. See Goodrich, *Eakins,* Whitney Museum, pp. 42–43, where Eakins is quoted: "A vessel sailing will almost certainly have three different tilts. She will not likely be sailing in the direct plane of the picture. Then she will be tilted over sideways by the force of the wind, and she will most likely be riding up on a wave or pitching down into the next one. Now the way to draw her is to enclose her in a simple brick-shaped form, to give in mechanical drawing the proper tilts, one at a time, to the brick form, and finally to put the tilted brick into perspective and lop off the superabounding parts. . . . I advise you to take a real brick or a pasteboard box of similar shape, and letter the corners, and keep it by you while you draw it." Goodrich comments, *ibid.*, p. 43: "His own system, however, was more advanced than this, making use of higher mathematics; as he went on to say: 'It is likely that an expert would not have got the tilts by drawing at all, but would have figured them out from trigonometric tables, but it is much easier for beginners to understand solid things than mere lines of direction.'"

4. *Ibid.*, p. 18.

5. Porter, *op. cit.*, p. 20.

6. Goodrich, *Eakins,* Whitney Museum, p. 42, quotes him: "I know of no prettier problem in perspective than to draw a yacht sailing. Now it is not possible to prop her up on dry land, so as to draw her or photograph her, nor can she be made to hold still in the water in the position of sailing. Her lines, though, that is a mechanical drawing of her, can be had from her owner or her builder, and a draughtsman should be able to put her in perspective exactly." Lane, it will be remembered, seems from present evidence to have inserted the boat into *Brace's Rock* at a later point, and to have used a photo of "Harvest Moon" in his drawing *Looking Up Portland Harbor.*

7. Beaumont Newhall, *The Daguerreotype in America,* (New York: Duell, Sloan & Pearce, 1961), p. 79.

8. See Newhall, *op. cit.*, p. 79: "Photography was called the pencil of Nature, the child of light, Nature's amanuensis: daguerreotypes were advertised as sun-drawn miniatures. 'It is a work of Nature, not of Art—and as far surpassing the production of the pencil as all Nature's effort[s] do those of man'"; and note 6, Chapter 9, p. 162.

9. Newhall, *ibid.*, pp. 26–27, quotes Charivari for August 30, 1839: "You want to make a portrait of your wife. You fit her head in a fixed iron collar to give the required immobility, thus holding the world still for the time being."

10. See Van Deren Coke, *The Painter and the Photograph* (Albuquerque, N.M.: University of New Mexico Press, 1964), p. 7, quoting Delacroix.

11. *Ibid.*, p. 8.

12. *Ibid.*, pp. 8, 9.

13. *Ibid.*, p. 16.

14. See especially Fairfield Porter, *op. cit.,* p. 15, pp. 116–17. See also William I. Homer and John Talbot, "Eakins, Muybridge, and the Motion Picture Process," *Art Quarterly,* XXVI, No. 2 (Summer 1963), pp. 194–216, where it is claimed that (p. 197) "Eakins' technique of recording overlapping images of a figure in motion on a single plate . . . had been utilized previously both by Muybridge and by the French physiologist Dr. Étienne-Jules Marey" and suggesting that, though Eakins might have improved on Marey's rotating disk by using two disks, the question remains of his original invention and the possibility that Muybridge had the two-disk camera first.

15. Quoted in Oliver W. Larkin, *Samuel F. B. Morse and American Democratic Art* (Boston and Toronto: Little, Brown, 1954), p. 146.

16. Quoted in Van Deren Coke, "Camera and Canvas," *Art in America,* XLIX, No. 3 (1961), 68.

17. Rev. Louis L. Noble, *The Course of Empire, Voyage of Life and Other Pictures of Thomas Cole, N.A.* (New York: Cornish, Lamport & Co., 1853), p. 282, reproduces a letter from Cole dated February 26, 1840, which states: "the art of painting is a creative, as well as an imitative art, and is in no danger of being superseded by any mechanical contrivance."

18. Van Deren Coke, *The Painter and the Photograph,* p. 13.

19. Porter, *op. cit.,* p. 13.

20. Goodrich, *Eakins,* Whitney Museum, p. 29.

21. *Ibid.,* pp. 51–52.

22. See Goodrich, *Eakins,* exhibition catalogue, p. 20: "That he came to consciously identify himself with Rush is shown by the fact that in one of the late versions he substituted for Rush's figure his own, handing the model down from the stand as if she were a queen."

23. Mount, too, had disliked working from plaster casts. See Ms. Stony Brook (undated), where he states: "I say paint from the living, rather than from the plaster model."

24. Porter, *op. cit.,* p. 15.

25. Quoted in Goodrich, *Eakins,* Whitney Museum, p. 75.

NOTES TO CHAPTER TWELVE

1. Lloyd Goodrich, *Albert P. Ryder* (New York: Braziller, 1959), p. 21.

2. *Ibid.,* p. 22.

3. Paul Klee, quoted in *Paul Klee,* ed. Will Grohmann (New York: Abrams, 1954), p. 181.

4. Goodrich, *op. cit.,* p. 31.

5. *Ibid.,* p. 22.

6. *Ibid.,* p. 29.

7. *Ibid.,* p. 22.

8. *Ibid.,* p. 13.

9. *Ibid.,* p. 24.

10. *Ibid.*

11. *Ibid.,* p. 20.

12. Ryder's *Forest of Arden* seduced Roger Fry into an uncharacteristic purple passage: "What invitation in the winding stream, what unrealized, oft-dreamt possibilities beyond those undulating hills, what seclusion and what delicious terrors in the brooding woods, and what happy augury in the sky!" See Roger E. Fry, "The Art of Albert P. Ryder," *Burlington Magazine,* XIII (April, 1908), 64.

13. Goodrich, *op. cit.,* p. 22.

14. *Ibid.,* pp. 21–22.

15. *Ibid.,* p. 23.

16. *Ibid.,* p. 14. (Ryder was born in New Bedford, Massachusetts, of a sea-faring family and moved to New York City about 1870.)

17. *Ibid.,* p. 115.

18 *Ibid.*

NOTES TO CHAPTER THIRTEEN

1. *Emerson: A Modern Anthology,* eds. Alfred Kazin and Daniel Aaron (Boston: Houghton Mifflin, 1958), pp. 104–5.

2. Alfred Frankenstein, *After the Hunt: William Harnett and Other American Still Life Painters 1870–1900* (Berkeley and Los Angeles: University of California Press, 1953), p. 31.

3. James Thrall Soby, *Georgio de Chirico* (New York: Museum of Modern Art, 1965), p. 66.

4. *Emerson,* eds. Kazin and Aaron, p. 112, quoted by Emerson.

5. *Ibid.,* p. 126.

6. Étienne Gilson, *Painting and Reality* (New York: Meridian Books, 1959), p. 50.

7. Frankenstein, *op. cit.,* p. 81.

8. *Ibid.,* p. 50.

9. *Ibid.*

10. *The Crayon,* I, No. 24 (June 13, 1855), 369.

11. *North American Review,* LXXXI (1855), 230.

12. For a consideration of attitudes toward selective imitation in nineteenth-century America, see the chapter on "General Aesthetic Attitudes" (V) in the author's doctoral thesis, "Cole and Durand: Criticism and Patronage, A Study of American Taste in Landscape 1825–1865," Radcliffe, 1957 (unpublished).

13. Frankenstein, *op. cit.,* p. 55.

14. See Cole's letter to Luman Reed (Ms. The New York Public Library) about his plans for painting *The Oxbow:* "I thought I could do something that would tell a tale."

15. Frankenstein, *op. cit.,* p. 55.

16. Frankenstein's chapter on "The Problem and its Solution" (*ibid.,* pp. 3-24) is a superb model of art-historical sleuthing.

17. Frankenstein, *ibid.,* quotes p. 110.

18. *Ibid.,* pp. 62, 63.

19. *Ibid.,* p. 66.

20. Quoted in Alfred Barr, *Matisse* (New York: Museum of Modern Art, 1951), p. 119.

NOTES TO CHAPTER FOURTEEN

1. Quoted in Royal Cortissoz, *John La Farge* (Boston: Houghton Mifflin, 1911), pp. 212–13.

2. William Dunlap, *A History of the Rise and Progress of the Arts of Design in the United States* (1834; rev. ed. by F. W. Bayley and C. E. Goodspeed, 1918; ed. Alexander Wyckoff, New York: Blom, 1965), I, 255, Stuart to Neagle.

3. Matthew Harris Jouett, quoted in John Hill Morgan, *Gilbert Stuart and His Pupils* (New York: New-York Historical Society, 1939), p. 81. See the artist's daughter, Jane Stuart, quoted in *Gilbert Stuart, Portraitist of the Young Republic 1755–1828,* catalogue of an exhibition at the National Gallery of Art, Washington, D.C., and the Museum of Art, Rhode Island School of Design, Providence, 1967,

p. 112: "He commenced a portrait by drawing the head and features, and then he sketched in the general tone of the complexion. . . . At the second sitting he introduced transparent flesh-tints, and at the third he began to awaken it into life and give it expression, and then the individuality of the sitter came out."

4. Quoted in *Gilbert Stuart,* catalogue, p. 30.

5. See Stuart on expression, in Morgan, *op. cit.,* p. 92 (to Jouett): "Expression is often taken in too limited a view, there is such a thing as a general & at the same time individual expression in every picture of any size, and where a genl good expression prevails, tis of singular service in producing pleasing emotion for the idea of an adaption to an end is an extremely pleasing one, and nothing can be of more singular service in this than the genl expression. . . . Expression is but too generally understood to relate to living character. It belongs as much to inanimate as animate being."

6. *Gilbert Stuart,* catalogue, p. 24, quoting Stuart in 1816. See Jane Stuart, *Scribner's Monthly,* XII, (1876), p. 372: "my father asked Mrs. Washington if she could let him have a piece of lace, such as the General wore, to paint from. She said, 'Certainly', and then inquired if it would make any difference if it were old. He replied, "Certainly not. I only wish the general effect."

7. Dunlap, *op. cit.,* I, 263. Quoting Allston's obituary on Stuart in the *Boston Daily Advertiser.*

8. *Ibid.,* p. 262.

9. See *Gilbert Stuart,* catalogue, p. 86, where Mrs. Perez Morton is noted as "Never finished, for reasons that can only be guessed." My own guess is that Stuart liked the portrait this way, and his relationship with the "American Sappho" was sufficiently close for him to ignore the protocol of portrait finish and indulge his natural instinct for utmost painterly freedom.

10. Dunlap, *op cit.,* I, 256.

11. Morgan, *op cit.,* p. 83, to Jouett.

12. Dunlap, *op. cit.,* p. 260, quoting Allston's letter of October 15, 1833.

13. Morgan, *op. cit.,* p. 83.

14 Flagg, *op. cit.,* quoting Henry Greenough to R. H. Dana, Sr., pp. 185–86.

15. See Joshua C. Taylor, *William Page, The American Titian* (Chicago: University of Chicago Press, 1957), especially p. 134, where a letter from Mrs. Browning to her sister from Rome (December 30, 1853), notes: "I stayed at home with Mr. Page the American artist to talk spiritualism." Taylor notes: "When, late in May of 1854, the Brownings went back to Florence, Mrs. Browning's notes to Page, usually postscripts to her husband's letters, were filled with the latest news of spiritual findings from all over. James Jackson Jarves had stopped on his way to Rome and told them of spiritual affairs in America and of a spirit circle right in his own family (footnote 101, June 16, 1854, letter from the Brownings to Page in the Page papers). See also Chapter Nine, "Page's Theories of Art," pp. 218 ff., for a consideration of the effect of Swedenborgianism on Page's aesthetic.

16. *Mary Cassatt,* catalogue of an exhibition at the M. Knoedler & Co. galleries, New York, February 1–26, 1966, introduction (unpaged) quoting André Mellerio.

17. Quoted in Van Deren Coke, *The Painter and the Photograph* (Albuquerque, N.M.: University of New Mexico Press, 1964), p. 13.

18. Quoted in George Inness, Jr., *The Life, Art and Letters of George Inness,* (New York: Century Co., 1917), p. 131.

19. *Ibid.,* p. 170.

20. Inness had remarked to his son, *ibid.,* p. 129: "There you see, George, the value of the gray color underneath glazing. The transparency of it comes out in tone. The shadows are full of color. Not pigment; all light and air. Wipe out a little more of it. Never was anything as nice as transparent color."

21. William Morris Hunt, in *Hunt's Talks on Art,* Second Series, compiled by Helen M. Knowlton (Boston: Houghton Mifflin, 1883), p. 63. See also *ibid.,* p. 27, where Hunt manifests a concern for measure and accuses "the Yank" of not measuring: "People think it isn't smart to measure, and take pains. Well, let such draw fine things—if they can. Michel Angelo measured. . . . Albert Dürer passed many years trying to get at a system of measurement for the human figure; carrying it so far that he found certain parts of the body to be so many lengths of the eye. One half of the art of the Egyptians is in their wonderful knowledge of proportions, but the Yank thinks it is smart to sit down and do horrible things without measuring." And *ibid.,* p. 19, where he comments, like Eakins: "Nature is ideal. The Greeks were realists. There is realism in Praxiteles and in the Egyptians. In order to be ideal you have got to be awfully real."

22. *Ibid.,* p. 63. Inness though, was a great admirer of Titian and spent a summer at his birthplace, Pieve di Cadore. His son notes that he thought Titian "the greatest colorist that ever lived." Inness, *op. cit.,* p. 75.

23. James Laver, *Whistler* (New York: Cosmopolitan Book Corporation, 1930), p. 280.

24. Quoted in Hesketh Pearson, *The Man Whistler* (New York: Harper, 1952), p. 109.

25. Maurice Denis, from *Definition du néo-traditionisme* (1890), quoted in Charles Edward Gauss, *The Aesthetic Theories of French Artists from Realism to Surrealism* (Baltimore: Johns Hopkins Paperbacks, 1966), p. 57.

26. Denys Sutton, *James McNeill Whistler* (London: Phaidon, 1966), p. 13, says Whistler was "almost certainly familiar" with Théophile Gautier's "l'art pour l'art" aesthetic.

27. James McNeill Whistler, *The Gentle Art of Making Enemies* (New York: Putnam's, 1890), pp. 142–43.

28. *Ibid.,* p. 145.

29. *Ibid.,* p. 144.

30. Charles Baudelaire, *The Mirror of Art* (London: Phaidon, 1955), p. 228, from the Salon of 1859.

31. Quoted in John Rewald, *Post Impressionism from Van Gogh to Gauguin* (New York: Museum of Modern Art, 1956), p. 148.

32. Laver, *op. cit.,* p. 247, quotes Duret in the *Gazette des Beaux-Arts,* XXIII (1881), 368: "Mr. Whistler's nocturnes . . . make one think of those Wagnerian compositions in which the harmonic sound, separated from all melodic design and any accented cadence, remains a kind of abstraction and conveys only a very indefinite musical impression." Laver adds, "In the early eighties to compare Whistler to Wagner was to proclaim his part in the modern intellectual movement and to rally to his side all those to whom the name of Wagner was a battle-cry." One might recall here R. H. Dana's record of Allston's comment (see Jared B. Flagg, *The Life and Letters of Washington Allston* [New York: Scribner's, 1892], p. 365): "I have been more affected by music than I have ever been by either painting or poetry."

33. Quoted in *Baudelaire, Rimbaud, Verlaine,* selected verse and prose poems, ed. with introduction by Joseph Bernstein (New York: Citadel, 1962), p. xxvi.

34. Quoted in *Mallarmé,* ed. Anthony Hartley (Baltimore: Penguin, 1965), p. ix and note, from a letter to Henri Cazalis, 1864, "Peindre, non la chose, mais l'effet qu'elle produit."

35. For a full account of the Whistler-Ruskin episode, resulting from Ruskin's famous reference to Whistler's "flinging a pot of paint in the public's face" in *Fors Clavigera,* July 2, 1877, see Whistler, *op. cit.,* pp. 1 ff.

36. See Rewald, *op. cit.,* p. 150.

37. Oliver W. Larkin, *Art and Life in America* (rev. ed.; New York: Holt, Rinehart and Winston, 1960), pp. 293 ff.

38. This extremely important book of theory by La Farge was offered first as a series of lectures in 1893 at The Metropolitan Museum, New York. See John La Farge, *Considerations on Painting* (New York and London: Macmillan, 1901), p. 40, footnote: "Question: 'The labour of two days then, is that for which you ask two hundred guineas?' Answer (Mr. Whistler): 'No. I ask it for the knowledge of a life-time.'"

39. *Ibid.,* p. 57.

40. *Ibid.,* p. 17.

41. Cortissoz, *op. cit.,* p. 101.

42. *Ibid.*

43. *Ibid.*

44. See La Farge, *op. cit.,* pp. 194–95: "For the eye which *sees,* the bird that flies has more than two wings; he may have four. The horse at full pace has more than four legs; he has at least eight. It is for us to adjust this multiplicity of sights, and in some way render the appearance of continual fluctuation." See also, especially, the chapter on Maia, or Illusions (pp. 159–205), where this notation appears and where, on pp. 189–91, he deals with illusions of perception in a manner that suggests recent books on the problem. As Seurat had done shortly before, La Farge noted (*ibid.,* p. 130): "A colour, a line, a sound may influence the soul with a similar sentiment of result. . . . Notes, lines and colours smile or weep, are sad or gay, equally, but each in its way." Acknowledging the chords between science and art he added (*ibid.*): "There is in each competent artist a sort of unconscious automatic mathematician, who, like the harmonist in music, the colourist in painting, resolves in his way the problem of sight or sound which the scientist puts into an equation."

45. Cortissoz, *op. cit.,* pp. 244 ff., quotes a letter from La Farge to Henry Adams in which La Farge notes: "I am . . . not quite certain that you are absolutely and entirely in the wrong about the wild Frenchman's being in Tahiti. I say 'wild Frenchman'—I should say stupid Frenchman. I mean Gauguin. No, I think that he went there just as we arrived in Paris in 1891. His pictures were on show with Whistler's portrait of his mother. (You know the people will consider, or used to consider Whistler as eccentric.) I was then told that our Frenchman was going to our Islands, and then Tati told me about him. . . . I have no doubt that your description of the Frenchman's paintings, which I understand you have not seen, must be quite accurate if one could be accurate about the peculiar shows which some of those good people indulge in. I say indulge in; I mean that they are driven to do something to attract attention. Even their own attention." La Farge's lack of appreciation for Gauguin tallies to a good extent with the split between his own theory and practice. *Considerations* shows remarkable theoretical advancement, revealing, for example, on his own trip to the South Seas, La Farge's awareness of the synthetic character of native childrens' sand drawings (*ibid.,* pp. 95–96): "the little lesson given to me in this way, by the small savage, brought to my mind the fact that he had begun *first* by making a complete synthesis of certain points that interested him, and that he had assumed to himself and to others that this synthesis —which was not a copy of nature—this arrangement and coordination of certain facts of sight, would be understood by others and represent the thing seen." Nevertheless, his paintings referred more often back to the Rubens-Delacroix-Chassériau tradition than forward. Cortissoz (*op. cit.,* p. 95) quotes him on Rubens: "Rubens I followed in Belgium, later, trying to see every painting of his throughout the whole kingdom, and as many of his pupils as I could gather in. . . . I made no studies; in fact Rubens is not one to work from easily, nor would it have been available for me to imitate, without a great knowledge of painting, the tremendous flow of color and light so gloriously spread over that enormous space of painted surface, either all his own or that of his pupils also."

1. The Eight was a group of New York artists that included John Sloan (1871–1951), George Luks (1867–1933), William Glackens (1870–1938), Everett Shinn (1876–1953), Robert Henri (1865–1929), Maurice Prendergast (1859–1924), Ernest Lawson (1873–1939), and Arthur B. Davies (1862–1928), who exhibited together at the Macbeth Gallery in 1908.

2. See John I. H. Baur, *Revolution and Tradition in Modern American Art* (Cambridge, Mass.: Harvard University Press, 1951), pp. 80–81, who notes: "Henri was the focal point of this dark impressionism in America," and "it was as a teacher and a liberal leader of the Eight that his influence was greatest."

3. See Baur, *ibid.,* p. 86, who calls romantic realism "realism slightly modified by various formal devices for more expressive and romantic effect."

4. *Ibid.,* pp. 11 ff.

5. Quoted in Lloyd Goodrich, *Max Weber,* (New York: published for the Whitney Museum of American Art by Macmillan, 1949), pp. 30–31.

6. Quoted in *The Selected Writings of John Marin,* ed. Dorothy Norman (New York: Pellegrini & Cudahy, 1949), pp. 4–5.

7. Henry David Thoreau, *Walden* (New York: New American Library, Mentor Books, 1953), p. 207.

8. *Emerson: A Modern Anthology,* eds. Alfred Kazin and Daniel Aaron (Boston: Houghton Mifflin, 1958), p. 135.

9. Thoreau, *op. cit.,* p. 207.

10. Quoted in John A. Kouwenhoven, *Made in America* (1948; New York: Doubleday, Anchor Books, 1962), p. 173.

11. Leo Marx, *The Machine in the Garden: Technology and the Pastoral Ideal in America* (New York: Oxford University Press, 1964), p. 236.

12. *Ibid.,* p. 356.

13. Quoted in H. H. Arnason, *Stuart Davis,* catalogue of an exhibition at the Walker Art Center, 1957, p. 36 (from "The Cube Root," *Art News,* XLI (February 1, 1943), 33–34.

14. Quoted in *Painters on Painting,* ed. Eric Protter (New York: Universal Library, 1963), pp. 252–53, from a statement of 1943.

15. Lewis Mumford in "The Metropolitan Milieu," *America and Alfred Steiglitz: A Collective Portrait,* ed. The Literary Guild, (New York: Doubleday, Doran, 1934), notes p. 46: "In the Bhagavad Gita, Krishna says that the way to contemplation may be found through action as well as through exercises that are directly meant to intensify and illuminate the spiritual life." The Transcendentalists, it will be remembered, made frequent reference to the Bhagavad Gita; see, for example, Thoreau, *op. cit.,* p. 198, where he notes: "In the morning I bathe my intellect in the stupendous and cosmogonal philosophy of the Bhagvat-Geeta." There are, of course, obvious connections here with the interest of the Hippie culture of the 1960's in this source.

16. Mark Rothko, quoted in *The Tiger's Eye,* I, No. 9 (October 15, 1949), 114.

17. *Primary Structures: Younger American and British Sculptors,* catalogue of an exhibition at The Jewish Museum, April 27–June 12, 1966 (unpaged).

Brief Biographies of Eighteenth- and Nineteenth-Century Artists

ABBREVIATIONS

Sources referred to frequently for biographical information will be abbreviated as follows:

Gardner and Feld

Albert Ten Eyck Gardner and Stuart P. Feld, *American Paintings: A Catalogue of the Collection of The Metropolitan Museum of Art.* Vol. I: *Painters Born by 1815.*

Groce and Wallace

George C. Groce and David H. Wallace, *The New-York Historical Society's Dictionary of Artists in America 1564–1860.*

Karolik Collection of Paintings

M. and M. Karolik Collection of American Paintings 1815–1865.

Karolik Collection of Water Colors and Drawings

M. and M. Karolik Collection of American Water Colors and Drawings 1800–1875.

WASHINGTON ALLSTON (1779–1843). Born Georgetown, S.C. 1800 graduated from Harvard. To Newport, R.I. 1800–1801 to Charleston, S.C. 1801 to London. Admitted to school of the Royal Academy. 1803 to Paris with John Vanderlyn, via Holland and Belgium. 1804 to Italy via Switzerland. Until 1808, remained mainly in Rome. 1808–11 to Boston. Painted, and wrote a volume of verse published 1813 in London and Boston. 1811 returned to England with Samuel F. B. Morse. 1817 made six-week visit to Paris with C. R. Leslie and William Collins. 1818 elected honorary member of American Academy of Fine Arts. Returned to Boston. Before 1821, wrote novel *Monaldi* (published 1841). 1830 moved to Cambridgeport, Mass. 1831 established studio on Auburn Street. 1839 exhibited forty-seven paintings in Chester Harding's studio. Died Cambridgeport.

References: Washington Allston, *Lectures on Art and Poems,* New York: 1850. Jared B. Flagg, *The Life and Letters of Washington Allston,* New York: 1892. E. P. Richardson, *Washington Allston,* Chicago: 1948.

JOHN JAMES AUDUBON (1785–1851). Born Les Cayes, Haiti. Spent youth in France. 1803 to United States. 1805 back to France. 1806 to United States. Practiced taxidermy. Lived for a while in Kentucky. 1820 taxidermist at Western Museum, Cincinnati, Ohio. From then on, dedicated to drawing and publishing birds and mammals of America. Traveled widely. 1826 to England, where arranged first publication of *Birds of America* (final volume issued 1839), for which Robert Havell, Jr. engraved most of plates. Lived for a while in Edinburgh, Scotland, where wrote *Ornithological Biography.* Spent much time between Great Britain and the United States. 1839 to New York City. *Ca.* 1841 bought land on Hudson River at 157th Street (now Audubon Park) and built home. Collaborated with sons John Woodhouse and Victor Gifford on *Quadrupeds of America.* 1842 trip to Quebec. 1843 trip to the West. Died New York City.

References: Gardner and Feld. Groce and Wallace. Alice Ford, *John James Audubon,* Norman, Okla.: 1964. Karolik Collection of Water Colors and Drawings. *The Original Watercolor Paintings by John James Audubon for Birds of America,* from the collection at The New-York Historical Society, introduction by Marshall Davidson, New York: 1966.

ALBERT BIERSTADT (1830–1902). Born Solingen, near Düsseldorf. To United States as child, raised New Bedford, Mass. 1853 to Düsseldorf, studied at Academy under Lessing and Andreas Achenbach. Spent a winter in Rome with Worthington Whittredge. 1857 to United States. 1858 to West with General Frederick W. Lander's expedition. 1860 elected to National Academy of Design. 1863 to West again with journalist Fitz Hugh Ludlow. See Ludlow's account of trip, *The Heart of the Continent,* 1870. 1867–69, *ca.* 1878–*ca.* 1880, 1883–84, 1887–88, 1891, once after 1894, returned to Europe. 1872 and 1873 on Pacific coast. 1877 to Florida and Nassau. 1880 Canada. 1881 Bahamas. 1886 summer in Wisconsin and Lake Superior. *Ca.* 1882 studio at Irvington-on-the-Hudson, N.Y., burned. Died New York City.

Reference: Karolik Collection of Paintings.

GEORGE CALEB BINGHAM (1811–79). Born Augusta County, Va. From 1819, spent most of life in Missouri. *Ca.* 1827–28, apprenticed to cabinetmaker, the Reverend Justinian Williams. *Ca.* 1833, began career as portrait painter. 1838 to Philadelphia to study. Possibly visited New York City. Short trip to Baltimore. From late 1840–44, in Washington, D.C. 1844 to Missouri. 1847 national fame spread when the American Art-Union distributed his engraving of *The Jolly Flatboatmen* to nearly 10,000 subscribers. Became involved in politics. 1848 served in Missouri State Legislature. 1862–65 State Treasurer. June, 1866, ran unsuccessfully for Congress from the 6th District. 1875–77 Adjutant General of Missouri. Painted series of political subjects. From 1850's, frequent trips to New York City and Philadelphia. Occasional trips to Washington, D.C. 1856 to Düsseldorf. 1859 returned to United States. Made summer trip back to Düsseldorf. 1877 Professor of Art, University of Missouri School of Art. Died Kansas City, Mo.

References: E. Maurice Bloch, *George Caleb Bingham, The Evolution of an Artist, A Catalogue Raisonné,* 2 vols., Berkeley and Los Angeles, Cal.: 1967. Bloch, *George Caleb Bingham,* catalogue of an exhibition organized by the National Collection of Fine Arts, Smithsonian Institution, Washington, D.C., 1967.

JOSEPH BLACKBURN (exact dates unknown). Born probably England. 1752–53 in Bermuda. 1754–63 active in America, mainly in Boston and Portsmouth, N.H. After 1763, few records, but some evidence of later activity in England.

References: Gardner and Feld. Groce and Wallace.

DAVID GILMOUR BLYTHE (1815–65). Born Ohio. 1832–35 apprenticed to carpenter and wood carver in Pittsburgh, Pa. 1835–36 worked as carpenter and house painter. 1836 to New Orleans. 1837–40 in U.S. Navy as ship's carpenter, visited Boston and West Indies. 1841–45 itinerant portrait painter in Pennsylvania and Ohio. 1846–51 lived in Uniontown, Pa., and toured with panorama of Allegheny Mountains to Baltimore, Cumberland, Md., Pittsburgh, Cincinnati, Ohio, and East Liverpool, Ohio. 1852–55 painted in western Pennsylvania. 1853 visited Indiana. 1855–65 in Pittsburgh. During Civil War followed 13th Pennsylvania Regiment as artist. Died Pittsburgh.

References: Groce and Wallace. Karolik Collection of Paintings. Dorothy Miller, *The Life and Work of David G. Blythe,* Pittsburgh: 1950.

MARY CASSATT (1845–1926). Born Pittsburgh, Pa. 1851–56 lived in Paris with parents. 1856–68 studied cast drawing at The Pennsylvania Academy of the Fine Arts. 1868 to Europe. Worked with engraver and painter Carlo Raimondi at Art Academy, Parma. Studied Correggio in Parma. To Spain where studied Velázquez and Rubens. To Low Countries where studied Rubens and Hals. 1874 settled in Paris. 1877, 1879, 1880, 1881, 1886 exhibited with Impressionists. 1879 met Mr. and Mrs. H. O. Havemeyer. 1891 first one-man exhibition at Durand-Ruel, Paris. 1893 decorations for north tympanum of Women's Building of World's Columbian Exposition, Chicago. 1897 first of several European tours with Mrs. Havemeyer, helping to form her art collection. 1899–1900 visited America. Died Château de Beaufresne, Mesnil-Theribus.

References: Adelyn D. Breeskin, *The Graphic Work of Mary Cassatt, a Catalogue Raisonné,* New York: 1948. Frederick A. Sweet, *Miss Mary Cassatt, Impressionist from Pennsylvania,* Norman, Okla.: 1966.

FREDERIC EDWIN CHURCH (1826–1900). Born Hartford. 1844–46 studied with Thomas Cole. 1849 elected member National Academy of Design. Traveled and sketched in Catskills, Berkshires, Connecticut, Green and White Mountains. 1848–49 William J. Stillman, an editor of *The Crayon,* accepted as his first pupil. 1850–51 Jervis McEntee second pupil. 1850–52 visited Grand Manan Island and Bay of Fundy, Mt. Desert Island and Mt. Katahdin region, Me. Mt. Desert Island became a favorite summer area, with visits until 1860. 1851 to Virginia, Kentucky, upper Mississippi River. 1853 first trip to South America. 1854 visits to Annapolis, Md., Nova Scotia. 1856 to Niagara Falls, Mt. Katahdin. 1857 returned to South America, traveling with artist Louis Remy Mignot. 1858 to Niagara. Moved from 497 Broadway to Studio Building, West Tenth Street, New York City. 1859 trip to Newfoundland and Labrador. Sailed with Cole's biographer, Louis L. Noble, from Boston to Halifax. Trip described 1861 by Noble in *After Icebergs with a Painter.* 1867 *Niagara* won the second medal at Paris Universal Exposition. Sailed for France in November and traveled extensively through Europe and Near East. November, 1868, to April, 1869, in Rome. Friendship with Sanford Gifford. 1870 built villa at Olana, Hudson, N.Y. 1873–74 in Vermont. 1876 W. W. Corcoran

bought *Niagara* for $12,500. 1876–82 in Mt. Katahdin region, Lake George, North Carolina. 1883–1900 most winters in Mexico, summers in Olana. Died New York City.

References: David C. Huntington, *The Landscapes of Frederic Edwin Church,* New York: 1966. *Frederic Edwin Church,* catalogue of an exhibition organized by the National Collection of Fine Arts, Smithsonian Institution, Washington, D.C., 1966.

THOMAS COLE (1801–48). Born Bolton-le-Moor, Lancashire, England. 1819 to United States. 1820 to West Indies. 1820–22 block engraver in Steubenville, Ohio. 1823 to Philadelphia. By 1825, in New York City. 1826 helped found National Academy of Design. 1829 visited Niagara Falls. 1829–32 in Europe, visited England, France, and Italy. Occupied Claude Lorrain's studio in Rome and developed lasting affection for Italian ruins. Returned to New York City and set up studio (1836) at Catskill, N.Y. 1841–42 second trip to Europe again took him from England to Italy, especially Sicily. His most famous pupil, though not his only one, was Frederic E. Church. Died Catskill.

References: Gardner and Feld. Groce and Wallace. Rev. Louis L. Noble, *The Course of Empire, Voyage of Life and Other Pictures of Thomas Cole, N.A.,* New York: 1853; Cambridge, Mass.: 1964. Esther I. Seaver, *Thomas Cole, 1801–1848, One Hundred Years Later,* catalogue of an exhibition held at the Wadsworth Atheneum, Hartford, 1948. The Cole papers are in The New York State Library at Albany, with photostats at The New-York Historical Society, New York City.

JOHN SINGLETON COPLEY (1738–1815). Born in or near Boston. Son of Irish parents. 1748 widowed mother married Peter Pelham, engraver and painter. 1751 Pelham died, having already influenced Copley's artistic education. From about 1753 on, painted in Boston, and by early 1760's had developed mature American style. 1765 sent portrait of half-brother Henry Pelham to Society of Artists, London, and exchanged correspondence with Benjamin West. 1767 sent another painting, *Young Lady with a Bird and Dog.* 1769 married Susanna Farnham Clarke (Sukey), daughter of Richard Clarke, Boston merchant, which tied him by marriage to a Loyalist family. 1771 trips to New York City and Philadelphia. June, 1774, to Europe (followed 1775 by wife and children). Visited London, then traveled with English artist, George Carter, via Paris to Rome. Visited Florence, Naples, and Paestum. Returned to England after ten months on Continent, via Parma, Venice, and Cologne. Copley's works are normally divided into two distinct periods, American and English. His work in England established him in English artistic circles. Elected to Royal Academy in 1779. Died London, having become history painter as well as portraitist. His son Lord Lyndhurst became Lord Chancellor of England.

References: Jules D. Prown, *John Singleton Copley,* 2 vols. Cambridge, Mass.: 1966. *Copley-Pelham Letters,* Massachusetts Historical Society Collections, 1914.

JASPER FRANCIS CROPSEY (1823–1900). Born Rossville, Staten Island, N.Y. 1837–40 won diploma for model house at Mechanics Institute, New York. Apprenticed to architect Joseph Trench in New York City. Diploma from American Institute for architectural drawing *The Temple of Minerva, Parthenon Restored.* Watercolor lessons from Edward Maury. 1841–42 designed two churches for Staten Island. Began painting. 1843 first work exhibited at National Academy of Design, an *Imaginary Landscape.* 1847–49 to Europe—London, Fontainebleau, and Italy. 1849–55 taught at New York City studio, sketching in White Mountains, New-

port, R.I., Greenwood Lake, Ramapo Valley, N.J. 1856 to Europe again; studio at Kensington Gate, London. 1863–64 returned to United States; Civil War scenes. 1865–66 helped found American Water Color Society. 1876 three paintings at Philadelphia Centennial. In later years, painted almost exclusively autumn landscapes. 1878–1900 designed platforms and waiting stations for Sixth Avenue elevated subway, New York City. Died Hastings-on-Hudson, N.Y.

References: Groce and Wallace. Peter Bermingham, *Jasper F. Cropsey 1823–1900, Retrospective View of America's Painter of Autumn,* catalogue of an exhibition held at the University of Maryland Art Gallery, 1968.

THOMAS WILMER DEWING (1851–1939). Born Boston. Early work as lithographer in Boston and as portrait artist in Albany. 1876 to Paris, studied under Jules J. Lefebvre. 1879 returned to New York City. 1880 elected member of Society of American Artists. 1881–88 taught at Art Students League, New York City. 1888 academician of National Academy of Design. 1897 resigned from Society of American Artists, and 1898 joined group known as The Ten American Painters. 1908 elected to National Institute of Arts and Letters. Died New York City.

Reference: Mary Bartlett Cowdrey, *The Dictionary of American Biography,* Vol. XXII, Supplement 2.

THOMAS DOUGHTY (1793–1856). Born Philadelphia. Early apprenticeship to leather currier. *Ca.* 1820, started painting landscapes. Painted in Pennsylvania, Baltimore, Washington, D.C., New England, New York. 1826–30 in Boston. 1830 returned to Philadelphia and began with brother, publication of the *Cabinet of Natural History and American Rural Sports.* 1832–37 back in Boston. 1837 to England. 1839 and 1840 worked at Newburgh, N.Y. 1841 to New York City and lived there till end of life, except for 1845–46 trip to England, Ireland, France, and a short residence 1852–54 in western New York.

References: Gardner and Feld. Groce and Wallace. Howard N. Doughty, "Life and Works of Thomas Doughty," unpublished manuscript in The New-York Historical Society, New York City.

ASHER BROWN DURAND (1796–1886). Born Jefferson Village, N.J. 1812–17 apprenticed to engraver Peter Maverick, then joined him as a partner for three years. Became an active and prominent engraver, especially for gift-book annuals and bank notes. Companies he headed: (1824) A. B. & C. Durand, (1826–27) A. B. Durand & C. Wright & Co., and (1828–31) Durand, Perkins & Co. Mid-1830's began to concentrate on landscape painting. 1840-41 to Europe with John W. Casilear, John F. Kensett, and Thomas P. Rossiter. Visited London, Paris, Rome, Florence, Belgium, Switzerland. Had helped found National Academy of Design in 1826; 1845–61 served as president. Home at Catskill Clove an important gathering place for artists of the Hudson River group, with whom he traveled to North Conway, N.H., Vermont, the Berkshires, Lake George, and so on. After the death of Thomas Cole, became the acknowledged leader of the Hudson River school. Died Jefferson Village, N.J. Son John Durand was editor of *The Crayon,* one of the most influential art journals of the day.

References: Gardner and Feld. Groce and Wallace. John Durand, *The Life and Times of Asher B. Durand,* New York: 1894. Durand papers at The New York Public Library.

THOMAS EAKINS (1844–1916). Born Philadelphia. Attended Central High School; excelled in science and mathematics. 1861–66 studied drawing at The Pennsylvania Academy of the Fine Arts and anatomy at Jefferson Medical College. September, 1866, to France. Studied with Gérôme at École des Beaux-Arts. 1867 visited Paris Universal Exposition, where admired American locomotive. Summer, 1868, to Italy and Germany. 1869 trip to Spain, especially interested in Ribera and Velázquez. 1870 returned to Philadelphia to family home at 1729 Mount Vernon Street, where spent rest of life. From 1876, taught classes in anatomy at Pennsylvania Academy. 1880 joined Society of American Artists. 1884 married pupil Susan Hannah Macdowell. Series of photographic experiments. 1886 resigned from Pennsylvania Academy. Started teaching at newly founded Art Students League of Philadelphia. 1887 summer on Dakota ranch. From 1888 on, lectured at National Academy of Design. Died Philadelphia.

References: Lloyd Goodrich, *Thomas Eakins,* New York: 1933. Fairfield Porter, *Thomas Eakins,* New York: 1959. Lloyd Goodrich, *Thomas Eakins, A Retrospective Exhibition,* catalogue of an exhibition held at the National Gallery of Art, Washington, D.C., The Art Institute of Chicago, and the Philadelphia Museum of Art, 1961.

ROBERT FEKE (1705/10–after 1750). Born probably Oyster Bay, L.I., N.Y. Life and origins still mysterious. 1741 in Boston. 1742 and again 1745 in Newport, R.I., 1746 in Philadelphia. 1748 in Boston. 1750 in Philadelphia again. Family tradition suggests that he was a mariner and that he died in Bermuda or Barbados. Most original of colonial portraitists prior to Copley; made significant advances amplified further by Copley's development.

References: Gardner and Feld. Groce and Wallace. H. W. Foote, *Robert Feke,* Cambridge, Mass.: 1930.

SANFORD ROBINSON GIFFORD (1823–80). Born Greenfield, N.Y. 1842–44 attended Brown University, then studied New York City under John Rubens Smith. 1854 member National Academy of Design. Abroad in 1855, summer in England, Wales, Scotland, winter in Paris. Traveled the following summer through Belgium, Holland, Switzerland, to Italy with Worthington Whittredge. Winter 1856–57, in Rome. Spring and summer traveled to Italy and Austria. 1857 to New York City. Studio at 15 Tenth Street (1866 renumbered 51 West Tenth). 1859 abroad with Jervis McEntee. Joined 7th New York Regiment during Civil War. Served in campaigns of 1861, 1863–64. Abroad in 1868, spending two years in Mediterranean area. Met Thomas Hotchkiss in Italy. 1870 traveled West with John F. Kensett and Whittredge. Joined geologist F. V. Hayden in Denver and visited Colorado and Wyoming. Died New York City.

References: Groce and Wallace. Karolik Collection of Water Colors and Drawings. *Gifford Memorial Meeting of the Century* [Club], New York: 1880. Ila Weiss, "Sanford Robinson Gifford," unpublished doctoral dissertation, Columbia University, 1968.

WILLIAM MICHAEL HARNETT (1848–92). Born possibly Clonakilty, County Cork, Ireland. Family to Philadelphia, presumably a year later. 1869 family first listed in Philadelphia city directory. Harnett listed as engraver. From about 1865, worked at engraving, developed skill in engraving silverware. 1867 Pennsylvania

Academy of the Fine Arts at night. 1869 to New York City. Studied at National Academy of Design and Cooper Union art school. Worked for jewelry firms during day, to art school at night. 1875 gave up engraving for painting. Spring, 1875, first work shown at National Academy. 1876 to Philadelphia, where showed still life of fruit. Opened studio at 400 Locust Street. Studied at The Pennsylvania Academy of the Fine Arts. 1880 to Europe. Spent spring in London; to Frankfurt for six months. *Ca.* 1881, to Munich, where remained for four years. *Ca.* 1884 or early 1885, to Paris, where painted *After the Hunt*. By summer, 1885, in London. By April, 1886, returned New York City; remained there until second trip to Europe (Germany), summer, 1889. Back to New York City late that year. Died New York City.

Reference: Alfred Frankenstein, *After the Hunt: William Harnett and Other American Still Life Painters 1870–1900*. Berkeley and Los Angeles, Cal.: 1953.

MARTIN JOHNSON HEADE (1819–1904). Born Lumberville, Bucks County, Pa. Early training with Thomas Hicks. *Ca.* 1837–40, to Europe. Studied in France, England, Italy (two years in Rome). 1843 studio in New York City. 1844 in Trenton, N.J. 1845 in Brooklyn, N.Y. 1847 in Philadelphia. 1852 in St. Louis. 1853 in Chicago, where speculated in real estate. 1854 or 1856, to Trenton. 1859 and 1860, and again 1866-81, studio at 51 West Tenth Street, New York City. 1861 worked in Studio Building, Boston. Visits to Newport, R.I., Maine, and Lake Champlain. 1863 accompanied Reverend J. C. Fletcher to Brazil to do illustrated book on hummingbirds of South America. Stayed until 1864. Made a Knight of the Order of the Rose by Emperor Dom Pedro II. 1865 to London. May have visited Holland and Belgium. 1866 visited Nicaragua. *Ca.* 1870, in Panama, Jamaica, and Puerto Rico. Also traveled to British Columbia at some time. Painted in various parts of the United States, including Long Island, Vermont, Maine, Rhode Island, New Jersey, California, and Washington, D.C., until *ca.* 1885, when he settled in St. Augustine, Fla. Died St. Augustine.

References: Karolik Collection of Paintings. Robert G. McIntyre, *Martin Johnson Heade,* New York: 1948.

WINSLOW HOMER (1836–1910). Born Boston. *Ca.* 1842, moved to Cambridge, Mass. 1854 or 1855-57, apprenticed to J. H. Bufford, Boston lithographer. 1857 began contributing to *Harper's Weekly* (till 1875) 1859 to New York City, where maintained residence until 1880's. 1859–61 drawing school in Brooklyn, N.Y. Study at National Academy of Design night school. 1861 brief study with Frédéric Rondel. 1863–65 war paintings and illustrations. Late 1866 to fall 1867, in France. Contacts with French Impressionists speculative and undocumented. Visited Paris Universal Exposition, where exhibited two paintings. After return, summer 1868 and 1869, trips to White Mountains. 1870 to Adirondacks. 1872 moved to studio at 51 West Tenth Street, New York City. 1873 summer in Gloucester, Mass.; first watercolor series. 1875 in Virginia. 1878 summer at Houghton Farm, Mountainville, N.Y. 1880 summer in Gloucester. 1881 spring, to Tynemouth, England. Winter, 1881–82, possible return to United States. 1882 Tynemouth. November, 1882, returned to United States. Early summer, 1883, Atlantic City, N.J. Settled in Prout's Neck, Me., where remained till end of life, with trips to Bermuda, Bahamas, Cuba, Florida, Adirondacks, Quebec. Died Prout's Neck.

References: William Howe Downes, *The Life and Works of Winslow Homer,* Boston and New York: 1911. Lloyd Goodrich, *Winslow Homer,* New York, 1944. Lloyd Goodrich, *Winslow Homer,* New York, 1959.

THOMAS H. HOTCHKISS (*ca.* 1834–69). Born probably Hudson, N.Y. Worked in brickyard as young man. *Ca.* mid-1850's, began painting landscapes. Summer 1855, at Palenville, N.Y. 1856–57 in New York City. 1858, in Catskill, N.Y. 1856–59, and again in 1865, exhibited National Academy of Design. Friendship with Asher B. Durand, whose home at Catskill Clove he visited. 1857–58 painted at North Conway, N.H. By early 1860, to Europe. Stopped briefly in London and saw Ruskin's collection of Turners. Visited Paris en route to Rome. Most of his rare works executed in Italy, especially in Rome and Sicily. 1865 visited London. Friendship with members of Pre-Raphaelite group, especially the Linnells. Among American artists abroad, Sanford R. Gifford and Elihu Vedder were close friends and admirers. 1868 returned briefly to America. Died Taormina.

Reference: Barbara Novak O'Doherty, "Thomas H. Hotchkiss," *Art Quarterly,* XXIX, No. 1, Summer 1966.

WILLIAM MORRIS HUNT (1824–79). Born Brattleboro, Vt. Attended Harvard. *Ca.* mid-1840's, to Europe, and spent time in Rome with sculptor Henry Kirke Brown. Possible study in Paris with Barye. Studied sculpture in Düsseldorf. Short visit to United States. 1846 entered Thomas Couture's studio in Paris. *Ca.* 1850, became close friend of Millet. Moved to Barbizon. 1855 or 1856, returned to United States. Worked in Newport, R.I., and Brattleboro. 1857–58 in Azores. 1866 to Europe. 1875 to Mexico. 1862 settled in Boston. Studio burned in Boston fire of 1872. 1875 received commission for murals at State Capitol, Albany. Drowned on Isle of Shoals, N.H.

References: Groce and Wallace. Karolik Collection of Water Colors and Drawings. Henry C. Angell, *Records of William M. Hunt,* Boston: 1881. William Morris Hunt, *Hunt's Talks on Art,* ed. Helen Knowlton, first series, Boston: 1875; second series, Boston: 1884.

GEORGE INNESS (1825–94). Born near Newburgh, N.Y. Grew up New York City and Newark, N.J. 1841 worked as map engraver with Sherman & Smith, New York City. 1845 studied briefly with Regis F. Gignoux of Brooklyn, N.Y. 1847 to England and Italy for short visit. 1850 to Europe again. 1851, first child, Elizabeth, born in Florence. 1852 back to United States. 1854 to Paris, where son, George, Jr., was born. Studied works of Barbizon painters. 1855 returned to United States. Studio in New York City. 1860's lived in Medfield, Mass., Eagleswood, N.J., and Brooklyn. 1867 exhibited in Paris Universal Exposition. 1868 elected member National Academy of Design. 1870 to London, Paris, Rome. Until 1872, in Italy. 1873 to Boston. 1873–74 Paris and Normandy. 1875 to Boston again. Spent rest of life in New York City and Montclair, N.J., with travel to Nantucket, Milton-on-Hudson, N.Y., Florida, California, Niagara, Virginia, New Brunswick, Cuba. Died on visit to Scotland in town of Bridge-of-Allan.

References: Groce and Wallace. George Inness, Jr., *The Life, Art and Letters of George Inness,* New York: 1917. Le Roy Ireland, *The Works of George Inness, An Illustrated Catalogue Raisonné,* Austin and London: 1965.

JOHN FREDERICK KENSETT (1816–72). Born Cheshire, Conn. *Ca.* 1828, worked as engraver in New Haven, Conn., shop of father and uncle, Alfred Daggett. 1829 possibly in New York City in shop of Peter Maverick. Returned to New Haven to work with uncle. 1832 engraved for Daggett & Ely, New Haven. 1834 worked for Daggett & Hinman. 1835 in New York City. 1837 back in New Haven, returned to New York City in spring. 1838 in Albany. 1840 to New York City.

Sailed for England in June, with Asher B. Durand, John W. Casilear, and Thomas P. Rossiter. To Paris, copied paintings in Louvre. 1841 possible return to England for tour of Midlands. In Paris until 1843, when returned to England. 1845 back to Paris. Trip through Switzerland to Italy. 1847 returned to New York City. From 1847, traveled and worked in Adirondacks, Lake George, Lake Champlain, the Berkshires, Green Mountains, White Mountains, North Conway, N.H., Franconia Notch, N.H., the Catskills, Connecticut, Narragansett, R.I., Newport, R.I., New Jersey, Niagara, Mississippi, Ohio, Maine, the Rockies. These American travels punctuated by trips to Wales, Scotland, the Lake Country in England, and 1856 to Lakes of Killarney, Ireland. 1861 to England and Continent. 1865 possible trip to Europe, and one in 1867. 1849 elected full member of National Academy and The Century Association. 1859 appointed to U.S. Capitol Art Commission. 1860 in Washington, D.C. 1870 to Colorado and Rockies with Sanford R. Gifford and Worthington Whittredge. Founder and trustee of The Metropolitan Museum. Died New York City. 1873 famous sale of works brought $136,312.

References: James Kettlewell, *et al., John Frederick Kensett,* Saratoga Springs, N.Y.: 1967. John K. Howat, *John Frederick Kensett,* catalogue of an exhibition organized by The American Federation of Arts, New York, 1968. Kensett papers, The New York State Library, Albany; James Kellogg Collection, Richmond Hill; Kensett Journal of 1840–41, Frick Art Reference Library.

CHARLES BIRD KING (1785–1862). Born Newport, R.I. Studied with Edward Savage in New York City and 1805–12 with Benjamin West in London. Then spent several years in Philadelphia and Baltimore, settling finally in Washington, D.C., where he died. Created some outstanding still-life paintings and is noted also for his portraits of Indians.

Reference: Groce and Wallace.

JOHN LA FARGE (1835–1910). Born New York City. 1853 graduated from Mount St. Mary's College, Emmitsburg, Md. 1854–55 studied law briefly. 1856 to Europe, met the Goncourts. 1857 in Paris. Worked briefly with Thomas Couture. Traveled to Munich, Dresden, Copenhagen, Belgium, England. Winter 1857–58, returned to United States. 1859 to Newport to study with William Morris Hunt. Met William and Henry James. 1860 returned to New York. Trip to Louisiana. 1860–70 some of most important flower paintings and landscapes executed. *Ca.* 1863, imported Japanese color prints. 1865 illustrations for Tennyson's *Enoch Arden.* 1867–70 illustrations for *Riverside Magazine* and other books. 1876 *The Last Valley,* a landscape of 1867–68, won medal at Centennial Exposition, Philadelphia. Murals for Trinity Church, Boston. 1877 began working with glass. 1886 to Japan with Henry Adams. 1887 Ascension mural, Church of the Ascension, New York City. Windows for Trinity Church, Boston. 1889 awarded Legion of Honor by the French government. 1890–91 to South Seas with Henry Adams. 1893 series of lectures at The Metropolitan Museum, afterwards published as *Considerations on Painting* (New York: 1895). 1894 to Italy for first time. 1899 to Chartres with Henry Adams. Publications by La Farge include *An Artist's Letters from Japan* (New York: 1897); *The Higher Life in Art* (New York: 1905); *Reminiscences of the South Seas* (New York: 1911). Died Providence, R.I.

References: Royal Cortissoz, *John La Farge: A Memoir and a Study,* Boston and New York: 1911. *John La Farge,* catalogue of an exhibition at the Graham Gallery, New York, 1966. Henry La Farge, *John La Farge, Oils and Watercolors,* catalogue of an exhibition held at the Kennedy Galleries, New York, 1968.

FITZ HUGH LANE (1804–65). Born Gloucester, Mass., christened Nathaniel Rogers Lane. 1832 to Boston to study lithography under William S. Pendleton. 1837–ca. 1845, worked for Keith & Moore, Boston publishers, 1845–47 in partnership with John W. A. Scott. Ca. 1848, returned to Gloucester. 1849 built granite house there with brother-in-law Ignatius Winter. Ca. 1848, 1850, 1851, 1852, 1855, and 1863, trips to Maine, visiting Penobscot Bay area. Also visited New York City, Norwich, Conn., Baltimore, Washington, D.C., New Brunswick, Canada, and possibly St. John's, Puerto Rico. Died Gloucester.

References: Groce and Wallace. Karolik Collection of Paintings. John Wilmerding, *Fitz Hugh Lane, 1804–1865, American Marine Painter,* Salem, Mass.: 1964. Wilmerding, *Fitz Hugh Lane, the First Major Exhibition,* catalogue of an exhibition held at the De Cordova Museum, Lincoln, Mass., and the Colby College Art Museum, Waterville, Me.

SAMUEL FINLEY BREESE MORSE (1791–1872). Artist and inventor. Born Charlestown, Mass. 1810 graduated Yale. 1811 to London with Washington Allston. Studied with Benjamin West. 1812 won Gold Medal for statuette of *Dying Hercules.* 1815 returned to United States. 1823 to New York City. 1826 helped form and became president of National Academy of Design. 1826–45, and again in 1861 and 1862, served as president. 1829–32 to Europe again, with Ithiel Town, architect. Winter 1829–30, spent time in Rome with James Fenimore Cooper. Devoted self more fully after return to electromagnetic telegraph. 1838 returned to Europe. Impressed by Daguerre's invention, and after return helped introduce daguerreotype to America. 1844 sent telegraph message from Washington, D.C. to Baltimore: "What hath God wrought!" Died New York City.

References: Groce and Wallace. Karolik Collection of Paintings. Karolik Collection of Water Colors and Drawings. Oliver W. Larkin, *Samuel F. B. Morse and American Democratic Art,* Boston and Toronto: 1954.

WILLIAM SIDNEY MOUNT (1807–68). Born Setauket, L.I., N.Y. Spent youth at Stony Brook, L.I. 1824 apprentice to brother Henry, a sign-painter in New York City. Ca. 1826 entered school of National Academy of Design. 1832 elected an Academician. Until 1836, spent much time in New York City. Rest of life at Stony Brook. One of the most important genre artists in America, who never went abroad, Mount nonetheless read a great deal about the old masters and studied carefully the examples of European painting, especially Dutch, exhibited in New York City. Died Setauket.

References: Gardner and Feld. Groce and Wallace. Bartlett Cowdrey and H. W. Williams, Jr., *William Sidney Mount, 1807–1868: An American Painter,* New York: 1944.

WILLIAM PAGE (1811–85). Born Albany. Raised New York City. Ca. 1825, entered law office of Frederick de Peyster, remained less than a year. Began study with James Herring. 1826 studied with Samuel F. B. Morse. 1827 joined Presbyterian Church. Shortly after, entered Phillips Academy, Andover, Mass., to prepare for ministry. Left in 1828 after a few months. 1835–43 in New York City. 1837 elected member of National Academy of Design. 1844–47 in Boston. 1850 to Italy. Important member of American expatriate colony. Stayed mainly in Rome. Close friend of the Brownings. Became interested in Swedenborg and spiritualism in

Florence. 1859 to Paris and London. 1860 to United States. Lived near George Inness at Eagleswood, N.J. 1866 to Tottenville, Staten Island, N.Y. 1871–73 president of National Academy. Died Staten Island.

References: Groce and Wallace. Joshua C. Taylor, *William Page, the American Titian,* Chicago: 1957.

CHARLES WILLSON PEALE (1741–1827). Born Queen Anne's County, Md. Apprenticed to wood carver and saddler. 1762 went into saddling on own, soon included harness-making, upholstery, silversmithing. First lessons in painting from John Hesselius. 1767 to London, studied with Benjamin West. 1769–75 in Annapolis, Md. Served three years in the Continental Army. 1778 settled in Philadelphia. 1786 established Peale Museum in Independence Hall. Helped excavate a mastadon in Ulster County, N.Y. 1795 one of founders of The American Academy of Fine Arts, Philadelphia. 1805 one of founders of Pennsylvania Academy of Fine Arts. Invented improved kitchen chimney, steam bath, made false teeth. 1797 wrote *Essay on Building Wooden Bridges.* Married three times, fathered seventeen children, many of whom were named for famous artists and scientists. Died Philadelphia.

References: Gardner and Feld. Groce and Wallace. Charles Coleman Sellers, *Charles Willson Peale,* 2 vols., Philadelphia: 1947. Checklist Portraits and Miniatures by Charles Willson Peale, American Philosophical Society Transactions (1952), vol. 42, part 1.

RAPHAELLE PEALE (1774–1825). Born Annapolis, Md. Raised in Philadelphia. Son of Charles Willson Peale. Painter-inventor, best known for his still lifes. Patented preservative for ship timbers, developed plan for heating houses, published new theory on astral bodies. 1797–1800 ran museum in Baltimore with brother Rembrandt, also a painter. 1800 chief assistant to father at Peale Museum in Philadelphia. *Ca.* 1803–5, went into profile-cutting business in New England and the South. Died Philadelphia.

References: Gardner and Feld. Groce and Wallace.

JOHN FREDERICK PETO (1854–1907). Born Philadelphia. Self-taught, but possibly studied briefly 1878 at Pennsylvania Academy of the Fine Arts. 1875–89 painted in Philadelphia. 1889–1907 painted in Island Heights, N.J. 1879–81, 1885–87, exhibited at Pennsylvania Academy. 1881 exhibited at St. Louis Exposition. 1887 to Cincinnati, Ohio. 1894 to Lerado, Ohio. Died Island Heights.

Reference: Alfred Frankenstein, *After the Hunt: William Harnett and Other American Still Life Painters 1870–1900,* Berkeley and Los Angeles, Cal.: 1953.

JOHN QUIDOR (1801–81). Born Tappan, N.Y. 1811 to New York City. Short apprenticeship with John Wesley Jarvis, portrait painter, probably 1814–22, when Henry Inman studied with Jarvis. Earned living painting signs, banners, fire-engine panels. Genre fantasist, who illustrated themes from James Fenimore Cooper and, most often, Washington Irving. *Ca.* 1830, Charles Loring Elliott became his pupil. Full documentation on life and sources of his art still lacking. Known to have painted a large Biblical series of seven paintings, now lost, possibly 1843–49, in exchange for a farm in Adams County, Ill., never obtained. 1837–50 place of

residence doubtful. 1847–50 possibly in the West for some time. 1868 moved to Jersey City Heights, N.J., where died.

References: Karolik Collection of Paintings. John I. H. Baur, *John Quidor,* catalogue of an exhibition organized by the Munson-Williams-Proctor Institute, Utica, N.Y., 1965.

WILLIAM RIMMER (1816–79). Born Liverpool, England. To Nova Scotia at age two. To Boston at ten. Early experience in sign-painting and lithography. 1838 T. Moore's lithographic shop. 1839 partnership with Elbridge Harris. 1845 settled in Randolph, Mass. Painted, made shoes, studied medicine. 1855–63 practiced medicine in East Milton, Mass. Began making sculpture at this time. Lectured on art anatomy in Boston and Lowell, Mass. 1863–66 lived in Chelsea and opened school of drawing and modeling in Boston. 1866–70 director of School for Design for Women at Cooper Union, New York City. 1870 to Boston, reopened his school, till 1876 taught art anatomy classes. 1876–79 taught at art school of Boston Museum of Fine Arts. 1877 publication of *Art Anatomy.* 1878 worked with William Morris Hunt on Albany mural designs. Died South Milford, Mass.

References: Groce and Wallace. Truman H. Bartlett, *The Art Life of William Rimmer, Sculptor, Painter and Physician,* Boston: 1882. Lincoln Kirstein, *William Rimmer,* catalogue of an exhibition held at the Whitney Museum of American Art, 1946; and at the Museum of Fine Arts, Boston, 1947.

THEODORE ROBINSON (1852–96). Born Irasburg, Vt. 1855 to Barry, Ill. 1856 to Wisconsin. 1860 in Evansville Seminary, Wis. 1869 or 1870 to Chicago to study art. To Denver. Returned to Evansville. Did crayon portraits from photographs. 1874 to New York City. Entered National Academy of Design. 1876 to France. 1877 studied with Carolus-Duran and later with Gérôme; possibly also with Benjamin Constant. 1879 to New York City. 1880 to Evansville. 1881 to New York City. Elected to Society of American Artists. 1882 New York, Boston, Nantucket, Mass. 1884 to France in spring. Summer at Barbizon. 1885–86 in France. Possibly Holland. Late 1886 or early 1887, possible return to United States. Returned again later in 1887. 1888 friendship with Monet. 1888–93 frequent trips between Europe (mostly France) and America. Kept a studio at 11 East Fourteenth Street, New York City, which he used, generally, until his death, during winter months. Died New York City.

Reference: John I. H. Baur, *Theodore Robinson,* New York (Brooklyn Museum): 1946.

ALBERT PINKHAM RYDER (1847–1917). Born New Bedford, Mass. *Ca.* 1870 to New York City. Studied at National Academy of Design. Taught informally by William E. Marshall, portraitist and engraver. 1873 first shown at National Academy. 1877 helped found Society of American Artists. 1878–87 exhibited there. 1877 to London for a month. Summer 1882, toured England with Daniel Cottier; they then visited France, Holland, Spain, Italy, and Tangier accompanied by Olin Warner. Visited studio of Matthew Maris. 1887 and 1896 short trips across Atlantic, mainly for the boat ride, stopping for a few weeks in London. From mid-1890's, lived at 308 West Fifteenth Street, New York City for *ca.* fifteen years. Spent last two years in Elmhurst, L.I., N.Y. Died Elmhurst.

Reference: Lloyd Goodrich, *Albert P. Ryder,* New York: 1959.

ROBERT SALMON (1775–*ca.* 1848–51). Born Whitehaven, Cumberland, England. 1800 earliest dated works already show maturity. 1806–11 to Liverpool. 1811–22 Greenock, Scotland. 1822–25 Liverpool again. Brief return to Greenock. Late 1826, to London, shortly after in Southampton and North Shields. 1828 to America, settling in Boston, where he had an important influence on the development of American marine painting. 1839 won silver medal from Massachusetts Charitable Mechanics Association's second annual exhibition and fair. 1842 returned to Europe.

References: Groce and Wallace. John Wilmerding, *Robert Salmon, The First Major Exhibition,* catalogue of an exhibition held at the De Cordova Museum, Lincoln, Mass., 1967.

JOHN SINGER SARGENT (1856–1925). Born Florence of American parents. Spent childhood traveling: Nice, London, Paris, Spain, Switzerland, Italy. 1868–69 Rome, wintered in studio of Carl Welsch, German-American artist. 1870 studied at Accademia delle Belle Arti, Florence. 1871–72 Dresden. 1874 Venice, entered studio of Carolus-Duran, Paris. 1876 first visit to United States. May-August saw Philadelphia Centennial. 1877 first entry in Paris Salon. 1878 first work shown in America at Society of American Artists, National Academy of Design. Whistler also shown for first time. 1879 Spain, met Henry Adams in Seville. 1880 Morocco, Holland, Venice. 1884 Paris, exhibited *Madame Gautreau* at Salon. 1885 took Whistler's old studio at 13 Tite Street, London. Visited by Henry James. 1887–88 America. Newport, R.I., and Boston. 1890 commission to decorate Boston Public Library. Winter in Egypt. 1893 nine pictures at World's Columbian Exposition, Chicago. 1895 installed part of Boston Public Library decorations. 1916 murals installed at Boston Public Library. Commissioned to do rotunda at Museum of Fine Arts, Boston. 1921 rotunda decorations installed. Commissioned to do stairway. 1922 murals for Widener Library, Harvard University. Died London.

References: David McKibbin, *Sargent's Boston,* Boston (Museum of Fine Arts): 1956. Donelson F. Hoopes, *The Private World of John Singer Sargent,* catalogue of an exhibition held at The Corcoran Gallery of Art, Washington, D.C., 1964.

GILBERT STUART (1755–1828). Born in North Kingstown Township, R.I. 1761 to Newport, R.I. 1771/72 to Scotland with Cosmo Alexander, Scottish artist. 1773 returned to America. 1775 to London. 1777–82 worked with Benjamin West. Remained in London till 1787, when moved to Dublin. 1792 returned to United States and launched a successful career, furthered considerably by his portraits of George Washington. Painted in New York City, Philadelphia, Germantown, Pa., Washington, D.C., Bordentown, N.J. From 1805 on, in Boston.

References: Gardner and Feld. Groce and Wallace. James Thomas Flexner, *Gilbert Stuart,* New York: 1955. John Hill Morgan, *Gilbert Stuart and His Pupils,* New York (New-York Historical Society): 1939. Lawrence Park, *Gilbert Stuart,* 4 vols., New York: 1926.

THOMAS SULLY (1783–1872). Born at Horncastle, England. 1792 to Charleston, S.C. Studied Richmond, Va. 1801 to Norfolk, Va. 1806 to New York City. 1807 to Boston, where met Gilbert Stuart. 1808 settled in Philadelphia. 1809 to London, where he was influenced by Sir Thomas Lawrence. 1810 back to Philadelphia. 1838 again in England, where painted Queen Victoria. Occasional visits to Baltimore, Washington, D.C., Boston, Charleston, Providence, Richmond. Died Philadelphia.

References: Gardner and Feld. Groce and Wallace. Edward Biddle and Mantle Fielding, *The Life and Works of Thomas Sully,* Philadelphia: 1921.

JOHN TRUMBULL (1756–1843). Born Lebanon, Conn. 1773 graduated from Harvard. From 1775–77, officer in the Continental Army. 1780 to London to study with Benjamin West; imprisoned as spy in retaliation for hanging of Major John André. Returned to America after release. 1784–89 back in London. Began work on scenes of American Revolution. 1794–1804 and 1808–16 returned to London. Received commission for four large historical paintings for Capitol Rotunda. 1816–35 president of American Academy of Fine Arts. 1831 collection of his works sold to Yale and formed nucleus of Yale University Art Gallery. Died New York City.

References: Gardner and Feld. Groce and Wallace. *The Autobiography of Colonel John Trumbull,* ed. Theodore Sizer, New Haven, Conn.: 1953. Theodore Sizer, *The Works of Colonel John Trumbull, Artist of the American Revolution,* New Haven: 1950.

JOHN HENRY TWACHTMAN (1853–1902). Born Cincinnati, Ohio. 1868 enrolled in evening school, Ohio Mechanics Institute. 1871 attended McMicken School of Design, Cincinnati. 1874 met Frank Duveneck. 1875 studied Royal Academy of Fine Arts, Munich. 1877 to Venice with Duveneck and W. M. Chase. 1878 back to Cincinnati. 1879 in New York City, member Society of American Artists. On staff of Cincinnati Women's Art Association. 1880 taught at Duveneck's art school in Florence. 1881 Europe. In Holland with J. Alden and John Weir. 1882 to Cincinnati. 1883 to Paris to study at Académie Julian. 1886–87 back to United States; painted cyclorama in Chicago. 1888 Greenwich, Conn., Hemlock Pool series. 1889 taught at Art Students League, New York City. 1893 silver medal at World's Columbian Exposition, Chicago. 1894 taught at Cooper Union, New York City. 1897 helped form group known as The Ten American Painters in New York City. 1900 summer in Gloucester, Mass. Died Gloucester.

Reference: John Henry Twachtman, catalogue of a retrospective exhibition held at the Cincinnati Art Museum, 1966.

JOHN VANDERLYN (1775–1852). Born Kingston, N.Y. Studied with Archibald Robertson, and briefly with Gilbert Stuart. 1796 sent to Paris by Aaron Burr. 1801 returned to New York City. *Ca.* 1803, abroad again, where he remained for nearly twelve years, two in Rome, the rest in Paris. 1808 important historical painting, *Marius Amid the Ruins of Carthage,* earned Gold Medal from Napoleon. 1815 returned to America and 1819 exhibited panorama of Versailles in specially-built Rotunda, City Hall Park, New York City. 1837, after much difficulty and rivalry with John Trumbull, got a Congressional commission to do *The Landing of Columbus* for the Capitol Rotunda. Returned to Paris to complete the painting. Died in Kingston.

References: Gardner and Feld. Groce and Wallace. Ms. of biography by Robert Gosman in The New-York Historical Society.

ELIHU VEDDER (1836–1923). Born in New York City. Childhood in Schenectady, N.Y. Some study with Tompkins H. Matteson at Sherburne, N.Y. 1856 to France, where studied eight months in Picot's atelier, Paris. Then to Italy, where met Thomas Hotchkiss. 1861 to New York City, then to Boston. 1865 elected full member of National Academy of Design. 1865 returned to Europe, stopping in England and France. Settled in Rome, with frequent visits to America. 1876 visited

London. 1884 published his famous illustrations to *Omar Khayyam.* Did much mural decoration in later life. Died Rome.

References: Groce and Wallace. Elihu Vedder, *The Digressions of "V,"* Boston and New York: 1910. Regina Soria, "Elihu Vedder's Mythical Creatures," *Art Quarterly,* XXVI, No. 2 (Summer 1963), 181–93. John C. Van Dyke, *The Works of Elihu Vedder,* catalogue of an exhibition held at the American Academy of Arts and Letters, New York, 1937.

BENJAMIN WEST (1738–1820). Born Springfield, Pa. Late 1759, to Italy. Spent time in Rome, visited Florence, Venice, Bologna. 1763 to London. 1772 became historical painter to George III. Charter member of Royal Academy. 1792–1820 president, with one year's exception. Extremely prominent in British art world. Studio a mecca for American artists abroad. Died London.

References: Gardner and Feld. Groce and Wallace. Grose Evans, *Benjamin West and the Taste of His Times.* Carbondale, Ill.: 1959.

JAMES ABBOTT MCNEILL WHISTLER (1834–1903). Born Lowell, Mass. 1843 to Russia, where father, Major Whistler, was civil engineer on St. Petersburg-Moscow railroad. 1845 drawing lessons at Imperial Academy of Science, St. Petersburg, and privately from officer Karitsky. 1847 and 1848 summers in England. 1848 remained in England at school at Portishead, near Bristol. 1849 returned to the United States. 1851 entered U.S. Military Academy at West Point. 1854 left West Point. Apprenticed for several months at Winans Locomotive Works. Then worked for U.S. Coast Geodetic Survey, etching maps and topographical plans. 1855 resigned. April, took studio in Washington, D.C. October, left for Europe; stopped in London en route to Paris. 1856–59 mostly in Paris. 1856 entered Académie Gleyre. 1858 met Bracquemond, Fantin-Latour, Courbet. 1859 to London, where lived most of rest of life. *Ca.* 1860, Joanna Heffernan became principal model. 1861 met Manet. 1863 met Swinburne, Morris, Burne-Jones. March, Paris. May, exhibited *The White Girl* at Salon des Refusés. 1865 painted with Courbet at Trouville. 1866 visited South America, mainly Chile. 1867 exhibited four paintings in American section of Paris Universal Exposition. 1877 Ruskin's criticism of *The Falling Rocket* in *Fors Clavigera.* 1878 Whistler-Ruskin trial. Whistler awarded a farthing's damages without costs. 1879–80 in Venice. 1884 Holland. 1885 delivered the Ten O'Clock lecture in Prince's Hall. 1887 to Holland and Belgium. 1888 to Paris and met Mallarmé, who agreed to translate the Ten O'Clock. 1889 summer in Holland. 1893-95 lived in Paris. Rest of life back and forth between London and Paris, with trips to Italy, the Mediterranean, Holland. Died London.

References: E. R. and J. Pennell, *The Life of James McNeill Whistler,* 2 vols., London and Philadelphia: 1908. Denys Sutton, *Nocturne: The Art of James McNeill Whistler,* London: 1963. James McNeill Whistler, *The Gentle Art of Making Enemies,* London and New York: 1890, 1943. Andrew McLaren Young, *James McNeill Whistler,* catalogue of an exhibition held at M. Knoedler & Co. galleries, New York, and Arts Council of Great Britain, Ipswich, Suffolk, 1960.

RICHARD CATON WOODVILLE (1825–55). Born Baltimore, Md. Attended St. Mary's College, Baltimore, a boy's school where may have studied with the English artist Samuel Smith or with Joseph Hewitt. Also may have studied with Alfred Jacob Miller. May have known Robert Gilmor's collection of Dutch and Flemish paintings, which also included at least two genre paintings by Mount. 1842–43

registered as medical student at University of Maryland. 1845 to Düsseldorf studying first at Düsseldorf Academy, then under Carl Ferdinand Sohn. 1847–52 contributed paintings to American Art-Union. 1851–55 in France and England. Died London.

Reference: Francis S. Grubar, *Richard Caton Woodville,* catalogue of an exhibition held at The Corcoran Gallery of Art, Washington, D.C. 1967.

Additional references may be found in the Notes and the Bibliography

Bibliography

The Bibliography has been revised and updated for this edition.

PRIMARY SOURCES

The establishment of the Inventory of American Paintings Executed before 1914, National Collection of Fine Arts, Smithsonian Institution, Washington, D.C. has made it possible to have a fuller recording of little-known works by individual artists, substantially assisting our knowledge of the scope and content of these works.

Other than the art itself, for the student of nineteenth-century American art, nothing is more valuable than the primary source material located in manuscripts—journals, letters, and so on—and in contemporary periodicals. These are the sources from which American art history can and should be rewritten and re-evaluated.

MANUSCRIPT MATERIAL

Much manuscript material has been scrupulously gathered and microfilmed by the Archives of American Art in Detroit. Microfilms are also available for study at the New York office of the Archives. For this book, I have consulted especially:

American Art-Union papers. The New-York Historical Society.

Thomas Cole papers, photostatic copies in The New-York Historical Society. Originals in the collection of The New York State Library, Albany.

Asher Brown Durand papers. The New York Public Library.

Martin J. Heade papers. Archives of American Art. Heade-Church correspondence.

William Sidney Mount papers. Suffolk Museum and Carriage House, Stony Brook, Long Island. Microfilm in The New York Public Library.

A good guide to manuscript collections in America is:

HAMER, PHILIP M. (ed.). *A Guide to Archives and Manuscripts in the United States*. Compiled for the National Historical Publications Commission. New Haven: Yale University Press, 1961.

CONTEMPORARY PERIODICALS

An excellent guide to nineteenth-century periodicals is:

POOLE, WILLIAM FREDERICK. *An Index to Periodical Literature*. New York and London: 1853. 3d ed., Boston: 1882. First Supplement, Boston: 1888. Second Supplement, Boston: 1895. Third Supplement, Boston: 1897. Fourth Supplement, Boston: 1903.

Among the periodicals in which I found material especially useful for the study of American painting were: *The Crayon; The Dial; New York Mirror; North American Review; The Knickerbocker Magazine; Southern Literary Messenger; Cosmopolitan Art Journal; The Literary World; The New York American.*

CONTEMPORARY CRITICISM AND HISTORIES

BENJAMIN, SAMUEL GREENE WHEELER. *Art in America: A Critical and Historical Sketch.* New York: Harper & Bros., 1880.

DICKSON, HAROLD (ed.). *Observations on American Art: Selections from the Writings of John Neal (1793–1876).* State College, Pa.: Pennsylvania State College Studies, No. 12, 1943.

DUNLAP, WILLIAM. *A History of the Rise and Progress of the Arts of Design in the United States.* 2 vols. New York: 1834. Reissued, ed. with additions by F. W. BAYLEY and C. E. GOODSPEED. 3 vols. Boston: 1918. Revised, enlarged edition, ed. ALEXANDER WYCKOFF, preface by WILLIAM P. CAMPBELL. 3 vols. New York: Blom, 1965.

JARVES, JAMES JACKSON. *Art Hints, Architecture, Sculpture and Painting.* New York: Harper & Bros., 1855.

————. *The Art-Idea.* New York: Hurd and Houghton, 1864. Reissued, ed. BENJAMIN ROWLAND, JR.; Cambridge, Mass.: The Belknap Press of Harvard University Press, 1960.

————. *Art Thoughts.* New York: Hurd and Houghton, 1869.

LANMAN, CHARLES. *Letters from a Landscape Painter.* Boston: J. Munroe and Co., 1845.

SHELDON, GEORGE WILLIAM. *American Painters.* New York: Appleton, 1879.

TUCKERMAN, HENRY T. *Book of the Artists.* New York: Putnam, 1867. Reprinted New York: James F. Carr, 1966.

A useful modern compendium of original sources is:

McCOUBREY, JOHN W. *American Art, 1700–1960, Sources and Documents.* Englewood Cliffs, N.J.: Prentice-Hall, 1965.

SECONDARY SOURCES

EXHIBITION RECORDS

COWDREY, MARY BARTLETT (ed.). *American Academy of Fine Arts and American Art-Union, 1816–1852.* 2 vols. New York: New-York Historical Society, 1953.

————. *National Academy of Design Exhibition Record, 1826–1860.* 2 vols. New York: Printed for The New-York Historical Society, 1943.

NAYLOR, MARIA K. (ed.). *The National Academy of Design Exhibition Record, 1861–1900.* 2 vols. New York: Kennedy Galleries Inc., 1973.

RUTLEDGE, ANNA WELLS (ed.). *The Pennsylvania Academy of the Fine Arts, 1807–1870; The Society of Artists, 1800–1814; The Artists' Fund Society, 1835–1845.* Cumulative record of exhibition catalogues. Philadelphia: American Philosophical Society, 1955.

ENCYCLOPEDIAS AND DICTIONARIES

An early work of interest is:

CLEMENT, CLARA E., and HUTTON, LAURENCE (eds.). *Artists of the Nineteenth Century and Their Works.* 2 vols. Boston: Houghton, Osgood and Co., 1879.

The best biographical encyclopedia to date is:

GROCE, GEORGE C., and WALLACE, DAVID H. *The New-York Historical Society's Dictionary of Artists in America 1564–1860.* New Haven: Yale University Press, 1957.

Also helpful is:

JOHNSON, ALLAN and MALONE, DUMAS (eds.). *The Dictionary of American Biography.* 20 vols. New York: Scribner's, 1928–36. Vol. XXI, Supplement 1 (to December 31, 1935), 1944. Vol. XXII, Supplement 2 (to December 31, 1940), 1958.

MUSEUM CATALOGUES OF SPECIAL INTEREST FOR BIOGRAPHICAL INFORMATION

GARDNER, ALBERT TEN EYCK, and FELD, STUART P. *American Paintings: A Catalogue of the Collection of The Metropolitan Museum of Art.* Vol. I: *Painters Born by 1815.* New York: Metropolitan Museum, 1965.

M. and M. Karolik Collection of American Paintings 1815–1865. Museum of Fine Arts, Boston: Museum of Fine Arts, 1962.

M. and M. Karolik Collection of American Water Colors and Drawings 1800–1875. 2 vols. Boston: Museum of Fine Arts, 1962.

GENERAL BOOKS ON AMERICAN ART

Older works include:

BURROUGHS, ALAN. *Limners and Likenesses: Three Centuries of American Painting.* Cambridge, Mass.: Harvard University Press, 1936.

CAFFIN, CHARLES HENRY. *The Story of American Painting.* New York: Frederick A. Stokes, 1907.

HAGEN, OSKAR. *The Birth of the American Tradition in Art.* New York, London: Scribner's, 1940.

HARTMANN, SADAKICHI. *A History of American Art.* 2 vols. Boston: L. C. Page, 1902.

ISHAM, SAMUEL. *The History of American Painting.* New York: Macmillan, 1905.

LA FOLLETTE, SUZANNE. *Art in America.* New York: Harper, 1929.

The best recent general books are:

BARKER, VIRGIL. *American Painting: History and Interpretation.* New York: Macmillan, 1950.

FLEXNER, JAMES THOMAS. *First Flowers of Our Wilderness: American Painting.* Boston: Houghton Mifflin, 1947.

————. *The Light of Distant Skies, 1760–1835.* New York: Harcourt, Brace, 1954.

————. *That Wilder Image.* Boston: Little, Brown, 1962.

LARKIN, OLIVER W. *Art and Life in America.* New York: Holt, Rinehart & Winston, 1949, 1960.

RICHARDSON, E. P. *Painting in America.* New York: Crowell, 1956.

————. *A Short History of Painting in America.* New York: Crowell paperback, 1963.

WILMERDING, JOHN. *American Art.* The Pelican History of Art. Harmondsworth, New York: Penguin Books, 1976.

Recent studies of specific themes include:

CORN, WANDA M. *The Color of Mood: American Tonalism 1880–1910.* Exhibition Catalogue. M. H. de Young Memorial Museum, San Francisco: 1972.

GERDTS, WILLIAM H. and BURKE, RUSSELL. *American Still Life Painting.* New York: Praeger, 1971.

HOWAT, JOHN K. *The Hudson River and Its Painters.* New York: Viking, 1972.

MCSHINE, KYNASTON (ed.). Essays by Barbara Novak, Robert Rosenblum, John Wilmerding. *The Natural Paradise, Painting in America 1800–1950.* Exhibition Catalogue. New York: Museum of Modern Art, 1976.

NAEF, WESTON J. and WOOD, JAMES N. Essay by Therese Thau Heyman. *Era of Exploration: The Rise of Landscape Photography in the American West, 1860–1885.* Exhibition Catalogue. Albright-Knox Gallery, Metropolitan Museum of Art, New York: 1975.

WILLIAMS, JR., HERMANN WARNER. *Mirror to the American Past: A Survey of American Genre Painting 1750–1900.* Greenwich, Conn.: New York Graphic Society, 1973.

WILMERDING, JOHN. *A History of American Marine Painting.* Salem: Peabody Museum, Boston: Little, Brown, 1968.

MONOGRAPHS

Allston

RICHARDSON, E. P. *Washington Allston: A Study of the Romantic Artist in America.* Chicago: University of Chicago Press, 1948. New York: Apollo, 1967.

Bingham

BLOCH, E. MAURICE. *George Caleb Bingham. The Evolution of an Artist. A Catalogue Raisonné.* 2 vols. Berkeley and Los Angeles: University of California Press, 1967.

Copley

PROWN, JULES DAVID. *John Singleton Copley.* 2 vols. Cambridge, Mass.: Harvard University Press, 1966.

Cole

MERRITT, HOWARD S. *Thomas Cole.* Exhibition Catalogue. Memorial Art Gallery of the University of Rochester: 1969.

NOBLE, Rev. LOUIS L. *The Course of Empire, Voyage of Life and Other Pictures of Thomas Cole, N.A.* New York: Cornish, Lamport, & Co., 1853. Reissued, ed. ELLIOT S. VESSELL; Cambridge, Mass.: Harvard University Press, 1964.

SEAVER, ESTHER I. *Thomas Cole, 1801–1848, One Hundred Years Later.* Exhibition Catalogue. Wadsworth Atheneum, Hartford, Conn: 1948.

Durand

DURAND, JOHN. *The Life and Times of Asher B. Durand.* New York: Scribner's, 1894.

LAWALL, DAVID B. *A. B. Durand 1796–1886.* Exhibition Catalogue. Montclair Art Museum, Montclair, New Jersey: 1971.

LAWALL, DAVID B. *Asher B. Durand.: A Documentary Catalogue of the Narrative and Landscape Paintings.* New York: Garland Publishing Inc., 1978.

Eakins

GOODRICH, LLOYD. *Thomas Eakins, His Life and Work.* New York: Whitney Museum of American Art, 1933.

Harnett

FRANKENSTEIN, ALFRED. *After the Hunt: William Harnett and Other American Still Life Painters 1870–1900.* Berkeley and Los Angeles: University of California Press, 1953.

Heade

MCINTYRE, ROBERT G. *Martin Johnson Heade.* New York: Pantheon Press, 1948.

STEBBINS, THEODORE E. JR. *The Life and Works of Martin Johnson Heade,* New Haven: Yale University Press, 1975.

Homer

GOODRICH, LLOYD. *Winslow Homer.* Published for the Whitney Museum of American Art. New York: Macmillan, 1944.

WILMERDING, JOHN. *Winslow Homer.* New York: Praeger, 1972.

Lane

WILMERDING, JOHN. *Fitz Hugh Lane, 1804–1865, American Marine Painter.* Salem, Mass.: Essex Institute, 1964.

————. *Fitz Hugh Lane.* New York: Praeger, 1971.

Mount

COWDREY, BARTLETT, and WILLIAMS, H. W., JR. *William Sidney Mount, 1807–1868: An American Painter.* Published for The Metropolitan Museum of Art. New York: Columbia University Press, 1944.

FRANKENSTEIN, ALFRED. *William Sidney Mount.* New York: Abrams, 1975.

Ryder

GOODRICH, LLOYD. *Albert P. Ryder.* New York: Braziller, 1959.

See biographical references for more extensive listings of monographs. Excellent additional bibliographies can be found in Neil Harris, *The Artist in American Society,* and Oliver W. Larkin, *Art and Life in America. The Magazine of Art,* XXXIX, No. 7 (November, 1946), contains a selected bibliography by Elizabeth McCausland (pp. 329–49) that is useful up to that date.

BOOKS OF RELATED INTEREST

ADAMS, HENRY. *The Education of Henry Adams.* Boston and New York: Houghton Mifflin, 1927.

————. *The United States in 1800.* Ithaca, N.Y.: Cornell University Press, 1955.

BODE, CARL (ed.). *American Life in the 1840's.* New York: Doubleday, Anchor Books, 1964.

CERAM, C. W. *Archaeology of the Cinema.* New York: Harcourt, Brace and World, 1965.

COKE, VAN DEREN. *The Painter and the Photograph.* Albuquerque, N.M.: University of New Mexico Press, 1964.

GIFFORD, DON (ed.). *The Literature of Architecture.* New York: Dutton, 1966.

GOMBRICH, E. H. *Art and Illusion.* Bollingen Series XXXV, 5. New York: Pantheon, 1960.

HARRIS, NEIL. *The Artist in American Society.* New York: Braziller, 1966.

HIMMELFARB, GERTRUDE. *Darwin and the Darwinian Revolution.* New York: Doubleday, Anchor Books, 1962.

HUTH, HANS. *Nature and the American.* Berkeley: University of California Press, 1957.

Ideas and Beliefs of the Victorians. Foreword by HARMAN GRISEWOOD. New York: Dutton, 1966.

KAZIN, ALFRED, and AARON, DANIEL (eds.). *Emerson: A Modern Anthology.* Boston: Houghton Mifflin, 1958.

KOUWENHOVEN, JOHN A. *Made in America.* Garden City, N.J.: Doubleday, 1948; New York: Doubleday, Anchor Books, 1962.

MARTINEAU, HARRIET. *Society in America,* ed. SEYMOUR MARTIN LIPSET. Abridged. New York: Doubleday, Anchor Books, 1962.

MARX, LEO. *The Machine in the Garden: Technology and the Pastoral Ideal in America.* New York: Oxford University Press, 1964.

MILLER, PERRY. *The American Transcendentalists.* New York: Doubleday, Anchor Books, 1957.

————. *Errand into the Wilderness.* New York: Harper, Harper Torchbooks, 1964.

————. *The Life of the Mind in America, From the Revolution to the Civil War.* New York: Harcourt, Brace and World, 1965.

———— (ed.). *Margaret Fuller: A Selection from her Writings and Correspondence.* New York: Doubleday, Anchor Books, 1963.

NEWHALL, BEAUMONT. *The Daguerreotype in America.* Duell, Sloan & Pearce, 1961.

PODMORE, FRANK. *Mediums of the Nineteenth Century.* 2 vols. New Hyde Park, N.Y.: University Books, 1963.

REINGOLD, NATHAN (ed.). *Science in Nineteenth-Century America: A Documentary History.* New York: Hill and Wang, American Century Series, 1964.

ROURKE, CONSTANCE. *The Roots of American Culture.* New York: Harcourt, Brace, 1942. New edition, preface by Van Wyck Brooks; Fort Worth, Tex.: Harvest, 1965.

SANFORD, CHARLES L. (ed.). *Quest for America 1810–1824.* New York: Doubleday, Anchor Books, 1964.

SMITH, HENRY NASH (ed.). *Popular Culture and Industrialism, 1865–1890.* New York: Doubleday, Anchor Books, 1967.

SWIFT, LINDSAY. *Brook Farm.* Reissued with introduction by JOSEPH SCHIFFMAN. New York: Citadel, Corinth Books, 1961.

TAFT, ROBERT. *Photography and the American Scene.* New York: Dover, 1964.

TROLLOPE, FRANCES. *Domestic Manners of the Americans,* ed. DONALD SMALLEY. New York: Random House, Vintage Books, 1960.

VOGEL, STANLEY M. *German Literary Influences on the American Transcendentalists.* New Haven, Conn.: Yale University Press, 1955.

WÖLFFLIN, HEINRICH. *Principles of Art History.* New York: Dover, 1932.

List of Illustrations

1-1 John Singleton Copley *Mrs. Theodore Atkinson, Jr. (Lady Frances Wentworth)*

1-2 Anonymous *Lavinia Van Vechten*

1-3 Anonymous *Girl in Red*

1-4 Attributed to John Watson *Mrs. Kiliaen Van Rensselaer (Maria Van Cortlandt)*

1-5 Robert Feke *Mrs. Josiah Martin*

1-6 John Singleton Copley *Mrs. Joseph Mann (Bethia Torrey)*

1-7 John Singleton Copley *The Royall Sisters*

1-8 John Singleton Copley *Mrs. Ezekiel Goldthwait* (detail)

1-9 Raphaelle Peale *Still Life*

1-10 John Singleton Copley *Portrait of Paul Revere*

1-11 John Singleton Copley *Portrait of Nathaniel Hurd*

1-12 John Singleton Copley *Portrait of Mrs. Jeremiah Lee*

1-13 John Singleton Copley *Mr. and Mrs. Thomas Mifflin*

1-14 John Singleton Copley *Mr. and Mrs. Ralph Izard*

1-15 John Singleton Copley *Mrs. John Montresor*

1-16 Gilbert Stuart *Mrs. John Bannister and her Son*

1-17 Gilbert Stuart *The Skater*

1-18 John Singleton Copley *Mrs. Ezekiel Goldthwait*

1-19 Gilbert Stuart *Mrs. Richard Yates*

1-20 John Singleton Copley *Portrait of Mrs. Seymour Fort* [?]

1-21 John Singleton Copley *Mrs. Richard Skinner*

1-22 Thomas Sully *John Myers*

1-23 Benjamin West *Agrippina Landing at Brundisium with the Ashes of Germanicus*

1-24 Benjamin West *Return of the Prodigal Son*

1-25 Benjamin West *The Death of Wolfe*

1-26 John Singleton Copley *Ascension of Christ*

1-27 John Singleton Copley *Watson and the Shark*

2-1 Washington Allston *Self Portrait, Rome*

2-2 Washington Allston *Tragic Figure in Chains*

2-3 Benjamin West *Death on the Pale Horse*

2-4 Washington Allston *Landscape with a Lake*

2-5 Washington Allston *Prophet Jeremiah Dictating to the Scribe Baruch*

2-6 Samuel F. B. Morse *Dying Hercules*

2-7 Benjamin West *Saul and the Witch of Endor*

2-8 Washington Allston *Saul and the Witch of Endor*

2-9 Washington Allston, Study for *Belshazzar's Feast*

2-10 Washington Allston *Moonlit Landscape*

2-11 Washington Allston *Coast Scene on the Mediterranean*

2-12 Caspar David Friedrich *Moonrise over the Sea*

2-13 Washington Allston *The Spanish Girl in Reverie*

2-14 Washington Allston *Flight of Florimell*

2-15 Washington Allston *Landscape, American Scenery: Time, Afternoon with a Southwest Haze*

2-16 Washington Allston *Elijah Being Fed by the Ravens*

2-17 Washington Allston *Ship in a Squall*

3-1 Thomas Cole *Study: Dream of Arcadia*

3-2 Thomas Cole *Expulsion from the Garden of Eden*

3-3 Thomas Cole *The Course of Empire: The Consummation of Empire*

3-4 Thomas Cole *The Course of Empire: Desolation*

3-5 Thomas Cole *The Voyage of Life: Manhood*

3-6 Thomas Cole *Landscape with Dead Tree*

3-7 Thomas Cole *Moonlight*

3-8 Thomas Doughty *Tintern Abbey*

3-9 Thomas Cole *View of Florence from San Miniato*

3-10 Thomas H. Hotchkiss *Torre di Schiave*

3-11 Thomas Cole *The Pilgrim of the Cross at the End of his Journey*

3-12 Thomas Cole *The Oxbow (the Connecticut River near Northampton)*

3-13 Thomas Cole *Vale and Temple of Segesta, Sicily*

3-14 Thomas Cole *View of the Falls of Munda near Portage on the Genesee Falls, New York (Mountain Landscape with Waterfall)*

4-1 Asher B. Durand *The Babbling Brook*

4-2 John F. Kensett *White Mountain Scenery*

4-3 Asher B. Durand *Head of a Roman*

4-4 Asher B. Durand *Imaginary Landscape: Scene from "Thanatopsis"*

4-5 Asher B. Durand *Sunset* (1838)

4-6 Asher B. Durand *Sunset* (1878)

4-7 Asher B. Durand *Kaaterskill Clove*

4-8 Asher B. Durand *Kindred Spirits*

4-9 Asher B. Durand *Study from Nature: Rocks and Trees*

4-10 Gustave Courbet *The Gour de Conches*

4-11 Asher B. Durand *Study from Nature: Stratton Notch, Vermont*

5-1 John F. Kensett *Shrewsbury River*

5-2 John F. Kensett *Bash-Bish Falls, South Egremont, Massachusetts*

5-3 John F. Kensett *Third Beach, Newport*

5-4 Frederic E. Church *The Heart of the Andes*

5-5 Frederic E. Church *Study of a Forest Pool*

5-6 Frederic E. Church *Blue Mountains, Jamaica, B.W.I.*

5-7 Albert Bierstadt *Wreck of the "Ancon" in Loring Bay, Alaska*

5-8 Albert Bierstadt *Indians*

5-9 Jeremiah P. Hardy *Catherine Wheeler Hardy and her Daughter*

5-10 John F. Kensett *Coast Scene with Figures*

5-11 Anonymous *Meditation by the Sea*

5-12 John F. Kensett *View from Cozzens' Hotel, near West Point*

5-13 Anonymous *Egg Salad*

5-14 Fitz Hugh Lane *Fresh Water Cove from Dolliver's Neck, Gloucester*

5-15 Anonymous *View of West Point from above Washington Valley*

5-16 Martin J. Heade *Storm over Narragansett Bay*

5-17 George Caleb Bingham *Fur Traders Descending the Missouri*

5-18 William Sidney Mount *Eel Spearing at Setauket*

5-19 William Sidney Mount *The Power of Music*

5-20 Piero della Francesca *The Flagellation*

6-1 Fitz Hugh Lane *The Burning of the Packet Ship "Boston"*

6-2 Fitz Hugh Lane *Gloucester from the Outer Harbor*

6-3 Robert Salmon *Harbor Scene*

6-4 Fitz Hugh Lane *Ships in Ice off Ten Pound Island, Gloucester*

6-5 Fitz Hugh Lane *New York Harbor*

6-6 Fitz Hugh Lane *Brace's Rock, Eastern Point, Gloucester*

6-7 Fitz Hugh Lane Study for *Brace's Rock, Eastern Point, Gloucester*

6-8 Photograph of "Harvest Moon" ruled off by Fitz Hugh Lane for inclusion in his drawing *Looking up Portland Harbor*

6-9 Fitz Hugh Lane *Looking up Portland Harbor*

6-10 Fitz Hugh Lane *View in Gloucester Harbor*

6-11 Fitz Hugh Lane *Owl's Head, Penobscot Bay, Maine*

6-12 Fitz Hugh Lane *Sea Shore Sketch*

6-13 Fitz Hugh Lane *Off Mount Desert Island*

7-1 Martin J. Heade *The Stranded Boat*

7-2 Martin J. Heade *Rocks in New England*

7-3 Martin J. Heade *Approaching Storm, Beach near Newport*

7-4 Martin J. Heade *Lake George*

7-5 Martin J. Heade *Dawn*

7-6 Claude Monet *Haystack at Sunset, Giverny*

7-7 Martin J. Heade *Sunset over the Marshes*

7-8 Martin J. Heade *Twilight, Salt Marshes*

7-9 Martin J. Heade *Salt Marshes, Newport, Rhode Island*

7-10 Martin J. Heade *Off Shore: After the Storm*

7-11 Gustave Courbet *The Waves (Seascape)*

7-12 Martin J. Heade *Hunters Resting*

7-13 Gustave Courbet *The Quarry*

7-14 Martin J. Heade *Magnolia Grandiflora*

7-15 John J. Audubon *Carolina Paroquet* (for Plate 26 of *The Birds of America*)

7-16 Martin J. Heade *Passion Flowers and Hummingbirds*

7-17 James Hamilton *Bayou in Moonlight*

8-1 William Sidney Mount *Dregs in the Cup (Fortune Telling)*

8-2 William Sidney Mount *Book of Perspective*, page 3

8-3 William Sidney Mount *Book of Perspective*, page 6

8-4 William Sidney Mount *Book of Perspective*, page 1

8-5 William Sidney Mount *Book of Perspective*, page 15

8-6 William Sidney Mount *Self Portrait with Flute*

8-7 William Sidney Mount *Dancing on the Barn Floor*

8-8 William Sidney Mount *Saul and the Witch of Endor*

8-9 William Sidney Mount *Farmers Nooning*

8-10 William Sidney Mount *California News*

9-1 George Caleb Bingham *Stump Speaking (County Canvass)*

9-2 George Caleb Bingham *Raftsmen Playing Cards*

9-3 Paul Cézanne *The Card Players*

9-4 George Caleb Bingham *Self Portrait*

9-5 George Caleb Bingham *The Concealed Enemy*

9-6 George Caleb Bingham *Wood-Boatmen on a River*

9-7 George Caleb Bingham *The Verdict of the People*

9-8 George Caleb Bingham *The Jolly Flatboatmen in Port*

9-9 George Caleb Bingham *Order No. 11*

9-10 George Caleb Bingham *The Palm Leaf Shade*

10-1 William Sidney Mount *Farmer Whetting his Scythe*

10-2 Winslow Homer *Veteran in a New Field*

10-3 Winslow Homer *The Morning Bell*

10-4 Winslow Homer *Croquet Scene*

10-5 Claude Monet *Women in a Garden*

10-6 Winslow Homer *The Bridle Path, White Mountains*

10-7 Winslow Homer *Girl with Pitchfork*

10-8 Winslow Homer *Prisoners from the Front*

10-9 Winslow Homer *Croquet Match*

10-10 Winslow Homer *Long Branch, New Jersey*

10-11 Winslow Homer *High Tide: The Bathers*

10-12 Winslow Homer *On the Beach*

10-13 Winslow Homer *Snap the Whip*

10-14 Nicholas Poussin *Bacchanal before a Herm*

10-15 Winslow Homer *Waiting for Dad*

10-16 Winslow Homer *Boys Wading*

10-17 Winslow Homer *Boys in a Pasture*

10-18 Winslow Homer *The Sick Chicken*

10-19 Winslow Homer *The Carnival*

10-20 William Sidney Mount *The Banjo Player*

10-21 Winslow Homer *Bo-Peep*

10-22 Winslow Homer *The Green Dory*

10-23 Winslow Homer *Hark, the Lark!*

10-24 Winslow Homer *Fisherfolk on the Beach at Tynemouth*

10-25 Winslow Homer *The Life Line*

10-26 Winslow Homer *Undertow*

10-27 Winslow Homer *Eight Bells*

10-28 Winslow Homer *The Gulf Stream*

10-29 Winslow Homer *The Turtle Pound*

10-30 Winslow Homer *Searchlight, Harbor Entrance, Santiago de Cuba*

10-31 Winslow Homer *West Wind*

10-32 Winslow Homer *Cape Trinity, Saguenay River, Moonlight*

10-33 Winslow Homer *Driftwood*

10-34 Winslow Homer *Early Morning after a Storm at Sea*

10-35 Winslow Homer *West Point, Prout's Neck*

11-1 Thomas Eakins *Max Schmitt in a Single Scull*

11-2 Thomas Eakins *Starting out after Rail*

11-3 Thomas Eakins *John Biglen in a Single Scull*

11-4 Thomas Eakins *Whistling for Plover*

11-5 Thomas Eakins Perspective study for *John Biglen in a Single Scull*

11-6 Thomas Eakins *The Artist and his Father Hunting Reed-Birds*

11-7 Photograph of a man running (Thomas Eakins)

11-8 Thomas Eakins *The Gross Clinic*

11-9 Thomas Eakins Study for *The Gross Clinic*

11-10 Thomas Eakins *The Agnew Clinic*

11-11 Thomas Eakins *William Rush and his Model*

11-12 Thomas Eakins *The Fairman Rogers Four-in-Hand*

11-13 Thomas Eakins *The Swimming Hole*

11-14 Thomas Eakins *The Crucifixion*

11-15 Thomas Eakins *Chess Players*

11-16 Thomas Eakins Perspective study for *Chess Players*

11-17 Thomas Eakins *Masked Woman Seated*

11-18 Thomas Eakins *Study of a Girl's Head*

11-19 Thomas Eakins *Home Scene*

11-20 Thomas Eakins *Miss Van Buren*

11-21 Thomas Eakins *The Thinker: Louis N. Kenton*

11-22 Thomas Eakins *Letitia Wilson Jordan Bacon*

11-23 Thomas Eakins *Portrait of Mrs. Edith Mahon*

12-1 Albert Pinkham Ryder *Moonlit Cove*

12-2 Albert Pinkham Ryder *The Race Track (Death on a Pale Horse)*

12-3 Albert Pinkham Ryder *Macbeth and the Witches*

12-4 Albert Pinkham Ryder *Evening Glow, the Old Red Cow*

12-5 Albert Pinkham Ryder *Jonah*

12-6 Albert Pinkham Ryder *Siegfried and the Rhine Maidens*

12-7 Albert Pinkham Ryder *Toilers of the Sea*

12-8 Albert Pinkham Ryder *Moonlight Marine*

12-9 Albert Pinkhham Ryder *Marine*

13-1 William Harnett *Still Life*

13-2 Richard Caton Woodville *Waiting for the Stage*

13-3 Charles Bird King *Poor Artist's Cupboard*

13-4 Thomas Eakins *Between Rounds*

13-5 William Harnett *After the Hunt*

13-6 John F. Peto *Still Life with Lanterns*

13-7 John F. Peto (formerly attributed to William Harnett) *Old Time Letter Rack (Old Scraps)*

13-8 William Harnett *A Study Table*

13-9 William Harnett *Old Models*

14-1 Gilbert Stuart *Mrs. Perez Morton*

14-2 John Quidor *The Money Diggers*

14-3 William Page *Self Portrait*

14-4 Sanford R. Gifford *Ruins of the Parthenon*

14-5 John Singer Sargent *The Wyndham Sisters: Lady Elcho, Mrs. Tennant, and Mrs. Adeane*

14-6 John Singer Sargent *Asher Wertheimer*

14-7 John Singer Sargent *Portrait of Paul Helleu, Sketching, and his Wife*

14-8 Mary Cassatt *Woman with a Dog*

14-9 John H. Twachtman *Hemlock Pool*

14-10 George Inness *Home of the Heron*

14-11 Thomas Dewing *The Recitation*

14-12 William Morris Hunt *The Ball Players*

14-13 James A. McNeill Whistler *The Lagoon, Venice: Nocturne in Blue and Silver*

14-14 James A. McNeill Whistler *The White Girl*

14-15 James A. McNeill Whistler *Head of an Old Man, Smoking*

14-16 James A. McNeill Whistler *Coast of Brittany: Alone with the Tide*

14-17 James A. McNeill Whistler *Crepuscule in Opal, Trouville*

14-18 James A. McNeill Whistler *Caprice in Purple and Gold No. 2: The Golden Screen*

14-19 Albert Pinkham Ryder *Flying Dutchman*

14-20 James A. McNeill Whistler *Arrangement in Grey and Black No. I: The Artist's Mother*

14-21 James A. McNeil Whistler *Nocturne in Black and Gold: The Falling Rocket*

14-22 John La Farge *The Last Valley*

14-23 Paul Gauguin *The Brooding Woman*

14-24 John La Farge *Maua, Our Boatman*

14-25 John La Farge *Flowers on a Window Ledge*

14-26 John La Farge *The Wolf Charmer*

14-27 Elihu Vedder *The Lair of the Sea Serpent*

14-28 William Rimmer *Flight and Pursuit*

15-1 John Sloan *Backyards, Greenwich Village*

15-2 Max Weber *Chinese Restaurant*

15-3 John Marin *Region of Brooklyn Bridge Fantasy*

15-4 John Marin *Maine Islands*

15-5 Marsden Hartley *Portrait of a German Officer*

15-6 Marsden Hartley *Smelt Brook Falls*

15-7 Arthur Dove *Sand Barge*

15-8 Arthur Dove *Life Goes On*

15-9　Charles Demuth　*Flowers*
15-10　Georgia O'Keeffe　*The White Flower*
15-11　Charles Demuth　*At a House in Harley Street* (illustration for *The Turn of the Screw*, by Henry James)
15-12　Georgia O'Keeffe　*Abstraction*
15-13　Charles Demuth　*I Saw the Figure Five in Gold*
15-14　Charles Sheeler　*Rolling Power*
15-15　Charles Sheeler　*American Landscape*
15-16　George Tirrell　*View of Sacramento, California, from across the Sacramento River*
15-17　Stuart Davis　*Owh! In San Pão*

15-18　Edward Hopper　*Early Sunday Morning*
15-19　Edward Hopper　*Nighthawks*
15-20　Ben Shahn　*Vacant Lot*
15-21　Andrew Wyeth　*That Gentleman*
15-22　Morris Graves　*Little Known Bird of the Inner Eye*
15-23　Jackson Pollock　*Number 1* (1948)
15-24　Willem de Kooning　*Door to the River*
15-25　Mark Rothko　*Number 10* (1950)
15-26　Robert Rauschenberg　*Canto XXXI* (illustration for Dante's *Inferno*)
15-27　Claes Oldenburg　*Dual Hamburgers*
15-28　Sol Lewitt　*Untitled Cube* (6)

Credits

Courtesy of Alinari: 5-20/ Courtesy of Cliché du Service de Documentation Photographique des Musées Nationaux: 10-5; 14-15; 14-20/ Courtesy of the Fogg Art Museum: 14-26/ Courtesy of the Frick Art Reference Library: 4-7; 5-5; 5-6; 10-32/ Courtesy of Sol Lewitt: 15-28/ Courtesy of the Museum of Fine Arts, Boston: 6-6/ Courtesy of the William Rockhill Nelson Gallery of Art: 9-10/ Photographed by the Philadelphia Museum of Art: 11-8/ Courtesy of Don Powell: 6-14/ Courtesy of Sandak: 5-19; 10-9; 10-33; 11-10/ Courtesy of Howard Young Galleries: 1-15.

The excerpt from John I. H. Baur's article "Peto and the American Trompe l'Oeil Tradition," which appeared in *Magazine of Art,* May, 1950, is reprinted by permission of The American Federation of Arts. The excerpt from *Painting and Reality,* by Étienne Gilson, Bollingen Series XXX-4, Copyright 1955 by the Trustees of the National Gallery of Art, is reprinted by permission of the Bollingen Foundation.

Index

Abstract Expressionism, 265, 281, 283, 286
Adam, Robert, 39
Adams, Henry, 235, 272, 276
Adams, John Quincy, 108
Adams, Samuel, 25
Agnew, Hayes, 200–201
Aids to Reflection (Coleridge), 47
Alexander, Cosmo, 32
Allston, Washington, 19, 25, 41, 43, 44–60, 150, 158, 188, 211, 212, 213, 214, 236, 239, 252, 257, 260; on colorism, 57, 58; and luminism, 55; on Michelangelo, 50
Analytical Cubism, 265
Anuskiewisz, Richard, 285
Arcadian or Pastoral State, The (Cole), 68
Armory Show (1913), 264
Art: and city, 277–79; and industrialism, 256, 257; and technology, 265, 272
Art, the Ideal of Art, and the Utility of Art (Bingham), 159
Art Poétique (Verlaine), 254
"Artist of the Beautiful, The" (Hawthorne), 60
Artist's Fund Society of Philadelphia exhibition, 158
Arts and Crafts movement (England), 257
Ash Can school, 263, 273
Asher, Elise, 225
Audubon, John James, 136
Avery, Milton, 285

Barbizon school, 245
Baudelaire, Charles, 252
Baur, John I. H., 48, 96, 102, 115, 122, 229, 231, 263
Baziotes, William, 285
Berenson, Bernard, 99
Bierstadt, Albert, 22, 82, 91, 94, 113, 119, 199, 270
Bingham, George Caleb, 105–6, 126, 152–64, 165; and spiritualism, 163

Binney, Horace, 236
Bird Maddened by the Whir of Machinery in the Air (Graves), 281
Blackburn, Joseph, 16
Blake, William, 40, 46, 49
Blaue Reiter, 268, 269
Bloch, E. Maurice, 156, 158, 159, 162
Bloom, Hyman, 283
Blythe, David Gilmour, 225
Boisbaudran, Lecoq du, 252
Boy with a Squirrel (Copley), 26
Boydell, John, 46
Bright Side, The (Homer), 171
Bruce, Captain R. G., 27
Bruegel, Pieter, 151
Brush, George de Forest, 264
Bryant, William Cullen, 84, 122
Bufford, John H., 166
Building of Carthage (Turner), 68
Burke, Edmund, 46
Business (Demuth), 274

Camera lucida, 108
Camera obscura, 108, 197
Cape Ann Historical Association, 112
Caravaggio, 22
Carlyle, Thomas, 48
Casilear, John W., 83
Cassatt, Mary, 243, 248
Cennini, Cennino, 127
Centennial Exhibition, Philadelphia (1876), 183, 199, 256
Cézanne, Paul, 87, 153, 155, 178, 220, 222
Champney, Benjamin, 119
Chapman, John Gadsby, 109, 158
Chardin, Jean-Baptiste Siméon, 222
Chassériau, Théodore, 257
Chateaubriand, François René, 38
Chatham, Earl of, 42
Chevreul, Michel Eugène, 59, 145
Chirico, Giorgio de, 126–27, 175, 223, 278

Christ Raising the Daughter of Jairus (Mount), 150

Christ-Janer, Albert, 159, 163

Church, Frederic Edwin, 82, 94, 113, 119, 198, 270, 281

Church of the Ascension, New York, 257

Classic 98, 104–5, 106, 107, 108, 112, 116, 122, 126, 128, 150, 156–57, 180, 184, 187, 262, 278

Classical, 39, 105, 108, 150, 202–3

Classicism, 18, 39, 157; in Bingham's art, 152, 156, 162; in Homer's art, 177, 180, 267; luminist 105–6, 155–56, 274

Cloudy Day, Rhode Island (Heade), 129

Cole, Thomas, 19, 51, 52, 61–79, 80, 82, 83, 85–87, 94, 109, 115, 138, 144, 161, 198, 211, 212, 213, 214, 217, 229, 249, 251, 255, 269; on truth, nature, and beauty, 70–71

Coleridge, Samuel Taylor, 47, 48

Colonial Cubism (Davis), 276

Colorism, 57, 285

Conceptual realism, 20, 21, 30, 111, 200, 221, 222, 224

Conceptualism, 18, 23, 29, 70, 87, 98, 101 110, 127, 129, 131, 153, 161, 220, 243–44, 245, 247, 255, 285, 287, 288; European, 264

Considerations on Painting (La Farge), 257

Cooper, James Fenimore, 122

Copley, John Singleton, 15–43, 49, 70, 97, 102, 117, 150, 157, 200, 208, 221, 236; colonial phase of, 19–20; early realism of, 22; and expatriate tradition, 27–43

Corot, Jean Baptiste Camille, 214

Cortissoz, Royal, 257

Cottier, Daniel, 214

Country School, The (Homer), 177

Courbet, Gustave, 59, 84, 87, 88–89, 91, 131–32, 133, 171, 172, 197, 251

"Course of Empire, The" (Cole), 68, 74

Courtly tradition, 16, 18, 19, 27

Crayon, The, 62, 89, 114

Cropsey Jasper Francis, 109

"Cross and the World, The" (Cole), 69, 74

Cubism, 226, 230, 264, 174, 283; Analytical, 265; Synthetic, 265, 276

Cuyp, Aelbert, 145

Dadaism, 226, 230, 274

Daguerre, Louis J. M., 197

Daguerreotype, 196, 197, 198

Darwin, Charles, 134

David, Jacques Louis, 158

Davis, Stuart, 123–24, 179, 225, 270, 276–77

Dead Bird (Ryder) 216

Death of Chatham (Copley), 42, 200

Death of Sardanapalus (Delacroix), 46

Death on the Pale Horse (West), 46

Degas, Edgar, 167, 172, 197, 243, 248

Delacroix, Eugène, 41, 46, 47, 49, 58, 88, 197, 212, 218, 257

Demuth, Charles, 225, 226, 264, 270, 273, 274

Denis, Maurice, 249

Destruction (Cole), 68

Dewing, Thomas Wilmer, 122, 246, 247, 285

Dickinson, Preston, 270

Discourses (Reynolds), 38, 40

Dom Pedro II, Emperor of Brazil, 136

Doughty, Thomas, 66–67, 115, 158

Dove, Arthur, 264, 268–70, 271, 273

Dream, 55–58, 60, 73, 120, 210, 237–38, 239, 252, 255, 285

Dunlap, William, 33, 238

Durand, Asher Brown, 59, 79, 80–91, 92, 128, 131, 138, 145, 166, 172, 173, 251

Dürer, Albrecht, 158

Duveneck, Frank, 263

Dying Hercules (Morse), 51, 62

Eakins, Thomas, 108, 109, 119, 122, 139, 140, 148, 183, 189, 191–210, 225, 230, 241, 248, 280, 286; and photography, 196–99

Eckhart, Meister, 223

Edwards, Jonathan, 22, 225

Eight, the, 263

El Greco, 218

Electrical Theory of the Universe, The— or the Elements of Physical and Moral Philosophy, 140

Elements of Logick (Andrews), 140

Emerson, Frederick, 140, 141

Emerson, Ralph Waldo, 22, 47 48, 61, 62, 99, 105, 110, 111, 119, 120, 121, 122–23, 134, 137, 223, 237, 252, 269, 270

Empiricism, 18, 20, 42, 124, 145

Expatriate tradition, 27–43, 237, 241, 252

Expressionism, 208, 211, 218, 283; Abstract 265, 268, 271, 281, 283, 286

Eyck, Jan van, 221

Feke, Robert, 16, 18

Flexner, James T., 94, 149, 166

Flower painting tradition, 133–36, 259, 270

Folk-art tradition, 15, 19, 99–103, 105, 267, 274

Forest of Arden, The (Ryder), 214

Fox Hunt, The (Homer), 188

Francesca, Piero della, 107, 108, 179

Francis, John F., 222

Frankenstein, Alfred, 221, 229, 233

Frankenthaler, Helen, 285

Friedrich, Caspar David, 55

Fry, Roger, 219

Fulton, Robert, 109, 140

Fuseli, Henry, 40, 41, 46, 49

Futurism, 259, 265, 273, 283; European, 268, 274

Gainsborough, Thomas, 30, 32, 236
Gardner, Albert Ten Eyck, 166, 170–71
Gargoyles of Notre Dame (Homer), 171
Gauguin, Paul, 174, 259
Gellatly, John, 214
Géricault, Jean Louis, 42
Gifford, Sanford Robinson, 240
Gilmor, Robert, Jr., 66, 115
Gilpin, William, 64
Gilson, Étienne, 221, 223
Glackens, William James, 263
Gleason's Pictorial Drawing Room, 86
Goethe, Johann Wolfgang von, 48, 137
Gombrich, E. H., 19, 98, 236
Goodrich, Lloyd, 166–67, 169, 170, 172, 182, 183, 215, 216
Grand Style, 19, 25, 30, 37, 38, 42, 49, 150, 282
Graves, Morris, 216, 281
Gray, Asa, 134
Greenough, Henry, 58, 238
Greenough, Horatio, 108, 150, 202
Greuze, Jean Baptiste, 158
Gross, Samuel D., 199
Guston, Philip, 283–84

Haberle, John, 231
Hals, Frans, 238, 241, 283
Hancock, John, 25
Harnett, William Michael, 22, 198, 221–34
Harper's Weekly, 166
Hartley, Marsden, 267-68
Hassam, Childe, 59, 89, 244
Hawthorne, Nathaniel, 44, 45, 46, 60
Hazlitt, William, 58
Heade, Martin Johnson, 22, 23, 91, 104, 122, 125–37, 227, 228, 251, 252, 270, 281
Healy, George P. A., 198
Hearn, W. Joseph, 200
Heda, Willem Claesz, 222
Hedge, Frederic Henry, 47, 147
Heffernan, Jo, 251
Henri, Robert, 263
Henry, Charles, 259
Herring Net, The (Homer), 187
Hiroshige, 171
History painting, 37, 38, 41–43, 50, 51, 61, 62, 65, 94, 150, 151, 152–53, 165, 200
Hogarth, William, 151, 153
Hokusai, 171
Homer, Winslow, 59, 89, 91, 119, 122, 124, 145, 165–90, 198, 213, 230, 241, 267, 278, 280; in England, 183–85; in Paris, 166–72; at Prout's Neck, 188–90
Hopper, Edward, 122, 174, 277–79

Hoppner, John, 236
Hotchkiss, Thomas H., 83
Hudson River school, 63, 79, 80, 81–82, 83, 84, 88, 92, 94, 95, 113, 115, 117, 172, 193, 281; tripartite division, 82, 84, 138
Hunt, William Morris, 247

Ideal, 37, 38, 63, 72, 79, 80, 82, 85, 91, 105, 117, 161, 249
Imitation, 63, 66–68, 71, 113–14, 160–61, 226, 228–29
Immaculates, the, 270
Impressionism, 59, 60, 89, 90, 91, 98, 121, 129, 165, 170, 173, 211, 239, 243–44, 245, 251, 265; dark, 263
Indiana, Robert, 225
Industrialism and art, 256, 257
Ingres, Jean Auguste Dominique, 197, 222
Inman, Henry, 158
Inness, George, 122, 245, 246, 247
Irving, Washington, 48, 240
Italian Shepherd Boy (Allston), 58

James, Henry, 165, 271
Jarves, James Jackson, 23, 50, 62, 80, 81, 93, 114, 115
Jeckyll, Tom, 247
Johns, Jasper, 225, 286, 287
Jouett, Matthew, 34
Judd, Donald, 287

Kahn, Gustave, 253
Kaprow, Allan, 225
Kensett, John Frederick, 22, 82, 83, 92, 99, 101, 103, 166, 172, 173, 251
King, Charles Bird, 158, 225
King Lear (West), 41
Klee, Paul, 212
Kline, Franz, 284–85
Knight, Elias David, 111
Kooning, Willem de, 282, 283–84
Kouwenhoven, John A., 108, 109

La Farge, John, 122, 166, 167, 171, 235, 257, 264, 270
La Porte Chinoise, Paris, 166
Laforgue, Jules, 253
Landscape painting, 23, 38, 61–65, 79, 82, 83, 94; Dutch, 113, 115; luminist, 97–98, 240; Oriental and Western attitudes toward, 137
Lane, Fitz Hugh, 23, 91, 99, 108, 109, 110–24, 125, 126, 162, 164, 166, 180, 197, 198, 230, 252, 267, 280, 281; primitivism of, 111
Larkin, Oliver W., 256
Leslie, C. R., 158
"Letters on Landscape Painting" (Durand), 89
Levine, Jack, 283
Lewitt, Sol, 287

Leyland, Frederick, 247
Lichtenstein, Roy, 225, 286
Limner tradition, 15, 16, 19
Lipman, Jean, 100
Little Wanton Boys (Sargent), 227
Lorrain, Claude, 68, 115, 158
Louis, Morris, 285
Louvre, the, 171, 178
Lucretius, 97
Luks, George B., 263
Luminism, 22, 48, 54, 55, 85, 91, 92–109,
 110, 125–26, 230, 270, 273, 278, 282;
 in Bingham's art, 152, 163; classicism
 in, 105–6, 116, 155, 274, 288; in Ho-
 mer's art, 178–79; and naturalism, 94;
 and panorama, 112–13; and spiritual-
 ism, 122

*M. and M. Karolik Collection of American
 Water Colors and Drawings 1800–1875*,
 102, 112, 118
McCormick, Gene E., 118, 122
McDermott, John F., 159
Machine and art, 140–42, 196, 271–72,
 276
Machine in the Garden, The (Marx), 109
McKim, Mead and White, 257
Mallarmé, Stéphane, 255
Manet, Édouard, 171, 172, 174, 197, 209,
 241
Mannerism, 63, 126, 128, 218
Marble Faun, The (Hawthorne), 44
Marey, Jules-Étienne, 197
Marguerite in Skating Costume (Eakins),
 207
Marin, John, 264, 265–67, 276
Maris, Matthew, 214
Marius Amid the Ruins of Carthage (Van-
 derlyn), 62
Marsh, Reginald, 225
Martin, John, 68
Marx, Leo, 109, 272, 274–75
Mathematics and art, 109, 119, 120, 134,
 135, 139–42, 148, 191, 195, 196, 252,
 255
Matisse, Henri, 234, 265
Matkovic, Tina, 287
Measure, 109, 119, 262, 285
Mechanical drawings, 108, 191
Mechanical methods, 108–9, 112–13, 119,
 148, 191, 262
Meissonier, Jean Louis Ernest, 233
Menéndez, Luis, 22
Mengs, Anton Raphael, 37–38
Michelangelo, 40, 49, 50, 158, 214
Miller, Perry, 22
Millet, Jean François, 247
Minimal art, 287
Missouri Republican, 152–53
*Modern Spiritualism, its Facts and Fanati-
 cisms, its Consistencies and Contradic-
 tions*, 147

Mondrian, Piet, 278
Monet, Claude, 59, 122, 129, 131, 145,
 167, 169, 172, 174, 244
Moonlight as theme, 53–54, 74, 188, 217
Morning Glories (Homer), 180
Morse, Samuel F. B., 19, 25, 51, 62, 109,
 140, 198
Mount, Robert Nelson, 141
Mount, William Sidney, 58–59, 106–8,
 109, 119, 122, 138–51, 158, 164, 165,
 166, 172, 178, 181–82, 189, 191, 196,
 198, 225; as luminist, 147–48; and
 spiritualism, 146–47
Munch, Edvard, 176, 218
Muybridge, Eadweard, 197
Mysteries of Udolpho (Radcliffe; Allston),
 46
Mysticism, 47, 256; Oriental, 213

National Academy exhibition, New York,
 158
National Academy of Design, 226
Neagle, John, 33, 158, 238
Neal, John, 115
Nelson, Edward D., 83, 87
Neoclassic eclecticism, 49
Neoclassic mode, 40
Neoclassicism, 37–39, 49, 67, 162
New York Mirror, 69–70, 71
New York News, 229
New York Tribune, 227
Newhall, Beaumont, 196
Newman, Barnett, 285
Newton, Sir Isaac, 108
Noble, Louis L., 72
*North American Arithmetic, The, Part
 Second, Uniting Oral and Written Exer-
 cises* (F. Emerson), 140
North American Review, 22, 62, 71
Nostalgia, 37, 48, 216, 229–30
Novalis (Baron Friedrich von Harden-
 berg), 48
Nymph of the Schuylkill (Rush), 201

O'Keeffe, Georgia, 270, 273
Old Violin, The (Harnett), 234
Oldenburg, Claes, 286
*On the Differential Action of Certain
 Muscles Passing more than One Joint*
 (Eakins), 203
Optical art, 285
Oriental art, 135–37, 259; influence on
 Homer, 166–67, 188; influence on Whis-
 tler, 247, 251–52
Oriental mysticism, 213

Pach, Walter, 215
Page, William, 122, 198, 240
Painterly mode, 16, 28, 30, 32, 35, 36, 57,
 59, 89, 91, 98, 129, 131, 132, 173, 193,
 235–61, 288
Palace of Diocletian (Adam), 39

Panorama and luminism, 112–13
Pantheist realism, 48
Paris Universal Exposition (1867), 166, 171, 191
Peale, Charles Willson, 67, 109, 140, 158
Peale, Raphaelle, 221, 224
Pelham, Henry, 26, 29, 38
Pendleton, William S., 110
Pennsylvania Academy, 201, 204
Penny, Edward, 42
Perspective studies, 119, 142, 145, 148, 195, 196
Peto, John F., 231, 232
Philadelphia Academy of Sciences, 203
Philosophical Enquiry into the Origin of our Ideas of the Sublime and Beautiful (Burke), 46
Photography, 118, 196–200, 274
Picasso, Pablo, 184, 265
Plein-airisme, 84, 86, 89, 145, 148, 167, 176, 189, 193, 194
Poe, Edgar Allan, 46, 198, 252, 253
Pollock, Jackson, 282
Pop art, 263–64, 286
Pope, Arthur, 156, 157
Porter, Fairfield, 192
Post-Impressionism, 172
Poussin, Nicolas, 98, 107, 158, 177, 178
Powers, Hiram, 122
Precisionists, 270, 271, 273, 276, 277
Primitivism, 15, 18, 19, 23, 99–103, 111, 143, 152, 157, 224, 267, 280
Proto-Impressionism, 33, 88, 91, 93, 121, 127, 128, 131, 155, 165, 172, 251

Quidor, John, 240

Raeburn, Sir Henry, 158, 236
Raft of the "Medusa," The (Géricault), 42
Raphael, 40, 157
Rauschenberg, Robert, 286
Read, Sir Herbert, 178
Realism: American, 15, 45; conceptual, 20, 21, 30, 111, 200, 221, 222, 224; luminist, 48, 96–97; romantic, 263; varieties of, 225; visual, 200, 235–36
Redon, Odilon, 255
Reed, Luman, 68, 76
Rembrandt, 148, 158, 208, 283
Remington, Frederic, 198
Renoir, Pierre Auguste, 255
Report Upon Weights and Measures (J. Q. Adams), 108
Revere, Paul, 25
Revue Indépendante, 255
Revue Wagnérienne, 253
Reynolds, Sir Joshua, 38, 40, 41, 48, 49, 65, 67, 71, 114, 151, 236, 249
Ribera, José de, 199
Richardson, E. P., 41, 54, 55, 58, 94
Richardson, Henry Hobson, 257
Richter, Johann Paul Friedrich, 48

Rimmer, William, 260
Rivers, Larry, 255
Robbers, The (Schiller; Allston), 46
Robinson, Theodore, 199, 244
Rodin, François, 271
Rollins, James S., 154
Romanticism, 45, 48, 55, 60, 74, 208, 211, 239, 246, 247, 263, 267; American, 37, 46, 47, 265, 271; in Eakins' art, 205; European, 73, 271; French, 47; Gothick, 46, 53; in Homer's art, 176, 188; in Ryder's art, 212, 214
Romney, George, 236
Rood, O. N., 259
Rosa, Salvator, 51, 68, 158
Rothko, Mark, 45, 219, 282, 285
Rousseau, Henri, 264
Rousseau, Jean Jacques, 61
Rowland, Benjamin, 135, 136–37
Royal Academy, 51
Rubens, Peter Paul, 57, 83, 145, 158, 238
Rush, William, 201
Rusk, Fern, 163
Ruskin, John, 114, 148, 248, 251, 255
Ruysdael, Jacob van, 115
Ryder, Albert Pinkham, 45, 51, 55, 60, 188, 211–20, 252, 253, 267, 270, 281, 282; in Europe, 214

Sacred Circle, The, 147
Saint-Gaudens, Augustus, 257
Salmon, Robert, 113
Sánchez Cotán, Juan, 22
Santayana, George, 97
Sargent, John Singer, 209, 227, 241–43, 248
Savage State, The (Cole), 68
Schelling, Frederick W. J. von, 48, 61
Schiller, Johann C. F. von, 46, 47
Schlegel, August Wilhelm von, 48
Schlegel, Friedrich, 48
Scott, John W. A., 110
Seurat, Georges, 131, 197, 255
Shahn, Ben, 122, 225, 279
Shakespeare Gallery, 46
Shaw, Joshua, 158
Sheeler, Charles, 23, 119, 264, 270, 274–75, 276
Shinn, Everett, 263
Signac, Paul, 255
Sloan, John, 263
Social Club, The (Harnett), 226
Society of Artists, 26
Society of Arts, 51
Spiritualism, 109, 122, 146–47, 148–49, 163, 256; and luminism, 122; and Transcendentalism, 147
Spooner, Shearjashub, 67–68
Spring Shower, Connecticut Valley (Heade), 129
Stamos, Theodoros, 285
Steen, Jan, 151

Stella, Frank, 287

Stuart, Gilbert, 30, 31–37, 52, 158, 235, 236, 237, 238, 241

"Studies from Nature" (Durand), 79, 86, 87

Sturges, Jonathan, 144

Sublime, 40, 46, 64, 66

Sully, Thomas, 36–37, 158

Sunset, Black Rock, Connecticut (Heade), 129

Sunset on Long Beach (Heade), 129

Surrealism, 95, 121, 127, 128–29, 175, 274, 283

Swedenborg, Emanuel, 147

Swedenborgianism, 122, 147, 240, 245

Symbolism, 223, 255

Symbolists, French, 197, 252, 253, 254

Synthetic Cubism, 265, 276

Taoism, 213

Technology and art, 262, 265, 272

Ten O'Clock lecture, 249

Teniers, David, 158

Thayer, Abbott H., 264

Things, preoccupation with, 22, 23, 70, 78, 96, 97, 98, 146, 211, 225, 230, 262, 265, 288

Thoreau, Henry David, 97, 123, 270

Titian, 30, 58, 145, 238, 247

Tough Story, The (Mount), 158

Toulouse-Lautrec, Henri de, 271

Transcendentalism, 22, 47, 48, 55, 110, 117, 213, 219, 223, 269, 271, 280; and spiritualism, 147

Treatise on Geometry and its application to the Arts (Lardner), 114

Treatise on Optics (Brewster), 141

Trompe l'oeil, 18, 20, 200, 223, 226

Tropical Flowers (Heade), 227

True Christian Religion, The (Swedenborg), 147

Trumbull, John, 19

Tuckerman, H. T., 80–81, 136, 138

Turner, Joseph, 68, 78

Twachtman, John Henry, 59, 89, 245

Twain, Mark, 152, 162

Tytler, Sarah, 44, 45

Van de Velde, Willem, 115

Van Dyck, Anthony, 19, 158

Van Gogh, Vincent, 283

Van Goyen, Jan, 115

Van Mander, Karel, 151

Van Ostade, Adriaen, 151, 158

Vanderlyn, John, 19, 62

Vedder, Elihu, 260

Velázquez, Diego, 199, 209, 238, 241, 247, 248, 252

Venetian color, 38, 57, 58, 61, 145, 238

Verlaine, Paul, 254

Vermeer, Jan, 197, 221

Vernacular technology, 108

Vernet, Joseph, 115

Veronese, Paolo, 247

View of Delft (Vermeer), 221

View of Toledo (El Greco), 218

Vinci, Leonardo da, 197, 238

Visual realism, 200

Vuillard, Jean Édouard, 255

Wagner, Richard, 217, 253, 254

Wallace, J. Laurie, 204

Wallenstein (Schiller), 47

Ward, Samuel, 69

Warhol, Andy, 286

Watteau, Jean Antoine, 158

Weber, Max, 264, 265, 276

Weir, J. Alden, 214

West, Benjamin, 19, 26, 37, 39, 40–41, 42, 43, 46, 49, 51, 150, 157, 158, 162

Whistler, James A. M., 45, 55, 70, 71, 167, 209, 213, 247–55, 285

Wilde, Oscar, 271–72

Wilkie, Sir David, 153

Williams, William Carlos, 274

Wilmerding, John, 113, 121

Winckelmann, Johann Joachim, 38

Wölfflin, Heinrich, 22, 104

Woodville, Richard Caton, 225

Wordsworth, William, 61

Worringer, Wilhelm, 218

Wyeth, Andrew, 122, 280

Zubarán, Francisco de, 222